Paul Klee and Cubism

Paul Klee and Cubism

BY

JIM M. JORDAN

PRINCETON UNIVERSITY PRESS

PRINCETON, NEW JERSEY

Copyright © 1984 by Princeton University Press

Published by Princeton University Press, 41 William Street,
Princeton, New Jersey 08540
In the United Kingdom: Princeton University Press, Guildford, Surrey

Works by Paul Klee are Copyright © 1984 by COSMOPRESS, Geneva and
ADAGP, Paris

Works by Georges Braque, Marc Chagall, Robert Delaunay, and Wassily Kandinsky are
Copyright © 1984 by ADAGP, Paris

Works by Juan Gris and Pablo Picasso are Copyright © 1984 by
SPADEM, Paris/VAGA, New York

Library of Congress Cataloging in Publication Data will be found on the
last printed page of this book

ISBN 0-691-04025-7

This book has been composed in Linotron Trump

Clothbound editions of Princeton University Press books are printed on acid-free
paper, and binding materials are chosen for strength and durability

Printed in the United States of America by Princeton University Press,
Princeton, New Jersey

Designed by Laury A. Egan

TO RACHEL JORDAN

CONTENTS

LIST OF ILLUSTRATIONS

Paul Klee kept a precise *oeuvre catalogue* in which his works were listed by year and by supplementary number, or sometimes letter, code. For example, the North Africa drawing *Sketch from Kairouan* is listed as 1914.46. In the Klee literature these *oeuvre numbers* are used customarily for ease of reference among the approximately nine thousand works by the aritst, and to distinguish among works that may have similar titles. Following this practice, Klee *oeuvre numbers* are given, after the medium, in the list of illustrations.

Works are here reproduced with the kind permission of the owners, who in most cases also supplied the photograph. Standard photographic credits are given following the illustrations list. For those plates which reproduce an earlier illustration, a full bibliographic reference is given.

COLOR PLATES
Following pages 56 and 136

BLACK AND WHITE PLATES

PHOTOGRAPH CREDITS

ACKNOWLEDGMENTS

My serious interest in Paul Klee began almost twenty years ago when I was myself a painter. The desire to know more about this extraordinary artist was a final catalyst in my decision to leave creative art for the pursuit of historical and critical studies. Klee was a focus for my graduate study and the topic of my dissertation, which has in turn served as the basis for the present book. To thank everyone who contributed to my thoughts on Klee would, in fact, mean naming all who had a part in my training and development as an art historian—a just, but impossibly long acknowledgment. I am sure that most of my friends, family, and colleagues will accept a tacit, but nonetheless heartfelt, thanks and will understand that I must limit the present note of appreciation to those who helped in immediate ways toward the realization of this book.

Paul Klee and Cubism is based upon my dissertation, of a similar title, finished in 1974 at the Institute of Fine Arts, New York University. It is therefore appropriate to begin my acknowledgments with those persons and organizations that gave help and encouragement during my early, predoctoral period of Klee studies. My appreciation goes to the Institute of Fine Arts and the Swiss National University (with the Institute for International Education) for fellowships which made possible my study during 1969-1970 of the collection of the Paul Klee Foundation, in the Kunstmuseum Bern, and of Klee works elsewhere in Europe. Dr. Hugo Wagner, then Director of the Kunstmuseum, and Dr. Kathalina von Walterskirchen, then Curator of the Klee Foundation, and the Museum's staff were most helpful in allowing me to study that essential collection at length and in detail. Dating from this time as well is my special debt of gratitude to Felix Klee, who made it possible for me to study the works and memorabilia in his collection, and who has through succeeding years responded with unfailing kindness to many questions about Klee and his art. Several other private collectors graciously allowed me to study their Klees and related materials, and they too are most sincerely thanked.

At the Institute of Fine Arts I was privileged to study with the late Robert Goldwater. The approach followed in this book was developed, to a large degree, in response to his classes and conversations in the late 1960s. Whatever strength

the method may have was gained in the impossible struggle (familiar to all his students) of trying to live up to Professor Goldwater's brilliant and rigorous intellectual standard. I am indebted to his memory not only for his advice and friendship, but even more for the lasting challenge. Robert Goldwater died shortly before I finished my dissertation, and Gert Schiff took over as my adviser at that late date. He too receives warmest thanks, not only as adviser but as a colleague and friend who has encouraged my Klee studies over the years. To Irving Lavin I owe special thanks for securing one final Institute fellowship which financially provided a summer away from my fulltime teaching post in which to complete my dissertation. To the whole faculty of the Institute and the Graduate School of Arts and Science of New York University go my appreciation for the honor of the James C. Healey Award for the most outstanding dissertation in the Humanities, which they bestowed on my work in 1974.

For the years during which I transformed my dissertation into a book, I am indebted to many who encouraged and tested my thinking. Charles Haxthausen has been a close and valued colleague in Klee studies, whose conversations and writings have been a frequent stimulus. Jürgen Glaesemer, Curator of the Paul Klee Foundation, has responded with constant help and encouragement to the countless questions and requests I have addressed to the Kunstmuseum, and his catalogues and essays on Klee have been models of precision and clarity. Angelica Rudenstine; Richard Martin, Editor of *Arts*; Armin Zweite, Director of the Städtische Galerie im Lenbachhaus, Munich; and John Elderfield, Director of the Department of Drawings at the Museum of Modern Art, New York, have on specific occasions provided encouragement to my work on Klee. Since the early seventies when I wrote my dissertation, significant new books and articles on Klee have appeareed by Felix Klee, Glaesemer, Haxthausen, Christian Geelhaar, O. K. Werkmeister, Marcel Franciscono, and others; and I have incorporated references to them at appropriate places in my book. But in addition I want to acknowledge the excitement and challenge these texts (some quite different in orientation from my own) have provided during the time of the recasting of my ideas. These authors have raised Klee scholarship to a new level, stimulating debate and obliging me along with the others to redraw and sharpen my own particular point. The editors and readers of Princeton University Press have contributed to my several revisions, and by reaction and query have helped to correct several matters of detail. Questions and discussion by my students, both at Dartmouth College and at the Institute of Fine Arts, have helped to crystallize parts of the book such as the conclusion where I try to define Klee's relationship to the broadest strains of modernism.

I am grateful to Mary Laing, who first considered this book for Princeton

University Press, and to Christine Ivusic, Fine Arts Editor at Princeton, who sponsored the manuscript for publication and has shepherded author and manuscript through the final complexities of preparation for the press.

The owners of the works by Klee and others here illustrated have been uniformly cooperative in providing photographs and granting permission for their reproduction. All of these, museums and private collectors alike, are thanked sincerely for their kindness. Special advice on illustrations was provided by the Kunstmuseum Bern, and by the Department of Rights and Reproductions of the Museum of Modern Art. The Kunstmuseum staff was extremely patient in helping me track down a few very elusive pictures. Particular help with the illustration details and with the location of works was kindly provided by Felix Klee; Jürgen Glaesemer; Armin Zweite; Angelica Rudenstine; Charles Haxthausen, Curator of the Busch-Reisinger Museum at Harvard; Ernst-Gerhard Güse, Curator at the Westfälisches Landesmuseum, Münster; Peg Weiss of Syracuse University; Michel Hoog, Curator of the Musée de l'Orangerie in charge of the Palais de Tokyo; Christian Geelhaar, Director of the Kunstmuseum Basel; and a number of others in Europe and the United States.

During the final stages of manuscript preparation, Jeffrey Horrell and the staff of the Sherman Art Library at Dartmouth helped in speedily securing interlibrary loans and in other bibliographic matters. Elizabeth O'Donnell offered expert photographic advice on a number of occasions. Norma Jean Zani has been a tireless aid in the correspondence occasioned by the book, typing countless letters and drafts. These and other friends share in my thanks.

To my wife, Rachel, to whom this book is dedicated, and to our son Christopher go my deepest appreciation for patience, encouragement, and the contributions of love, wit, and good spirit that enabled me to carry the work to completion.

PREFACE

The theme of this book is the definition, historically and stylistically, of the part that Cubism played in Paul Klee's art. I propose to assess the relationship by reexamining the direct Cubist influences on Klee from 1912 to 1914, and by analyzing his successive stylistic responses to, and uses of, Cubism from 1912 to 1926. From around 1927, I have found Klee's work to no longer yield particular insight through Cubist interpretation, since it conforms increasingly from that date to the styles of Constructivism and abstraction. My inquiry will close, accordingly, with an account of the onset of Klee's post-Cubist period.

First, a review will be given of Klee's early work, with an eye to how he characteristically uses artistic sources. Then, a detailed chronological examination will be made of the events of 1911/1912-1914 through which he became acquainted with his Cubist sources. Representative works through 1926 will subsequently be examined in context, starting with the probable first appearances of Cubism in his art. At each stage, the type or phase of Cubism—specific works where discovered—to which Klee relates will be discussed.

This will involve a detailed consideration of just what Cubist form itself consists of. As working criteria, Klee's works (and his sources) will be consistently examined for Cubist shape, Cubist interrelationship, and Cubist composition. The device of *passage*, the interrelationship of foreground and background planes by means of an intermediary inclined plane, will receive attention as the central indicator of the Cubist nature of Klee's space. The poles within Cubism of the Analytic and the Synthetic will be recognized and assessed for Klee. It will be seen, for instance, that while many of Klee's shapes resemble Synthetic Cubism, from a period even before Synthetic Cubism emerged in Paris, his shapes always interrelate in ways borrowed from high Analytic Cubism.

Klee will be observed, at times, to reverse some of the classic Cubist procedures; piling up, for example, not shards of a fragmented still-life, but rather tiny, discrete pieces of a fantasy world. Alternatively, as in the face of his well-known *Senecio* (Colorplate VII), Klee uses a Cubism of small facets to articulate

a large form, in this case a circular head, which maintains itself an unbroken, non-Cubistic integrity of outline.

But the most essential element of Cubism for Klee was not its abstraction or schematization but its pictorial space. Cubism provided Klee with a means for structuring and controlling space. Through Cubist *passage*, a shallow, ambiguous, but visually rationalized (if not precisely rational) volume could be created without the use of traditional perspective or modeling of form. This space was extremely useful to Klee, for while it was relatively "pure" and modern, the shallow Cubist box was also an efficient stage for the graphic and plastic effects of his linear imagery.

The most mysterious characteristic of Cubist space, which originated in the Analytic phase, is its implication that more is being represented than is actually shown—more complexity, more spatial ambiguity, and more richness than is in fact depicted. In French Cubism this is a function of one's awareness that one is viewing the end product, however emblematic, of an analytic process. For Klee, the effect served very different ends. This hinting at spaces not precisely measured, at relationships only half-revealed, could hardly have been better suited to his goal of Romantic, metaphysical, and psychological suggestion. With Klee, the visual complexity of Cubism became a paradigm for the inner complexity of the mind.

By applying the criteria of Cubism to Klee's career, we shed light, moreover, on several phases of his art that until now have been misunderstood. The beginning of Klee's Cubist adoption has been placed usually, for example, in rough simultaneity with his "traumatic" experience of color in Tunisia in April 1914. A check of the chronology of works indicates, however, that he had had almost two years of Cubist-influenced work prior to the North African trip. His extremely important 1913 phase will subsequently be examined in detail. Klee's close association with Auguste Macke during the Tunisian trip will be seen as the means by which a second wave of influence from Robert Delaunay reached Klee, modifying the adoption of Cubism which Klee had already begun.

Under the further influence of Cubism, from 1915 to 1918, Klee's usual linear element is subordinated to the interests of color and plane. Klee's works of these little-studied years take on a new logic, as steps in his development of a new flexibility in his Cubist space. His work around 1920 is in turn marked by a balance among all the pictorial elements; so sure had Klee become by then of his space that he again gave full rein to his linear tendency. His characteristic black-line designs of 1920-1926 are firmly fixed on the surface and within the shallow *passage* of a classic Cubism.

During 1926 this space weakened rapidly in consistency, as Klee left his

period of dominantly Cubist structure. The *passage* device, in particular, was rarely used in his later work. From this point on, Klee moved from relativism into the formal absolutism of his last fourteen years.

This teminus marks off Klee's Cubist period of 1912-1926 as precisely the centerpiece, the middle third of his career. It has been usual, in past literature, to divide Klee's art into a large number of small periods coinciding more or less with his changes of location: for example, a Weimar period, a Dessau period, a Düsseldorf period, and so forth. This new division into larger pre-Cubist, Cubist, and post-Cubist periods is based, by contrast, on the chronology of style, rather than merely on biography. It can thus offer a basis for further stylistic study and reappraisal of Klee's many-sided, complex oeuvre.

A NOTE ON THE ARTIST

Klee's life spanned the first half-century, the pioneer years, of modern art. He was born in Münchenbuchsee near Bern, Switzerland, in 1879, the son of a professional musician and music teacher.[1] Klee was himself undecided during his school years between a career in music or in art. After finishing at the Bern Gymnasium, however, he took the decisive step by beginning academic art training in Munich in 1898. After two years in the private drawing school of Knirr, he studied in the Academy class of Franz Stuck during 1900-1901. Concluding his formal study at this point, he undertook a six-month trip to Italy, staying for the longest time in Rome.

From June 1902 to 1906, Klee lived with his parents in Bern and in 1905 visited Paris for the first time. Klee's work, particularly his etchings, during this period was based primarily on international Symbolism and Jugendstil, the style of his teachers' generation. Klee's intensity and self-examination during these early years are richly recorded in the diaries, which he had begun in his last gymnasium year.

In September 1906 Klee married the Munich music student Lily Stumpf and settled back in that city. Nonetheless, he remained artistically much on his own for the next five years, as he experimented with a looser, Impressionist-related style. The Klees' only child, Felix, was born late in 1907.

Toward the end of 1911, Klee made the acquaintance of the more well-known Munich painter Wassily Kandinsky, and was drawn into the avant-garde circle of the Blue Rider group. Over the winter, in two Blue Rider exhibitions, Klee first saw examples of Cubism; and in the spring of 1912 he traveled to Paris for two weeks again to study new developments. Klee's critical writings of the time show that he very carefully analyzed the elements of the new art; but in his own work, the Cubist influence appeared only very slowly, over 1912-1913.

In 1914, at the age of thirty-five, Klee entered a new phase, the beginning of his artistic maturity. In April he traveled with friends to Tunisia and there advanced suddenly, "traumatically," to the mastery of color. Simultaneously, a

full realization of Cubist structure was achieved in his art, the fruition of two years of intense stylistic study and growth.

The First World War, declared in August 1914, deeply affected artistic life in Germany. Franz Marc and August Macke, close friends of Klee and leaders of the Blue Rider, were killed at the front, and Kandinsky returned to Russia. Klee himself was drafted, and served subsequently as a noncombatant in 1917-1918, in an office-work post, near Augsburg. He continued to paint during the war years and was able, on leave and in spare hours, to tend to the publications, sales, and exhibitions that accompanied his burgeoning career.

After the end of the war, Klee was invited to join the faculty of the new Staatliches Bauhaus in Weimar, founded by the architect Walter Gropius, and he began to teach there in January 1921. This was perhaps the busiest period of his life, as he kept up a tremendous production of art (299 works in all media, for example, in 1924) and presented in addition long courses of theoretical lectures at the school, which he recorded in copious notes. Klee exchanged ideas freely at the time with fellow artists such as Kandinsky, Feininger, and Moholy-Nagy. In Weimar, too, the slightly darkened coloristic style Klee had evolved during the war years was clarified. Klee's Cubistic structure, present in all essential elements since 1914, was finally lightened and systematized, a response, in part, to the rational idealism that inspired the early Bauhaus.

In 1925-1926 Klee moved with the Bauhaus to Dessau. The rise at this time of a Constructivist, engineering orientation in the Bauhaus gradually disaffected the "Romantic" Klee. He traveled widely during the Dessau years to Italy, Corsica, the Basque country, Brittany, and at the end of 1928, to Egypt. Finally, in 1931, he left the Bauhaus to take up a more congenial teaching post at the Art Academy of Düsseldorf. In his painting of the time, however, Klee responded more positively than one might expect to Bauhaus Constructivism. By 1926 he had gradually shifted the structural basis of his art completely from Cubism to his own version of international Constructivism.

A period of increasing abstraction followed for Klee's art, culminating in the nonobjective Egyptian pictures of 1929-1930. The early thirties were a time of some stylistic uncertainty, of abstraction mixed with other modes, including a system that resembled Neo-Impressionism. This was a troubled period for Klee personally, as well, as the Nazis came to power in Germany. They had Klee dismissed from his Düsseldorf Academy post, and at the end of 1933 he and his wife moved back to Bern.

After two years of intensive work, Klee's life was again disturbed, in 1935, this time by the onset of the chronic illness, scleroderma, that would bring about his death just five years later. Then during 1937 Klee's productivity took a mi-

raculous upsurge when, recovered from the first attack of sickness, he initiated the broad style of his final years. Runic signs and symbols, which had long been a part of his art, now took the forefront as he developed a mode of near-gestural ideogram. Resembling language, but not literally decipherable, these marks are bold, unqualified statements, far from the pictorial intricacy of his Cubist years. Klee developed color much further as well, increasing its intensity and independent value in his painting as he continued to work, despite illness, close to the end of his life. Klee died in a clinic in Muralto-Locarno, on June 29, 1940.

Paul Klee and Cubism

Introduction

THE STRUCTURE
OF FANTASY

Klee's widest source of appeal is his humor. Amusement is often the initial reaction to a Klee painting. This develops subsequently in most viewers, however, into a more reflective, bemused state. Klee's strange, exotic pictures, when examined for more than a moment, reveal great richness. One begins to savor a taste of irony in his visual puns and jokes, and the eye becomes engrossed in the intricacies of line and color through which Klee projects the image. His forms lie flat on the surface of the painting, and yet they suggest mysterious depths and complex relationships. Step by step, the simple, childlike marks develop into a fantasy world of many layers, full of strange actions and suggestions of meaning.

The casual observer may experience such feelings, for example, while looking at Klee's watercolor *Dying Plants* (Plate 1) in The Museum of Modern Art. The first glance shows luminous, plantlike forms, floating before a dark ground of horizontal steps or layers. One might well suppose this to represent a half-abstract stage scene, a ballet, play, or opera. A closer look, following this thought, reveals two central characters, humanoid flowers, that appear to shed their petals, fall down, and die. Their despairing gestures suggest high tragedy, as in, for example, the last scene of *Romeo and Juliet*. The half-human features and miniature scale, however, belong less to a real stage than to the children's theater of tiny dolls, puppets, and marionettes. The bizarre, phosphorescent lighting here calls up even stranger associations, as in a hallucination or dream. Klee takes us full circle in our thoughts, reminding us finally that such a scene is but a playful fantasy of the mind.

3

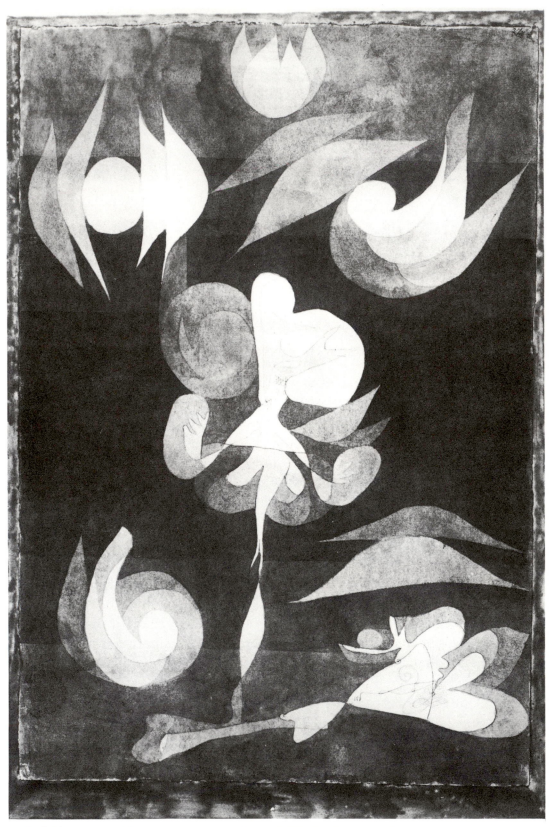

1. Paul Klee, *Dying Plants*, watercolor and pen, 1922.82, 19⅛ x 12⅝".

We recognize now that Klee leads his "reader" into the picture by appealing to his or her imaginative faculties. By his sketchy faces, for example, Klee suggests a humanization of the plant world. Does he imply by this that he thinks lower orders of life really experience humanlike emotions? Or does he merely point out by this device how readily, through empathy and with figure of speech, we project our feelings out onto the inanimate world?

Dying Plants, with further reflection, sets up other mental resonances, awakening more fantasies, and even philosophical speculations. Another look at Klee's characters reveals that they are not only plant-people but embody other species as well. The central face, with its beak and sharp teeth, suggest a "snapdragon," a predatory insect, or reptile. The other face, with its large eyes, is perhaps a gentler, nocturnal creature, such as a small mammal or a moth. The biological forms, as Klee draws them, are really quite nonspecific, suggesting now a person, now an animal, now an insect, now a flower. Similarities among all life forms are implied by this generalization.

A viewer with a pantheistic turn of mind might subsequently read Klee's scene as a symbol of the kinship, and common fate, of all life. Just at death, Klee might seem to say, the flame of life burns brightest. In its final moment Klee's central flower surges upward, glowing, through many strata of existence. One might even imagine that it is the soul of the lower bloom, launched forth by death into the journey of transmigration.

Only a slight change of emphasis, by a viewer perhaps more science-minded, places Klee's scene in the world of comparative biology. Science, in our century, has made us all familiar with the simplest, cellular level of life, where all forms—plant, animal, and viral—appear virtually identical. Klee's generalized shapes, thus, might have come from under a microscope. Or they might even belong to biological prehistory, when all of life was just a few undifferentiated cells. We observe, quite possibly, a fantasy of evolution, with some things turning into plants, some into animals, and some into humans.

A more literary scenario might connect *Dying Plants* with the classical legends of Apollo and Daphne, or of Narcissus. At the climax of both these stories, a human undergoes a metamorphosis into a tree or flower. The painting and the myths themselves may refer to a more primitive, psychological dread, embodied for example in the lore of the mandrake root, of the nightmare image of a plant-man monster.

An even more sinister drama is suggested by the tiny details of sexual difference between the plants. The upper figure has a large headdress, balletic arms, and tiny, pointed feet. Suggestive forms about the middle may represent curving hips, a skirt, or pendulous breasts, all decidedly female. The lower creature, dead

or dying, has a phallic body and a homely, masculine face. The love-death of the praying mantis is possibly called to mind, wherein the female devours the male in the course of the mating act. The swollen form of the female may suggest the fullness of satiation, cannibalism, and pregnancy all at once. The desiccated male form with its pinched neck, in this reading, suffers a tragi-comic *Liebestod*, the victim of a cruel plant-insect-vampire.

In their shadowy world, Klee's forms easily provoke such atavistic thoughts. The very structure of the psyche, with its layers of consciousness and obscure depths, may even be suggested by Klee's dark strata. The popular notion of the Freudian model of the mind, with repressed thoughts imprisoned in the lower levels, could well be represented. The Jungian theory of a shared unconscious may even be depicted in the way figures stem upward from a common base. Klee's painting thus has the very unususal characteristic of not only representing images but presenting as well diagrammatic suggestions of the structure imposed on such images by the mind.

This brief reflection shows what a large amount of meaning Klee can invest in a single work. His method is suggestion—assembling forms that resemble other forms and call to mind even others until whole worlds of thought seem to be implied. In our "tour" of *Dying Plants* we were led in many imaginative directions, through ideas of theater, classical legend, comparative biology, evolutionary history, and psychosexual fantasy. No single reading, moreover, canceled any other. All were equally plausible, interrelated, augmenting one another. Once the speculative, analogical nature of Klee's thought is grasped, the viewer strikes out on his own, assured that he is following the artist's intention by bringing as many interpretations to the work as his mind can provide.

One source of Klee's fame should be clear from this. He is a painter of ideas. Unique among the semiabstract artists of our century, Klee stands out as being legible, on some level, to almost everyone. Other artists involved in modern psychology, the Surrealists and Expressionists, for example, are accused frequently of being obscure, of treating themes that are limited only to their personal interests. Klee, by contrast, seems Goethean, encyclopedic, touching on most of the central concerns—mental, physical, and spiritual—of our time.

Much writing on Klee, in the past, has followed the foregoing approach, reading his images, and compiling their almost endless interpretations. There is both strength and weakness in this. First, the iconographic approach was obviously encouraged by Klee as he contrived his images, setting them up into a communicative structure.

But there are limitations to this approach as well. Exclusive focus on Klee's

6

content and poetic meaning can obscure the pictorial structure at hand. The iconographer is guided along by the machinery of a Klee and cannot examine its inner workings. Responding to all the effects, he does not ask the equally crucial question of how Klee brings it all about. How does Klee compact so much imagery and meaning into such a minimal group of forms? How, without actually "illustrating," does he so provoke our thought?

A few of Klee's pictorial *means*, how he achieves his ends, might be pointed out. We note, for example, in *Dying Plants* that Klee has seemingly pulled his plants apart, breaking them into fragments and then putting the pieces back together in unusual, fantastic combinations. Thus, through fragmentation and dislocation, he sets up many of the chains of imaginative and emotive association that we noted before. In addition, most of the forms are transparent or translucent. They seem to interpenetrate, or partially pass, one through another. This device obviously corresponds to the dense interlocking of ideas we experienced in the earlier interpretation.

We may note, moreover, that the interpenetrated forms are differentiated tonally, layered in stages from dark to medium to light. This stepwise progression of facets is a model of revelation, of coming to light, and is, we may now realize, the visual device that lay behind much of our psychological interpretation of the picture. These tonal gradations, too, maintain the illusion of a shallow stage space for the scene. The eye places the lightest forms in the foreground, in the spotlight, and the darkest forms at the backdrop. The intermediate planes, like stage flats, step back and forth to fill the space between. Thus, both the drama of stage lighting, and the sense of limited enclosure—both essential to the emotional urgency of the scene—are created by the simple tonal device.

Finally, Klee's composition of the scene, his allover arrangement of the forms, has a great effect on our thoughts of its meaning. He has obviously not employed a traditional perspective. There is no strong sense of up and down, as the objects seem to float about freely. This weightlessness contributed to our feeling, earlier, that the scene had an "other" reality, as in a dream. Freed of gravity, the forms are evenly spaced along a background grid. This gives them the nature, as well, of a diagram, prompting our feeling that they were in some way a mysterious, pseudoscientific chart.

It became clear to me in the course of my study that this structural side of Klee had received less attention than it deserved. The great quantity of content-interpretive writing on Klee in the past, such as the monographs of Grohmann, Haftmann, and Huggler, were there no other reason, called for the corrective of a more formal-analytic approach.[1] After an initial period of comparing Klee's

works to one another and to works by Picasso, Kandinsky, Mondrian, Léger, and other artists of the same generation, two discoveries were made which confirmed my earlier sense that there was more to Klee's form than had been explained.

First, when isolated and analyzed, Klee's forms compared very favorably with the other artists of his period. Studied in detail, his structure showed great intricacy and sophistication. Klee's formal language is as subtle and witty as his language of images. Even when considered—at an extreme—as abstractions, Klee's works embody many of the advances and interests of a Picasso or Mondrian. Yet, traditionally, Klee writers had tended to "excuse" him from such rigorous formal comparison, thinking perhaps that because he was a miniaturist and "illuminator," he was not up to competition with the great structuralists. This view of Klee as a special, isolated case in modern art is ultimately condescending, and needlessly protective. Clearly, Klee's form needed full reappraisal. Our whole concept of him as a fantasist would have to be modified, following a realization of his stature as a structural modernist.

At another point in my study, while tabulating the structural devices of a painting such as *Dying Plants*, I realized that Klee's pictorial elements strongly resembled those of Analytic Cubism. While it had been long recognized, in the literature, that Klee knew of Cubism, Picasso, Braque, and Delaunay, this was usually treated as a passing interest, an influence that Klee outgrew with maturity. In strong contrast to this, it now appeared to me that the major formal aspects of Klee's whole middle period, 1912-1926, were best understood as Cubist. This included, for example, the fragmenting and dislocating of forms, the interpenetration of translucent planes, the shallow space, the tonal gradations, and the centralized, gridlike composition. Far from merely observing Cubism around 1912, Klee had in fact *become* a Cubist, in all ways but one. Clearly, he had had little interest in the subject of still-life, as pursued by the Parisian Cubists. But with the image problem set aside, all his forms matched exactly with the Cubist criteria.

This view of Klee admittedly involves difficulties. The focus is on means rather than ends; and by setting aside the artist's affective goals, one might appear temporarily to do violence to the art. Problems arise, too, with Klee's own theories, which date from these same middle years. My own Cubist interpretation (below, Chapter 8) of *Double Tent*, for example, appears to run counter to Klee's own discussion of such work in his published Bauhaus notes.[2] One of Klee's key tenets there is that art should be read in terms of formal genesis, with shape growing out of shape as an expression of a "Bergsonian" life force. Klee interprets work like *Double Tent* in this way, emphasizing color "movement and countermovement." His well-known directional arrows, both in diagrams and in many

paintings, frequently symbolize the forces, physical and metaphysical, of change. But this dynamic approach, too, can obscure form, and therefore the structures of Klee's finished works will be here considered as fixed and static, rather than in a state of becoming.

Ultimately, formal consideration as a Cubist can only increase appreciation of Klee's poetic goals. On reflection, we may recognize, for example, that the meaning and fantasy of *Dying Plants* are in no way diminished by analysis of its parts. Quite to the contrary, new levels of meaning are added by an understanding of structure. The eye, probing these delicate, butterflylike constructs, discovers anew their paradoxical stability. The Cubistic patterns, open-ended and infinitely suggestive, are the perfect medium for Klee's style of content. We see through each form, as in a house of mirrors, to another and another, as Klee's images resonate, reflect, and double back. Their richness is increased many times, as their symbolic value is compounded by the mysteries inherent in Cubist form.

Chapter 1

EARLY KLEE: THE EXPLORATION OF SOURCES

Klee's early career had prepared him well for his later contact with Cubism. Through the exhibitions of the Blue Rider in the winter 1911-1912, he was introduced to Cubist painting, which changed the subsequent course of his art. Yet by this date, he was already thirty-one years old and had behind him twelve years of artistic endeavor. He was conscious of his search for style; in the spring of 1911, just a few months before his introduction to Cubism, he gave the following analysis:

> The longer my production moves in a definite direction, the less gaily it progresses. But just now something new seems to be happening to the stream: it is broadening into a lake. I hope it will not lack a corresponding depth. I was the faithful image of a part of art history; I moved toward Impressionism and beyond it. I don't want to say that I grew out of it; I hope this is not so. It was not dilettantism that made this small-scale replica out of me, but modesty: I wanted to know all these things, so as not to bypass any out of ignorance, and to assimilate some parts, no matter how small, of each domain that was to be given up.[1]

The broad outlines of the early influences on Klee are briefly stated: *Jugendstil* and Symbolism until around 1906, and Impressionism and Post-Impressionism, 1906-1911. The premodernist influences had ultimately, I think, a less determining effect on Klee's work after 1911 than one might perhaps expect.

10

Certainly some of his linear motifs and general choice of subject-poetry continued throughout his career to reflect the legacy of Symbolism-Art Nouveau. But regarding the form of his painting, the importance of such influences pale in comparison to the overwhelming impact of Klee's adoptions from modernism and particularly Cubism. Over 1912-1914, the Cubist influence overwhelmingly supersedes the earlier formal influences in Klee's art. There is, however, another reason to review those years when Klee was a "faithful image" of art history.

Klee's early years are extremely well documented by his published *Diaries*, which start with 1898 and contain supplementary childhood memories of an even earlier date. For Klee's student years and early professional life, we are given detailed accounts of personal and artistic events of every description: there are the sexual confessions of the adolescent art student in Munich and extraordinary analyses, by a brilliant mind, of numerous books, plays, musical compositions, and art exhibitions that were part of his formative years; detailed records are given of friendships and family matters, and day-to-day chronology is logged precisely with addresses, schedules, concert programs, and reading lists. Then, starting around 1911, at the time of his acquaintance with the Blue Rider and Cubism, Klee became much more reserved. Just when we wish to know more about his exciting new contacts, he reports less. The entries for 1911 to 1918—the extent of the published *Diaries*—are much fewer and briefer than those of the earlier period. Perhaps, as Klee matured artistically, literary introspection became less important to him: perhaps the challenge of dealing with new forms left him with less time or energy to write. And possibly, with the growth of fame and recognition, he became more self-conscious—even secretive—about discussing his sources. In the Expressionist milieu of the 1910s and 1920s, the dominant image, after all, was of the wholly self-inspired artist.

Thus, based on the written record, we have far less detailed knowledge of Klee the modernist than of the early Klee. There is considerably less in the later *Diaries*, and the situation is improved only slightly by Klee's published letters.[2] Extremely important post-1911 influences, such as Kandinsky, Cubism, and Robert Delaunay, are mentioned only briefly, and then usually without significant comment. The important stylistic events of Klee's whole middle career are passed over almost in silence.

To fill this vacuum in the artist's own commentary, we must rely on the heavily documented early period. By 1911, although Klee had not yet developed a mature style, he had established, surely—by thirty-one years of age—habits of study and patterns of assimilation which would hold true for the rest of his life. By examining the early account, we can form reasonable speculations based on

the scanty record of the later period. Conclusions about how Klee used his early sources can thus guide us in studying his later art. A short review and analysis of the early period, therefore, is in order.

Probably no other major artist has left such extensive writing shedding so much light on his early work.[3] Among the hundreds of influences mentioned by Klee and reflected in his early work, I will concentrate on those which appear relevant, in an introductory way, to Klee's later acquaintance with Cubism. In the following analysis of Klee's works from the pre-Cubist period, emphasis will be placed not only on the individual works and their specific influences, but on Klee's whole style of source-use and assimilation.

During his early Munich Academy period, 1898-1901, Klee had been relatively unresponsive to the more decorative, linear strain of international *Art Nouveau-Jugendstil* as practiced in Germany by August Endell, Otto Eckmann, T. T. Heine, and countless others who contributed illustrations and decorations to the periodicals *Jugend, Pan,* and *Simplizissimus*. Klee's few works in this style are from 1901.[4] The culminating work of Klee's early years was the series of etchings, the "Inventions" of 1903-1905, the post-Academy period in Bern. These images belong to quite another branch of *Jugendstil*: the classicizing Symbolism of Hodler and Stuck and other Germanic artists who drew upon the earlier Classicist Romanticism of Böcklin and Marées. This branch of Symbolism emphasizes, although to be sure in a contorted way, the volumetric plasticity which the decorative *Jugendstil* denied.

Sources have been identified for many aspects of Klee's early etchings. *Virgin in a Tree* of 1903, for example, probably depends upon the Symbolist Giovanni Segantini's composition *The Evil Mothers,* of 1894, which Klee could have known from reproductions.[5] Certainly there is a great deal of Ferdinand Hodler in the parallelisms of limb, tense musculature, and abstract background of *Virgin*—an influence confirmed by Klee drawings.[6] Klee had admired Hodler, the most famous Swiss Symbolist, for several years and so the influence (which is visible in several other of Klee's "Inventions" as well) is not surprising.[7]

A number of other, less obvious, influences have been adduced for the etching series. For example, Hans Hofstätter has suggested a source for Klee's *New Perseus,* 1904, in an illustration to Lavater's *Physiognomische Studien* of 1775-1778.[8] Marcel Franciscono, by contrast, believes that this same print may possibly reflect the influence of certain Roman mosaic heads which Klee would have seen on his Italian study journey.[9] This situation—where more than one source seems equally plausible—is, as we will see, far from unique.

Klee's interest in Aubrey Beardsley is well recorded in the *Diaries*. On a trip

to Munich in October of 1904, he looked at Beardsleys in the museum print room, noting shortly after:

> During her brief stay in Bern this summer Wassiliew [an old friend] had got me excited about Beardsley. I asked for his earlier and later work. His style is influenced by the Japanese and is thought-provoking. There is something seducing about it, and one follows with some hesitation.[10]

Nevertheless, Beardsley's influence on Klee's art is somewhat elusive. Carola Giedion-Welcker suggested that Klee's print *Menacing Head*, of March 1905 (Plate 2), reflects Beardsley's illustration to Edgar Allan Poe's story "The Black Cat," in which a satirical monster-animal crowns a grimacing human head.[11] Another Beardsley, a portrait of *Balzac* (Plate 3), is even closer to the Klee in physiognomy. This drawing, a *Cover Design from Balzac's "La Comédie Humaine,"* was reproduced in *The Later Work of Aubrey Beardsley*, which along with a companion volume, *The Early Work of Aubrey Beardsley*, had appeared with John Lane publishers in 1899-1900.[12] Since Klee asked for the "earlier and later work," it is more than likely that these volumes were his chief Beardsley source.

In comparing *Balzac* and *Menacing Head*, one notices how closely matching in both Klee and Beardsley are the general conceptions of the head above a horizontal base. The delineations of the mouth are similar, and the noses, with their black nostrils and segmented bridges, are virtually identical. The skin-folds diagonal from the nostrils, the eyebrow lines, and the knotted folds between the eyes are very much the same in the two heads. Klee exaggerates and intensifies the feature distortions, particularly around the eyes, and renders the whole head, with his odd stippling technique, into a relieflike plasticity, which for all its modeling is finally less sculptural than Beardsley's masterfully abbreviated line drawing.[13]

Another Beardsley derivation is instructive because it stretches over three years and as many techniques. The final version of Klee's *Portrait of a Sentimental Lady* (Plate 4), is a glass painting (*Hinterglasbild*), a medium Klee took up in 1905 as a freer-drawn alternative to etching.[14] The source for this image would appear to be Beardsley's *The Lady with the Rose* (Plate 5), which appeared in *Late Beardsley*, Plate 166, in half-tone.[15] In both, a very large-busted woman— with very similar face, neck, and breast contours—reaches forward languidly with a Symbolist rose; the quarter-turn of the face to the front spatially emphasizes the profile distortion of the torso—so evidently plastic, yet rendered by a flattened

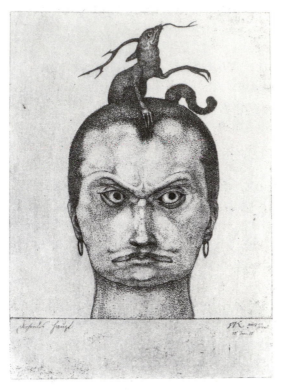

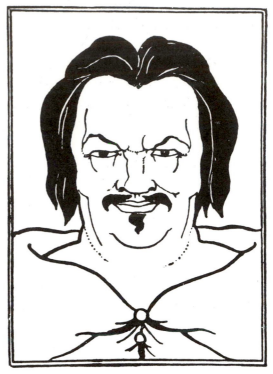

2. Paul Klee, *Menacing Head*, etching, 1905.37, 7¹¹⁄₁₆ x 5¾".

3. Aubrey Beardsley, *Cover Design (Side) from Balzac's "La Comédie Humaine"* (from *The Later Work of Aubrey Beardsley*, pl. 67).

stylization; and both figures similarly relate to an abstract horizontal in the background. To be sure, the eroticism of Beardsley is modified by Klee into something like a satire on Symbolism itself. The *amorino* of Beardsley becomes a small dog in Klee, and the lady in face, dress, and in the form of the whole lower half of her body has been coarsened, made plainer and less erotic, and thus somehow more ethically serious by Klee.

The first version of this image by Klee had been an etching, done in June of 1904, titled *Dame*. In the spring and summer of 1905, a proof of this etching was reworked by Klee and inscribed with the title "Critique of Normal Woman."[16] It should be noted that the date of the first version places it almost five months prior to the October 1904 visit to the Munich print room. But on the face of the strong visual evidence of the connection, we must take seriously the hint, offered in the diary entry quoted above, that Beardsley had been studied the previous summer.[17] Klee's diary of ca. June 1904 notes, " 'The Lady' had something attractive as a silhouette, but the modeling, because of its compromise with realism, has destroyed the whole charm of it."[18] This might seem to reinforce the

14

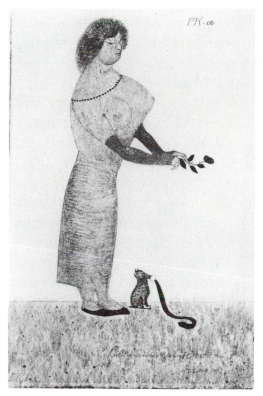

4. Paul Klee, *Portrait of a Sentimental Lady*, glass painting, 1906.16, 9½ x 6¼".

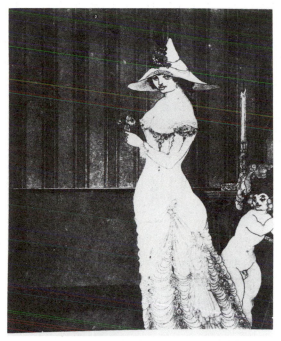

5. Aubrey Beardsley, *The Lady with the Rose from Théophile Gautier's "Mademoiselle de Maupin"* (from *The Later Work of Aubrey Beardsley*, pl. 166).

idea that Klee had seen the Beardsley, which is indeed attractive as a silhouette, and to explain why he felt the need, months later, to rework the image several times. Whatever the original form of *Dame*, the reworked etching has stonelike legs, securely rooted to a mountain top, and had thus come to resemble a monumental Hodler rather than an erotic Beardsley in this respect.[19]

Klee does not mention all his reworkings of *Dame*, but the spring and summer of 1905 were a time of dissatisfaction with the recently completed "Inventions." "In my eyes the engravings lie before me as a completed Opus One, or exactly behind me. For they already seem curious to me like some chronicle taken from my life" (ca. August 1905).[20] Subsequently in January 1906, the image of *Dame* was reversed through its execution as the glass picture *Portrait of a Sentimental Lady*. The hair design and face were changed, with the face now more nearly approximating Beardsley than in the earlier versions. The addition of gloves, necklace, and the slight emphasis of the difference between the skirt and nude torso restore a certain Beardsley-like eroticism to the early image.[21] The slippered feet, grassy ground, and dog (which resembles other puppet imagery

15

of the same time) replace what had been, in the earlier version, the stone feet and rocky plinth. Klee notes, "Drawing and painting on glass give me all sorts of little pleasures. A sentimental lady, with hypertrophied bosom, accompanied by a tiny dog, is completed."[22] But there has been no discussion, we should note, of the specific references in this work to Aubrey Beardsley.

Something of this odd and elusive use of sources pervades the case with Goya as well. During the key 1904 Munich trip, Klee saw some Goya etchings, and Lily gave him some photographs of Goya paintings.[23] At the time he printed *Menacing Head*, in 1905, Klee wrote, "I turn my eyes toward Spain where Goyas grow."[24] In April of 1906 while visiting Berlin, Klee was given a book on Goya by a critic, as "collateral" for the loan of some of his own prints.[25] On return to Bern, Klee avidly read the book, and reported, "Goya hovers around me," seeming to cause problems for his own work from nature.[26] He apparently acquired a Goya, probably a print, by July of 1906.[27] But after his marriage and move to Munich later in 1906, Klee makes no further references to Goya in his *Diaries*.

Klee's voiced interest in Goya, 1904-1906, thus spans the transitional period in which he abandons his "strict style" (his term) for less linear work in which he sought to master tonalities.[28] Goya, a consummate tonalist, must have been an inspiration in the search, but it is difficult to be more specific about his influence on Klee than this. It has been suggested that the imagery of flying men from Goya's "Proverbios" influenced Klee's 1905 etching *Hero with the Wing*.[29] This appears likely, and indeed the sardonic humor of Goya seems present in any number of Klee's satirical drawings, such a *Soothsayers Conversing*, 1906.33.[30] These are, nevertheless, strictly iconographic references, for neither Klee's print nor the drawings bears much resemblance to Goya's formal style. Only occasionally, and chronologically well after the recorded interest in Goya, does a study by Klee recall the rich and contrasting tonalities of Goya's etchings. Klee's two resist (*reservage*) technique etchings of 1907, particularly the *Drinker*, probably refer to Goya, but they are largely unsuccessful in form.[31] The 1907 drawing *In Ostermundigen Quarry, 2 Cranes*, possibly shows a knowledge of Goya's rich tonalities.[32] Not until 1909, however, are there Klee figure drawings which in their full and rich tonal structure—masterfully understated and executed—are recognizable as "Goyesque." Plate 6, the wash drawing *Friends Visiting a Sick Girl, 5 Figures*, of 1909, fulfills the formal interest in Goya voiced three years earlier.[33] Klee absorbed Goya's imagery first and his forms only later. Consciously or not, he has treated these two stylistic aspects as separate, revealing yet another level of complexity in the way he studies the art of others.

In the retrospective diary passage of 1911, Klee freely acknowledged Impressionism as a predominant influence of the post-Bern period.[34] Klee studied Impres-

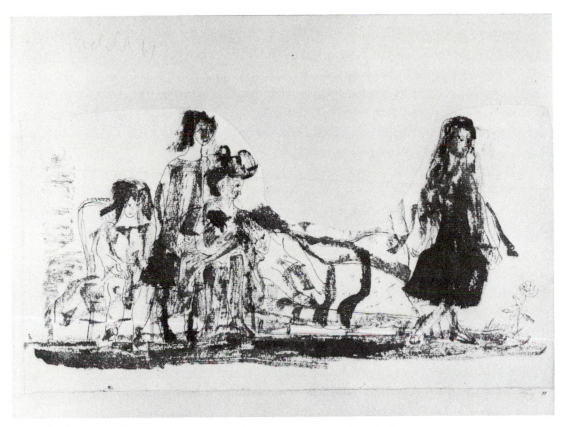

6. Paul Klee, *Friends Visiting a Sick Girl, 5 Figures*, pen and wash drawing, 1909.11, 6⅝ x 12⅜".

sionism closely on his first visit to Paris in April 1905, recording an interest in Manet, Monet, Renoir, Pissarro, and others.[35] In March 1906, Klee studied another collection of Impressionist paintings, this time apparently in Basel.[36] The interest continued into the Munich period: about an exhibition in early 1907, Klee records that Manet's *Absinthe Drinker* "helped me greatly in my efforts with tonality."[37] Klee read Impressionism, for the most part, as a tonal style, based on study from nature, and he took it as a model for stylistic reduction. The Impressionists' way of interpreting all forms of nature by a single type of brushstroke must have been on his mind as he noted, during 1908: "Reduction! One wants to say more than nature and one makes the impossible mistake of wanting to say it with more means than she, instead of fewer. Light and the rational forms are locked in combat."[38]

Given this approach, Klee's artistic responses to Impressionism are unusual, even idiosyncratic. His interpretations are very different from the typical Monet-

inspired landscapes by such contemporaries as August Macke. For Klee, Impressionism was not particularly a coloristic style, but a style of light that could take many different forms. *Young Walk* (*Junge Alee*) and several other prints of around 1910 represent Klee's most nearly orthodox kind of Impressionism.[39] In these works, small hatchlike strokes build up the landscape forms through mass effects. In wash drawings like *Tidy Path in the Woods near Bern* of 1909, Klee uses an opposite approach to subtract light from the surface, filling the shadow areas of the scene to three levels of density.[40]

Klee's most radical interpretation of Impressionism resulted in what he called the "light-form." "By this," Klee explained, "I mean the conversion of the light-dark expanse according to the law by which lighted areas grow larger when opposed to dark areas of mathematically equal size" (March 1910).[41] Klee had observed in 1908 that light "bends what is straight, makes parallels oval, inscribes circles in the intervals, makes the intervals active."[42] Light is a distorting principle which the artist controls by "recapturing these motions, contouring them and binding them firmly to each other."[43] This kind of abstract thinking plays an important part in Klee's preparation for Cubism.

While Klee saw many Impressionist paintings in the original, he also appears to have studied them in the black and white illustrations in books. Klee had read his first books by the critic Julius Meier-Graefe (one on Boecklin, one on Manet) in December 1905.[44] His interest in this prolific and influential writer continues through early 1909, when he meets Meier-Graefe and shows him a portfolio of his drawings.[45] In March 1908, he mentioned Meier-Graefe's theories in his *Diaries*, just two entries below a discussion of the *Balcony*, one of Klee's glass paintings which includes distorted light forms.[46] It is probably no coincidence then that another drawing in this style, *On the Meadow* of 1908 (Plate 8), closely resembles an illustration from Meier-Graefe's *Impressionisten*, a book published the year before.[47] The reproduction is of Manet's *La Plage de Boulogne sur Mer* (Plate 7), and Klee had studied it thoughtfully. The tiny figures in both works are conceived as separate units, subdivided by sharp tonal divisions and casting clear shadows on an empty plane. An application of Klee's "light form" can be found, in fact, in the exaggerated zones of highlight on his figures.

This proposed relationship raises some problems. The source work is a bit atypical for Manet as we usually think of him. Access to the work, through a book, is a bit indirect and obscure, though not inconsistent with Klee's studious habits. The general issue of twentieth-century artists working from readily available printed reproductions is a difficult one. Nevertheless, the small scale and vagueness of the reproduction may have interested Klee. The very limited range

18

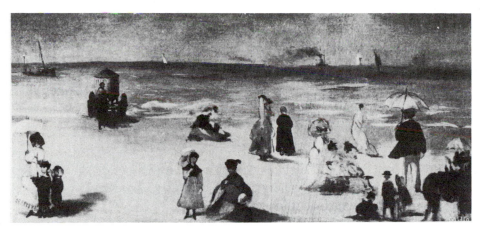

7. Edouard Manet, *La Plage de Boulogne-sur-Mer* (from Julius Meier-Graefe, *Impressionisten*, p. 93).

8. Paul Klee, *On the Meadow*, pencil drawing, 1908.71, 3¼ x 11½".

of early half-tone reproductions may have helped Klee toward a more reductive tonal style.

During the pre-Cubist period Klee several times records his interest in Ensor and Van Gogh. The extreme individualism of these artists represented a stylistic antidote, a counterweight to Klee's Impressionistic interests. "I swing like a pendulum between the sobriety of my recent tonal studies from nature . . . and the fantasticality of Ensor" (late 1907).[48] The balance, however, between Klee's notes on these artists and the way he actually mirrors them in his work would have been hard to predict.

Klee mentions Ensor less than Van Gogh, but his art appears closer to Ensor.

19

The 1908 Klee drawing *Four Nudes of Partly Religious Expression, Three Adults, One Child* (Plate 9) illustrates the many parallels between Klee and Ensor's grotesquerie from an early date. The difficulty here is not in finding examples, but in separating parallels from influence. There is hardly an etching or related drawing, for example, of the 1903-1905 Bern series which could not be compared to some figuration in Ensor; yet Klee's diary first mentions Ensor much later, in Autumn 1907.[49]

In *Four Nudes* the relation of the graphic line and the bitter-humorous subject matter to Ensor hardly needs emphasizing. It should be noted, however, that Klee's line here is more abstract than Ensor's, in the sense of its having a degree of design independence from the image-making function. This is seldom the case with Ensor's line which, for all its unbridled fantasy, is rather traditionally tied to the image. The end of the pervading similarity to Ensor, however, came about abruptly. Following drawings such as *Four Nudes*, Klee began to change his figurative style in 1908. By mid-1909, when Klee actually came to own an Ensor print, his art had greatly diverged, following new simplifying, geometric tendencies.[50]

Klee learned of Van Gogh and Ensor at about the same time, but he commented on Van Gogh much more frequently. He recorded thoughts on his art and on his personality as revealed in Van Gogh's famous letters: "Van Gogh is congenial to me, 'Vincent' in his letters. . . . Too bad that the early Van Gogh was so fine a human being, but not so good as a painter, and that the later, wonderful artist is such a marked man. A mean should be found between four points of comparison; then, yes! Then one would want to be like that oneself."[51] Klee's interest is further spurred by two Van Gogh exhibitions that he saw in Munich in spring 1908; and he sums up Van Gogh's brilliance and tragedy with a memorable phrase. "Here the brain is consumed by the fire of a star. It frees itself in its work just before the catastrophe."[52]

By contrast to this voiced fascination, it is quite difficult to pinpoint Van Gogh's influence on Klee's art. There are a few works, such as Klee's 1910 drawing *Houses at the Exercise Field, Oberwiesenfeld, near Munich*, where a steepened perspective and a degree of excited distortion in trees and buildings remind one generally of Van Gogh.[53] A Van Gogh shepherding scene, also illustrated in Meier-Graefe's *Impressionisten*, may be reflected in a Klee drawing and glass painting.[54] But these examples fall far below the expectations of influence raised in Klee's diary passages on Van Gogh.

A more suggestive connection appears to exist between Klee's *Young Man Resting (Self-Portrait)* drawing of 1911 (Plate 10) and both Van Gogh's *Portrait of Dr. Gachet* and certain of his self-portraits. The pensive, leaning pose of the

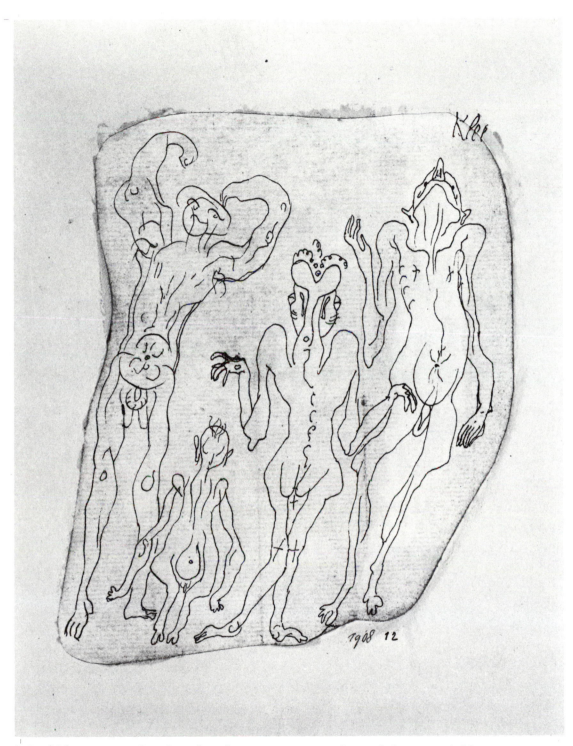

9. Paul Klee, *Four Nudes of Partly Religious Expression, Three Adults, One Child*,
pen drawing, 1908.12, 5¾ x 4¾".

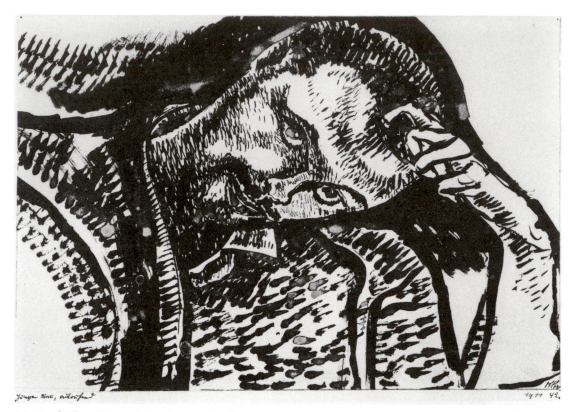

10. Paul Klee, *Young Man Resting (Self Portrait)*, pen and brush drawing, 1911.42, 5⅜ x 7⅞".

Klee, the air of problematic lassitude, and the tight relationship of the figure to the format quite possibly come from the well-known *Dr. Gachet*. Klee has exaggerated the posture, and the supporting hand is even playful compared to Gachet's clenched fist. Details of the eyes, nose, lips, and beard, however, match closely and convey the same introspective stare. The bold form-molding brushstrokes of Dr. Gachet's clothing and the more restrained application of the technique to his face are possibly referred to in Klee's application of a stipple stroke.[55] Particulars of Klee's face, in the close-cropped hair, forehead, structures of the eye sockets and the area of the mouth are close to such Van Gogh self-portraits as the famous Impressionist period *Self Portrait before Easel*.[56] Thus it was perhaps the biographical sense in which Klee felt himself ultimately most related to Van Gogh. This would account for the isolated nature of this particular formal derivation; but it also raises questions, far beyond the scope of this book, about the development of Klee's self-conception as an "expressionist" during this period.

The apparent discrepancy between Klee's verbal and visual references to Van Gogh may be explained by the following observation he made about him in the

22

spring of 1911: "His line is new and yet very old, and happily not a purely European affair. It is more a question of reform than of revolution. The realization that there exists a line that benefits from Impressionism and at the same time conquers it has a truly electrifying effect on me."[57] Van Gogh, Klee indicates, is valued not so much for his characteristic distortions, his stylistic "trademark," but for the organizing effect of his line which goes beyond Impressionism, "conquers" it, and composes fleeting effects into a coherent whole. We must conclude that for Klee Impressionism and Post-Impressionism were closely interrelated, and were thought of mainly (as Goya had been) as ways of dealing with the observation of nature.[58] Klee seems, in fact, to avoid other artists' obvious trademarks as he sifts through their styles to appropriate elements for his own.

The first conclusion we can draw from this account of Klee's early interests is that his sources are likely to be difficult to spot; they are unusually obscure and deceptively disguised. Another way of saying this is that Klee thoroughly digests his sources. As he expressed it early on, "Everything shall be Klee."[59]

Klee's use of Hodler's influence was about as one would have expected, drawing on the anatomy and composition tendencies of this master. In Beardsley, however, Klee concentrated on something unexpected. Instead of focusing on Beardsley's whiplash line and flat decoration, Klee used him as a model of plasticity and solidity of form. This certainly exists in Beardsley, as the *Balzac* (Plate 3) well indicates, and Klee has been surprisingly literal in his adaptation of it; but solidity and plasticity are not the characteristics of Beardsley that usually come to one's mind. From *The Lady with the Rose*, Klee lifted a Beardsley form but appeared uneasy with its content, and he vacillated between the effects of the monumental and the erotic. Of the lesser influences of the Bern period, such as Lavater, Segantini, and possibly Roman sources, Klee says nothing direct in his *Diaries*. They too are characterized by a curiously literal yet surprising usage.

From Klee's first study of Impressionism in Paris in 1905 until the emergence of Impressionist influence on his style, at least two years elapse. This delayed effect is much the case with Goya. Klee knew Goya's work from 1904; and reflected his imagery by 1905. But not until 1909, as we have seen, is any influence of Goya's form traceable in Klee's work. Klee separated form from iconography in this case, treating them as different stylistic entities. This distinction will be applied again to Cubism, with several important effects.

The Meier-Graefe plates indicate that Klee was capable of taking complex stylistic information from illustrations in books. This fact, on the one hand, makes the traditional method of tracing his sources much more difficult, but on the other hand, it reassures the observer that where a visually convincing source relationship appears in Klee's work, there is more likely to be factual substance than if he were known to draw only on the necessarily limited number of originals

he saw. The reductions in size and color-tonal complexity prevailing at the time in book illustrations and prints may have made them particularly appealing to Klee.[60] Such reduced works could be easily assimilated to Klee's small-scale and, until 1914-1915, predominantly monochrome way of working.

Klee's discussions of Ensor and Van Gogh in the *Diaries* are not mirrored equally in the effect on his work. On the basis of resemblance, one could have posited an Ensor influence on Klee as early as 1903, but the connection with Ensor, factually, came only four years later. And over 1907-1910, the period of recorded interest, Klee's art progressively loses its resemblance to Ensor. The Van Gogh connection was very nearly the opposite. In contrast to Klee's voiced interest, reflection of Van Gogh's work in his art is hard to find. While later in the twentieth century, Van Gogh would be read exclusively as a Post-Impressionist, a rebel against the optical style, Klee still valued him as an Impressionist and a guide to the *plein-air* study of nature. Klee's judgment of Van Gogh, just as his judgment of Beardsley, strikes us as unusual, outside the majority opinion, unexpected. We must conclude moreover that an artist discussed in the *Diaries* may appear immediately, much later, or not at all as an influence in Klee's work. And as an important corollary, we may expect that artists not mentioned in the *Diaries* may nonetheless appear as artistic influences.

Some of the peculiarity and delay which characterizes Klee's use of sources can be explained by the part memory plays in the work of an intensely individualistic artist. At first intellectually and emotionally impressed by a work—for example, a Goya print, Klee may have then consciously forgotten it, only to have it reemerge months or years later in an assimilated form in his own drawing. The sources we have been able to identify attest to the great accuracy of Klee's visual memory. Whether during the latent period the conscious mind struggled unsuccessfully to find a satisfactory response to the stimulating example, or whether Klee's mysterious process of assimilation took place mainly in the unconscious, one cannot finally judge. It is interesting, however, that Klee himself seems to have been aware of memory's unpredictable role in art. "Everything shall be Klee," he wrote in 1906, "regardless of whether impression and representation are separated by days or moments."[61] In 1912 Klee specifies, in a critical article, that this idea of the creative delay is precisely the difference between Impressionism and Expressionism:

They indicate the determining moment in the genesis of the work, Impressionism the moment of the reception of the impression from nature, Expressionism the later moment of the rendering of the impression, in some cases at times no longer traceable as connected with the first. With Expressionism years can lie between the reception and the

rendition, parts of several impressions can be struck off again in altered combination, or older impressions can be awakened from long latency by more recent ones.[62]

Another sort of awareness, in part, guides Klee through his difficult period of searching, and it is, in part, formed by the search. Klee tends to see stylistic sources as correctives which restore and insure balance in his own development. We have seen how, for instance, Manet "helps" him with tonalities, and how Van Gogh is an example of a new kind of line. Klee early developed this very objective way of thinking about the *means* of art. As early as 1902 he remarked: "Everything that used to be foreign to me, all the rational procedures in my profession, I now begin to resort to after all . . . I imagine a very small formal motif and try to execute it economically . . . and repeated small acts will yield more in the end than poetic enthusiasm without form or arrangement."[63] In June 1905, after the linear style of the etchings, Klee noted, "Thus I glide slowly over into the new world of tonalities."[64] "Tonality is beginning to mean something to me, in contrast to the past, when I seemed to have almost no use for it" (early 1907).[65] In 1908: "Learned how to differentiate tonality (with or without colors) from the coloristic. Got it!"[66] Late in 1908 Klee theorized that in naturalistic tonal painting line could appear "as a substitute for the color limit between two areas of identical tonal value and different color value in nature."[67] In March 1910 he decided that "to adapt oneself to the contents of the paint-box is more important than nature and its study. I must someday be able to improvise freely on the chromatic keyboard of the rows of watercolor cups."[68]

Thus, Klee isolates for study and improvement the various formal elements of his art. This cool analytical and self-pedagogical attitude, and his ability to differentiate and consider the formal means of art on a par with subject and content, was whetted and perfected in his response to early influences. It later enabled him, in contrast to the more expressionistic Marc, Macke, and Kandinsky, to fully appreciate Cubism. Klee's creative will, quite as strong as the others', was not as single-mindedly directed; he was more able to profit from a variety of experiences. His inquiring approach prepared him to understand in Cubism the revolutionary elevation of the means of art above and beyond the objects of depiction, and to appreciate the Cubists' exclusive fascination with structure.

The objective habit of mind enabled Klee to winnow from Cubism, over the years, the spatial structures and modes of representation that suited his own inner purposes. Objective flexibility, and the knowledge of how one learns what one needs from the art of others, are therefore the most important legacies of Klee's early period of premodernist study.

Chapter 2

THE BLUE RIDER AND PARISIAN CUBISM

Klee and his family usually spent the summers with his parents in Bern. At the end of their stay in 1911 and their return to Munich, Klee made his first contacts with the circle which at just this time was forming the Blue Rider Group. Klee's contacts with Marc, Macke, and Kandinsky were to be very important for him and greatly stimulated his work. The three were at the time more aggressive artistically and in the promotion of their careers than Klee, and through their association Klee gradually achieved wider recognition. Acquaintance slowly grew into close personal friendship, particularly with Marc, up to the dispersal of the group by the war. Extremely important for Klee was the international, particularly French, artistic contact fostered by the Blue Rider. In this context Klee made his acquaintance with the art of Cubism.

The period of late Summer 1911 through March 1912 occupies only three-and-one-half pages in Klee's published *Diaries*.[1] One surmises that artistic matters had so accelerated and become so engrossing that there was less interest than before for his usual introspections. Late in the summer Klee met Macke at the home of Louis Moilliet, Klee's old friend. In the autumn, Klee records his membership in a small artists' association to be called "Sema," the "sign"—the only other notable member of which was Alfred Kubin. The Munich dealer Thannhauser, with whom Klee had had a small graphics exhibition over the summer, was to hold the group show, and a graphic portfolio was to be published.[2] Moilliet stayed with the Klees in Munich sometime during the fall, and through his and Cuno Amiet's introductions Klee came to know Kandinsky, who lived in the next house.

26

Luli [Moilliet] often goes to visit him, sometimes takes along works of mine and brings back nonobjective pictures without subject by this Russian. Very curious paintings.

Kandinsky wants to organize a new society of artists. Personal acquaintance has given me a somewhat deeper confidence in him. He is somebody and has an exceptionally fine, clear mind.

. . . Then, in the course of the winter, I joined his "Blaue Reiter."[3]

Klee quotes in his *Diaries* for ca. January 1912 the review of the first Blue Rider exhibition at the Modern Galerie Thannhauser, which he sent to *Die Alpen*, the small art and literary journal published in Bern.[4] In this now much-quoted paragraph Klee enthusiastically voiced the artistic program of the "still more radical offshoot," of the new Association:

I should like to reassure people who found themselves unable to connect the offerings here with some favorite painting in the museums, were it even a Greco. For these are primitive beginnings in art, such as one usually finds in ethnographic collections or at home in one's nursery. Do not laugh, reader! Children also have artistic ability, and there is wisdom in their having it! The more helpless they are, the more instructive are the examples they furnish us.

Klee draws another parallel to the art of the insane and closes by stating his belief that the exhausted end of "the currents of yesterday's tradition are really becoming lost in the sand."[5] Unfortunately, he attempted no detailed comment on the art at this time. Next (probably in February) Klee notes the organization by Kandinsky and Marc of the second Blue Rider exhibition at Goltz' Bookshop. Klee here voices his excitement over avant-garde French art: "And it [the public] will be converted when the French manage again to make capital out of the new. And that will be sooner than one dares to think. . . . This dealer [Goltz] was the first in town to dare to exhibit Cubist art in his display windows; the *badauds* describe it as a typical Schwabing production. Picasso, Derain, Braque, as Schwabing cronies, a nice thought!"[6] In this last statement and in the *Alpen* article, even after allowing for the necessary "voice" required of an art reviewer, can be recognized a much more enthusiastic view of the latest artistic developments than Klee had voiced up to now. He had, it appears, taken encouragement and positivism from his new friends' approach; he had discussed Expressionist doctrines with them, and had viewed with excitement this even more advanced art, which they had assembled.

The immediate predecessor to the Blue Rider was the association to which Klee referred in his review: "Die Neue Künstlervereinigung München," or NKVM. This group had been organized by Kandinsky and a group of his friends, which included Gabriele Münter, Alexej Jawlensky, and Kubin, in 1909.[7] Klee records nothing about the NKVM, though his old friend, the sculptor Hermann Haller, and another acquaintance, Karl Hofer, were associated with the group. While the group had no consistent style, the dominant mode, from its more conservative members such as Adolf Erbslöh, to Kandinsky, was a generalized Fauvism, with emphasis usually on landscape—illustrated here by Münter's *Village Street in Winter* (Plate 11).

A most important activity of the NKVM was the expansion of its second exhibition, held in September 1910, to include avant-garde French art.[8] The Parisians Pierre Girieud and Henri Le Fauconnier became long-distance members of the NKVM, and at this time early Cubist-related art came to be represented in the group's second exhibition. This appearance in Germany was the more remarkable in that it was not until that same autumn that the Cubists in Paris were becoming aware of themselves as a movement. Le Fauconnier, Gleizes, Metzinger, and Delaunay became closely associated through the 1910 Salon d'Automne which took place a month after the Munich show.[9] Moreover, Picasso, Braque, and Derain were also represented in the NKVM exhibition by several canvases, perhaps invited through Kandinsky's Parisian contacts, as even Le Fauconnier did not meet Picasso until late 1911.[10]

Though he was most actively involved in the association, Le Fauconnier's entries were not the most exciting French works show. His painting, *The Coast*, is of the same Fauvist style as Münter, with rounded, somewhat blockish forms, only slightly flattened in space. Le Fauconnier had not yet entered the Cubist phase represented by his *L'Abondance*, which was not painted until the winter of 1910-1911.[11] Generalized Fauvism of this type dominated the exhibition, characterizing entries by Derain, Vlaminck, Rouault, and Von Dongen, as well as by the NKVM artists Erbslöh, Kanoldt, Kandinsky, Jawlensky, and Münter. Surely the most startling Cubist work shown was Picasso's drawing, *Head of a Woman*, of 1909.[12] This is in the strongly faceted, early Analytic style of that year, with much sculptural implication and indecision, compared to Picasso's later flattening of forms in the high Analytic style. Picasso's other two offerings were conceivably of this style as well. Braque, too, exhibited solid, early Cubist work, with four pieces from 1907-1909. Illustrated in the NKVM catalogue was *The Valley*, a classic Braque of the second half of 1908, perhaps from L'Estaque. Here, as with the Picasso, great tension is felt between cubic geometry and the flattening tendency.

28

11. Gabriele Münter, *Village Street in Winter*, oil on cardboard, 1911, 20⅝ x 27⅛".

The NKVM had then assembled a sampling of recent Analytic Cubist and Fauvist art which must have stimulated a great deal of discussion in Munich. It was a broad introduction to the most advanced Parisian styles. Klee would certainly have heard accounts of the exhibition, although he did not personally see it. He was, from August until November of this year, in Bern.[13] The stage had been set, nevertheless, for the even wider international contacts of the Blue Rider.

By the time of its third exhibition in December 1911, the NKVM was overshadowed by the first Blue Rider exhibition, held at the same time in adjacent rooms of the Thannhauser Gallery.[14] Following the second NKVM exhibition, Franz Marc had joined their association in early 1911 and had become friends over the winter and spring with Kandinsky. Marc and August Macke already had a close friendship, dating from January 1910. In June 1911, Kandinsky and Marc had begun to plan their Blue Rider Almanac, and Macke joined them in this project when he visited Sindelsdorf (Marc's Bavarian home) in October, directly after meeting Klee in Switzerland.[15] In early December, internal tensions arising

from stylistic differences split the NKVM. After a stormy session—ostensibly over the admission to the third exhibition of Kandinsky's outsized *Last Judgement*—Marc, Kandinsky, Münter, and Kubin left the association. The Blue Rider name stood ready for their hastily organized "opposition" exhibition.

The first Blue Rider exhibition provided Klee's earliest direct contact with Cubist art. The major Cubist contributions to the exhibition were the four paintings and one drawing sent by Robert Delaunay.[16] Delaunay had gained wide attention in Paris the previous spring by his participation in the Cubist Salle 41 in the Salon des Indépendants. There he had shown one of his *Eiffel Tower*'s and his *The City No. 2*, both of 1910. A friend of Kandinsky's in Paris, the artist Elizabeth Epstein, had been impressed by the works of Delaunay and had initiated the contact between him and Kandinsky. From October, Delaunay appeared on various lists as a contributor of illustrations to the forthcoming Blue Rider Almanac and had been in correspondence with the group.[17] Delaunay sent to the Blue Rider exhibition *Saint-Séverin no.1*, 1909, *The City No. 2*, 1910, *Eiffel Tower*, 1910 (dated in this exhibition catalogue 1911), *The City*, 1911, and an unidentified drawing. Bernhard Koehler, the patron of the Blue Rider group, acquired the *Eiffel Tower* at the opening.[18] Curiously, Adolf Erbslöh of the rival NKVM acquired the *Saint-Séverin No. 1*.

These four works, even with an uncertainty of sequence regarding the *The City No. 2* and *Eiffel Tower*, give an impressive representation of Delaunay's development through 1911. With the *Saint-Séverin*[19] Delaunay had put some of the basic forms of early Cubism, such as those of Braque's 1908 *Houses at L'Estaque*, into the service of his own sensibility. Delaunay had taken up the geometrizing forms of early Cubism without, however, understanding their full implications for the flattening of the picture plane. Instead of Braque's Cubist convexity (to be further discussed later), Delaunay's *Saint-Séverin* presents a comparatively traditional perspective concavity: a view into the ambulatory of this small Parisian Gothic church. A slightly flattened spatial composition and a simplified tonality derived from early Cubism have been adapted in *Saint-Séverin* to a linear scheme which emphasizes potential movement. Involved in the picture as well is the power of light and color, conceived as capable of bending and transforming physical substances.

In the *Eiffel Tower* (Plate 12) the opening of form and flattening of the composition are carried much further.[20] The tower, seen from at least two points of view, has been splayed and fragmented; and along its broken contours it interpenetrates with the planes of the sky area. The dynamism implied in the *Saint-Séverin* has become almost explosive as large compositional lines radiating

from the tower penetrate and realign the architectural forms at the side of the picture.

The City No. 2 and the similar *City* (Plate 13) represent, from an elevated point of view, a city scene with the Eiffel Tower in the distance.[21] The fragmentation of individual building forms is approximately as in Plate 12. But instead of seeming to burst and bend under the pressure of a central form, the individual pieces are aligned along a rather clearly stated compositional grid. Something of dynamism is lost, but compositional coherency is gained. Beyond this, the larger planes are now further articulated by grids of small color checks. This last development represents in Delaunay's work the reentry into the picture of light and color as independent forms and recalls his earlier period of Neo-Impressionism. The color checks complicate the forms they cover, and make spatial reading of these two works more difficult. The small squares are, however, constant in size and do not diminish with the depicted distance. In the later painting, *The City*, they tend to align with the horizontal and vertical axes of the canvas as much as with the tilting of the Cubist planes. They thus restate the flatness of the picture plane. These paintings (along with the contemporaneous *Fenêtre sur la Ville no. 4*, not in the Blue Rider exhibition), comprise one of Delaunay's near approaches to the regularity and structured form of high Analytical Cubism.

The four Delaunays seen together in the Blue Rider exhibition formed an impressive display. When seen as a sequence, moreover, they present a seemingly coherent development. Starting with *Saint-Séverin*, forms have been analyzed and rendered in a simplified, geometrizing way. With the *Eiffel Tower*, the geometric forms are fragmented and the resultant facets are flattened out, or tilted at a shallow spatial angle to the picture plane. These facets have a degree of independence from the objects they represent and they tend to form two-dimensional patterns. There is a further statement of the abstract equivalency of forms in the interpenetration of tower, sky, clouds, and buildings. In the two *City*'s, the autonomy of the facets as picture elements is further stated. The two-dimensional patterns come to dominate the representation. And while the space with its many interpenetrations becomes extremely complex from a rational point of view, the many paradoxes seem to resolve themselves on the abstract level of the surface grid.

The four Delaunays presented a stylistic story that could be understood even by viewers previously unacquainted with Cubism. While Delaunay's development is not the same as that of Picasso and Braque, it yet runs a course roughly parallel to that of "central" Cubism, from the early Analytical through the Hermetic phases. The inconsistencies of Delaunay's works, when compared to the

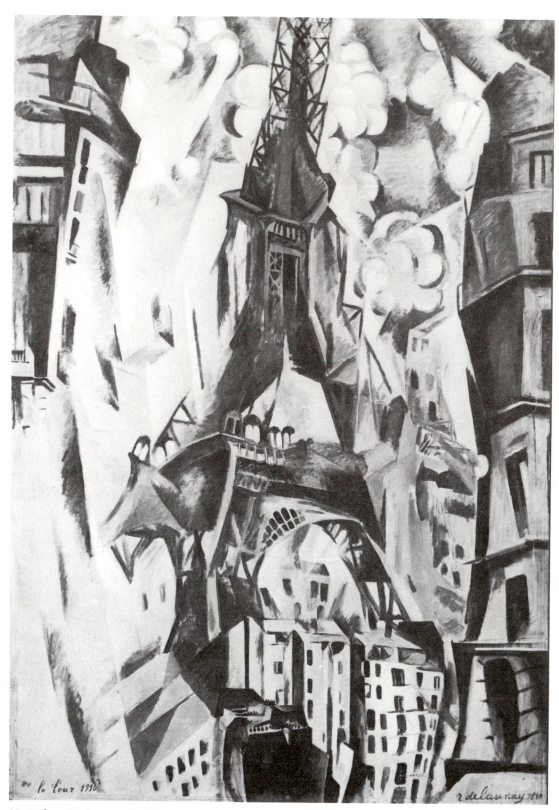

12. Robert Delaunay, *Eiffel Tower*, oil on canvas, 1911, 79½ x 54½".

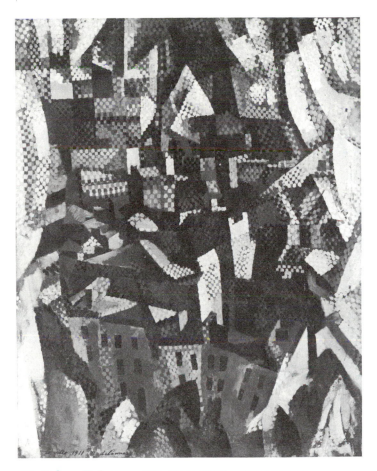

13. Robert Delaunay, *The City*, 1911, oil on canvas,
57⅛ x 44½".

work of Picasso and Braque, would probably have been helpful to a viewer's understanding, in the Blue Rider context. Delaunay's loose and prodigal use in each canvas of a number of Cubist devices presents the viewer with a veritable dictionary of Cubist usage. In their fluid, even unfinished-seeming, forms the Delaunays would have appeared more suggestive of possibilities perhaps than the tightly organized, classic works of Picasso.

The broader characteristics that made Delaunay particularly appealing to the Germans have been mentioned several times in the literature. They are worth considering, since they account for his great influence on the Munich painters: his interest in color, the emotional feeling of his form distortions, and his iconography. The Gothic forms of *Saint-Séverin* could not fail to appeal to painters who claimed, as did the Blue Rider artists, a spiritual kinship to the "expressionism" of the Gothic. The *Eiffel Tower* and the *City*s suggest, too, a dynamic

apotheosis of the modern city, a monumental theme infinitely more appealing to Expressionists than the detached still-life motifs of Picasso and Braque.

This Delaunay-Cubist contrast should not, however, be overdrawn. It is probable that in 1911-1912 Delaunay appeared to the Germans as a fairly representative Cubist. And indeed similar formal comparisons, to be made shortly, will tend to support a view which deemphasizes these iconographical contrasts within Cubism. Rather, in the first Blue Rider exhibition, where he was the only Parisian Cubist represented, Delaunay stood for the general characteristics of the style.

It is useful to consider how much Klee might have learned of Cubism from secondary artists in the exhibition. The *Portrait Study*, ca. 1911 (Plate 14), by Vladimir Burliuk is, I think, instructive.[22] Burliuk and his brother David were leaders of the Russian avant-garde, friends of Kandinsky, and had been members of the NKVM, showing in its 1910 exhibition.[23] Vladimir Burliuk seems to have been aware of Cubism relatively early, and his adaptations of its devices in *Portrait Study* introduce problems we will encounter several times in our study. The head, formed of large, simplified planes derived from early Analytical Cubism, is a rather solid form. The summary handling of facial features is peculiar in relationship to Cubist sources. In even the simpler heads of Picasso and Braque of 1908-1909, the facial features themselves prompted the artists to carry out an analysis, and complex depiction, of their internal plastic forms. Burliuk attempts no such analysis.

Picasso's 1910 *Girl with a Mandolin* (Plate 15) is a good comparison; indeed some elements are so close to Burliuk's *Portrait Study* as to suggest the Picasso as a specific source. The Picasso shows, as the Burliuk, a simplified treatment of the head in large facets. The angles of the neck on the left, and the lines bordering the face and shoulders on the right, are very similar in both works. Picasso is concerned less with analyzing facial details than with interrelating the large facets with the surrounding background planes. In doing this, he dissolves the coherent facial outline, a step Burliuk is unwilling to take. Proportioned to its frame like a traditional portrait, Burliuk's head imitates Picasso's Cubist styles of 1908 and 1910, while lacking the plasticity of the former and the radical analysis of the latter. Burliuk's adaptation is thus very problematic, but in this it is also typical of the younger German and eastern European artists. He borrows forms from various phases of Cubism without regard for the formal logic which produced the innovations. In the context of the Blue Rider, however—far from Paris—Vladimir Burliuk could have appeared as quite solidly Cubist-related.

Klee's Blue Rider friends Marc and Macke showed possibly the first traces of Cubist relationship in their own paintings in the exhibition. Marc's famous *Yellow Cow*, 1911, and Macke's *Indians on Horseback*, 1911, are very close in

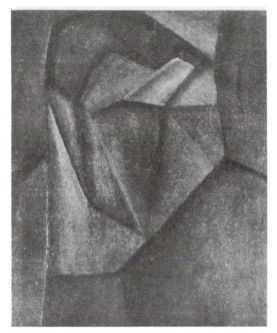

14. Vladimir Burliuk, *Portrait Study*, oil on canvas, ca. 1911, dimensions and location unknown (from Wassily Kandinsky and Franz Marc, eds., *Der Blaue Reiter*, p. 15).

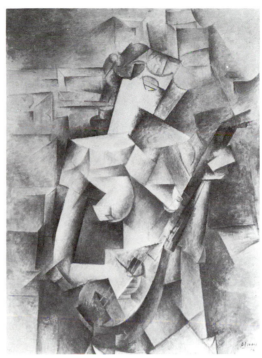

15. Pablo Picasso, *Girl with a Mandolin*, 1910, oil on canvas, 39½ x 29".

style, for as Selz has remarked, Macke was much under the influence of Marc's work at this time.[24] Planar simplifications and geometrization of forms are present in these works as elements of generalized Fauve-Expressionism. Some slight transparencies of form, along the bottom of the Marc, and some ambiguities of space on the side borders of the Macke, do occur; but they are not essential to the composition, and can be seen at most as the first inklings of the Cubist influence. Yet these works would no doubt have interested Klee, since they evidence a closer knowledge of Cubism than Klee himself had at this point.

Kandinsky's *Composition V*, a large, nearly abstract work of 1911, was also in the exhibition.[25] This kind of Kandinsky may well be the source for the marginal "proto-Cubism" seen in Marc and Macke. Kandinsky's colorful, animated, and flowing forms are ultimately different from Cubism.[26] Where Cubism, during the Analytic period, is successively more reductive in color, Kandinsky explores color as an independent stylistic element, floating free of linear contour. Where Cubism geometrized form, Kandinsky deals almost wholly with the irregular and biomorphic.

There exist, however, some interesting, if general, parallels between such

35

Kandinsky works and those of the Cubists. A brief examination of this subtle matter is important for our present subject of initial Cubist assimilations, by artists living a great distance from Paris. Both kinds of art are semiabstract, in that resemblance of the painted form to its natural subject is stretched to near the breaking point. Kandinsky and the Cubists are equally committed to raising the artistic means to an equivalence with, or primacy over, the subject matter of art, although Kandinsky's intense involvement with his legendary subjects makes this parallel less certain. The considerable interpenetration of form in Kandinsky's work, as in *Composition V*, resembles Cubism to a degree. However, Kandinsky's complete dematerialization of some forms through a total transparency clearly distinguishes him from the Cubists, whose interpenetrations were more physically stated. Finally, *passage*, or the use of slanted planes with open contours that spatially bridge between picture plane and background, and effect a movement from plane to plane, is shared by Kandinsky and Cubism. This sense of pictorial space as organized however tightly or loosely, by partially transparent overlapping planes, can be seen, I think, as the common heritage of Cézanne—directly restudied by the Cubists, and explored more independently by the Expressionist Kandinsky.

Klee did not exhibit in the first Blue Rider exhibition, but it contained much for him to study. Some of the structural interests of Kandinsky, Marc, and Macke could be interpreted as belonging to the same general movement as Cubism. The adaptations by Vladimir Burliuk were more strongly linked to the work of Picasso and Braque. Finally, the painting of Delaunay showed Cubism in its broadest Parisian interpretation. Klee had not yet, however, been introduced to Cubism in the strictest sense, in the recent work of Picasso and Braque.

The next development in the Blue Rider circle, chronologically, was the publication of Kandinsky's theoretical book *Concerning the Spiritual in Art*, a large part of which he had written in 1910.[27] The first edition of the book appeared in January 1912, or possibly a few days before, around Christmas 1911.[28] Klee mentions Kandinsky's book in his January 1912 article partially quoted above: "The boldest of these [the Blue Rider artists] is Kandinsky, who also tries to act by means of the word. (*The Spiritual in Art*, published by Piper)."[29] Klee had, evidently, read the first edition of this important book. While a full consideration of Kandinsky's theories lies certainly beyond the scope of our present interest, we should examine *Concerning the Spiritual in Art* for the ideas it expressed about Cubism, since they would have been of great interest to Klee at the time. It is not difficult to isolate Kandinsky's few discussions of Cubism in the book, and, interestingly, they rather closely match one's expectations, based on our prior comparisons of Kandinsky and Cubist painting. Kandinsky sees Cubism,

like his own art of the period, as a transitional form leading toward a future perfection in art. But, unlike his own art, he considered Cubism to have certain misleading tendencies.

To quote one of Kandinsky's ideal prescriptions for modern painting: ". . . there is gradually coming into use, as the only possible road to objective form, a more denuded type of construction. It is not obvious geometrical configurations that will be the richest in possibilities, but hidden ones, emerging unnoticed from the canvas and meant for the soul rather than the eye."[30] According to him, this pure constructive art guided by the principle of "inner necessity" had been prefigured by Cézanne, whose art tended toward abstract composition and was also a direct expression of the soul: "He painted things as he painted human beings, because he was endowed with the gift of divining the internal life of everything."[31] In the path toward the future art, Kandinsky sees twin pitfalls: that the abstract, constructive urge can lead to "mere geometric decoration," and that the spiritual drives can be misapplied to produce "fairy-tale" illustrations.[32] Both faults are rooted in man's present-day limited sensibility. In general, Kandinsky felt that anything or any application of principle that limited artistic possibilities was bad; even purely abstract form, if prematurely forced on the artist of the present, would restrict freedom and potential.[33]

Kandinsky's most censorious statement about Cubism probably refers to Picasso and Braque's art of around 1908-1909, or possibly to Léger's of a slightly later date. Modern painting, says Kandinsky, rejects alike traditional deep space and absolute, material flatness. The Cubists whom Kandinsky has in mind have lapsed into a grotesque and empty formalism: "Out of composition in flat triangles has developed a composition with plastic three-dimensional triangles, that is to say, with pyramids; and this is cubism. But here a tendency has arisen towards inertia, towards a concentration on form for its own sake, and consequently once more a reduction of potential values. But that is the unavoidable result of the external application of an inner principle."[34] Again, he considers the Cubists to have erred in following physical rather than spiritual laws in the development of their new painting.[35] More favorably, "Cubism, as a transitory form, demonstrates how natural forms are subordinated to constructive purposes and what unessential hindrances these realistic forms are."[36]

The first part ("A. General") of Kandinsky's book was undoubtedly written later than the passage just quoted.[37] Here Kandinsky sympathetically appraises Picasso and Matisse as important developers of the new art. "Matisse—color. Picasso—form. Two great signposts pointing toward a great end." Matisse follows Cézanne in that he "endeavors to render the divine," by "means that belong to painting alone, color and form." Similarly, Picasso's purposes are described

37

expressionistically: "Torn by the need for self-expression, Picasso hurries from means to means." Picasso, the originator of Cubism, "In this latest work (1911) . . . reaches through logic an annihilation of materiality, not, however, by the dissolution of it, but through a kind of fragmentation of its separate parts and a constructive dispersal of these fragments over the canvas. But, strangely enough, he seems to wish to preserve the appearance of materiality. He shrinks from no innovation, and when color distracts him he throws it overboard, painting a picture in ochre and white; these problems constitute his main strength."[38]

Kandinsky thus shows familiarity with early and high Analytical Cubism. He disapproved of what he saw as a physical bias in very early Cubism, and in general, of the seemingly cold formalism of the French movement. What interested Kandinsky most was Cubism's rejection of descriptive naturalism and its increasing interest in constructive or compositional form.

With his great capacity for visual study, Kandinsky had been able to develop these views, it would seem, with only a relatively brief exposure to Cubist painting. He had no doubt thoroughly familiarized himself with the Cubist works sent to the September 1910 NKVM exhibition. Kandinsky's description, which dates from this period, of "pyramids" may indeed refer to the Cubist Picassos and Braques in that earlier exhibition. Picasso's *Head of a Woman* and Braque's *Valley* were, as we have seen, of the blocky, 1908-1909, highly sculpturesque phase. It is still most likely that the more advanced 1911 Picassos, which Kandinsky appraises, were known to him mainly through photographs. Kandinsky had obtained Picasso photographs the previous autumn from Kahnweiler in Paris in preparation for *Der Blaue Reiter*.[39]

Remarkable, too, is Kandinsky's objectivity in considering Cubism, and, on the whole, his sympathy for an art so far removed from his own. The evangelical, even polemic, tone of most of *Concerning the Spiritual in Art* did not preclude his appreciation of these artists. The Cubists labored as well in the cause of the new art, and no contributions to this cause were to be shunned. Kandinsky saw similarities where we, as modern historical analysts, seek distinctions. Kandinsky's interest regarding any or all modernism, and his excitement at being, as he judged, at the dawn of a new era, seem to have inspired Klee as well.

Early in 1912, probably opening in February, the second Blue Rider exhibition, composed only of graphics, drawings, and watercolors, was held in Goltz' Bookshop-Gallery.[40] Klee himself was represented by seventeen drawings, making his first appearance in an advanced modern exhibition a major one. He had evidently, over a short period of time, been thoroughly accepted by the original Blue Rider group. In contrast to the relatively modest first group exhibition, the second Blue Rider exhibition included over three hundred works by around thirty

artists. The very wide range of styles gathered by the planners, Marc and Kandinsky, made the exhibition as much "international-modern" as "Blue Rider," a fact noted by every commentator.[41] On this point, Kandinsky writes in 1931, "In reality there never was a 'Blue Rider' association, nor any 'group,' as it is often incorrectly stated. Marc and I took that which appealed to us, which we freely chose without worrying ourselves about any kind of opinions or wishes. So originated the watercolor exhibition, for which Hans Goltz put his new rooms at our disposal without a moment's hesitation."[42] Kandinsky goes on, in this account, to say that Marc's return, full of excitement, from Berlin, with a quantity of watercolors by the Brücke artists, was the event which prompted the organization of the exhibition.[43] As Marc's Berlin visit took place in January, it is amazing that such an exhibition could have been gathered on, at most, two months' notice—even considering that much must have come from the private holdings of the Blue Rider artists and the stocks of such sympathetic dealers as Goltz.[44]

Internal evidence indicates that the following review by Klee, quoted out of sequence in the *Diaries* under "1913," describes the second Blue Rider exhibition:

> Hans Bloesch in Bern occasionally prints a short piece by me in a small paper he is editing. For instance: "Munich offered a delightful little surprise in the opening of the privately operated Goltz Gallery . . . The new art has thus acquired a real home, after having depended until now on the hospitality (which involved some concessions) of organizers who did not really share its ideas.
>
> Now at Goltz's, besides the local Blaue Reiter and the local New Association, are the brave Swiss of the Modern League and our allies from Berlin and Paris. For this first mass demonstration, the handsome room is just large enough to exhibit three or four works by each contributor. To those friendly to the 'new trend' much remains obscure, but one-man shows will follow later."[45]

The "New Art" was indeed comprehensively shown, to judge from the impressive list of contributors. However, the short catalogue titles, and the perennial difficulties in identifying untitled works on paper, have prevented detailed discussion in the literature of the entries and indeed limit discussion now. The four major Blue Rider painters showed, as did Gabriele Münter and the lesser-known Bloch and Morgner. Nolde, Kirchner, Heckel, Pechstein, and Mueller represented Die Brücke; and Gontcharova, Larionoff, and Kasimir Malevich, the Russian avant-garde. The Swiss, led by the then little-known Hans Arp, had founded their

Moderner Bund in October 1911, and among them Arp, Oscar Lüthy, Walter Helbig, and Wilhelm Gimmi showed with the Blue Rider.[46] Klee was already marginally associated with the Moderner Bund, though his involvement with them centers at a later date—the summer of 1912 and winter of 1912-1913.[47]

The illustrations in the Blue Rider second exhibition catalogue offer an interesting juxtaposition (though doubtless merely alphabetic in origin) between a Klee drawing and a not-dissimilar landscape by Lüthy.[48] This minor comparison, nevertheless, indicates something similar to our discussion above of Burliuk, Marc, and Macke. Both artists here too are aware of Cubism, and both "cubicize," or facet their forms, to about the same degree. But the exact degree of Cubism, at this first stage of contact, seems impossible to determine.

French Cubism was represented in the show by the works of Braque, Delaunay, Derain, de la Fresnaye, and Picasso. These graphic works, more easily available at a distance than paintings, included examples of the most up-to-date phase of Cubism yet seen in Munich; and being graphics, they offered a linear artist such as Klee considerable material for study. Picasso's and Braque's *oeuvres* for 1911-1912 are particularly rich in drawings, etchings, and drypoints which embody, with a particularly light and sure execution, the most advanced characteristics of high Analytical Cubism. The minimal use of texture in such works, and their graphic abbreviations, reveal—probably more than the comparable paintings—the structural scaffolding, or grid, of Cubism.

Georges Braque's single drawing in the exhibition (no. 12, "Akt") is unidentified. Some of Picasso's entries however are readily identifiable. Along with four drawings, Picasso exhibited "Frames with Etchings and Pages from the Work *Saint Matorel.*"[49] Max Jacob's *Saint Matorel*, illustrated by four Picasso etchings, had been published by Kahnweiler in February 1911.[50] We may consider two of these etchings, Plate II, *The Table* (Plate 16), and Plate IV, *The Convent*, as examples of the most advanced Cubism in the second Blue Rider exhibition. The intimate scale of these works, and the modesty of their still-life subjects, would have made them very easy for the German graphic artists to study and assimilate. The freely sketched contours and loosely hatched tones emphasize the studio informality of the works. In addition, this neglect of "finish" underscores the artist's primary interest in structure and composition, with the means of form taking clear precedence over description of specific objects.

In such classic prints one reads clearly the Cubist elements of the facet-form, the interrelation of form, and the composition. The individual forms are nearly geometric: triangles, parallelograms, and half circles derived from simple objects. The interrelationships of these forms are of several kinds: juxtaposition, overlapping, and interpenetration. In early Cubism, around 1908, overlapping not

40

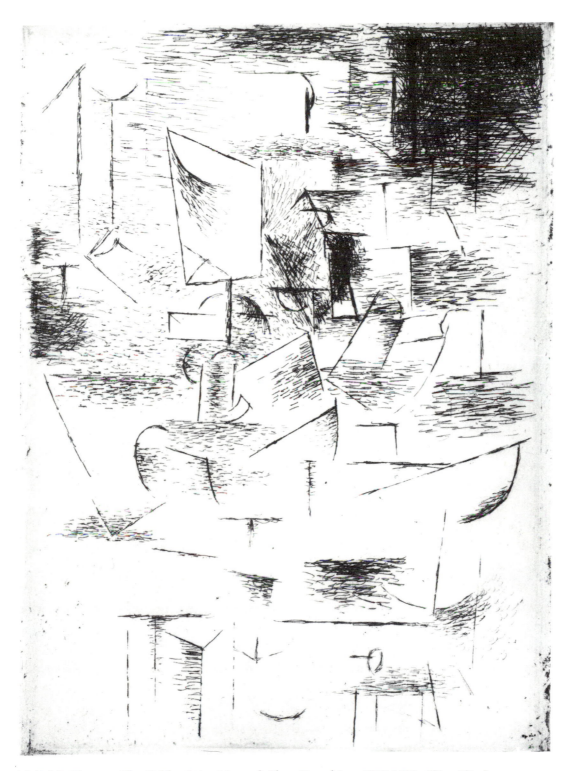

16. Pablo Picasso, *The Table, Saint Matorel*, Plate II, etching, 1910-1911, 7⅞ x 5⁹⁄₁₆."

unlike that employed in Fauvism had determined most spatial relationships. In later Synthetic Cubism, juxtaposition of form, particularly of different whole-views of objects, signifies complex relationships. But here, whole and partial interpenetration of form creates a shallow picture space. Through the Cézann-esque device of *passage*, inclined and skewed planes, tonally indicated, seem to form a bridge between the foremost picture plane and the farthest background plane. The open contours allow the eye to move between adjacent planes in a way that is both two- and three-dimensional. A partially transparent bas-relief has been well suggested as a description of such high Analytical Cubist space.[51]

It is worth noting for our future discussion that "X" and " + " configurations of lines occur in the Picasso etchings, and in his contemporaneous work, much less than one would presume on a first examination. These configurations vis-ually indicate the complete interpenetration on two lines or contours and offer the ultimate ambiguity in spatial reading, complete transparency. By far more common in high Analytical Cubism is the "⊢" configuration, which offers ambiguity at the juncture of two or three planes, yet preserves a vestige of physical solidity in spatial terms. Planes emerge and disappear behind one another in this configuration, but the visual opacity of one plane limits the possibilities. The planes here interrelate in ways more schematic than with natural objects, but their interpenetrations, and hence dematerialization, are limited by the careful control of opacity and translucency.

Analytical Cubist composition, as exemplified in Plate 16, culminates in a system of large diagonals, both explicit and implied, along which the various key contours are aligned. In *The Table*, these large diagonals are loosely interlaced, but in other works, particularly Picasso's paintings of 1911, they are tightened and locked into a "hermetic" grid of crossed axes.

As these axes cross in the middle of the pictures, they thicken the forms and centralize the composition. Characteristically, as in these etchings, the forms toward the center of the Cubist picture field are given the most pronounced plastic modeling; moving toward the borders, the forms are less modeled, more open, and tend more and more to lie on the picture plane. Composition is thus centralized in both its two-dimensional and its spatial effect. Needless to say, rich visual and theoretical paradoxes arise at this point in Cubism, depending on whether the central forms are thought to lie behind, on, or before the picture plane. We must understand, in general, that in the Cubist models, forms move both back and forth, hovering optically in a shallow zone, just before and just behind the picture surface.

Over the next several years, Klee showed a progressive understanding and

42

adaptation of these aspects of high Analytical Cubism. His assimilation, as we shall see, was slow, and during the interim he had many further opportunities for study. Nonetheless, his first encounter with these advanced forms in the second Blue Rider exhibition appears to have been decisive. From this point on, he actively pursued knowledge of Cubism, seeking to satisfy a curiosity and appetite that had been whetted in the exhibitions of the winter of 1911-1912.

Around the first of April, Klee decided to travel to Paris and acquaint himself at first hand with the new developments there. Over the previous five months or so, he had seen important French works, many of which were Cubist, and he was eager to see more. Klee, accompanied by his wife, was in Paris from April 2 to April 18. His diary entries are so brief as to constitute merely an itinerary; he did not elaborate on his impressions of the trip here or elsewhere in the *Diaries*.[52]

Klee says remarkably little about the Parisian art which was to have such a lasting influence on his development. We will defer our ultimate appraisal of this trip until the extended consideration of Klee's actual work. The itinerary indicates, however, that beyond visits to the popular sights, and several musical performances, Klee was a very thorough art tourist. Among the masters at the Louvre, he notes seeing El Greco (about whom he had already written an article for *Die Alpen*), Delacroix, and Ingres.[53] He visited the apartment of the famous dealer Durand-Ruel and saw works of Matisse and Goya at the Galerie Bernheim-Jeune. Among the immediate forerunners of modernism, he notes Degas, Guys, and three specific works of Manet, *The Balcony*, *Olympia*, and the *Déjeuner*.

More pertinent, Klee rounded out his knowledge of Cubism, which had been sketchy and a bit onesided up to this point. To his previous knowledge of the painting of Delaunay, and perhaps of the work of Le Fauconnier, he added personal acquaintances with these artists and, one can presume, a look at the works currently in their studios. Visiting the 1912 Salon des Indépendants, moreover, afforded Klee the broadest view of the various permutations of Cubism current at this time. Even more significantly, through visits to Uhde's and Kahnweiler's galleries, Klee deepened his acquaintance with the styles of Picasso and Braque, the "true" Cubists.

The 1912 Salon des Indépendants which Klee saw the afternoon of April 4 was perhaps not so startling as the Salon of 1911 had been, but it provided a full overview of Cubism, excluding Picasso and Braque, who did not show in the Salons. Klee would have seen *Les Fumeurs* of Léger and Le Fauconnier's *Chasseur*, which was an adaptation of Léger's style.[54] Gris made his public debut in this exhibition, where his *Portrait of Picasso* hung a bit apart from the other Cubists

43

in a room devoted mostly to Russian painters; but as it was next to a Kandinsky *Improvisation*, Klee is sure to have seen it.[55] The most impressive canvas in the Salon, according to many accounts, was Delaunay's single entry, the large *La Ville de Paris*. Among the other Cubists exhibiting were Gleizes, Duchamp, and La Fresnaye.[56]

What Klee saw in the Léger and the Le Fauconnier probably seemed, to him, to be close to the Delaunay formulation with which he was already familiar: broad cloudlike areas, lightly colored, set off by black lines from areas of dense geometric detail—the composition animated and restless. This linear interpenetration of Cubism, with broad areas of generalized *passage* separating nodes of minute activity, became an element of Klee's Cubist adaptation in 1914; but by then it was abstracted, so to speak, from the burly physicality of these French examples.

As John Golding has remarked, the polished, icy-toned Gris *Portrait of Picasso* no doubt made an effective contrast, on the Salon wall, with its Expressionist neighbor, the Kandinsky. Kandinsky's "Improvisations" of 1910-1912 are more open than his "Compositions" of the period, with free-flowing line and warm color, and while they border on abstraction, they retain an intense feeling of the "northern" poetic fantasy of their subjects.[57] The stylistic questions which Klee faced over the coming years could hardly be stated more clearly than by this juxtaposition: how could one wed the spatial order and formal rigor of Cubism with the personal subjects and emotional color of Expressionism?

Gris had inscribed along with his signature on the portrait, "Hommage à Pablo Picasso." One is reminded of Klee's use of the same title two years later, and this also strengthens the probability that he looked closely at the Gris in 1912, for there are more suggestive, general similarities between Gris' Cubism and the later adaptation by Klee. Both artists emphasize the linear surface grid of Cubism, exploiting its potential for regularity, while, however, retaining the spatial complexity so markedly missd in the lesser "systematic" Cubists, such as Gleizes and Metzinger. This similarity, and Gris' return, just after this period, to an intense color palette, lie behind a number of other formal parallels between the works of Gris and Klee over the next decade.

Klee's personal contacts on the trip were with Swiss and German friends, and with Delaunay and Le Fauconnier, who as we have seen, had had close contacts with the Blue Rider. Kandinsky had written Klee a note of introduction to Delaunay, and in these visits (Klee also called at Galerie Barbazanges at Kandinsky's request) one can sense the role of modest observer that Klee played on the Parisian scene. Klee's visit with Delaunay in the morning of April 11, however, began a brief friendship, and probably brought Klee up to date with a cubistic

style that would prove crucial to his own development. Delaunay's work would have, as we will see, a delayed, uneven, but lasting effect on Klee.

Klee had no doubt studied Delaunay's large, ambitious *Ville de Paris* at the Salon des indépendants the week before.[58] As has been frequently remarked, this curious painting summed up Delaunay's advanced stylistic researches and at the same time paid homage to the grand French tradition of the large salon painting with allegorical overtones. The figural motif comes from a Pompeian painting of Three Graces, with possibly an oblique reference to Renaissance treatments of the theme. The landscape in the left third, as Golding suggests, may well refer to themes from Le Douanier Rousseau.[59] In its right third, the composition compiles the various *Eiffel Towers* of previous years. Several details in this area of the painting, the composition, and the style of very translucent interpenetrating planes significantly prefigure the *Fenêtres*, which Delaunay began about the time of Klee's visit. The same details, as we will see even later, seem to serve as a source for Klee after a lapse of months and even years.

It is probable that Delaunay had a lot of work in his studio at the time of Klee's visit. Earlier that spring, from February 28 to March 13, Delaunay had had a retrospective at the Galerie Barbazanges, with forty-one works, spanning his production from as early as 1904.[60] Not wanting to reexhibit any of these works (which included his most recent paintings done during January in Laon) at the Indépendants, which opened only one week after the retrospective closed, Delaunay had attempted a synthesis in the large salon work.[61] Although Klee missed seeing the retrospective, it is very likely that Delaunay had many of the works on hand in his studio. All of the key works in his stylistic development had been collected for the exhibition: a *Saint-Séverin*, Bernhard Koehler's *Eiffel Tower* (which had been loaned back for the occasion), several versions of *The City*, and the paintings done recently in Laon. The works from Laon were not so radical in form or implication as the *City*s. They would have impressed Klee, however, with their lightness and relaxed feeling.[62]

It is very likely that Klee saw some of Delaunay's work on the "Fenêtre" theme—which Delaunay developed over the coming summer—and quite possible that Klee was shown the first finished version. *Les Fenêtres sur La Ville. (1re partie, 2e motif)* (Plate 17) was dated by Delaunay on the back "Avril 1912." This modest-sized painting is a thematic condensation of the panoramic *City* (Plate 13), a type of cityscape Klee had already seen in Munich. Most of the compositional lines and their intersections are the same. The broad border-zones of the earlier paintings are omitted in the *Fenêtre*. This smaller painting shows, in addition, only a minimal, schematic Eiffel Tower and a few indications of middle-ground buildings. The *Fenêtre* is made much simpler, as well, by the

45

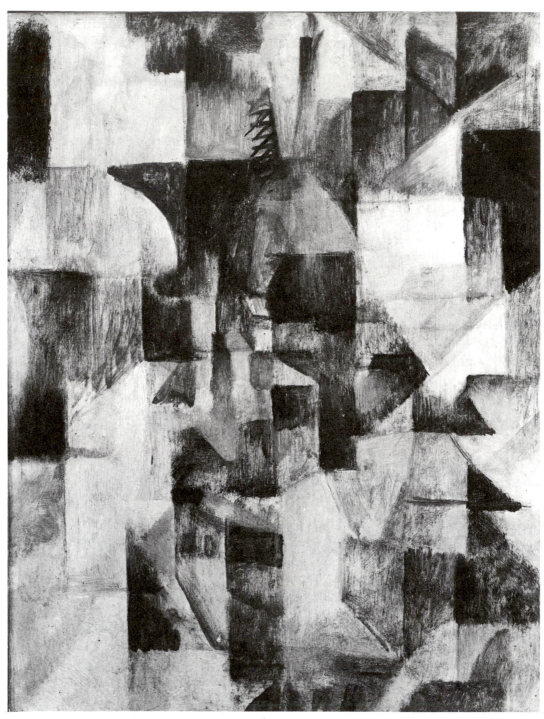

17. Robert Delaunay, *Les Fenêtres sur la Ville (1ʳᵉ partie, 2ᵉ motif)*, oil on cardboard, 1912, 15³⁄₈ x 11⁵⁄₈".

omission of the color checking, which is replaced by a greater openness, the light tone of the unpainted ground standing for the picture plane and effecting, among the more colored facets, the Cubist *passages*.

The "window" of Delaunay's titles is more effectively realized in the April 1912 painting than ever before since one can read the light facets as the effects of a semitransparent plane placed between the eye and the scene. This and the light-handed execution, in delicate tinted colors, gives a fantasy or mirage-like feeling to the small distant cityscape, which indeed almost dissolves, as the small shapes form themselves into compelling abstract patterns. Representational elements are, however, still present in this *Fenêtre*, and in its sublimated balance between object and system Delaunay makes, I think, his closest parallel to the high Analytical Cubist style of Picasso and Braque.

Delaunay and Klee could well have discussed this new work and its precedents during their morning visit. The likelihood that Klee saw this first *Fenêtre* is even stronger when we learn that Delaunay showed both it and the *Towers of Laon*, only three months later, with the Swiss Moderner Bund.[63] Klee was a key member of this group, and it is very possible that Delaunay discussed sending these paintings to the July exhibition in Zurich.[64] Given Klee's prior acquaintance with Delaunay's work, we may certainly imagine that he asked some modest but knowledgeable questions. The latter, to judge from his writings and reputation, would have answered with voluble, if not entirely clear, statements. Delaunay's characteristic excitement over his latest work makes it likely that the new *Fenêtre* was discussed in a lively exchange, and Klee probably left the meeting with a clear view of Delaunay's evolution from 1909 up to the important, transitional work on his easel.

It is significant that Klee met Delaunay at just the point in the latter's development that was closest to mainstream Cubism. During the coming year, 1912-1913, Delaunay left the Cubist orbit in his progress toward color abstraction. Thus while Delaunay himself found greatest fulfillment and his later, widest fame, outside of Cubism, Klee was thoroughly conditioned—by the timing of their contact—to accept him as a Cubist master.

In Klee's diary entries for the two succeeding days, April 12 and 13, he notes, "In the afternoon, at Uhde's, Rousseau, Picasso, Braque," and, "then at Kahnweiler's shop. (Derain, Vlaminck, Picasso)." These laconic notes indicate the rounding-out of Klee's acquaintance with the high Analytical, pre-Collage Cubism of Picasso and Braque. The galleries of Kahnweiler and Uhde were the only places outside their studios where works of the central Cubists could be seen.[65]

Exactly what Klee saw there cannot now be known, but it is most reasonable to imagine that he saw paintings which expanded and fulfilled the expectations

raised by the Cubist graphics seen not long before in Munich.[66] Very likely Klee was able to study such essential works of 1911 and the winter of 1911-1912 as Picasso's *"Ma Jolie"* (Plate 18), Braque's *Portuguese,* and Picasso's *Clarinet Player.*[67] Possibly Klee saw work in the new oval format (which Picasso and Braque had developed in 1911) with which Klee would also work in the future.[68]

The critical terms we used in discussing Picasso's *Saint Matorel* prints could be applied in the same way to *"Ma Jolie"* or the other key Cubist paintings, as they are of precisely the same style. The structural scaffolding is given such primacy in these works that the images are nearly lost in abstraction. These paintings give the perfected form of the compositional grid, the final conclusion in the logic of Analytical Cubism; after such works Cubism would change radically with the introduction of Collage. The forms, interrelationships, and composition of high Analytical Cubism made a very great impression on Klee, and it was this phase of Cubism, clearly more than any other, that furnished him with material over several years.

In the afternoon after the Kahnweiler visit, Klee called on Henri Le Fauconnier. It is not likely that Klee would have been impressed by Le Fauconnier's *Chasseur,* which he had seen at the Indépendants. The forms were a comparatively indecisive rendition of a Légeresque motif. At about this time, in the spring of 1912, Le Fauconnier was separating from his former close relationship with Gleizes and Metzinger and personally and artistically passing from the center of Cubist activity.[69] While Le Fauconnier had been early connected with Germany through the NKVM, showing with them in 1910, Klee had not seen that exhibition, and Le Fauconnier had had nothing in the first Blue Rider exhibition. Up to the point of the visit, Le Fauconnier was undoubtedly known to Klee more by reputation than by example of his work.

Le Fauconnier's masterpiece, *L'Abondance,* had been in the Indépendants of 1911 and would shortly appear as an illustration in *Der Blaue Reiter.*[70] It is interesting to speculate that Klee could have seen this work in Le Fauconnier's studio, as it does, in 1913, find a distant general reflection in his own work.[71] As it is usually stated in criticism, *L'Abondance* seems merely pseudo-Cubist. The forms of a woman and child before a landscape are not indeed subjected to radical Cubist analysis, or transformation, but are rather geometricized into blocky forms superficially similar to those of early Cubism, ca. 1908. Yet details, particularly of the background, as we will see, apparently did stay with Klee for some time.

The interest of Klee and the Germans in Le Fauconnier was, again, a case of a less "pure" expression of Cubism being more accessible at first to the outsider

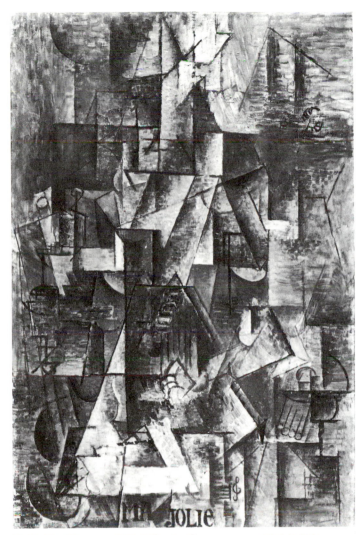

18. Pablo Picasso, *"Ma Jolie,"* oil on canvas, 1911-1912, 39⅜ x 25¾".

than the stringent forms of Picasso and Braque. Le Fauconnier's iconography, like Delaunay's, appealed to the Expressionists; his large canvas seemed to refer to the monumental human themes of life, work, and generation, matters much closer than nearly abstract still-life to the ethical concerns of the Blue Rider artists. But also, as with Delaunay, we shall see that the symbolism interested Klee less than one might have supposed. It is possible that he discussed with Le Fauconnier on this occasion the works which he, too, would loan to the July

Moderner Bund exhibition. Klee evidently enjoyed his visit because when mentioning him in his review of the exhibition, Klee referred to "the moderation of this personality . . . the calm with which he avoids obstacles."[72]

Klee's Paris trip thus completed his firsthand introduction to French Cubism in both its high Analytical and more marginal forms. Klee's work of this period, as we will presently see, was still dominated by his Impressionist mode; and following the patterns established early in his career, he did not reflect the Parisian influence in his newest paintings and drawings. The assimilation took three full years. Over this time, Klee had further opportunities to expand his knowledge of Cubism; but the basic directions open to his interest had been already established.

Chapter 3

THE FORM-PHILOSOPHERS

The external events of Klee's life through the rest of 1912, after the visit to Paris in April, appeared to offer no artistic stimulation comparable to that of the trip. It was a time of consolidation in which he again took mental inventory. He sorted out his feelings about the many things he had seen, and he wrote for publication his first theoretical appraisal of the Cubist influence. During this time as well, Klee did his earliest drawings that incorporated a Cubist element. But in these first months, at least, Klee's intellectual response to Cubism was far more orderly and impressive than his artistic response.

Klee's writing on Cubism appeared on a wave of theoretical and exhibition activity by his two artistic groups, the Blue Rider and the Swiss Moderner Bund. After his return to Munich from Paris, the long-awaited Almanac, *Der Blaue Reiter*, edited by Marc and Kandinsky, appeared in mid-May. The Klees again spent the summer and early autumn in Bern. On the way there, Klee saw in Zurich the Moderner Bund exhibition, in which one of his own drawings, as well as works by certain of the Cubists, was included. He published a review of the exhibition and exchanged visits with Hans Arp and others of the Moderner Bund group, in Weggis in central Switzerland. Back in Munich in the autumn, Klee received letters from Marc, with whom he was becoming increasingly close friends, telling of Marc's own trip (with Macke) to Paris and suggesting that Klee send works for exhibition in Cologne and Berlin. This probably referred to the first Blue Rider exhibition which, after closing in Munich, had begun to travel around Germany during 1912, including stops in Cologne and Berlin. Later in

the fall, while Klee was trying to find a publisher for his Candide drawings, Marc introduced Klee and his work to Herwarth Walden, art entrepreneur and founder of the Berlin periodical and gallery *Der Sturm*. The occasion for this meeting was a traveling exhibition of the work of the Italian Futurists, which Walden brought to Munich. Finally, sometime during this period, Delaunay sent his manuscript "La Lumière" to Klee for translation from French into German.[1]

Der Blaue Reiter contains several commentaries and illustrations of Cubist art. While it presented Klee with nothing materially new about Cubism, yet it no doubt influenced him. By contrast, Delaunay's essay "La Lumière" is basically a post-Cubist document, and its celebration of universal light-symbolism appears to have disillusioned Klee a bit toward Delaunay. While he still responded positively to Delaunay's art, Klee had reservations about his metaphysical theories and appears to have been cautious, too, about the more apocalyptic flights of prose even by his friends Kandinsky and Marc, the *Blaue Reiter* editors. Further in this vein of hard-minded anti-Romanticism, Klee all but dismissed the art of the Futurists. He had only an amused tolerance for their aggressive, world-changing theories. In his analytic mood, Klee was interested primarily in form and the mechanics of structure. For the time being, he had lost interest in grand speculations on art and the broader synthetic theories.

The Blue Rider Almanac was planned as the first in a series of yearly reports on the international avant-garde. It had been in preparation by its editors Kandinsky and Marc for almost a year, predating by many months the artists' secession from the NKVM.[2] Only a small drawing by Klee was illustrated in the book (p. 197), and he had had no part in the volume's preparation. Klee did not discuss the book in his *Diaries*, but he must certainly have read it with great interest as the major theoretical expression of the Blue Rider aesthetic. In at least one case Klee adopted its ideas into his own critical writing. Therefore, we must now look to *Der Blaue Reiter* for its special references to Cubism, and closely related topics.

The illustrations in *Der Blaue Reiter* were carefully chosen and served didactic purposes. Similarities of "inner sympathy" were indicated by juxtaposition: for example, a Gauguin wood relief was placed *vis-à-vis* a grotesque Archaic Greek relief (pp. 114-115).[3] Cubism is represented by three Delaunays, *Saint-Séverin*, *Eiffel Tower*, and *The City No. 2*, all from the first Blue Rider exhibition; two Le Fauconniers, *L'Abondance* and *Paysage lacustre*; and a Picasso, *Femme à la Guitarre*, of early 1911. Several very early, student-period Cézannes were illustrated, presumably for the quality of naive, but "true," realism which they shared with the many works, which the editors reproduced, of Rousseau. One Cézanne, *Apples, Pears and Grapes*, was illustrated from the style of the 1880s-

1890s which had been relevant as a source for Cubism. Of the lesser-known Blue Rider artists, works by Albert Block and Vladimir Burliuk illustrate their early Cubist adaptations. The Kandinskys, Marcs, and Mackes reproduced show the same minimal relationship to Cubism discussed above with the first Blue Rider exhibition; one Kandinsky and one of the Mackes illustrated had been in that show.

Delaunay's *Eiffel Tower* is juxtaposed with an El Greco, *St. John the Baptist* (pp. 68-69).[4] The compositional similarity is striking: a tall flamelike central form, with broken or undulating outline, thrusts upward. The editors contrived this comparison because, according to Blue Rider belief, outer formal similarities indicate inner, extra-historical, spiritual affinities. This lay at the heart of the El Greco revival, in which the Blue Rider participated, which claimed him as an ancestor of Expressionism.[5] This also shed light on the great enthusiasm with which the Blue Rider artists greeted Delaunay's iconography. His painting not only described the modern city, but it was also a mystical revelation of the future. Le Fauconnier's *L'Abondance* (p. 127) was to be similarly read for its epic symbolism. The smaller Le Fauconnier reproduced (p. 79), a landscape depicting a lake, was more stylistically coherent and quite close to the 1911 Cubist landscapes, for example, of Gleizes.

Opposite the Analytic Cubist Picasso (pp. 26-27) were two children's drawings of still-lifes. Something like a reversed perspective appears in one of them, and in both distortions in size and some avoidance of overlapping produce a flattened space. Children, according to Kandinsky, draw objects in a "true" and objective manner, free from convention. Inner reality, therefore, is shown in its strongest form.[6] Pure abstraction and pure realism are equivalent in their pursuit of inner harmony.[7] The Picasso and the children's drawings are therefore, in Kandinsky's theory, equivalent in spiritual purpose.

The central article on Cubism in the volume was Roger Allard's "The Signs of Renewal in Painting."[8] It was probably the first major critique of Cubism that Klee ever read. As Edward Fry has noted, Allard, a Parisian critic, was aware of the Cubism of Picasso and Braque when he wrote this, but he was most interested in the Le Fauconnier-Gleizes-Metzinger group.[9] Allard shares with the Blue Rider members an excitement over the birth of a new tradition:

> The subject of the picture, the external object, is merely a pretext: the *subject* of the equation. This has always been true; but for many centuries this basic truth lay in a deep obscurity from which today modern art is seeking to rescue it.[10]

53

Allard speaks of the process of Cubism as "dematerialization," and—very like Kandinsky—sees obvious precedent for this in the long-accepted abstractions of music and poetry.[11]

Cubism, according to Allard, is a new discipline, and the artists' seeming anarchy (*Wilde* or "Fauves" is used by all the Blue Rider writers) exists only in the eyes of those who do not understand their constructive purposes.[12] Cubism is an almost mathematical style, which in the wake of the structurelessness of Impressionism, seeks to restore art to its original sense of order.

> What is cubism? First and foremost the conscious determination to reestablish in painting the knowledge of mass, volume and weight.
>
> ... cubism gives us plain, abstract forms in precise relation and proportion to each other. Thus the first postulate of cubism is the ordering of things ... cubism feels space as a complex of line, units of space, quadratic and cubic equations and ratios.
>
> The artist's problem is to bring some order into this mathematical chaos by bringing out its latent rhythm. In this way of looking at things, every image of the world is the point of convergence of many conflicting forces.[13]

In this careful, constructive approach to art, hasty, arbitrary syntheses of the new ideas must be avoided; and for this, Allard roundly condemns the Futurists.[14]

After acknowledging Derain, Picasso, and Braque as the founders of the movement, Allard praises Le Fauconnier and Albert Gleizes for their logic, Fernand Léger for his "new ways of relating masses," and Delaunay for "revealing the rhythm of the limitless depths."[15] For this art which proceeds by a kind of numerical logic, Allard proposes no end or purpose; it exists, one assumes, only for itself. This is very different from the views of Kandinsky and Marc, who always intended an ultimate spiritual purpose for art.

The more mystical side of number and mensuration in art is presented in an interesting passage, reprinted in *Der Blaue Reiter* from the "Italian Impressions" of 1909 by a contemporary Russian writer Wassilij Rosanow. Rosanow interprets Antique sculpture as embodying a search for perfect mensuration, and points to the constant repetition in the Old Testament of numbers and dimensions—*ad absurdum*—of sacred objects. Pythagoras' belief that number is the essence of all things is cited, and the passage ends, "There is a peculiar secret in numbers and measurements; God is the measure of all things. . . ."[16]

The generalized theory of numbers in art—so often brought into discussions of Cubism at this time—is presented by Kandinsky in "On the Problem of Form,"

where he again theorizes about Cubism.[17] From time to time, Kandinsky says, man has turned to that which is "the most regular . . . and the most abstract."

> Thus, we see that throughout different periods of art the triangle was used as the basis for construction. This triangle was often used as an equilateral one. Thus the number received its significance—that is, the completely abstract element of the triangle. In today's search for abstract relationships, the number plays a particularly great part.[18]

Numerical formulas, he continues, are cold, hard, and lasting as are all things produced by "inner necessity"—Kandinsky's touchstone of artistic quality.

> The searching to express the compositional in a formula is the cause for the rise of so-called Cubism. This "mathematical" construction is a form which must sometimes lead—and with consistent use does lead— to the nth degree of destruction of the material cohesion of the parts of the thing. (For instance, Picasso.)[19]

The goal of this is to make the picture into a living essence.

> If this [Cubist] course can in general be reproached, it is for *no other reason* than that the use of the number here is too limited. . . . Why should one diminish artistic expression by *exclusive* use of triangles and similar geometrical forms and bodies?[20]

Here again Kandinsky voices a philosophical fascination with numerical theories for the new art, but expresses at the same time an uneasiness with the geometry of Cubism which he believed to be the result of an overly rigid application of such theories.

The other editor, Marc, was even less sure of this cool Cubist approach. In general, he welcomed his French colleagues in the struggle for modernism, but in one passage in his essay "The German Fauves," he states with characteristic rashness:

> The most beautiful prismatic colors and the famous Cubism have become meaningless as purpose for the German Fauves.
> Their thought has another purpose: through their work of their time to create *symbols* which belong on the altars of the coming spiritual religion. . . .[21]

David Burliuk's article "The Russian Fauves," like his brother Vladimir's painting, evidences much early study of Cubism. Among the principles he proposes for the new painting, several are Cubist-derived:

> ... the relations of the picture to the graphic elements themselves ... to the planar element,
>
> the law of displaced construction—the new world of linear construction,
>
> .
>
> employment of several viewpoints ... the reconciliation of perspective representation with the ground plane,
>
> the manipulation of planes and their intersections (examples of which are Picasso, Braque, and W. Burliuk).[22]

There is nothing new about these ideas, and Burliuk may well have borrowed them from an earlier French critic. What makes the article notable in *Der Blaue Reiter*, rather, is its clarity of method. The author has isolated and described some specific formal elements of Cubist painting. This is more critically incisive than the vague and general discussions of Cubist space and spirit by Marc and Kandinsky. Burluik's precision soon found a sympathetic echo in Klee.

In "Delaunay's Compositional Methods," Erwin von Busse, a Munich critic, discusses Delaunay's development through the *Saint-Séverin–Eiffel Tower–The City* sequence which we have already considered. Von Busse interprets Delaunay in Expressionist terms. At the point of his dissatisfaction with his early work, this critic suggests, Delaunay's capacity for feeling (*Empfindungsleben*) was increased:

> ... and he recognized his artistic mission in the representation of that which he felt from offering nature ... no more the imitation and repetition of objective nature, but the embodiment of the idea which had come to him from the consideration of nature.... The search for the means of expressing his ideas understandably and consistently down to the smallest detail of painting technique is the *Leitmotif* of the development of the artist.[23]

The central dynamic idea of *Saint-Séverin* is obscured, Von Busse says, by the overwhelming representational element. The *Eiffel Tower*, as the next step, was also inconsistent, with fragments of representation still obscuring the pure

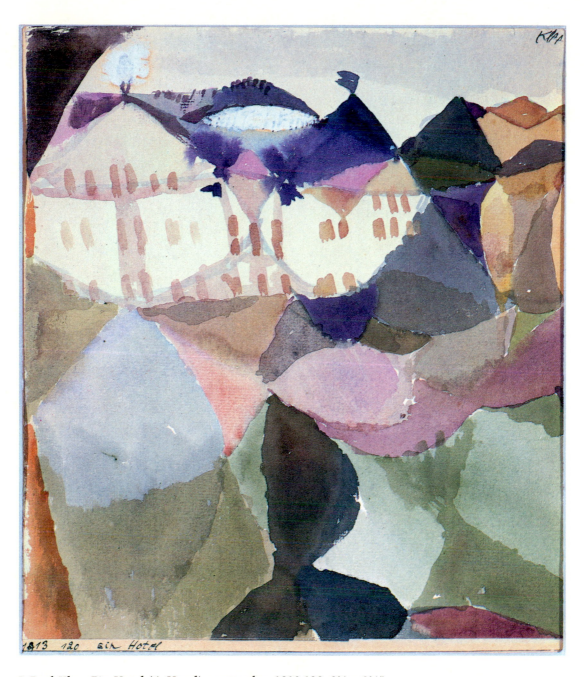

I. Paul Klee, *Ein Hotel (A Hotel)*, watercolor, 1913.120, 9¼ x 8¼".

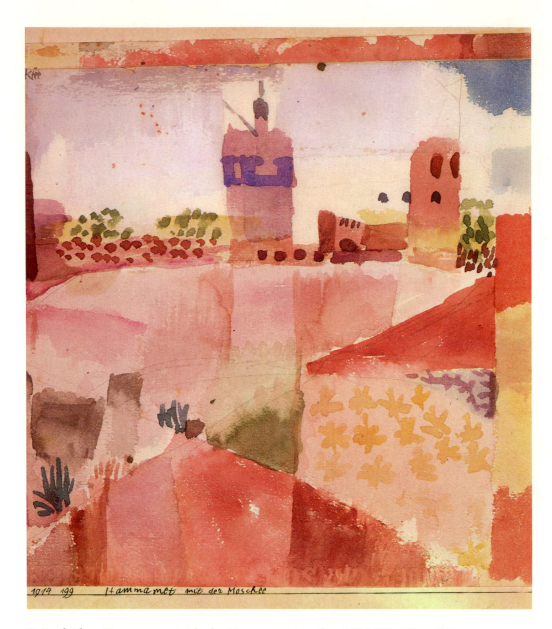

II. Paul Klee, *Hammamet with the Mosque*, watercolor, 1914.199, 8⅛ x 7½".

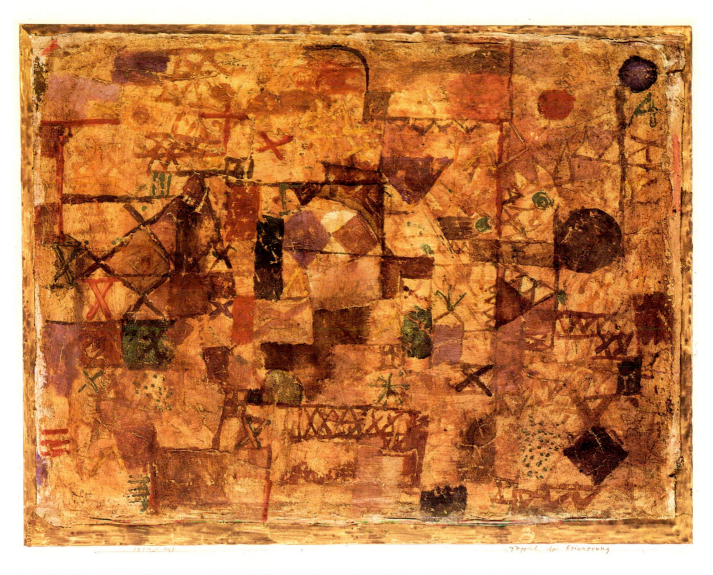

III. Paul Klee, *Carpet of Memory*, oil on chalk-and-oil ground on fabric, 1914.193, 15⅞ x 20⅜".

IV. Paul Klee, *With the Eagle*, watercolor, 1918.85, 6¾ x 10⅛".

formal expression of feeling. Then, in the first *City*, consistency is approached by transposing all externals into the form of the geometric cube (*Kubus*); only a consistent *Raumdynamik* is lacking, according to Von Busse. *The City No. 2* solves the final problem, that of a balance of movements and directions: "The depth and height movements are opposed to a corresponding width movement, as well as a circling and, finally, a concentric movement."[24] Von Busse notes the cubes become smaller and the lines more broken as they approach the center of the picture, and that the spatial dynamic is supported through the movement of color patterns as well.[25] The article does not mention Cubism or any of Delaunay's sources. Even though pedestrian in quality, Von Busse's article had significance for its time. It was a coherent, sequential explication of a Cubist-related development which fascinated the Blue Rider artists.

Der Blaue Reiter embodied and demonstrated the ideas of the Munich group. On the subject of Cubism it presented few new ideas, but it no doubt served to direct and stimulate Klee's thinking on his recent experience with that style. The clearer thoughts of Allard, Kandinsky, Burliuk, and Von Busse would appeal to Klee's intellect. Perhaps this writing challenged him to record his own thoughts and to deal specifically with those areas of the new art where he found the other writers lacking.

The main issues of difference between Blue Rider art and Cubism had been clearly raised in the Almanac. Chief among these was the matter of intention. The ultimate purposes of the leading Cubists seemed rather obscure to the Blue Rider painters, and one could not be sure that even Delaunay and Le Fauconnier were really headed toward that pantheistic unity which was the goal of Kandinsky and Marc. But the French were clearly anti-naturalistic, and they had methods of seemingly mathematical analysis. Number and proportion too might finally lead, as well as color and flowing bio-morphic form, to mystical truth. This problem of intention was to remain an acute one for Klee, who was willing to go much further than Kandinsky, Marc, or Macke into the study of Cubism in order to appropriate elements of its structure. Over the next several years Klee's intentions at times resembled those of Cubism more than those of Expressionism, as he slowly fashioned his unique position, embodying elements of both styles.

Klee's review of the July Moderner Bund exhibition in Zurich appeared in the August number of *Die Alpen*.[26] He must have written it very quickly, clarifying and composing thoughts that had been in gestation for several months. The exhibition had included works not only of the Swiss, but of the Blue Rider and the French. There was thus ample field for commentary. Several parts of the essay can be considered for their appraisal of Cubism, which gives us a unique

57

view, at least on a theoretical level, of Klee's ideas on our subject in mid-1912. For this reason, it is the more remarkable that it has received comparatively little attention in the Klee literature.[27]

The review is in three parts. In a lively introduction, Klee defines the Swiss Bund as a young branch of the modern school which originated in Paris. He uses Expressionism similar to the way in which Fauvism was used in *Der Blaue Reiter*, as a generic term for all modernism. He discusses how it differs from Impressionism. The main body of the article is a discussion of Cubism with some conclusions regarding Delaunay, and an appreciation of Kandinsky. Finally, Klee discusses several of the Swiss artists in the exhibition, singling out a few works for illustration and analysis. For illustrations of the Blue Rider and French artists, interestingly, Klee refers to *Der Blaue Reiter*, to which, deferentially, he calls the reader's attention.[28] Klee's words on some topics, for example his appraisals of Kandinsky and Münter, fit so clearly within the Blue Rider Expressionist aesthetic that they can be omitted from our discussion. While considering parts of the article relating to Cubism, we note that at several points Klee seems to draw upon the essays of Allard, Kandinsky, and Von Busse that he had recently read in *Der Blaue Reiter*.

We earlier noted Klee's basic definitions of Impressionism and Expressionism. By Expressionism he means generically all Post-Impressionist modernism. Impressionsim renders the experience of nature directly and immediately, while Expressionism renders the experience only after a time lapse, which can effect transformations on the original material.[29] The two movements also differ in relation to pictorial structure:

> An important tenet of Expressionist belief is the emphasizing of the constructive, the raising of the constructive to a means of expression. Impressionism in its time no longer recognized construction at all; each artist elementarily rendered the phenomena of the colored external world, in this or that choice and emphasis, according to his temperament. By contrast, construction was more than a means for earlier epochs, it was indeed their characteristic.[30]

Like Kandinsky, Klee sees modernism as restoring art to its original, constructive purposes. Here, as in Allard, Impressionism, as a radical naturalism, is seen to culminate the unfortunate structurelessness of nineteenth-century art.

Klee says that now, with the resumption of assimilated (*verarbeiteten*) painting and painting from memory (*Auswendigmalen*), construction returns to im-

portance: "The scaffolding of the picture organism comes to the foreground, and—cost what it may—becomes a reality."[31]

This scaffolding or grid, however, makes new demands on the representational elements of painting. Klee continues: "Houses, in order to adapt themselves to an interesting picture scaffolding, become oblique, and as no one will choose a construction-idea of only verticals and horizontals, trees are mangled, humans become incapable of life."[32] But, he adds, only the laws of art are valid in art, and painted people do not need to breathe. The sequence in Klee's ideas should be noted: the compositional scaffolding comes first, and the forms of objects must be adapted to it. Klee thus identifies the primacy of the abstract, compositional order on the picture plane, and not object-distortion, as the central issue in modernism.

"Cubism is a special branch of Expressionism," Klee writes. "This school of form-philosophers" is not unlike the Old Masters in that it works in proportions reduced to numbers. However one now goes beyond the Golden Section to more radical consequences:

> Only now one draws the consequences in the formal elements. While the Old Masters more or less measure out a compositional idea along general lines, they carried out the construction only softly in detail so that it is left open for everyone, as before nature, to perceive the precise measure or not. The Cubists fix these measurements in all exactitude down to detail—one more the planar measure, as Le Fauconnier, others the light and color measure, as Delaunay. That such a picture consequently looks like a crystallization or like combined polished stones is no joke, but rather the natural result of Cubist form-thinking, which consists principally in the reduction of all proportions, and which leads to simple projection forms such as the triangle, rectangle, and circle.[33]

For Klee it is clearly Cubist compostition—the surface grid—which produces the smaller Cubist forms, and not the other way around. This somewhat distinguishes Klee's thought from that of many other Cubist critics. In his *Blaue Reiter* article, Roger Allard tended to describe Cubism as being first a way of seeing, then a way of composing: "The artist's problem is to bring some order into this mathematical chaos by bringing out its latent rhythm."[34] Allard is saying that the Cubist starts with his new analysis of form, then finds a composition appropriate to it; by contrast, Klee has the Cubist start with abstract composition, then develop forms that are appropriate to it.

59

Given the semantic inexactitude of such early Cubist critics as Allard, one should perhaps not insist on his side of the contrast. But the clarity with which Klee sets up his sequence is characteristic of his formal thinking. The distinction Klee makes here between Cubist composition and Cubist form affected his exploration of the Cubist style in his own work through 1913-1914. Klee does not here question the spatial paradox implied in the statement that three-dimensional forms, "polished stones," are the result of a way of thinking which tends toward two-dimensional forms, triangles and rectangles. But again, the problem of two dimensions versus three dimensions, common to many Cubists, will later arise and be given peculiar solutions in Klee's own work.

Klee continues, discussing the consequences of Cubist form distortion: "I mention this, first, because I have myself found certain inconsistencies disturbing, but particularly to make the justification of the last step, the abandonment of the object, comprehensible." Cubist distortions are not very disturbing in a landscape, but:

> Stronger organisms bear such reevaluations less well. Animals and men, which are the way they are in order to live, lose in viability with each reduction. Or [lose] entirely when they have to arrange themselves to a heterogeneous picture organism, or—as with Picasso—dissected into separate motifs, they are placed wherever the picture-idea requires. Destruction for the sake of construction?[35]

Somewhat like Von Busse, Klee believed that Delaunay had found an important resolution to the problem:

> One artist who has been particularly concerned with this inconsistency, Delaunay—one of the most gifted of our time—had understood how to solve it in a startlingly simple manner; in that he has created the type of an autonomous picture, which leads, without motifs from nature, a completely abstract form-life. A structure of plastic life, *nota bene*, almost as far removed as a Bach fugue is from a carpet [design]. A very close connecting link to this latest epoch in Delaunay's production was to be seen in Zurich, the View out the Window, second motif, first part.[36]

Thus Klee has theorized that the tensions generated by forcing objects to fit an abstract picture-structure can be resolved only by abandoning the object, baring the structure of its burden. Here, Klee's words imply that he had already seen Delaunay's new *Fenêtre* in Paris and had had time to think about it. At any

rate, Klee was certainly prepared to understand the *Fenêtre* and its place in Delaunay's development immediately when he saw it in Zurich.[37] He recognized the abstract direction the series was taking, and accordingly he took Von Busse's history of Delaunay one step further. Klee implies that all Cubism would lead to abstraction. In mid-1912, before the Collage transformations of Picasso and Braque, this would certainly have been a fair prediction. Critics of even our own day have frequently noted the closed quality of 1912 Hermetic Cubism, referring to it as an "impasse." Analytic Cubism, in all its forms, seemed to be moving directly into abstraction at that time. Klee's observations thus take on added interest and authority in hindsight. The notion that all art advanced toward abstraction, it need hardly be said, posed problems which Klee would deal with in his work long beyond his Cubist period. He later passed in and out of several "abstract" phases, thus refuting any such overly deterministic scheme.

The concluding section of Klee's review, where he discusses Kandinsky and very briefly characterizes works in the exhibition by Matisse, Le Fauconnier, Marc, Münter, Arp, and other Swiss painters, adds nothing essential to the foregoing theory. With Oscar Lüthy, however, Klee discusses a Cubist-related drawing which he reproduces (Plate 19): "He has a basically impulsive relation to it [the landscape], as demonstrated by pieces which are not yet completely reduced to a skeleton, but still have flesh and blood." Klee describes the illustration as

> the skeleton of a picture and a landscape at the same time. The disposition is concentric; in the middle stand, let us say, a couple of dark, severe fir trees. The terrain circles around them, and further out above follow mountains—or, what is the same thing, the segment of the sky left by the mountains—and below, houses as an answer.
>
> Lüthy does not go the dangerous way of Delaunay, nor does he hold the moderation of Le Fauconnier. . . . He knows how to hold the picture and object in a conciliatory relationship, although the picture idea predominates in strength.[38]

The description of the composition as concentric recalls Von Busse.

The statement of equivalence between the "positive" and "negative" shapes of the mountains is most interesting. Lüthy, Klee might have said, had avoided inconsistency by according all forms the same linear treatment and by scaling the motif so that compositional lines and details are virtually the same. Klee's acceptance of the representational side of Lüthy's art is, in light of some of the earlier parts of his article, at first surprising. But the example indicates, I think, that it was pictorial rather than theoretical consistency that concerned Klee. The

19. Oscar Lüthy, *Landscape Drawing*, ca. 1912 (from Paul Klee, "Die Ausstellung des Modernen Bundes . . . ," p. 703).

ideological compromise implied in "Cubist landscape" or "abstract landscape" was perfectly tenable to Klee, provided the elements of representation were made commensurable with the elements of composition. Modern art then need not find its only fulfillment in abstraction. Because Lüthy's drawing, of all the examples discussed in the review, is the nearest in form to Klee's own work of 1913, the year of his first deep involvement with Cubism, this modest critique at the end of Klee's article takes on added significance. It can help to pinpoint his own developing position in the modernist movement.

Sometime during the fall of 1912, Delaunay sent Klee his article "La Lumière," and Klee's German translation of it appeared in Herwarth Walden's *Der Sturm* in January 1913, at the time of a large Delaunay exhibition in Walden's Berlin Gallery.[39] Klee's diary states, "Now Delaunay wrote and sent me an article by himself about himself."[40] Gustav Vriesen, who studied Delaunay's papers, states that the little correspondence Klee and Delaunay exchanged was quite cool and limited to such matters as clarifications for the translation. No close, lasting friendship had been established, not surprisingly in view of the very different personalities involved.[41]

"La Lumière" was the more complete of two theoretical pieces Delaunay had written over the summer of 1912 at La Madeleine, near Paris.[42] This text, first in a large body of theory which Delaunay wrote over the years, sets forth in poetic and polemic tone the basic tenor, principles, and vocabulary of what Guillaume Apollinaire at about this time was naming Orphic Cubism. Delaunay's themes are light, color, movement, and simultaneity:

Light in Nature creates the movement of colors.

. .

Simultaneity in light is *harmony, the rhythm of colors* which creates the *Vision of Man.* Human vision is endowed with the greatest *Reality,* since it comes to us directly from the contemplation of the Universe. . . .

The idea of the vital movement of the *world* and *its movement is simultaneity.*

. .

Clarity will be color, proportion; these proportions are composed of diverse elements, simultaneously involved in an action. This action must be the representative harmony, the *synchronous movement* (simultaneity) *of light* which is the *only reality.*[43]

There is no evidence that this essay had much influence on Klee's thinking at the time. He had, in the Moderner Bund review, shown himself to be an analytical thinker, and Delaunay's essay is anything but analytical. Klee's appraisal of Cubism and Delaunay had been essentially structural. The new art, Klee had said, gained in purity and effectiveness the more it laid bare the bones of linear composition. Delaunay, by contrast, states strongly, in one paragraph of his essay, that even an art which concentrates on essential relations between objects cannot be pure, unless the revelatory element of light is the ordering principle.

For Delaunay, color, as the embodiment of light, was the most important constructive and symbolic element in painting. In a contemporaneous letter to Kandinsky, Delaunay disavowed the other Cubists on this point. His reasoning can also serve as a statement of his theoretical difference from Klee. "I do not know in Paris any painters who could be really in pursuit of this ideal world. The cubist group of which you speak seeks only in line, reserving for color a secondary and non-constructive place."[44] At this point, by contrast, Klee was rejecting the light principle as part of the destructive legacy of Impressionism.

A wide difference of intention separated Delaunay's and Klee's thought, in 1912, which makes all the more amazing the great influence Delaunay would have on Klee's art in Tunisia in 1914. During 1912 Delaunay was emerging from what he called his "destructive" period and was thinking in sweeping, synthetic terms about the relation of art to reality: "the *synchronous movement* (simultaneity) *of light* . . . is the *only reality.*" The art Delaunay envisions would celebrate the transcendent essence of reality, "the limit of sublimity." It would

63

PAUL KLEE AND CUBISM

draw upon the truth of man's total perception, and by simultaneity, would treat the "vital movement of the world." Simultaneity would transcend all the limits of time and temporal succession.

By contrast, Klee seemed to avoid such all-embracing theories for the time being and concentrated only on pictorial structure. Broadly synthetic ideas about art and life were not new to Klee, who had been traditionally schooled in nineteenth-century German Romantic theory. Moreover, he would, in the future, synthetically combine in his painting subject elements from many aspects of experience—including time, movement, and simultaneity; and he would have much to say about this in his writings of the 1920s. Color too would later take on a structural and mystical role in his work. But for the fall and winter of 1912-1913, the linear elements of form and composition—the most reductive aspects of modern art—were uppermost in his mind.

Skepticism, too, characterized Klee's first response to Futurist art and theory. Most of Klee's account appears under 1913 in his *Diaries*, but it clearly refers to an exhibition of October 1912.[45] Herwarth Walden, who was greatly attracted to the excitement of the Futurists' ideas, brought their work to Germany. Walden had arranged for Futurist works from their most famous group exhibition in Paris, at Galerie Bernheim-Jeune, February 1912, to be shown in Berlin after first traveling to London. The exhibition took place at Walden's Sturm Gallery in April-May 1912; over the following months it circulated through northern Europe, more or less under Walden's direction.[46] He arranged a Futurist show in the Galerie Thannhauser in Munich, opening October 27.[47]

This exhibition included many of the revolutionary works which had so startled Paris a few months before. Boccioni showed five works, including *The Noise of the Street Penetrates the House* and *Laughter*. Carlo Carrà showed nine paintings, including *The Funeral of the Anarchist Galli*, *What the Streetcar Said to Me*, and *Woman With a Glass of Absinthe*. Among Luigi Russolo's entries was *Revolution*, and among Gino Severini's, *The "Pan-Pan" Dance at the Monico*.

The Munich public, including Klee, was introduced to Futurist theory as well, since Marinetti's "Manifest des Futurismus" was printed in the catalogue. In the Berlin catalogue Walden had already printed German translations of three such tracts: "Initial Manifesto of Futurism," "Futurist Painting: Technical Manifesto," and "The Exhibitors to the Public"; and copies of this may well have been on hand in Munich.[48] Klee's essential remarks on the Futurists follow:

The great talent that I call attention to is Carrà; one needn't trip in crossing this new threshold and may think of Tintoretto or of Delacroix,

so related are the sonorities of his color and even the spirit of his execution. With Boccioni and Severini, to be sure, the relation with the old masters is a less happy one. For instance it says in the Manifesto: "When one opens a window, all the noise of the street, the motions and the substance of things suddenly invade the room," or: "the power of the street, the life, pride, and fear that can be observed in the city, the oppressive feeling caused by noise." Such things, in fact, have been convincingly represented. (Holy Laocoön!!)

... The frenzy of the hot-blooded young people needn't have been misunderstood either; they lavish it on their manifestoes, partly to scare people, but partly to establish their presence proudly and gloriously.[49]

Klee admired the Futurists' enthusiasm, and he enjoyed their bravado, but their broad synthetic claims again ran counter to his reductivist mood. The Futurists wanted their art to embrace all of modern life. It was to recreate in the spectator, who "must in the future be placed in the center of the picture,"[50] the sights, sounds, and motions of an exalted dynamic world. Not only were the Futurists' subjects synthesized from many experiential sources, but the artists developed expansive, synthetic forms as well. When the traditional limits of materials were felt to be inadequate, for example, Boccioni did not hesitate later to clothe his experiential content in physically literal—if poetically conceived—combinations of real objects. His *Head + House + Light* (1912) was a synthesis of a plaster sculpture, controlled lighting, metal, and apparently wood and glass objects combined to portray the totality of an experience.

Klee's reaction to Futurism was not far from Roger Allard's. The latter wrote in *Der Blaue Reiter*:

... a fervent urge towards synthesis leads to arbitrary theoretical arrangements which drive poetry to the picturesque, the threshold, precisely, of the anecdotalism which the new artist shuns: a vicious circle. Thus futurism seems to us a tumour on the healthy stem of art.[51]

Klee's joking "Holy Laocoön!!" refers, of course, to Gotthold Lessing's famous essay *Laocoön* of 1766, which explored the limits of the visual arts in portraying movement.[52] Klee had, incidentally, named *Laocoön* in his Moderner Bund review as an example of the kind of school-learning which prevented Europeans from seeing art with unprejudiced eyes.[53] Here, he juxtaposes the Futurists' "lines of force" and simultaneous movements with the classic theory that such things are inappropriate for the plastic arts. Even if it is only with a

verbal quip, Klee sides with the more static approach, preferring once again clarity of structure to the ambitious metaphors of art-life synthesis.

Klee's preference among the Futurists for Carrà over Boccioni and Severini still might appear somewhat puzzling. But based on Klee's intellectual and emotional reservations about Futurism, we may put forth the following explanation as likely for this choice. The lines of force in Boccioni and Severini, given Klee's bias, must have appeared excessively literal in their dislocation of objects. By comparison even to the Paris-based Severini, Carrà's large compositional lines probably appeared, to Klee, to be abstractly and coolly composed. Carrà's art had a more positive relationship with the Cubism which Klee had come to admire.

Carrà, in his forms of 1911-1912, was closer than most of the other Futurists to the Analytical Cubist style. His *Funeral of the Anarchist Galli*, *What the Streetcar Said to Me*, and *Woman with a Glass of Absinthe* are all near-Cubist in their angularity of form. The *Woman with a Glass of Absinthe* is particularly close to the Parisian iconography of the cafe scene, and its network of horizontal, vertical, and diagonal lines its characteristic of the high Analytic style.[54]

Klee's remark on Carrà's color and facture is more difficult to understand. However, his works, such as the *Funeral of the Anarchist* and the *Woman with Absinthe*, are quite similar to Analytical Cubism in their reduction of color to a near-monochromatic base. Carrà's method of highlighting, or of superimposing streaks of lighter reds and greens over the darker base, would appear to be that which reminded Klee of a similar practice by the Old Masters. The comparison to Tintoretto can be understood in this way. The Italian Futurists had found the heritage of the Old Masters to be a stultifying weight from the past. Klee, by contrast, could still analyze the Old Masters in structural terms and was far from wanting—with the Futurists—to destroy the museums.

Klee's appreciation of the Futurists thus emphasized the static over the dynamic. He responded to those qualities which had fascinated him in Cubism and Delaunay: consistency of form and emphasis on the compositional framework—that is to say, the least-Futurist qualities. The "cinematism" of the Futurists, like Delaunay's theory of light, did not interest Klee at the time. Both were extra-pictorial, metaphysical. Given Klee's intellectual background and lifelong theoretical turn of mind, his lack of interest in these ideas is a measure of how intense his preoccupation was during 1912-1914 with questions of pure form and structure.

This orientation, and the habit of setting content aside in order to better study form, ran counter to the mainstream in the Blue Rider milieu. For example, Klee's static response to Futurism was very different from that of Franz Marc. Marc responded very positively, over 1912-1913, to the dynamic elements of

Futurism, and his painting, from this time until his early death, shows an increasing adoption of the Futurist lines of force and simultaneous movements. Klee's response recalls his loss of interest in the expansive theories of Delaunay almost after his first reading. August Macke, by contrast, remained devoted to Delaunay and his ideas for a comparatively long time. Inside the Blue Rider circle, Klee was never as taken up, as Marc and Macke were, with momentary enthusiasms; and consequently he never had to violently reject them. Klee kept even the most interesting theories and commitments at a distance until he could thoroughly assimilate them.

It is clear how the Futurists' concern with dynamism, technology, and social revolution made their art and ideas particularly attractive to most of the German Expressionists. While they started from different premises, both of these schools envisioned an apocalyptic purification of art and life. It is further true that both the Italians and the Germans shared the same major complaint about Cubism: Cubism seemed to lack significant content, and it seemed to squander great artistic resources on exclusively formal problems. Cubist art had a cold, abstract beauty and provided a fund of formal ideas upon which to draw, the Expressionists might concede, but it ultimately lacked human meaning.

These criticisms did not disturb Klee. Like Marc and Macke, Klee "went to school" to French Cubism; but, unlike his friends, Klee was not overly troubled with the "lack" of Cubist content. The Cubists to Klee were "form philosophers" (his phrase from the Moderner Bund review), and their studies in pictorial structure merited extended contemplation. Klee would not, I think, have expected the Cubists to teach him anything about subject and content, which he at one time called the "private" aspect of art.

It is possible that Klee simply understood Cubism better, and therefore appreciated it more, than Marc or Macke. It is certain that Klee was much more patient and experienced than his friends in the business of drawing profitably on artistic influences. When Klee finally worked out his own solutions to the form-content problems inherent in Cubism, they were considerably more complex than those of Marc and Macke. The result of slower assimilation, Klee's formulations lacked some of the emotional force of Marc and Macke, but Klee also avoided the sense present in their work of a rather hasty compromise—arrived at under intense emotional pressure. In both these aspects, Klee's work lay outside the scope of Expressionism.

Chapter 4

KLEE'S
FIRST RESPONSE
TO CUBISM

By the end of Spring 1912, Klee was well acquainted, through exhibitions and visits to studios and galleries, with the major forms of Cubism. By the end of the summer, as we have seen, he had made an orderly analysis of the key features of this style and had even speculated on its origins and ultimate direction. During this year, as well, Klee made his first formal adoptions from Cubism in a series of drawings. But by comparison to his writing, his first Cubist forms are very tentative. True to his earlier habits of study and assimilation, he proceeded very slowly. He underwent no instantaneous conversion to Cubism in Paris or while standing before the pictures of an exhibition. Rather, he began a thorough process of taking from Cubism, carefully and step by step, the forms and structures that fit his own inner needs.

The Cubist drawings are in the minority of Klee's 1912 works and by no means dominate the year's production. Moreover, the Cubist element in them is, at first, difficult to spot. It appears initially as the solution to a formal problem which had arisen previously in his Impressionist drawing style. Qualitatively, Klee's Impressionist works had reached a high degree of elegance, and the early Cubist forms, by contrast, appear blocklike, clumsy, even ugly. This is overshadowed, however, by their central developmental, and historical, importance.

In 1912 Klee's Cubism is limited to the motif of puppetlike figures. By comparing these with earlier and later Klees, and with the French sources, we can verify that these were Klee's first Cubist works, and that they lie at the beginning of a long and coherent cubistic development in his art. But however logical this issue might appear to us today, with our advantage of historical

hindsight, Klee's stylistic situation would have been far from clear to an observer in 1912. His work contained at that time a number of elements which at first glance appear to be Cubist-related. Most of these strains of "proto-Cubism," however, developed out of Klee's Impressionist manner and did not contribute directly to his subsequent Cubist restructuring. Nevertheless, his decorative proto-Cubism set the stage for his Cubist work proper and provided the context for his first essay of a Cubist motif. We will, therefore, consider Klee's proto-Cubism briefly, the better to recognize and fully grasp the truly Cubist innovations when they do appear.

Several of the strains of Klee's Impressionism and Post-Impressionism develop through 1912 into apparent proto-Cubism. His open, linear Impressionism of around 1910 can generate, in drawings of complex geometric motifs, forms having the lightness and transparency of a superficial Cubism. This effect is visible in the right side of the well-known drypoint print *Railroad Station* of 1911, where an abbreviated sketching of buildings and scaffoldings produces some effect of dissolution and interpenetration of form.[1] As has sometimes been noted, the effect of a thatchlike proto-Cubism is particularly evident in drawings of crowded cityscapes such as the 1911 *Bern, Original Entrance to the City II*, and the 1912 *Street with Cart*.[2] Nevertheless, what is, in Cubism, the result of analysis of form is here merely the product of the informal superposition of sketches.

In another variation of the effect, abstract patterns of short lines, used as hatching, move across and through various planes. This occurs to some extent in the *Railroad Station* drypoint, but reaches its richest development in the tonal inflections of the 1911-1912 *Candide* drawings (for example, Plate 20). Here the linear patches move not only through and around the figures, but in their compositional relationship to the borders, have a remarkable similarity to the free tonal hatchings of Analytical Cubist graphics, as in Picasso's *Saint Matorel* etchings (Plate 16). The proto-Cubist *passage*, or inflection of a planar edge, occurs in the Klees, however, only in relation to the borders—where it functions decoratively to delimit the drawing field.[3] This hazy facture of Analytical Cubism, present in both graphics and in paintings such as Picasso's *"Ma Jolie"* (Plate 8), is itself a distant legacy of Impressionism. Klee's drawings here merely share a common inheritance from the Impressionist style.

Klee's study through 1912 of light and tone, and their relation to the graphic line, produces two other interesting lines of proto-Cubism, both related to what he described in his diary from 1910 as the "light form." In a passage of 1908, Klee refers to a line which could bind and structure light impressions. There are, over 1909-1912, several variations and many examples of this one basic technique. In this mode, Klee draws—directly from nature in many cases—the dom-

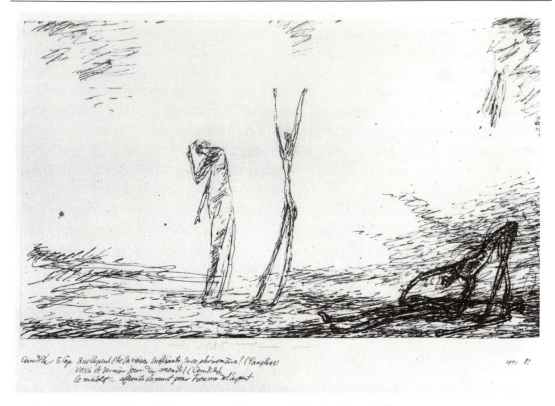

20. Paul Klee, *Candide, Chapter 5*, pen drawing, 1911.81, 5⅜ x 8¾".

inant forms of a motif as flat planes of reflected light, bounded by thin lines. One side of the line is then toned by a wash, as in *Bern, the Industrial Section of the Matte with the Munster Above* (Plate 21), and something very close to Cézannesque *passage*, or the abstract lifting of the planar edge, occurs. With these shaded patches rhythmically distributed through the landscape, surprising similarities to the abstract tonal patterns of high Analytical Cubism can appear. Klee seems to have prized this type of proto-Cubism; as an example of the type, *Stonecutters* was the only work from the early year of 1910 which Klee showed in the second Blue Rider exhibition. It was reproduced in the catalogue and was the only Klee illustrated in *Der Blaue Reiter*.[4] At this crucial stage in his career, we may assume Klee showed a special fondness in choosing such a work for his first wide publication.

The several drawings which Klee did during his April 1912 visit to Paris, for example, *Parisian Sketch, Sidestreet of St. Michel* (Plate 22), also fall within this basically Impressionist mode. Klee's excitement with Paris and the boldness of the new art he saw there may indeed have contributed to the openness and sureness of this work, compared to earlier examples. The radial composition of this and

70

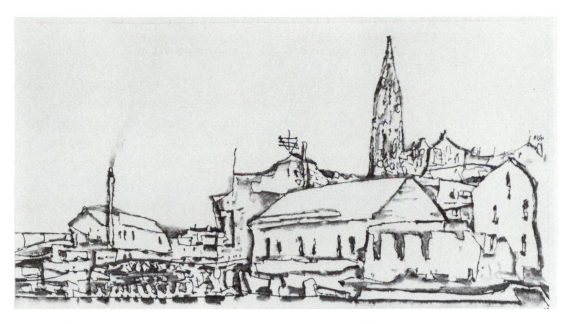

21. Paul Klee, *Bern, the Industrial Section of the Matte with the Munster Above*, pen and wash drawing, 1910.75, 5⅜ x 10″.

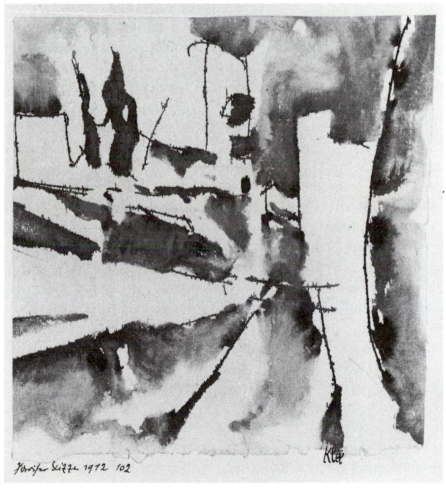

22. Paul Klee, *Parisian Sketch, Sidestreet of St. Michel*, pen and wash drawing, 1912.102, 4⅞ x 4⅝″.

other Parisian sketches quite possibly reflect Delaunay's dramatic apotheoses of the city, which were much in Klee's mind at the time. But, however proto-Cubist we might wish to label this drawing, it still remains clearly an outgrowth of the light-form landscapes of the previous years. Klee's habit of study and his self-respecting modesty precluded his doing any outright, on-the-scene pastiches of the new art he saw on the trip.[5]

In *Woman's Head* of 1912, we encounter Klee's most radical type of the light-form.[6] This form, too, Klee evolved out of his Impressionism. By experiments with squinting and unfocusing the eyes, and by more straightforward optical meditations, Klee observed the ways light can distort natural forms.[7] In *Woman's Head* he isolated and outlined the pattern of highlights on a head, creating globular and straplike forms. These straps are optically analytical, and at the same time lend themselves to abstract, arabesque patterns.

A common derivation from Impressionism, moreover, lies at the root of a striking parallel between Klee's light-forms and certain works of the Futurist Boccioni. Details of Klee's *Woman's Head* (and related drawings) resemble, for example, Boccioni's painting *Materia* and his sculpture *Anti-Graceful*. These works were not in the 1912 Munich Futurist show; they were in fact only created over the winter of 1912-1913.[8] Klee could not therefore have been directly influenced by them. But what the parallel does show clearly is the frequency with which artists, working from an Impressionistic base, could create a Cubist-looking form entirely on their own, in this early day. The strapwork highlights in both Boccioni and Klee, however, derive from the study of reflective light and not, as in true Cubism, from the analysis of plastic form. While this development proved central to Boccioni, it was, however, only a momentary stage for Klee, for he abandoned such pseudo-Cubism almost immediately when he discovered the exciting possibilities of a more directly applied Cubist form.

We noted earlier how in 1908, as a consequence of his interest in Impressionism, Klee abandoned his grotesque style of figure drawing exemplified in Plate 9. But with his first *Candide* drawings of 1911, he reapproached the genre of figurative grotesquerie. About these drawings, Klee speculated in his diary, "Perhaps I actually recovered my real self."[9] It is this area of Klee's work—close to the heart of his most personal, graphic talent—that afforded the first opportunity to try out forms from Cubism. The manner of this assimilation is closely bound with the internal history of these tiny figures. Will Grohmann, for example, recognized the general importance of what he called Klee's "illustrative style . . . of harlequins and grotesque animals (from 1912 on),"[10] and their significance, as we shall see, is very far reaching.

While in the 1908 *Four Nudes* (Plate 9) there are expressive gestures, equally

important for the satirical effect are the lines of sagging detail in the sacklike bodies. These details obscure rather than explain the anatomical jointing or membering of the limbs. The *Candide* figures, equally unanatomical, are virtually all gesture (Plate 20); their forms are reduced to sticklike proportions.[11] The typical willowy form was so expressive for the nuance of gesture that Klee did many drawings, in 1912, outside the Candide subject in this manner, for example, *Promises, Two Nudes*.[12]

Promises has forms more appropriately called strap-figures than stick-figures, and one can see through them how closely related Klee's "light form" strip is to the Candide figure type. But an entirely new interest of Klee's suggests itself in *Promises*, and in a few of the *Candides* as well: the possibility of slightly broadening the figures to accommodate new alternatives of limb articulation. From the suppleness and approximation of the strip-figure, Klee turned in his next stylistic step to the jointings of the puppet.

Klee's general interest in puppetry is well known. The hand-puppet theater which he made for his son Felix during the teens and early 1920s, for example, has been widely reproduced.[13] James Smith Pierce investigated this interest of Klee's, and some of his conclusions are relevant here. Pierce revealed that Klee's interest should be understood in the context of a general European revival of interest in puppetry as a folk form early in the twentieth century.[14]

The common Punch and Judy show, in German-speaking Europe, is called the *Kasperletheater*. Pierce points out the similarity in such later Klees as *Battle Scene from the Comic Operatic Fantasy "The Seafarer,"* of 1923, to these puppet dramas; and he cites the *Wajang* shadow-puppets of Java—which were in many European ethnographic museums by early in this century—as the source for the figure in the 1922 painting *A Girl's Adventure*.[15] Pierce concludes that puppets were used thematically by Klee for "animating the inanimate and mechanizing the natural."[16] And he further observed that in the Blue Rider group, where a general interest in puppets was common, "Klee was the only one who conceived any of his pictures in terms of the traditional forms and passions of the popular puppet theater."[17]

As a further refinement in the matter, I think the distinction must be kept in mind between jointed-body puppets, of both the flat two-dimensional (*Wajang*) and the three-dimentional (European stringed puppet) types, and the hand-puppet such as in Felix Klee's theater. For it is the jointed-body puppet, moving back and forth within his little stage box, which is most relevant for Klee's 1912 early Cubist figures.

Klee's puppet forms literally appear on the stage in his *Harlequinade*, a problematic, transitional drawing done sometime in 1912 (Plate 23). A strapwork

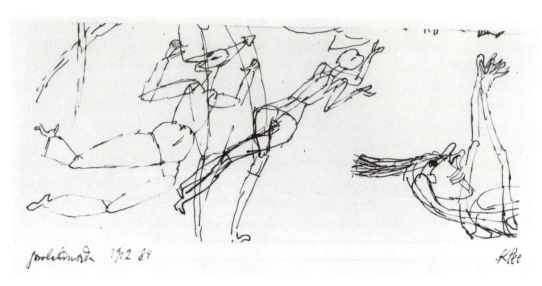

23. Paul Klee, *Harlequinade*, pen drawing, 1912.84, 2⅜ x 5⅜".

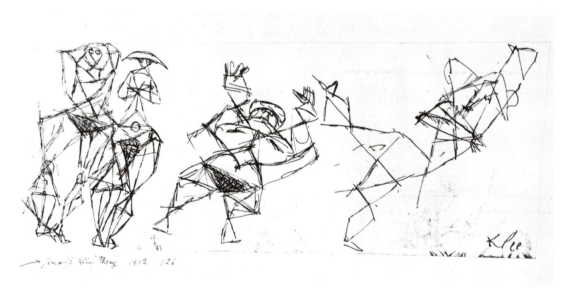

24. Paul Klee, *Rapture of the Dance*, pen drawing, 1912.126, 3½ x 8⅜".

manikin appears on the right, and to the left there are two puppetlike figures, with broad seams across their limbs representing joints. It has sometimes been suggested that puppeteers' strings appear in this drawing. But a careful examination of many originals of this period reveals that Klee often cropped such drawings from larger sketch pages, and the lines at the center top here are most likely the remnants of other figures.[18] But the figures do behave like puppets,

apparently suspended and skittering from left to right with wildly expressive gestures. The anthropomorphic potential of the puppet—an ironic image, having its own rich, comic tradition—had come to interest Klee more than the thin strap-figure.

Moreover, the puppet raised possibilities of articulation which intrigued him. When one examines the articulation of the waist and legs of the lefthand figure in *Harlequinade*, it becomes apparent that the random piecings of the joints are visually immobile, opaque, and limited to only one frozen gesture. The left-arm joints of the same figure, however, are transparent, apparently hinged, and suggest a wide possibility of gesture.

The tiny figures in another 1912 drawing, *Rapture of the Dance* (Plate 24)— and particularly the figure on the right—show an elaboration of this transparent method of puppet articulation. These puppets are membered totally by means of geometric facets—primarily triangles—which I believe Klee had observed in Cubism. The geometric shapes or facets here appear to grow out of one another; and by simple extension of some of the lines, as in the waists and thighs of the figures, very complex graphic and plastic suggestions are made. Transparent, crystalline solids, sliding planes, and infinitely flexible joints are all suggested by this very economical means. The puppet takes on a new complexity and simplicity at the same time.

There are only a few 1912 Klee drawings of this type.[19] Perhaps the most successful among them is *An Uncanny Moment* (Plate 25). Here, a very great openness, suggestive of movement, and even of plasticity, is afforded by an articulation made entirely of triangles. Klee has drawn dogs which, at the same time, are read as graphically consistent structures. The man and boy to upper right, made similarly of triangles, are however even more complex. These two figures share common geometric forms which make them seem to sprout from a single pair of legs. This transparent and ambiguous formal relationship, it need hardly be emphasized, gives the figures a psychological and symbolic complexity which goes beyond any previous figures we have examined. The two humans in *Uncanny Moment* are not only the most complex and engrossing of Klee's 1912 puppet figures, they are clearly the most cubistic. As we will shortly see, they lead directly as well to Klee's further Cubist developments of 1913.

It is important, however, to examine the ways the men differ from the animals in this drawing. For the contrasts within the *Uncanny Moment* provide important keys to the general meaning of Klee's hinged-facet figures of 1912. The dogs in *Uncanny Moment*, just as the dancers in Plate 25, do have geometric parts resembling the facets of Analytic Cubism, but the relationship of the facets here is like a mere stringing of beads. The dogs are simple triangle-hinged puppets.

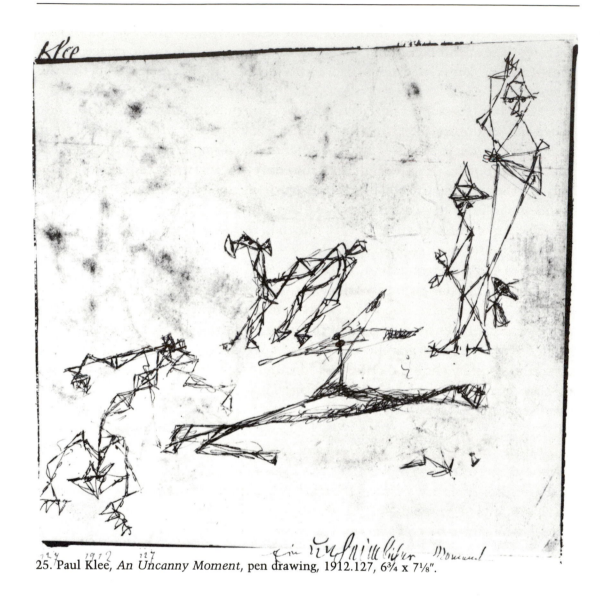

25. Paul Klee, *An Uncanny Moment*, pen drawing, 1912.127, 6¾ x 7⅛".

But the two humans, by contrast, have a rich ambiguity, overlapping, and inter-mingling of parts. The man and boy, in other words, have the rudiments of a truly Cubist interpenetration of parts; while the animals in the drawing show an adoption of Cubist shape alone.

On the whole, the Cubist-shape drawing, the string of facets, is the major advance in Klee's work of 1912. The complex interrelation of parts is explored on a large scale only in 1913. *An Uncanny Moment* and its related drawings, finally, are still well within the Renaissance, illusionistic, stage-space tradition.

76

The most complex of Klee's transitions, the adoption of the typical Cubist compositional format, would come only in 1914.

While it cannot be objectively proved that Klee's 1912 faceted figures directly reflect the influence of Cubism, this is the most likely source of the geometrizing tendency. We reviewed earlier Klee's many contacts with Cubism from late 1911 through 1912. By the end of Spring 1912, Klee had seen both Blue Rider exhibitions, had visited Paris, and the *Blaue Reiter* Almanac was in his hands. This was the time when his labor on *Candide* was coming to a close, and he would have been interested in exploring new figurative forms. We can, I think, confidently, date the faceted marionettes to the middle or the latter half of 1912.[20] They represent Klee's meditations on the Cubist forms he saw earlier in the year.

Specific Cubist sources for the type are, however, more difficult to suggest. The generally faceted nature of most Cubism, including the variants of Delaunay and the Futurist Carrà, is obvious; and the triangular and rectangular individual forms are common to the works of almost every Cubist. Figurative French Cubism, however, seldom gives a puppetlike impression. Picasso's *Girl with a Mandolin* (Plate 15) is pieced together out of geometric facets, but they relate to one another by the means of overlap, *passage*, and juxtaposition and have little connection with the jointed puppet. Picasso's figure is the result of an analysis and Klee's figures are, as has been observed in *An Uncanny Moment*, the result of an additive process, whereby a small geometric unit is multiplied into a figure.[21]

In addition, the latticelike joints of Klee's triangles, with their frequent "X" configurations, are more mechanical and dematerialized than the "⊢" joint, which is more common to true Analytical Cubism. The checkering and the larger triangles of Delaunay's *The City* (Plate 13), which Klee saw in the first Blue Rider exhibition; and the triangle-and-diamond grid of Delaunay's first *Fenêtre* (Plate 17), with which Klee was very familiar by mid-1912, come to mind as sources for Klee's crystal combinations. To a limited extent, Delaunay had applied this facet system to the figure in the large *La Ville de Paris*, which Klee had seen at the 1912 Salon des Indépendants.[22] There is, for example, a similarity in detail between the faceted legs of *La Ville de Paris'* central figure and the type of faceting in *Rapture of the Dance*. But the Delaunay figure like the *Girl with a Mandolin* is a coherent form analyzed—rather than built up—by triangles.

A more awkward and manikinlike precedent might have been the two figures of Le Fauconnier's *L'Abondance*, which was illustrated in *Der Blaue Reiter*.[23] Fauconnier's large emblematic figure gives the impression of being built up of blocky forms, faceting into triangles and rectangles on their surfaces. The figure is, however, except for its far leg, entirely coherent, and its relation to the background is wholly traditional. In this Le Fauconnier, a faceted figure strides before

a faceted landscape, but the space is still that of the Renaissance figure-background. In Picasso or Delaunay, by contrast, figures and grounds interrelate, creating a new kind of space. This suggests that, ironically, the conservative, minimally Cubist work of Le Fauconnier, which Klee knew, may have had greatest importance for him during this 1912 transition period. Le Fauconnier may have provided a one-step Cubist model that was easily understood. It is certain, at any rate, that Klee shared, for the time, Le Fauconnier's conservative formula of cubistic figure in traditional space.

In these and subsequent comparisons with Klee, one must constantly be aware of the tremendous, startling size differences involved. Most Cubist paintings are a moderate two or three feet in each dimension. The Le Fauconnier and the Delaunay *Ville de Paris* just discussed, however, are very large, over two yards. By contrast, the works in which Klee fashions his response to Cubism are *minuscule*. Drawings like *Rapture of Dance* and *An Uncanny Moment* are only seven or eight *inches* across. We must therefore recognize that Klee had the unusual ability, not only to abstract forms away from their original subjects and compositions, but to dissociate them—radically—from their original size as well. This realization does little to alleviate the many shocks of scale-difference encountered when dealing with Klee, but it does inform us that, however miniature a Klee work is, we must be prepared to give it the same consideration—in a formal analysis—that we would if it were a larger, more usual size.

By far, however, the most intriguing Parisian parallel to Klee's 1912 puppet forms is Marc Chagall's large painting of Adam and Eve, *Temptation* (Plate 26), done that same year. The Cubist facets and jointings, and even the odd posture of the figures, here have affinities with Klee's drawings such as Plates 24 and 25. The awkward jointings of Adam's right arm and his balletic stance are particularly close to Klee. Yet the similarities must be understood strictly as parallels; for while Klee probably saw some Chagalls in the 1912 Salon des Indépendants, this work was not among them, and there is no evidence that Klee could have known it.[24]

While Klee and Chagall have been frequently mentioned together in the literature, the comparison so far has only been on a superficial basis, stating merely that both fantasists borrowed in a general way from Cubism.[25] By contrast, we have here a concrete parallel of exactly contemporaneous works, with analogous places in the two artists' *oeuvres*, which is instructive indeed. Both artists present figurative scenes that are half-comic in their animated dance of the passions. And they have chosen identical aspects of Cubism to aid in the fantasy. Both have recognized that the hinging facet shape could lend to their figures not only an air of movement, but humorous double readings of form as well. Most

78

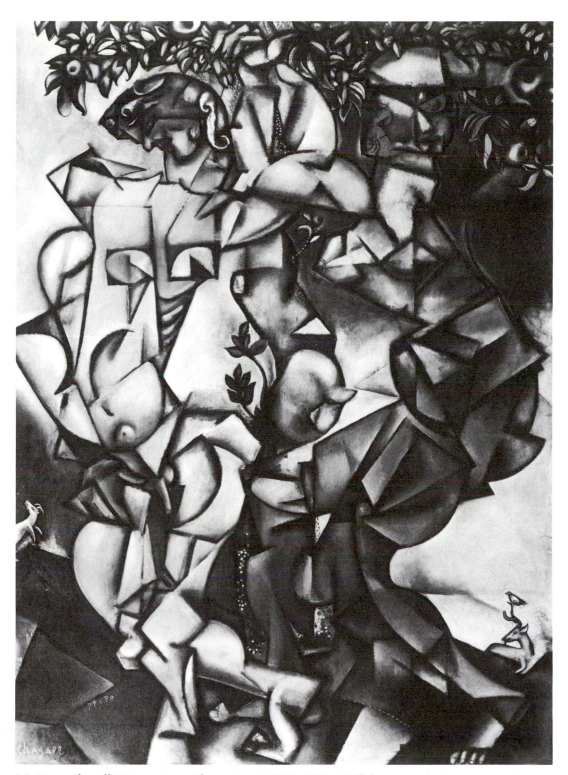

26. Marc Chagall *Temptation*, oil on canvas, 1912, 63³⁄₁₆ x 44⅞".

important ultimately, to Klee and Chagall, the transparent facet increased the mystery of the figure, giving it on the surface a geometric simplicity while hinting at the same time that its crystalline depth holds untold complexity of form and content. Klee and Chagall had never met, but they approached Cubism for the same things at the same time, and it is therefore hardly surprising that they reached in 1912 a point of near congruity.[26]

Finally, Klee's *Uncanny Moment* suggests a key comparison from the contemporaneous world of German-Austrian Expressionism. Klee made friends in the winter of 1910-1911 with Alfred Kubin, the Austrian draftsman and writer who was associated with the Blue Rider. The two artists have often been bracketed, since the Blue Rider days, as having similar graphic sensibilities. Klee's *Candide* drawings, for example, are frequently compared to Kubin's work, because, as illustrations, they have a relation to text comparable to Kubin's illustration of his own fantasy prose.[27]

The forms of Klee's *Candide* drawings (Plate 20) are indeed very close to Kubin's *Lively Dispute* of around 1912, among many other examples.[28] Both artists use willowy strap-forms to enact scenes of wild gesticulation. Kubin further articulates his figures by sausagelike or cactuslike constrictions in the limbs, producing loose joints which augment his figures' flailing action. If we turn, however, to Klee's next step, in the *Uncanny Moment*, we observe that the two draftsmen soon part company, in a very important way. Klee's move, from *Candide* to *Uncanny Moment*, was in the direction of control. His new puppet-membering was an orderly system based on triangles. Klee's system maintained flexibility while at the same time opening the figure up to new possibilities of structural richness. In terms of emotive choice here, Klee has opted for the contemplation of structure over the direct near-hysteria of Kubin. In so doing, he moved outside the more usual one-way emotional trend in German Expressionism.

It should be emphasized, in our survey of 1912, that Klee's first Cubist adaptation took place in relatively few drawings, of tiny dimensions. This modesty of scale does not obscure their importance, but it is a reminder that pre-Cubist modes still dominated his work for most of that year. Klee's exciting light-forms, his magnificent wash-planar drawings, the Candide illustrations, and even the more frenzied strapwork figures reflect more confidence and a greater formal sophistication than his few Cubist-influenced figures. Nevertheless, we have seen that during this year, Klee was constantly involved with French Cubism on an intellectual level. This interest was only slowly and painstakingly reflected in his work. We have, then, a repetition, with Cubism, of the time-lag relationship

that characterized Klee's earlier study of the forms of Goya; while he was most closely involved with an influence, it did not appear in his art.

While Klee had a mental grasp of all the Cubist principles by mid-1912, he chose for his first adoption only a single feature, the geometric facet. This feature filled a definite need in his current work. It coherently hinged the gesticulating puppets and opened up their form to a rich structural elaboration. Parallel to the case of Klee's Aubrey Beardsley study, he chose again a specific, unusual aspect of his source. Klee had borrowed from Beardsley not the famous whiplash line, but an aspect of sculptural plasticity. In the same way, in 1912 Klee imitated neither of Cubism's most striking, salient points: still-life iconography nor the startling sense of fragmenting—almost physically breaking—the objects apart.

In annexing the facet alone, Klee lifted the Cubist shape free of its whole developmental context in French art. He had not yet explored the interrelation of shape, the overlapping, analytical *passage* of parts which, in the original Cubism, had *produced* the facet shape. Neither, yet, had he reflected that his conservative stage space and vignette design might benefit from the Cubist compositional revolution, wherein objects and images were interdistributed with a fragmented background. These aspects of Cubism, however, mark the central direction of Klee's studies over the succeeding two years.

81

Chapter 5

THE INTERRELATION OF PLANES: 1913

The year 1913 was extremely important for Klee's art, and once again increasingly satisfactory results in the studio seem to have lessened his interest in recording thoughts in his diary. Later, he would comment on this period of transition: "1913 . . . The inner struggle in my art is abating."[1] Yet there are few entries for 1913 in his *Diaries*, and in them few details of substance or hints for chronology.[2] He may have visited Bern in the summer of 1913, and he spent Christmas there. Other than that, he was probably in Munich all year. To judge from his work, Klee was extremely active over this time. Nevertheless, his few words on the Futurists, at Thannhauser Galerie, were his last serious diary discussion of art until, a year and a half later, his notes on the Tunisian journey.

Klee's silence is all the more disappointing since the pace of international modern art contact was quickening in Germany at just this time. Lacking material, at this point, to fully document Klee's year, we may yet note the most outstanding circumstances and events in his milieu that made reference to Cubism. For even if Klee recorded nothing about them, he doubtless knew of these things, and they formed the background of his artistic studies and reactions during the year.

A one-man exhibition of Picasso was held in February 1913 in Munich at Thannhauser.[3] From August to September, the Galerie Goltz hosted a "Collective Exhibition of the New Art" in Munich, which included works by Picasso, Braque, Gleizes, and Gris, and had a catalogue with prefaces by Wilhelm Hausenstein and André Salmon.[4] Sometime during the year, Goltz also published a German translation of a 1912 essay by Le Fauconnier.[5] These exhibitions would have

refreshed Klee's knowledge of high Analytical Cubism. The February Picasso exhibition, moreover, had at least one example, *The Poet*, of Picasso's highly textured, Collage-related style of 1912, with which Klee could have thus made his first acquaintance.[6]

According to several accounts, moreover, Klee first met the important Bernese collector and close associate of Kahnweiler, Hermann Rupf, in 1913.[7] Rupf owned several of the great Cubist masterpieces, acquiring new Collage-related works by Picasso, Braque, and Gris during that very year. While the exact date of their meeting has not been determined, access to these advanced works during 1913 probably brought Klee up to date on the very latest Cubist style.

Outside of Munich, the most important art event of the year in Germany was the first German "Salon d'Automne" in Berlin. The Walden-sponsored *Erster Deutscher Herbstsalon* opened in late September. Klee mentioned this in only token fashion in his diary, concerning his own drawing entries; there is no record that he attended the exhibition.[8] Yet he could hardly have missed reports of this show that included a wide spectrum of works from the whole European (and even American) avant-garde. The *Herbstsalon*, for example, marked the high point of Robert Delaunay's prestige in Germany. Delaunay's reputation had gained in strength after a one-man *Sturm* exhibition in Berlin in January-February. While Klee had lost interest in Delaunay's theory by that time, he cannot, given his background, have missed the general impact Delaunay was having in all the Expressionist circles. In a distant echo of this, Delaunay influenced Klee a second time, through the agency of Macke, a year later in North Africa.

Among the Picassos and Braques which Klee saw this year, several were very advanced stylistically, and they were essential to rounding out Klee's Cubist education. In addition to *The Poet*, for example, Picasso's *Violin, Glass, and Pipe on Table* of 1912 appeared in the February Thannhauser exhibition.[9] Here Klee could see the classic oval Cubist format, which he later used in two or three pictures of his own. This transitional work is further remarkable for the very literal "stenciling" of words and numbers across—paradoxically—an extremely dematerialized, late-Analytic space. *The Poet* has passages humorously representing hair and moustache in the Collage-related technique of paint textured by the physical striations of a comb. In August-September, the Goltz Galerie show included, moreover, the now well-known Picasso *Violin and Grapes* (in The Museum of Modern Art).[10] Here, the striated texture (originally an innovation of Braque's) imitates wood-graining. More important, in this work Klee would have observed, for the first time in full measure, the optical wrenching and clashing of planes that accompanied the emergence of the flattened Synthetic-Cubist forms—over mid-1912—through the older, looser Analytic space.

83

What Klee saw in Hermann Rupf's collection would have augmented his knowledge of 1912-1913 Cubism even further. Through his close connection with Kahnweiler, Rupf usually acquired his Cubist works within the year they were painted. Thus, over 1913, he made striking additions to his collection in the Collage-period style: Picasso's well-known *Violin on a Wall* (Plate 27) and Georges Braque's *L'Echo d'Athènes*. And by the year-end holiday (by which time Klee is certain to have seen the collection), Rupf had acquired his first Juan Gris, *The Three Cards*, dated "9-13" (Plate 28).[11]

In *Violin on the Wall* (Plate 27) there are strong textural and coloristic differentiations of planes. Imitation wood paneling is painted in the careful *trompe-l'oeil* that Klee had probably seen before. Forms in the violin body and finger board are raised by a heavy admixture of sand into physical bas-relief. The bold colors and aggressive shapes demonstrate the flattened precisionism that in Synthetic Cubism supplants the tilted, faceted approximation of the Analytic style. And at this crucial stage, the outermost, Synthetic zone of *Violin on a Wall* contrasts markedly with the still-Analytic planes at the center. By comparison, Braque's *L'Echo d'Athènes* is conservative for 1913. In oil and charcoal on canvas, the Collage-related passages have been carefully imitated in illusionistic *trompe-l'oeil*.

It was Rupf's *The Three Cards* by Gris (Plate 28), however, that provided Klee with his closest look at early Synthetic Cubist art in 1913. Highly advanced, its severe juxtapositions are very much a paradigm of the emerging Synthetic style. The abutted, geometric shapes appear to step back and forth, abruptly. The staccato rhythms are very unlike the tilting and melding of forms in the older Analytic space. Flattened forms like the cards have a new, emblematic equivalence with the things they represent. Other forms in the painting, however, appear quite abstract, functioning more as compositional weight and counterweight rather than as the depictions of objects.

It is interesting to note that none of the works Klee studied this year were in the most radical Collage technique, *papier collé*. Rupf, for his part, probably hesitated to collect works in the more ephemeral materials. But this foreshadows the fact, as well, that in the long run the more subversive aspects of Collage— for example, the incorporation of cut-outs from popular printed material—would have relatively little impact on Klee. Rather, guided by the works to which he had early access, and by his own sensibility, Klee read Collage-period Cubism not for its most startling aspect, but for those logical characteristics that gave birth, directly, to the Synthetic Cubist style. Klee's interest in Cubism was focused on the elements of structure and continuity rather than novelty.

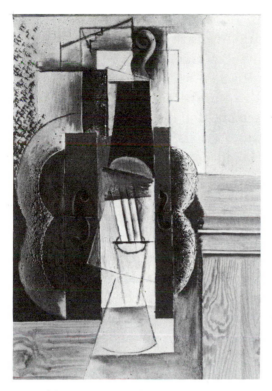 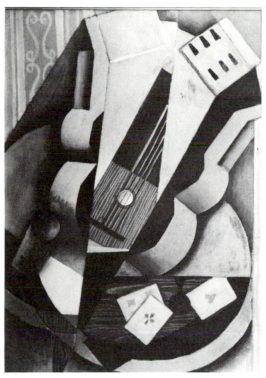

27. Pablo Picasso, *Violin on a Wall*, oil with sand on canvas, 1913, 25⅝ x 18⅛".

28. Juan Gris, *The Three Cards*, oil on canvas, 1913, 25¾ x 18⅛".

Rupf owned many other key works, such a Braque's 1908 *Houses at L'Estaque*, his 1912 *Bar Table*, his 1911 etching *Job*, and the Picasso *Saint Matorel* etchings (Plate 16) which Klee had seen in a Blue Rider exhibition. Rupf's collection constituted, in fact, a complete museum of Cubism. In this ambient, Klee probably rethought all that he had seen of the whole Cubist style. This was doubly fortunate, since within half a year, in mid-1914, the outbreak of World War I shut down all routes, and particularly the French-German ones, of international art communication.

Given the fact of wartime isolation, it is important to summarize what Klee had seen of Cubism by the end of 1913, for it would be from this information that he forged his own Cubist style and which to a great degree determined his whole later understanding and usage of the style. He knew the early, high, and late Analytic styles and the first stage of the Synthetic style. But his access was cut off just after that point, and he saw comparatively little of Synthetic Cubism, which he encountered only later, after the war, when his own style was already fully formed. His acquaintance therefore centered overwhelmingly on the Ana-

lytic. As a consequence, all the way up to 1927, Klee's own Cubist style refers much more to the Analytic than the Synthetic. Moreover, his wide experience with Analytic Cubism, in 1912-1913, convinced him that that style was not, as some would have it, a Picasso-Braque straitjacket, but rather a flexible, pictorial *lingua franca* that could be employed in any number of ways.

True to pattern, Klee's art in 1913 lagged behind his intellectual and critical studies of Cubism. Nevertheless, 1913 was a crucial year in his development, as, step by step, he devised ways and expanded his forms to better serve his content. In the course of this year he developed a close affinity with Fauvism, particularly as it was represented in Germany in the NKVM and the Blue Rider. Initially, he replaced his traditional Impressionist mode of composition with Fauvist-style composition. Along with this, he experimented, through many twists and turns, with the Fauvist manner of tightly overlapped planes, exploring this new form to its limits. Subsequently, he replaced this overlap with the Cubist method of interlocked planes. We saw how Klee's 1912 response to Cubism was the isolated adoption of the Cubist facet shape. In this next year Klee managed new interrelationships of these shapes, working out the complexities of Cubist pictorial space.

As a useful introduction to these developments, we may compare a typical figurative drawing of 1913 to works of similar motif of 1912 and 1914. Klee's *Human Weakness* (Plate 29) is here compared to the 1912 *Uncanny Moment* (Plate 25) and to *Sketch from Kairouan* of an advanced 1914 style (Plate 30).

Human Weakness is similar to the 1912 drawing in its continuation of the puppetlike figure. The figures are constructed of the triangular shapes, or facets, which we have seen originating in Cubism. There is in the 1913 figure, however, a greater confidence in this shaping method and a suggestion, moreover, in the crystalline breasts and complex leg regions, of a translucent complexity. This arranging of two-dimensional shapes to suggest a limited and highly ambiguous three-dimensionality is characteristic of the details in high Analytical Cubist work. The triangular planes in their apparently hinging, sliding relationships to one another effect *passage*, or a tilted, slanted spatial relationship, with one point or side lying on the picture plane, and other points or sides projecting back to a shallow background depth.

More strikingly, in contrast to 1912, lines in the 1913 drawing describe large geometric shapes which appear to interrelate the figures in complex two- and three-dimensional ways. With the sun at the top and the differences in scale in the figures, indeterminate distances are implied among the elements of *Human Weakness* in direct correspondence to the psychological title. Theoretical, even

86

cosmic, relationships appear to be diagrammed in the skein of the drawing. By contrast, the 1912 *Uncanny Moment* maintained the optical scale and implied stage space of the premodern tradition. We have in Klee's 1913 drawing, thus, not only the *passage* of individual planes but his first attempts to organize the whole picture in this manner—in other words, to compose in a Cubist way.

There remains, however an important difference between the composition of *Human Weakness* and the Cubist composition of Picasso and Braque, for example, "*Ma Jolie*" (Plate 18). In Analytical Cubism proper, the lines which form the edges of the facets of figures and objects are extended to become themselves the compositional grid. The analysis and redistribution of the object is synonymous with pictorial composition. There is no disparity of scale between detail and the larger elements; all are consonant within an almost modular scheme. In the 1913 Klee drawing such disparities do exist; the figures have one scale, the compositional lines another. The figures have not been taken apart, but have been merely diagrammatically related to one another by a gridline scheme.

There is a subject-related tension as well as a formal one in such drawings as *Human Weakness*. With his figures, Klee sought to maintain the cohesion of his subject narrative. Such a narrative would be difficult to maintain if the figures were totally dismantled by Cubism; and many solutions to this problem were to be attempted as well by Klee in 1913.

With the 1914 *Sketch from Kairouan* (Plate 30) a more thorough assimilation of Cubism is reached. The Cubist shapes, now broadened, are all interrelated in the *passage* manner giving, at points of conjunction, complex suggestions of interpenetration and of parallel, overlapping planes. The figures have been enlarged in relation to both the architectural elements and the overall format, so that the figures' lines now become also the main compositional lines. This was, in 1914, the final step in Klee's Cubist assimilation.

The foregoing comparisons define the stylistic parameters of Klee's 1913 work and make clear its central issue: the geometric facets from 1912 are now spatially interrelated in Cubist ways. Secondarily, Klee makes tentative essays into Cubist composition. The details of Klee's numerous and varied works of this year are, however, very difficult to order beyond this.[12]

The intrayear oeuvre numbers that Klee gave his works are not a reliable guide to specific dating, and we know few details of his life in this year. A few points of stylistic contact have been established, the February Picasso exhibition and the August-September Goltz Cubist show, for example. But we know it was not Klee's habit to react immediately to a stylistic influence. The examples he saw in 1913 of advanced Collage and early Synthetic Cubism appear as influences

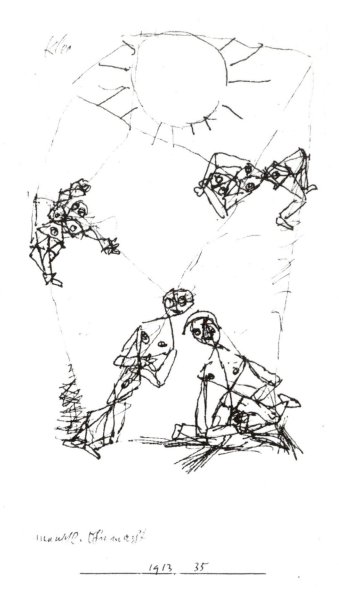

29. Paul Klee, *Human Weakness*, pen drawing, 1913.35,
7 x 3⅞".

in his work only after delays of many months. They thus provide no convenient "pegs" upon which to hang a stylistic chronology.

Comparatively few Klees were treated with a detailed stylistic analysis in the early literature. Recent books and articles have been more specific, but the crucial and productive year of 1913 has nonetheless suffered almost total neglect.

30. Paul Klee, *Sketch from Kairouan*, pen drawing, 1914.46, 6¼ x 4⅛".

A number of works of the time have been published at random, but their significance has never been discussed. It appears that for most writers the 1913 works are completely overshadowed by the spectacular Klees of 1914, particularly of the Tunisian period. But as we have already seen to the contrary, in the broader outline, Klee's works of 1914 would not have been possible without the achieve-

ments of 1913. Moreover, appreciation of the finer points of Klee's later works is greatly enhanced by an understanding, step by step, of his evolution of this time.

Four stylistic groupings, or focuses, for the many Klees of 1913 represent four distinct stages in his development. While they have no exact correspondence to time periods, such as for example quarters of the year, the groups do have some implication for chronology, and relationships can be discerned to the events of the year. The first group, primarily drawings, has its stylistic base in the faceted figure style of 1912 and culminates in such drawings as *Human Weakness*, discussed above, in which these figures are tied together by a diagrammatic sort of composition. Because advanced works of this type dominated Klee's exhibitions in the *Erster Deutscher Herbstsalon* in September, I see this group as belonging essentially to the first half of 1913.

A second line of development is more planar in form and includes a number of drawings, prints, paintings, and some of Klee's most significant landscape watercolors. This series began, I suggest, with Klee's first positive absorption of influence from the Fauvism of the NKVM and the Blue Rider (specifically Kandinsky of 1910-1912), probably early in 1913, and continued through the summer and into the fall. The possibility that Klee visited Bern and saw part of the Rupf collection in the summer is strengthened by the reflection, in the latter part of this group, of a new level of Cubist influence. Some works of this group may be traced, through their motifs, to Switzerland—whether they were done during the elusive summer trip or later.

Centered, more or less, in the summer and further suggestive of a visit to Bern, is a third group, stylistically less systematic and more varied than the other 1913 categories. In these works, Klee's apprehensions of Cubist form are applied to motifs observed from nature. Many of these works are wash drawings and muted watercolors, some more linear, some more planar in form. But all have an openness and relation to nature different from the other three, more hermetic, types of 1913, and foreshadow the freshness of the later Tunisian works.

The fourth group, drawings and prints, is distinguished by Klee's limited but nonetheless direct approach to the problem of making his poetic subject-interests commensurable with the complexities of Cubist space. Characteristic here is an open and broken linear patterning, virtually identical with the high Analytical Cubist scaffolding, which is composed, moreover, in a near-Cubist way. This group, too, may have had its origins in the late spring and summer, as there are wash drawings which relate the type transitionally with the groups from earlier in the year. The culminating examples of this last group, however, probably date

from the last months of the year. It is almost certain that they are reflected in a famous passage in Klee's diary of that time, in which he voices satisfaction with newly developed ways of shape-relation and composition.

Group One

Citing only the most handsome drawings of the first group, a line of logical development can be observed. The well-known *Afflicted Policemen* and *Fleeing Policemen* are related clearly to the puppet-theater forms of such 1912 works as *Harlequinade*.[13] The figures in *Afflicted Policemen* are based on a traditional ground line with, however, an undefined spatial relationship to the small group in upper left. This tiny manikin seated in a scroll-backed ledge surmounted by heavenly signs may possibly refer to the figures and signs on the famous sixteenth-century clock tower of Klee's native Bern.[14] Clearly, something of a psychological and cosmological relationship—however comic—is indicated by the relations of the two groups in the drawing. *Fleeing Policemen*, with its change in scale and free distribution of the figures over the picture field, is less clearly related to the puppet-stage proscenium. It presents, I think, early thoughts on a Cubist-like, nonground-line, nonperspective relationship among discrete figures.

Of the same kind of figure arrangement is *Idols* (Plate 31). Taken together, *Fleeing Policemen* and *Idols*, with their rhythmic intervals among limbs and figures, indicate, I think, that something like an implied Cubist grid for the picture plane was present in Klee's mind during these first essays in allover composition. Most similar, too, in this respect, is the drawing *Joseph's Chastity Provokes the Enmity of the Dark Regions*.[15] Because this latter is a clear, if unusual, continuation of the 1912 non-Cubist strap-figure type, it emphasizes that the relational or compositional method could exist in Klee's mind independently of the figure type.

Idols belongs to a series of figures, masks, and heads of 1913 in which identifiable influences from African art appear in Klee. Scholars, including James Smith Pierce, have correctly identified the source for *Idols* in the sculptural guardian figures of the Kota people of the Gabon, illustrated here by Plate 32.[16] Other drawings of the series confirm Klee's African interest.

Drawing as it does on the background of the primitivism of the Blue Rider, the start of Klee's African interest tends to confirm his growing friendship with Franz Marc and his increased involvement with the general Blue Rider style

91

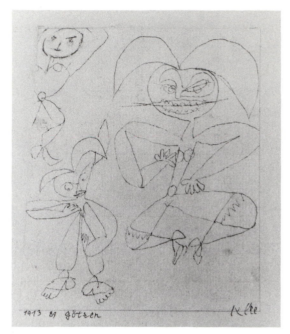

31. Paul Klee, *Idols*, pen drawing, 1913.89, 5 x 4".

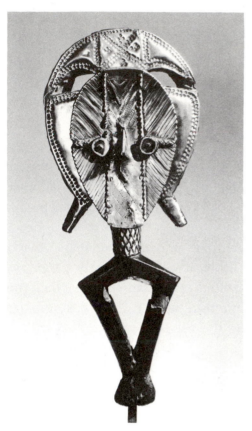

32. Kota, Gabon, *Reliquary Figure*, metal-work sculpture, 19th-20th centuries, height 16⅝".

during the first half of 1913.[17] Furthermore, to quote Robert Goldwater, one aspect of the Blue Rider interest in primitive art was "the formal apprehension of primitive styles peculiar to nascent Cubism."[18]

Certainly Kota guardian figures (as well as other African works) had been extremely important for Picasso, over 1907-1908, as sources for his *Demoiselles* and his "Negro Period" works.[19] A comparison of his interest with Klee's is informative. While Picasso drew at times on the flattened, plaquelike quality of the Kota figures, it appears that the faceted plasticity of other African sculptures was probably more inspiring to him, ultimately, in his development of Cubist space. Pierce has suggested, by contrast, that it was primarily the flat frontality of the Kota type that made it most appealing for Klee, and that Klee's choice of the source was an expression of the dominant two-dimensionality of his work.[20]

92

However, I would emphasize another aspect, underscoring that, by 1913, the problems of Cubist plasticity, what I have called the spatial interrelation of planes, was very much on Klee's mind. His thinking encompassed aspects very close to Picasso's interest. Within the shallow relief of many Kota guardians (as in our example) there is a layerlike relationship between the face and the "head-dress" behind it. This suggestion of leaflike overlapping and laterally sliding relationships is present in the heads and bodies of Klee's *Idols*. With other examples, such as the double drawing *Heads* (Plate 33), the leaflike emergence of forms is emphasized.[21]

In terms of pictorial space, this shallow overlapping in *Idols* and *Heads* most resembles the method of Fauvism. In Fauvism, and in these drawings, the forms are pressed flat and sandwiched tightly one over another. The tensions that arise, from flattening both the objects and their interrelationships, account for a great deal of the emotional feelings of anxiety and urgency that we associate with the Fauvist style.

There are, nevertheless, factors in *Heads* that take it beyond the Fauvist model. The facial forms are given as geometric facets of the almond head. And we observe as well in *Heads* the combination frontface-profile which originated with Cubism. In their branching from the center line and in their intersections the lines form interpenetrating relationships, simultaneously as they "add up" to a face. Insofar as they are additive, the drawings resemble Klee's "modular" puppets of 1912. But they differ from the 1912 figures in that the facets are fitted together with greater planar emphasis and are less regular, crystalline, and transparent than, for example, the animals in *"An Uncanny Moment"* (Plate 25). Present here, in other words, in miniature, is that tension between spatial translucency and two-dimensional flatness which characterizes high Analytical Cubism.

Klee sent twenty-two works to the *Erster Deutscher Herbstsalon*, which opened in September, among them the drawings *Human Weakness* (Plate 29, to which we have already been introduced) and *Fiery Ensemble*.[22] In these and related works, Klee reaches beyond the single figure to tie whole groups together with long, field-division lines. These drawings are the most advanced in our Goup One, as Klee attempts with them to enlarge the relationships among small figures into a more general compositional significance.

Men and Animals Despairing, for example, is a drawing of this type which has an implied compositional system.[23] But here the grid presence is so evident as to suggest that Klee had, in fact, begun the drawing with an open, abstract pattern and then only secondarily closed the shapes and added the details of eyes

93

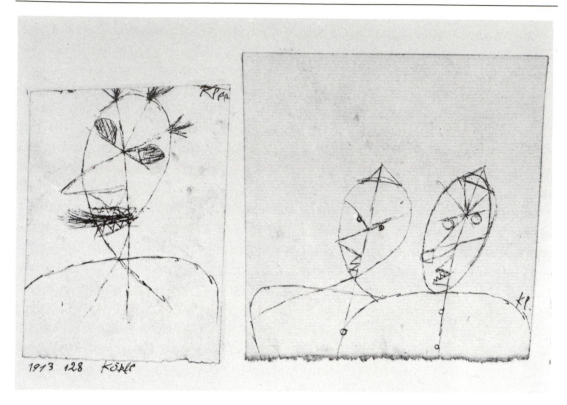

33. Paul Klee, *Heads*, pen drawing, 1913.128, 3⅞ x 2¾" and 4¼ x 4¼".

and feet. This is an interesting formal parallel to Klee's written description, in the Moderner Bund review of midsummer, of the Cubist who first creates his pictorial scaffolding and then tailors the figures to fit.

Another, tentative, variation is represented in the well-known drawings *Children as Actors* and *Good Conversation*.[24] Here, a row of frontal figures is held together by connecting lines, resembling mountaineers' safety ropes, strung between the waists, heads, and feet. It has been aptly suggested, in the past, that these lines derive from the ground lines and other literal schemata of children's art.[25] This is certainly true, but it is equally interesting to observe that this childhood manner first appeared in Klee's art in the context of developing Cubism. Klee had a recorded interest in child art since at least 1911; but the compositional scheme in *Children as Actors* was only fully activated by Klee's developing Cubist interest.[26] This amazing unification of the childhood, Cubist, and primitivist sensibilities can be seen, moreover, in the large-headed doll-like forms of Klee's child "actors": for they are, without a doubt, derived on another level from the child-beauty wooden dolls of the West African Ashanti.[27]

94

Forming a close group with *Human Weakness* (Plate 29) are the drawings *The Last Stage of Don Juan's Infatuation, The Suicide on the Bridge,* and *Fiery Ensemble*.[28] As we noted for *Human Weakness,* the whole picture area has been organized by a skein of long, intersecting lines which enmesh and interrelate the separate figures. Emotional and cosmological relationships are symbolized by the lines. In *Don Juan* this basically Cubist device achieves an intensity of psychosexual tension seldom equaled again by Klee. The *Suicide,* just as savage emotionally, is however less compelling. Large, malevolent heads, as well as a clock, are generated by the skein. But the mode is here unsuccessfully applied, since perception of the large faces severely disturbs the internal coherence of the drawing. Composition and meaning, in this imperfect piece, do not work together and tend to cancel each other out.

Fiery Ensemble, from the Herbstsalon, represents Klee's furthest step, by midyear, toward the openness of the 1914 style. A large relational scheme, *Ensemble* is combined with the open, approximate hatching (or thatching) Klee had developed in 1912. The figures, particularly that of the frenzied conductor in the center, are opened up to integrate with the larger lines. Compositionally balancing the figurative nexuses are the schematic "sound lines" in the upper center and forms in the upper left and right, which one can recognize through their relation to some more descriptive work of 1911, as the chandeliers and gallery of a famous Munich concert hall.[29] Perhaps even more than with *Don Juan,* a near-Cubist composition has here been utilized successfully to an Expressionist end.

Group Two

The second major group, which appears to be more widely distributed throughout the year, comprises works in several media. The etching *Garden of Passion* (Plate 34) is an important and probably early example of the type. In contrast to the small-figure drawings just examined, the emphasis here is predominantly planar. In *Garden of Passion* the shapes are closed and biomorphic and are spread compositionally from border to border with relatively little focus.

The relationships between planes are of two types, both variations on *passage.* In the central area of the print, planes overlap in a shallow, leaflike way. Here the individual, interleaved planes are tonally inflected by the means of hatching lines into slanting, skew relationships with the picture plane, with the background, and each other. This opaque and dense interpenetration of Cézannesque *passage* was characteristic of Fauvism, particularly as it was developed

95

in the Munich circle of the NKVM and the Blue Rider. And we have already seen how such leaflike planes had interested Klee in African art. Finally, toward the corners and borders of *Garden of Passion* appear areas of the more open, ambiguous, and interpenetrated *passage* which we associate with high Analytical Cubism.

The situation with overall composition is similar. Insofar as the shapes in *Garden* are slightly more plastic and focused in the center of the field, the composition resembles Cubism. But ultimately the more dominant allover, carpetlike distribution of shapes, again, most resembles German Fauvism. In works of this type, in other words, Klee consolidates a manner of Fauvism, while continuing to probe, from this secure stylistic base, the more difficult forms of Cubism.

This involvement in Blue Rider Fauvism was historically conservative for 1913 in that it represented the fruition of an influence already a year and a half old. Klee had gradually become more active in Blue Rider circles, participating in early 1913 in a collaborative Bible-illustration project. Evidence in Klee's work indicates, moreover, that at the time of *Garden of Passion* he was—as a rare instance—under the direct influence of Kandinsky, the guiding light of the Blue Rider group.

In the long run, this temporary adherence to Fauvism enabled Klee to sort out his thoughts on Cubist structure and to further understand its possibilities. I have shown that Klee understood Cubism progressively as a new kind of shape, a new relationship between shapes, and finally as a new way of composition. In the present group of works, Klee experimentally intermixed the first two of these elements with Fauvist shapes and overlaps, in Fauvist compositions. The result, as we will see, was not entirely satisfactory.

This forced Klee, I think, to understand the limitations of any piecemeal Cubist application. He came to appreciate not only the individual Cubist elements but the desirability of reintegrating all the elements together. The heavy literalness of Fauve *passage* revealed the advantages for spatial structure and even for subject matter of the translucent Cubist *passage*. The relative lack of focus in Fauve composition emphasized, by contrast, the stability and legibility of centralized, Cubist composition. The possibilities of full pictorial integration, which Cubism offered, were thus indicated to Klee by his brief Fauvist experiment. The inconsistencies and disjunctures of works like *Garden of Passion* pointed Klee, over the coming months, toward the full interweaving of all elements that characterizes mature Analytic Cubism.

We must consider the relationship of "Garden of Passion" to Kandinsky a bit further because it is one of the few instances when Klee came under Kandinsky's specific influence. Kandinsky was a powerful, charismatic figure, and

he completely dominated at times the Blue Rider milieu. Klee, however, usually kept his distance, stylistically, from Kandinsky. In this case of near-congruity, in fact, we may observe him to diverge from Kandinsky precisely over the issues of Cubism.

Klee had first met Kandinsky in the autumn of 1911, at the point when the latter was first moving into abstraction.[30] Klee was fascinated by this development; but for relationship to his own work, he looked less to Kandinsky's abstraction than to his Fauvist manner of ca. 1910, out of which the abstraction was developed. A very quick glance at Kandinsky's *Study for Composition II* of 1910 (Plate 35) will show it to be a general structural precedent for Klee's *Garden of Passion* (Plate 34).[31]

There are, however, more specific similarities that tend to indicate that this and similar Kandinskys were models for the Klee. In *Composition II* space is presented in approximately three horizontal zones. The lowest is a rather vague foreground where small generalized figures recline and emerge. The next zone of the picture is a complex middle ground full of assorted gesturing figures including two "legendary" riders in the center, and kneeling (or praying) figures to the right. The top band represents the distant landscape with the abstract forms of rocks, mountains, and trees. On the border between the middle and top zones, to the upper left of center, a small figure gestures with open arms, apparently to the more abstract forms around him. Finally, a vague suggestion of winged shapes, possibly angels, fills the top left corner of *Composition II*.

Many of these features appear also in the *Garden of Passion*. The same compositional division into three zones is present: a vague foreground of slanting hillocks and rocks; a more specifically drawn middle ground with, at center right, a sharp rocky ledge; and at the top a band of generalized, more distant forms. The figures in Kandinsky and Klee are even more similar. Just below the center of the Klee there reclines, or rises from a ground line, a featureless, bundle-shaped figure of exactly the same type as in the center and right foreground of the Kandinsky. Of the four easily identifiable figures in Klee's middle zone, the three on the rocky ledge—and particularly the two near its edge—duplicate the open-armed gesture of the tiny figure to the upper left of center in the Kandinsky. Their relationship to their ground line and to the more abstract forms around them is similar to the handling of Kandinsky as well. The Klee figure at the righthand border of the central zone "grows" from his ground line, and relates to a "rock" precisely as does a figure in the corresponding position of the Kandinsky painting.

Even more relationships exist between this Klee and Kandinsky: similarities, for example, with the reduced woodcut of *Composition II* that was printed in

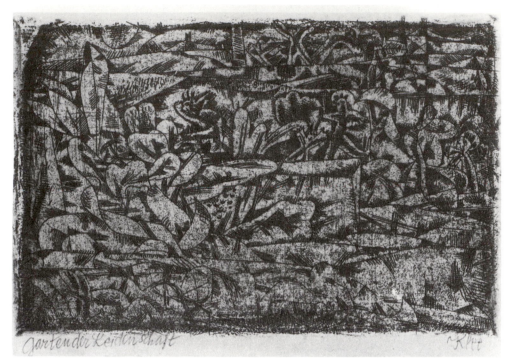

34. Paul Klee, *Garden of Passion*, etching, 1913.155, 3¾ x 5¾".

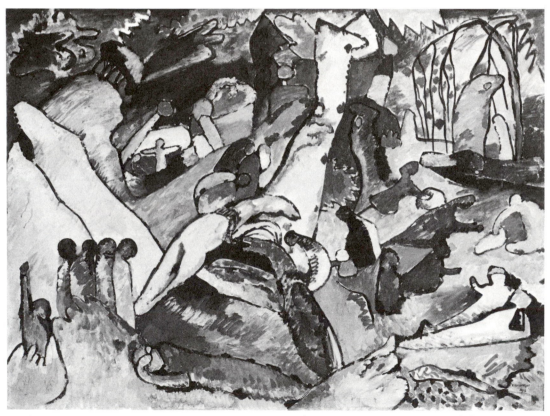

35. Wassily Kandinsky, *Study for Composition II*, oil on canvas, 1910, 38⅜ x 51⅝".

Kandinsky's poetic book *Klänge*, which appeared in late 1912, and even with the extremely advanced 1911 Kandinsky *Composition V*.[32] However, the similarities already pointed out are sufficient for our purposes here—to dramatize the difference in developmental *trend* between Klee and Kandinsky at the time.

Klee tends toward the sharply defined and crystalline. He crowds his forms into a dense weave that is at this point almost unintelligible. Shortly, however, through the Cubist transformation, this fabric will open up, and the translucent shapes will become visible, one through the other. When we consider Kandinsky's *Composition II* we understand that his trend was in some ways nearly the opposite. Kandinsky's next step after this, as in *Composition V*, is to render things abstract, in direct fashion, by generalizing their contours. To facilitate this, Kandinsky moves his forms farther apart rather than impacting them, as Klee does. The internal colors and tones of things are dissociated from their outlines by Kandinsky; they become unmoored and float as gaseous clouds. They intermingle freely with the soaring, abstract lines, one form passing through another. All is insubstantial, dematerialized.[33]

Kandinsky's vision, in both form and content, resembles the vaporous spirit-world described by the Theosophists (and at the time, Kandinsky partly subscribed to this spiritualistic religion).[34] Spatial scale and measure were destroyed by Kandinsky, who purposely avoids any step-by-step structure of *passage*. For him, the physical, down-to-earth implications of Cubism appeared as an undesirable limitation. How very different is his vague, floating form from Klee's hard, specific description. Klee's *Garden of Passion* is, similar to the Kandinsky, a biblical story, possibly a Garden of Eden, but it is couched in a very different language. Klee has seen the possibilities in the dense, ambivalent tangles of Cubism for conveying the rich, multivalent subject.[35] When Klee later completes this Cubist transformation he will have—unique among the Expressionists—a wholly rational structure for his fantasy.

The religious subject of *Garden of Passion* associates it with the Blue Rider Bible-illustration project, and further suggests, from this connection, that this stylistic group of Klees dates from early in the year.[36] Drawings that share closely in this form and content are *The Spirit on the Heights*, *Song of Lamentation*, and *A Fragment of Eden*.[37] In yet another example, Klee commented metaphorically, in form and content, on the limitations of the Fauve style which he sought to overcome. He titled this work *Region of Inhibitions*.[38]

Yet, in one illustration done specifically for the project, *Sketch for the 137th Psalm* (Plate 36), we see Klee's form one step further along in his new direction. Here Klee has thinned out the allover, carpetlike, Fauve composition of *Garden of Passion* by loosening up the passages between planes.

99

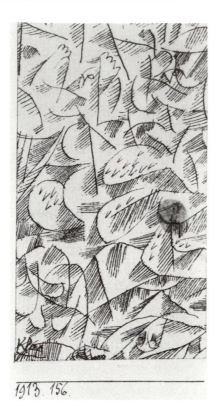

36. Paul Klee, *Sketch for the 137th Psalm*, pen drawing, 1913.156, 3⅝ x 2".

A series of watercolors represents the most aesthetically successful aspect of Group Two and includes some of Klee's best work of the year.[39] Four closely related works can be identified with Swiss motifs, and these must date from the summer or possibly early fall of the year.[40] Relationships may be proposed to Cubist works, particularly an early Picasso, which Klee had probably come to know this year in the Rupf collection. There appear as well hints of a relationship to Delaunay in these works—the first (to my knowledge) instance his influence on Klee. Beyond the interest of these influences, there is an inspired lyricism and a highly successful compositional focus to the carpetlike, Fauvist patterns. The watercolors are *In the Quarry* (Plate 37), *Villa in the Valley*, *A Hotel* (Color Plate I), and *Small Landscape in the Rain*, the latter three in a proposed stylistic sequence.[41]

In the Quarry (Plate 37) is perhaps the quintessential Fauve Klee. Recognized are the shallow overlapping planes and the broad composition, which here beautifully climaxes in the pinnacle center form, provided presumably by the observed motif. The color, while it cannot here be discussed in detail, is a rich combination of blue, tan, greens, purples, and oranges, much more thoroughly controlled than in Klee's earlier color work. Essential shifts in the center and on the left in the

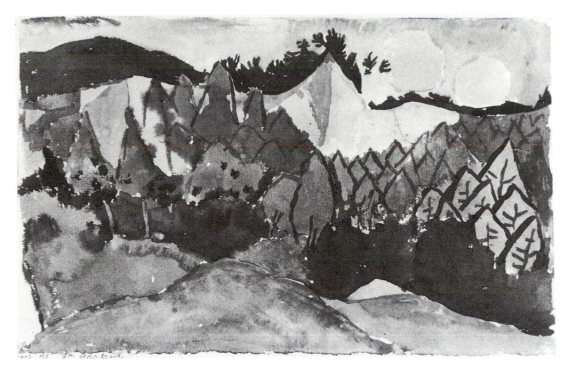

37. Paul Klee, *In the Quarry*, watercolor, 1913.135, 8⅞ x 13⅞".

planes of the naturally "cubic" quarry walls are handled by the classic Fauvist device of the color change which efficiently denotes a planar change. The congestion usually associated with Klee's Fauvism is relieved here by the band of sky at the top, and the simple flat triangle of the foreground at the bottom. This foreground, it should be noted, however, represents an uneasy mediation here between the near and middle distances.

One realizes, on reflection, that Klee's Fauve drawings—and prints, too, such as *Garden of Passion*—had no foregrounds, or only vestigial foregrounds; they were usually located spatially in some theoretical middle-ground. I think it possible that by the time Klee did *In the Quarry* he had seen Picasso's 1908 gouache *Landscape* in Rupf's collection.[42] But whether or not Klee had seen the Picasso, there are similarities in the two works that are extremely informative. Immediately apparent is the similarity between Picasso's mountain peak and Klee's quarry wall, with almost identical inflective color shadings. Klee's leaf-form trees to the right, as well, resemble the spade-form bush of Picasso. While the proportion of the fields—with the Picasso vertical and the Klee horizontal—are different; yet long diagonal composition lines guide the forms of midpicture in each.

101

Klee's foreground, however, produces a very different spatial feeling from that in the Picasso. Klee's flat triangles simply solve, or negate, the problem of near-landscape space by means of compositional abstraction. Picasso, by contrast, boldly presents the foreground problem by the interrelation of the heavily modeled trees, two of which create a tremendous spatial immediacy by running over the lower border. Picasso's lower-zone triangles and facets measure spatially as well as two-dimensionally the foreground distances involved. The Picasso foreground, indeed the whole scene, is extremely plastic, though not of course in a traditional way. The Klee by contrast is very flat. To be sure, Picasso was in 1908 developing Cubism for the first time, and Klee in 1913 was trying out its previously developed forms, but the comparison puts before us in a paradigmatic way an essential difference in meaning which Cubism would have for the two masters.

Comparatively, for Picasso, Cubism represented an exploration of plastic, even sculptural interests, with the intricate spatial conundrums of the style foremost in his mind throughout the Analytical phase. For Klee, much more graphic in his stylistic origins, Cubism was never sculptural, and it was seldom a dissection of observed plastic phenomena. It was much more a way of ordering composition and space: a shallow theoretical grid through which objects, and even schematized thoughts, could be conditioned for pictorial existence. Cubism lent to Klee's native graphic abstraction spatial—and subsequently structural, psychological, and metaphysical—resonance. We might further observe that plastic interests had forced Picasso in his Analytic phase to almost wholly abandon color in favor of tone—as the more potent element of plasticity. Whereas Klee, by avoiding such strong plastic drama here (and even in his more developed work), maintained the stylistic latitude to integrate color with Cubism in a way that served his more Romantic purposes.

Villa in the Valley, A Hotel (Color Plate I), and *Small Landscape in the Rain* appear to represent the same motif, a resort hotel in the mountains. The most naturalistic picture, *Villa in the Valley*, shows the twin-gabled hotel, as seen across a valley full of intervening plants and trees.

In *A Hotel* the problem of this intervening space is reduced by the introduction, somewhat as in *Quarry*, of an abstract foreground. The forms here may well be simplifications of the brushy hillside, but they are compositionally aligned by circular, flowing, rhythmic arcs. One observes, particularly in the upper zone of mountain peaks and hotel gables, gridlike diamond forms, and "X" configurations. A Cubist-like translucency breaks the hotel façade, particularly at the left, and also may underlie some of the tonal ambiguities of the foreground—as in the large irregular hexagon which dominates the lower left. *Small Landscape*

can be seen as very nearly a repetition and enlargement of details of *A Hotel*, including the leaf-form foreground shapes, the mountain, and the bifurcated hotel façade—now amalgamated into the hills.

The intuition of a translucent grid system underlies these watercolors and opens their curving Fauve planes to a new—if not precisely Cubist—degree of ambiguity. The high Analytical Cubist work, particularly Braque's, which Klee restudied at Rupf's, could certainly have been an influence here. This would account for his new interest in compositional grids, but not for the swinging curves of the pictures, not the dematerialized nature of the lattices, which—somewhat like a scored windowpane—seem to merely facet the scenes without really displacing their elements.

The formulation of Delaunay comes to mind, and indeed I believe the gridded "windowpanes" of *Les Fenêtres* of 1912 (Plate 17) exert their first, oblique influence on Klee in works like *A Hotel*. Delaunay's grid is less plastic, more wholly transparent, than Picasso and Braque's, and it uses as dominant forms the diamond, the " + " and the "X" crossings—elements that also appear prominently in the Klees. Delaunay's *Towers of Laon*, inevitably, forms a part of the stylistic background as well. In this painting, which Delaunay painted not long before the *Fenêtres*, we find the same tension as in these Klees between system and the observation of nature. The upper zone of each work is regularized by the grid, but the foregrounds are equally uncertain, with joggled facets and extended curves.[43]

We observe again, in the nature of his models, that Klee favors the more schematic, abstract potentiality in Cubism. In his unconscious tendency toward Delaunay (for such stylistic references are seldom made consciously by Klee, or any other artist), he instinctively recognized the suitability of the shimmering *Fenêtre* for his own dreamlike approach. The symbolic window of Delaunay comes to serve as a mental, imaginative window onto a half-fantastic scene. Over the years, Klee continually profited from the model Picasso and Braque offered him of structural stability. But the physical, naturalistic basis of their art was constantly overruled by Klee's desire for dematerialization and imaginative transcendence.

Group Three

There is a group of 1913 Klees which lacks the stylistic unity of either of the groups so far discussed. It contains, however, formal elements of both. One or two examples from this group appear to link all three of Klee's stronger substyles of 1913, and their examination forms a good introduction to Group

Four. Works of Group Three lack both Klee's characteristic elegance and the logical will-toward-system we have observed. Rather with relative stylistic conservatism, they present specific instances of the application, often before nature, of previously studied forms. Group Three comprises the stylistic residue from the other groups, and with its several types it represents the isolated works and momentary interests which one would expect to exist, as a relaxing counterbalance, among the surprisingly closed systems which comprise Klee's other 1913 groups.

Planar in form like the Fauve group, yet limited to modest description and tonally shaded much like 1912 light-forms, are such watercolors and wash drawings as *Smoking Man (Hans Klee)*, and *Cardgame in the Garden. Schosshalde Woods*, another example, has the rough facture and penciled color notations of a sketch done in the field.[44] Several of these works seem to come from the same sketchbook, and they are no doubt from the summer trip to Bern.

A number of other comparatively unpolished landscapes, typically in watercolor and ink-line, can be identified with various outdoor motifs in Switzerland and Munich. *Utility Poles* and *Mountain Behind the Evergreens* appear to belong to the same Lake Thun region as *A Hotel*.[45] *Suburb (Munich North)* (Plate 38) shares the looping curves and problematic, Cubist-like faceting of most of this group. The forms of the buildings in particular are geometrized and are even offset, along the right border of the drawings, in a close approximation of the Analytic Cubist scheme. While some of the planes here are given a tonal *passage*, the relationship of plane to plane still follows the same loose style of diagram as in Groups One and Two.

Like *Suburb*, the watercolor drawing *Crossroads* probably derives as well from Klee's sketching-trip walks around his Munich neighborhood.[46] *Crossroads*, which is based on a smaller on-the-spot drawing, had connections with several of the divergent modes.[47] Much like *Human Weakness* (Plate 29) of Group One, figures are here related by large compositional lines; but with *Crossroads* the relation describes semiabstract city streets rather than cosmic forces. The whole active area of the composition is crowded at the top of the composition, and in its repetitive, lateral pattern, lacking internal emphasis, we recognize the Fauvist inspiration. The interrelation of the planes in *Crossroads* is, however, more open than in Klee's central Fauvist style. Here, the alternately light and dark (hatched) planes appear to lightly shift and interpenetrate in a very nearly Cubist version of *passage*. Indeed, only two characteristics distinguish Klee's *Crossroads* from thoroughly Cubist work: the disparity or lack of integration between the tiny "narrative" figures and the linear scaffolding; and the lack of effective focus in

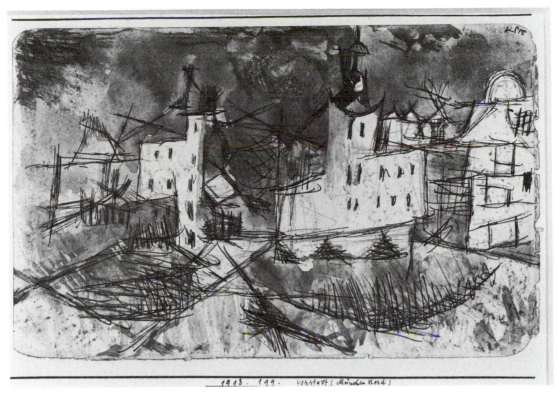

38. Paul Klee, *Suburb (Munich North)*, pen and wash drawing, 1913.199, 4¾ x 7⅝".

the composition. The solutions to these problems, along with further exploration of Cubist *passage*, are the focuses of Klee's fourth stylistic group of 1913.

Group Four

We may now consider a small group of drawings and prints with which Klee was, evidently, most satisfied. They embody, I believe, the formal developments to which Klee referred in two key diary entries. Considering their context, these words probably date from the last months of the year. They are quoted in full:

921. Tie small-scale contrasts together compositionally, but also large-scale contrasts; for instance: confront chaos with order, so that both groups, which are separately coherent, become related when they are

105

placed next to or above each other; they enter into the relation of contrast, whereby the characters of both sides are mutually heightened.

Whether I can already accomplish such things is questionable on the positive side—and more than questionable, unfortunately, on the negative side. But the inner urge is there. The technique will develop in time.

922. Sometimes, a long time passes without struggle. Then I turn out "Innocence upon Innocence." A naive style. The will is under anaesthesia.

1913.162 is a rich declaration of love toward art. Abstraction from this world more as a game, less as a failure of the earthly. Somewhere in between. The man in love no longer drinks and eats.[48]

The first of these entries refers to just that concern which we have seen guiding much of Klee's 1913 work: the development of satisfactory compositional relationships on the whole and in detail. That these detailed relationships included not only two-dimensional arrangement (composition), but also three-dimensional suggestion (*passage*) is indicated, I think, by Klee's phrase *neben-oder übereinander gestellt*, which can be translated as "next-to or superimposed on one another."[49]

The work which Klee mentions, "1913.162," is not known to me, but we know the works numbered on either side of it in the oeuvre series: 1913.161, *A Fragment of Eden*, and 1913.163, *Song of Lamentation*.[50] Klee's oeuvre number groupings, as we have observed, sometimes indicate stylistic groupings, and thus we may guess that the work on which Klee comments here was bracketed within the *Garden of Passion* (Group Two) series. *A Fragment of Eden* is more satisfactorily composed than *Lamentation* in both two and three dimensions; and 1913.162 probably had compositional advances in the same direction.

We previously identified the *Garden of Passion* group with the Bible-illustration project of the first part of 1913. A chronological problem obviously is presented when a connection is established between this group and a diary entry from, most likely, late in the year. Several solutions can be imagined: that the series begun early in 1913 was worked on intermittently throughout the year; that the *Diaries* passage was written by Klee, in retrospect, while considering—possibly during his year-end oeuvre inventory—a work done months before; or, that while grouping the 1913 works for oeuvre-list entry, Klee noticed a compelling stylistic relationship between works from early and late in the year, and consequently grouped and numbered them together to indicate a satisfying continuity.[51]

106

The oeuvre-list chronology problem cannot be totally resolved with the information now at hand. But the connection between Group Two and the works in which Klee found greatest satisfaction is important, for it shows that the most advanced Klees of 1913 developed from a stylistic foundation in Group Two, and that it was from his solid, Fauvist basis that he reached toward a more complete Cubist assimilation.

We may begin to examine this development by comparing *Garden of Passion* (Plate 34) to *Torment* (Plate 39) and to *Flight to the Right, Abstract* (Plate 40). Noticeable immediately is the much greater openness of the two latter drawings. The tightly controlled shapes of *Garden* which, for the most part, have an opaque, overlapping relationship with their neighbors, are in *Flight* both more rectilinear and more broken. Shaded or "lifted" along one edge, the planes of *Flight* appear to be translucent, and they interpenetrate in Cubist *passage* with their neighbors. The effect is light and spatially ambiguous. Comparatively, there was no spatial ambiguity in *Garden*, where the several depth levels were clearly, almost physically, stratified.

Cubist composition, in the sense of an interesting and climactic centralization of the scaffolding, is also present in *Flight*, in contrast with the relative monotony and lack of focus of *Garden*. But this was not, I think, as simple for Klee as it might first appear. Examination of the original of *Flight to the Right* reveals that it is to a large extent, particularly on the left and right sides, "composed" by cropping (this is not normally visible in the line-cut method by which the drawing has been often reproduced).[52] Evidently, Klee selected the segment we know as Plate 40 from a larger pattern he had drawn, cutting it down to its present composition. Even if this is procedurally different from composing within a predetermined field, and though it indicates Klee's hesitation at the moment about composition, it still resulted in the desired new effect.

In the formal concentration of *Flight to the Right*, Klee has given up all recognizable subject matter. This is rare for 1913, rare indeed for Klee's entire oeuvre. It indicates how far, for the moment, Klee was willing to venture into the hermetic world of nondescriptive form in order to understand there—on neutral ground—the forms first developed by the still-life sensibility of Cubism. In the drawing at hand he appears to have recognized, as embodied in the title which is usually quoted, *Flight to the Right, Abstract*, the resemblance to a flock of birds. The resemblance was probably noticed as an afterthought, since Klee's alternative, and possibly earlier, title for this drawing is of a more general nature: "Shift (or Displacement) to the Right."[53] The instance well demonstrates how a dynamic, or image-oriented, reading of a Klee—in this case a concentration on the birds and flight aspects—can make it difficult to analyze the basic structure.

107

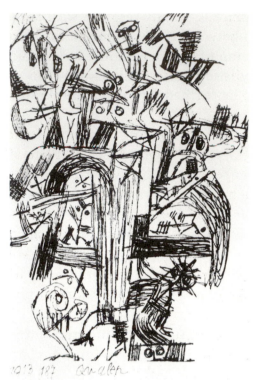

39. Paul Klee, *Torment*, pen drawing, 1913.187, 4⅛ x 3".

40. Paul Klee, *Flight to the Right, Abstract*, pen drawing, 1913.158, 5⅝ x 4¼".

Torment (Plate 39), by contrast, has a very positive subject relationship to *Garden of Passion*. It can be seen as a clear continuation of the biblical themes. The Christ-cycle scenes of "Agony in the Garden" or of the "Temptation in the Wilderness" appear to be implied by both image and title. The haloed or thorn-crowned figure in the lower right of *Torment* is thus Christ with, opposite him, possibly, a ministering angel holding the cup of sorrow. Above him appears an oppressive chaos of demons, gesturing devils, and malevolent winged spirits. Recognizing this, the formal difference between *Torment* and *Garden* is easily phrased: in *Torment* figures and landscape have been opened up and mutually interpenetrated as the formally interchangeable elements of a Cubist scaffold. In this small drawing, representation and structure have come close to identity. Figure and landscape are here unified by the same tiny scale. It will require only the thinning-out and enlargement of this common scale for the shapes and relations of Plate 39 to become also the Cubist composition of, for example, *Sketch from Kairouan* (Plate 30).

We may thus call the two types of Group Four work the "fabled" and the

108

"abstract." The works which are intermediate between *Garden of Passion* and the two types provide a great deal of developmental information. In *Sketch for the 137th Psalm* (Plate 36), for example, we have previously noted an opening of form which allowed adjacent planes to flow more ambiguously into one another. It is a brief step from these to the other examples of the "abstract" pole of Group Four (both prints): *Plants at Night in the Rain* and *N.t., Abstraction II* (Plate 41).[54]

By comparing *Abstraction II* to the presumably earlier *137th Psalm*, we can see that what has primarily been done is a substitution of a short straight line for most of the leaflike curves. The relationship of the hatchings to the lines has remained the same. Here, the straight lines have been subsequently magnetized, as it were, by right angles and forty-five-degree-angled forces, which are themselves slightly canted from the vertical and horizontal. A very even, tilted grid results. Within this rectilinear consistency, as a relieving variation, are vestiges of the earlier curved forms.

The two prints can be seen as a singularly dogmatic application of the basic Cubist grid. As my developmental history for them is meant to imply, Klee's allover Fauvist mode has been, step by step, rectangularized and opened to a shallow, ambiguous depth. We have in these two prints an almost theoretically perfect, shallow Cubist "box": its top surface coincident with the picture plane; its parallel back surface, while not literally depicted, yet measured in depth every few millimeters by the dozens of nearly identical *passage* planes.

The prints lack any pretense to meaningful composition, save the slight openness toward the bottom of Plate 44. But this, I think, clarifies their developmental (if not aesthetic) significance. They document that at a point, probably late in 1913, Klee fully understood and could appropriate the spatial nature of the Cubist grid. By means of a coordinate pattern of checker-lines, which are simultaneously the edges of open passage planes, a completely nonperspectival pictorial space is created. The scheme has graphic consistency on the picture surface, yet is capable of visually precise, and infinitely variable, measurement into depth. Because of their peculiar, and constant, hinging or devolution from the frontmost (picture) plane, the *passage* planes have endless ambiguity. And however many paradoxes of intersection and interpenetration may be generated three-dimensionally, all is visually—even logically—resolved on the two-dimensional level.

The almost totally nonrepresentational quality of these prints deserves further comment. Klee would rarely employ such nonobjective forms even in the future. His most frequent use of abstract geometry only occurs in works from the late 1920s to the mid-1930s. There, he rationalizes the forms through such

109

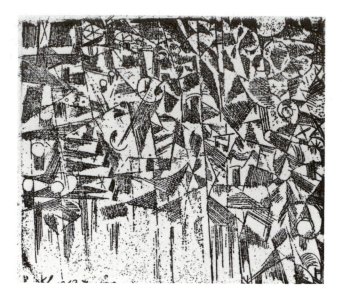

41. Paul Klee, *N.t., Abstraction II*, etching, 1913.182,
2⅞ x 3¼".

titles as *The Current Six Thresholds* or *Hovering (Before Rising)*, which imply that, although abstract, the shapes have the properties and structures of physical things. Here in 1913, no such careful rationale accompanies the abstraction. Rather, these four works appear almost as laboratory experiments. In them, I think, Klee temporarily abandoned any attempt to integrate form and content, Cubist scaffolding with subject-matter. He set aside his figures and landscapes for the moment in order to work, for once totally unencumbered, with the stripped-down, bare essentials of Cubist space. The attempt as we have seen was successful, yielding the purest Cubist structure. But having achieved this, Klee immediately withdrew from this abstract, denatured realm. In the rest of the advanced Group Four works of 1913 he again employs the new transparent space for the enrichment of fabled content.

This leads us, finally, to Klee's ultimate reason for appropriating Cubist space for his work from this point up to 1926 (and for using it, from time to time, even beyond that). By adopting Cubist space Klee possessed himself of a tool that was rigorous and measurable, yet infinitely subtle and ambiguous—exact yet mysterious. One recognizes in these phrases, of course, adjectives that have been often applied generally to Klee's artistic psychology and poetry. That they apply with precision here to Klee's space indicates, I submit, the far-reaching importance that Cubism had in Klee's creativity. For the central fourteen years of his

career, his works were structured almost wholly in this idiom; and, not only were his fantasies molded to fit Cubist form, but inevitably the Cubist way of thinking influenced the imaginative structure of the fantasy itself.

Our final examples from 1913, if less dogmatic in form than the prints just discussed, yet embody characteristics of the new space and must be considered contemporaneous and parallel. I have taken the name of the "fabled" type of drawing (which includes *Torment*) from the title of its best-known example, *Fabulous Island* (Plate 42). In this group, one recognizes, as well, a line of descent from the *Sketch for the 137th Psalm* (Plate 36). Equally visible are the bars and facets of an advanced Cubist scaffolding. But here, unlike the above etchings, where the fable dissolves into abstraction, figuration flourishes in riotous integration with the nonrepresentational elements. In *Fabulous Island*, the abstract branches are inflected into planes by various kinds of hatching. Small signs representing eyes, beaks, and claws are then "salted" in, and all the elements are freely interspersed as graphic equivalents.

More obviously than *Flight to the Right*, *Fabulous Island* is a fragment cut from a larger sheet of run-on drawing.[55] The composition, such as it is, and no doubt the titling as an "island" were contrived after the fact. This is true, too, of another example, the lower-left drawing of the sheet called *Three Vignettes*.[56] This particular fragment has an image-affinity in its upper-left "angel" with *Torment* (Plate 39). The two remaining *Vignettes* show as well some "composition by scissors": the top vignette runs off its sheet at top and bottom, and the lower-right one runs over its lower border. But along their sides the drawings appear to have been consciously composed.

The two lower *Vignettes* have a very explicit linear grid. Compared even to the abstract prints discussed above, the scaffolding here is extremely close to Analytical Cubism for Klee's 1913 work. If one withholds focus from the tiny figures one might well be looking at a detail of a Picasso or Braque of 1910-1912, with its grid of verticals, horizontals, and diagonals now outlining, now dissolving into, the open *passage* planes.

By this point it is clear that Klee's advanced Group Four works, for all their accomplished *passage*, are greatly lacking in composition. The best works we have seen still run undramatically from border to border, or at best have been cropped into a measure of focus. There is but one exception to prove the rule: the small etching, *N.t., Abstraction I*, of which, curiously, only one print was ever made.[57] Here we have the usual tiny eyes and suggestions of wings and claws, but this work is distinguished from all the other works we have discussed by its centralized focus.[58] It is unique for 1913 in its approach to Cubist composition: its grid thickens as it approaches the middle of the field, carving out a

111

42. Paul Klee, *Fabulous Island*, pen drawing, 1913.189, 2⅜ x 7⅝".

spatial depth and complexity, and conversely, it flattens and thins out as it reapproaches the border. In this tentative, sketchy work, Klee anticipates his major advance of 1914.

Throughout Group Four, one is constantly reminded of the tremendous attraction Picasso's and Braque's prints must have had for Klee. As a printmaker and graphic artist, he would have found their work in the etching and drypoint media of great interest at this time. And, as we have seen, from the Blue Rider show through the visits to Rupf, Klee was well acquainted with such examples as Picasso's *Saint Matorel* illustrations and Braque's *Fox*. A glance, indeed, at *The Table* (Plate 16) shows that this type was the ultimate model for much of what Klee accomplished in 1913.[59] Here Picasso's light and delicate touch, more than in comparable paintings, would have informed Klee of the lyrical, playful potential of Cubist ambiguity.

It would be well to briefly summarize the various directions and influences in Klee's 1913 work. Most important, over this year Klee developed the "middle term" of his Cubist adaptation: Cubist spatial relationships and *passage*. This is done along several stylistic fronts. The various sortings and verifications of Cubist knowledge involved in this are decisive for Klee's structural development through the mid-1920s. Most of the terms for this future development are stated or implied in these problematic works of 1913, and this, I think, justifies our lengthy examination of them.

Klee began the year with a fragmentary feeling for Cubism. From his extensive observation he had adopted into his own work only the Cubist facet-shape, which he used in a non-Cubist way. Following our new chronology, we have

112

seen that during the spring Klee advanced in two directions. In an important group of drawings, he experimented with large skeins of lines which united his puppet figures across the drawing surface. Usually closed in form, the skeins were often thematically rationalized as "cosmic" relations among the figures. In only one or two drawings of the type, notably chosen by Klee for the Herbstsalon, were the skein, and even the figures, opened to suggest richly ambiguous relationships. During this period, too, in the works of the biblical series, Klee tried combinations of Cubist and Fauve ideas. In essence, small Cubist shapes or facets were interrelated or composed in ways typical of German Fauvism. This was a delayed development from forms common in the NKVM and Blue Rider, which Klee had known for at least a year and a half. The allover and slightly monotonous patterning of Fauvism subsequently served Klee through the rest of 1913 as his dominant compositional method.

The Fauve interrelation of individual shapes, however, presented Klee with formal and ideational limitations. Essentially an *opaque passage* of interleafed planes, the Fauve relationship was spatially fixed and limited. Fauve space could be developed no further in terms of either structural or image complication and ambiguity. It was in order to solve this problem, I think, that Klee turned to the alternate method of Cubist *passage*, which offered spatial flexibility and ambiguity. Klee experimented with this over the middle to late months of 1913. Sometimes he appeared to study Picasso's understated structure, sometimes he referred to Delaunay's more schematized grid. But by the end of the year he had definitely carried through his adoption of Cubist *passage*.

This represented not only a step-by-step progress toward Cubist structure, but it also suggested to Klee—importantly, I think—the wholeness and consistency of the Cubist formal language. It now appeared to him that a piece-meal adoption of one or two aspects of Cubism could never yield the same rich results as a thorough assimilation of all the structural aspects of this revolutionary style. In a few works of late 1913, such a whole assimilation is approached with his attempts at Cubist composition. The complete integration in Cubist terms of facet, *passage*, and composition would take place in the next year.

The almost deterministic scheme just outlined does not, of course, do total justice to the rich and wide variety of Klee's 1913 works, considered for themselves. At each substage of 1913 Klee produced work of very high quality. We must also recognize that he responded to sources outside Cubism at the same time, and these influences were also significant. Klee's Fauvist works took him uniquely close to his friends of the Blue Rider and particularly to Kandinsky. The Kandinsky derivations for the bibical series were not, interestingly, from

113

1913 Kandinsky, but from Kandinskys of 1910-1911. Nonetheless, Kandinsky and Klee moved—the former from 1911 and the latter from 1913—subsequently in different directions.[60] They developed a second community of style only later, in the 1920s. The comparison in 1913 of Klee with Kandinsky, however, emphasizes how far, in the latter day of the Blue Rider, Klee had turned to Cubism for instruction. Against Kandinsky's sweep and flow, Klee appears a veritable Parisian Cubist in his insistence on the specifics of gridlike construction.

By locating Klee's borrowings from African art and children's art within the context of 1913, we are better able to understand how he viewed these sources as well. He shared the common Blue Rider belief that primitive art represented a more direct, and hence truer, expression of human emotion than conventional European art. But beyond this, his interest in primitive objects resembles that of Picasso as much as it does the other Blue Rider artists. Klee's attitude that Cubist modernism, primitive art, and children's art all shared certain basic stylistic principles perhaps accounts for the great ease with which he would continue to employ forms from exotic sources in the future.

Klee's broadest realization about Cubism this year was of its unity as a stylistic system. He arrived at this largely through trial and error, as when he mixed, somewhat unsuccessfully, elements from Fauvism and Cubism. He had started 1913 with the assumption that Cubism was a collection of shapes from which he could borrow at will. By the end of the year, I think, he understood that the most advantage was to be gained by adoption of the unity in Cubism of shape, shape-relation, and composition. At this point Klee realizes that for his wide subject and motivational interests he could best use the whole Cubist structure.

By mid-1912, Klee had already understood, intellectually, that the central dynamics of Cubism lay in the conflict between the shapes of objects and the overriding demands of composition. In his review of the Moderner Bund show, he had praised Delaunay for knowing how to solve the problem "in a startlingly simple manner; in that he had created the type of an autonomous picture, which leads, without motifs from nature, a completely abstract life."[61] But we have seen that in actual application, in his own work of 1912-1913, Klee did not follow this simple formula. He did not take a direct leap into absolute abstract art, but worked out his adaptation within the relativism of Cubist structure.

We may apply to Klee, at this point, his own words, written in 1912 of Oscar Lüthy:

[He] does not go the dangerous way of Delaunay, nor does he hold the measure of Le Fauconnier. . . . He knows how to hold the picture and

114

object in a conciliatory relationship, although the picture idea predominates in strength.

Klee had admired a very modest Lüthy picture (Plate 19) for its unified consistency of design and detail. On much the same scale, in small works—many of which he perhaps never intended for the public—Klee had, in 1913, made large steps in the development of his own pictorial structure.

Chapter 6

CUBIST
COMPOSITION: 1914

The completion of Paul Klee's assimilation of Cubism was made in 1914. To his previous adaptation of Cubist shape and *passage* was now added Cubist composition. As he reintegrated the elements of Cubism, he found himself in possession of a complete, coherent, and extremely flexible pictorial language; and as he moved in late 1914 and in 1915 beyond this assimilative phase, his creation had a Cubist syntax. All the stylistic variations that he developed through ca. 1926 can be best understood as variations on this structure.

The tentative quality of Klee's 1913 work disappears, and his 1914 production is of extremely high quality. Klee's position in relation to French Cubist sources changes, too; developing from that of the disciple to the artist fully possessed with Cubist structural means. From 1914 on he can be compared as an equal to the major French artists, and his post-1914 stylistic inventions are parallel to the later phases of mainstream Cubism itself. With the start of World War I in August 1914, many channels for the international study of art were cut off, and examples of Cubism were not easily accessible to him for several years thereafter. He had not, however, usually depended upon the immediate presence of sources for his inspiration. Moreover, he had less need of them than before. Thus it was fortunate in terms of time and stylistic economy that Klee was able to complete his Cubist assimilation by the time opportunities for study became limited.

Klee's adoption of Cubist composition took place along two lines of development: one more planar in form and one more linear. The linear style encompasses drawings from throughout the year. The planar style is embodied chiefly in his watercolors of the famous Tunisian journey and its aftermath. Of the two

strains, the linear is more related to the immediate past, growing directly from the advances of 1913. After midyear, with some influence from the Tunisian developments, Klee creates some work, in both painting and drawing, that is extremely close to his high Analytical Cubist prototypes. The openness and formal flexibility thereafter disappear from his work for a few years, and he picked up this open-grid style only in 1919. For his work of 1915-1918, the Tunisian watercolors are the essential model in their broad-cubistic, color-planarity.

In comparison to his advanced, abstract etchings of late 1913, the 1914 output had a more purposeful definition. Centralized composition—frequently an oval zone of focus within the rectangular format—is a landmark of Analytical Cubism. Klee adopts this aspect of Cubist composition most fully in the latter part of the year. If we compare *Sketch from Kairouan* (Plate 30) with the 1913 *N.t., Abstraction II* (Plate 41) on one hand, and with the later-1914 *Clock in the City* (Plate 43) on the other hand, we clearly see his direction during these months toward compositional centralization. Moreover, a quick comparison of *Clock in the City* with Picasso (Plate 16) reveals how very close to high Analytical Cubism Klee comes later in the year. The image of *Clock in the City* is centered, bounded by large, open planes around the perimeter; and spatially it thickens from the borders inward toward greatest complexity in the middle.

Klee's most striking departure from his earlier work is in the watercolors done on the Tunisian journey of April 1914. As an example, *Hammamet with the Mosque* (Color Plate II) might appear at first glance to be stylistically isolated from the Klees we have seen before. The lightness of color and the sureness of touch are unprecedented; and unusual as well is the fresh, naturalist observation of the open-air, North African motif. But the planarity and to some extent the colorism are recognizably akin to the earlier 1913 watercolors such as *In the Quarry* and *A Hotel*. Moreover, the rectangular scaffolding of *Hammamet with the Mosque*, considered by itself, is very close to the Cubist grid we observed above in the 1913 etchings. The emergent compositional style, more or less focused in the middle, however, confirms the Cubist direction we identified in *Sketch from Kairouan* and *Clock in the City*.

The most innovative aspect of the Tunisian watercolors is the structural use of color, well exemplified in *Hammamet with the Mosque*. In Cubist terms, color and tone effect the *passage* of the major planes. Virtually each form in the sky and in the center of the landscape is spatially inflected by a flowing color change: from dark and intense along one edge of the plane to lighter and more faded along another edge. In the most complex area of the painting, the lower half, the grid of crossed diagonals and interlocking planes generates a spatial richness and ambivalence fully equal to French painting of the high Analytic period.

117

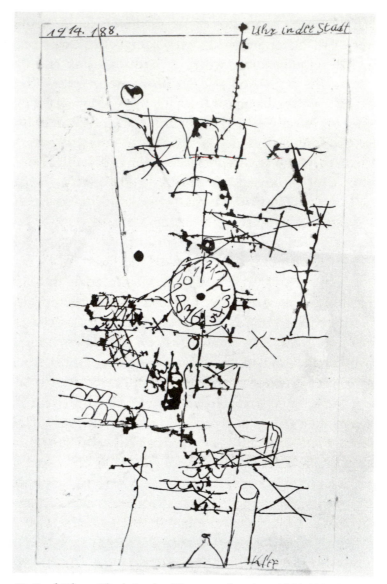

43. Paul Klee, *Clock in the City*, pen drawing, 1914.188, 6 x 3⅜".

It is not Picasso and Braque, however, who are called to mind by the windowlike rectangles and the brilliant colors. These most strongly resemble, rather, the *Fenêtres* of Delaunay. We observe in Klee's Tunisian work, in fact, the full fruition of the contact with Delaunay's art of two years before. The nature and occasion of this second wave of Delaunay influence will merit close examination, as it explains in part the abruptness of Klee's stylistic change. The catalyst for this development was, I think, Klee's friend August Macke, an outspoken disciple of Delaunay, with whom Klee worked side by side in North Africa. Comparisons

118

among works by Klee and Macke and the prototypical Delaunays reveal details of Klee's final Cubist assimilation and emergent pictorial structure that have not been heretofore carefully studied.

In many ways, Klee's Tunisian trip was the central event of 1914. It had a great, almost revelatory, significance for his self-conception. We know a great deal about the three-week journey. A number of watercolors have been identified from the thirteen days he spent in North Africa; several compilations have been published; the key watercolors have been widely reproduced; and Klee himself, after the relative silence of 1913, gave a long account of the trip in his *Diaries*. He recognized the importance of the experience while he was living it, and he recorded its details and his feelings about it with great thoroughness. Its significance has been recognized in every monograph since on Klee, and the period has been the subject of much specialized study.[1]

This quantity of information is both unusual and fortunate, for, as we have seen, the historical record has seldom provided us with detailed circumstances of Klee's major stylistic changes. Nonetheless, all this information is open to interpretation, and reexamination in the Cubist context leads to some new conclusions about the period.

Klee, his old friend Louis Moilliet, and his newer Blue Rider associate August Macke planned the trip at a meeting in early January 1914 in Switzerland, the Klees having traveled to Bern for the Christmas holiday with his parents. On January 4 they met at Macke's house in Hilterfingen.[2] It has been suggested that the Tunisian journey was originally Klee's idea, but this is not known for certain. The three artists immediately became enthusiastic about the trip and arranged various ways to finance their expenses—Klee with an advance from a Bernese patron and Macke with a grant from Bernhard Koehler.[3]

After two months back in Munich, Klee returned to Bern on April 3 and with Louis Moilliet proceeded to Marseille on April 5, where they met Macke. The three embarked the next day on an overnight steamer to North Africa, arriving on April 7. They were met by their host, the Bernese Doctor Jäggi, an old friend of Moilliet's, with whom he and Klee stayed; Macke stayed in a Tunis hotel. The next two days and Easter Sunday were spent at Dr. Jäggi's summerhouse in St. Germain, a suburb of Tunis. On Monday, April 13, they visited the coastal town of Sidi-Bou-Said and the site of ancient Carthage.

The next day they took a train south to the town of Hammamet, and on Wednesday proceeded, with many humorous incidents, to the famous mosque city of Kairouan. After a day and a half of intense impressions, they returned, following Klee's leadership, to Tunis. After another day in Tunis, Klee embarked alone for Europe on Sunday afternoon, April 19, and Macke and Moilliet returned

119

a few days later. Klee changed ships at Palermo and landed at Naples on April 21, proceeding through Rome and Milan by rail. He reached Bern on the twenty-second and three days later returned to Munich. The whole trip took only nineteen days.

Klee's diary contains a great deal of travel observation and some very perceptive remarks on himself and his fellow travelers. He appears as the rather solemn commentator, with curious presentiments of the importance of the journey for his artistic development.[4] Many years later Moilliet stated that Klee's Tunisian diary had been written in a "somewhat formal literary style," with some events being modified in the recounting.[5]

Klee's prose on this occasion is impressive. He is at his most poetic, resonant, and reflective. In their poetic aspect, Klee's Tunisia remarks have seemed to many to be generically applicable to all of Klee, from April 1914 onward. Subsequently, the notes have been widely quoted outside their historical context and used as prophecy and explanation for even Klee's final paintings, done twenty-five years after the notes were written. Although this anachronism is perhaps not unusual in art criticism—the beauty of Klee's words may even offer some justification for it—it does obscure the timeliness of Klee's remarks. For even his most poetic passages must be seen to yield their greatest meaning in the context of his 1914 work.

A number of passages, such as those that follow, describe specific motifs and work sessions:

Wednesday, 4.8. Tunis. My head is full of the impressions of last night's walk. Art—nature—Self. Went to work at once and painted in watercolor in the Arab quarter. Began the synthesis of urban architecture and pictorial architecture. Not yet pure, but quite attractive, somewhat too much of the mood, the enthusiasm of travel in it—the Self, in a word.

Saturday, 4.11. St. Germain near Tunis. Some watercolors on the beach and from the balcony. The watercolor of the beach still somewhat European. Could have been painted near Marseille just as well. In the second, I encountered Africa for the first time. . . . The heat overhead probably helped.

Tuesday, 4.14. Tunis-Hammamet. . . . one is allowed to enter the cemeteries here. There is one splendidly situated by the sea. A few animals graze in it. This is fine. I try to paint. The reeds and bushes provide a beautiful rhythm of patches. . . .

120

Thursday, 4.16. [Kairouan] In the morning, painted outside the city; a gently diffused light falls, at once mild and clear. No fog. Then sketched in town.

Friday, 4.17. [Kairouan] In the morning, again painted outside the town, close to the wall, on a sand hill. Then went on a walk alone because I was so overflowing. . . .

Back through the dusty gardens before the town, painted a last watercolor while standing. . . . Today I had to be alone; what I had experienced was too powerful. I have to leave to regain my senses.[6]

The following passages are the most frequently quoted and convey in highly poetic terms the strength of Klee's impressions. The first is from early in the trip, the second from the last stage of the journey.

Easter Sunday, 4.12. St. Germain. . . . The evening is deep inside me forever. Many a blond, northern moonrise, like a muted reflection, will softly remind me, and remind me again and again. It will be my bridge, my alter ego. An incentive to find myself. I myself am the moonrise of the South.

Thursday, 4.16. [Kairouan] . . . I now abandon work. It penetrates so deeply and so gently into me, I feel it and it gives me confidence in myself without effort. Color possesses me. I don't have to pursue it. It will possess me always, I know it. That is the meaning of this happy hour: Color and I are one. I am a painter.[7]

The culminating experience in Kairouan overwhelmed Klee. He left abruptly for Europe, not wanting to dilute his impression. At stages on his return journey he wrote: "Most of it inside me, deep inside, but I'm so full that it keeps bubbling out"; and "I was in the East and now I must remain there. That music must not be mixed with others."[8] Klee's words convey remarkably his imaginative thought processes and his heightened—almost prescient—consciousness during the trip.

It has been common to emphasize Klee's coloristic "conversion" over other aspects of his Tunisian experience. Certainly this did have a long-lasting effect, increasing dramatically the importance of color in his work. Simultaneously, on another level, the trip was decisive in stimulating Klee's sense of romanticism and fantasy. From this point on, exotic, particularly Near-Eastern, orientalizing motifs, titles, and forms appear with great frequency in his art. It even appears

that in the following decade Klee took on a more exotic *persona*, partly identifying himself with the "South," by which he meant the Near East. Klee's self-portraits of the later teens, for example, show him as something of a genie, a magus, or a sorcerer's apprentice; and he seemed to enjoy the image of the artist-magician who conjures up fabulous worlds with the stroke of his brush.[9] In very large terms, Klee ultimately did fulfill—in his uniting of "Southern" sensuousness with "Northern" fantasy—his ideal of transforming himself into the "moonrise of the South."[10]

There has been, on the other hand, comparatively little emphasis on other important aspects of this period: the origins of Klee's Tunisian style in his earlier work, and more specifically, the relationship of the Tunisian works to his Cubist sources. Consequently, important structural aspects of the watercolors have been misunderstood. In spite of the contributions in recent years by Uta Laxner, Regula Suder Raeber, and others, the tendency has continued to overlook or undervalue the Cubist connection.[11]

My purpose here is to emphasize the role of Cubism in the Tunisian works to see how the watercolors first embodied Klee's new Cubist composition; and, in a more complex relation, how this structural influence interacted with those coloristic and mystical urges which are usually described as the central meaning of the Tunisian trip.

There are, moreover, interesting hints usually overlooked, in the Tunisian diary, that Cubism was in fact the topic of conversation, and even a source of some tension, among the three artists. The evidence is largely circumstantial, but potentially it can augment the more poetic passages in shedding light on works painted during the trip.

A few passages emphasize structural and compositional, rather than coloristic, interests. For example, Klee remarked, on first sighting the African coast, "Side-Bou-Said, a mountain ridge with the shapes of houses growing out of it in strictly rythmical forms."[12] We have already quoted Klee's comment made in Tunis on "the synthesis of urban architecture and pictorial architecture."[13] In Hammamet, Klee describes a motif in which "the reeds and bushes provide a beautiful rhythm of patches."

To this can be added remarks on his travel companions. Moilliet, in the interview already cited, stated that Klee had been a bit solemn and "stuffy" on the trip: "Always prone to jokes and good natured mockery, Macke frequently twitted Klee when they were in Tunisia."[14] Klee's diary alludes to this; Moilliet several times made superficial remarks about color motifs which, by contrast, had interested Klee deeply.[15] Klee, with his retiring manner, did not wholly

122

approve of the rowdy pillow fights, jokes on the North Africans, and other antics of "Ma and Mo."

According to Moilliet, Macke invented a word for Cubist faceting that galled Klee. *Plätzlimalerei*,[16] Swiss-German for "cutlet painting." Not only does the reference make light of Cubism, but the joke was made in Klee's local dialect. Noting that he could address Macke with the familiar "du" form in Swiss-German but never in High German, Klee indicated that Macke spoke *Schweizerdeutsch* in a joking way, which Klee did not entirely appreciate.[17] Within this slightly eccentric context, the indication is clear that Cubism was a topic of banter and probably of more serious conversation as well.

This is reinforced by an incident at a rural cafe in Kalaa-srira, on the way from Hammamet to Kairouan. As Klee relates it, Macke and Moilliet irked the cafe manager by tossing bread and cheese to unwelcome neighborhood chickens. Klee added, "From the 'cheese bit' further came a 'cheese cube,' and then everything was silent."[18] Klee recalled the incident, apparently, at the moment his ship departed Africa, pulling away from the dock where his friends stood waving:

... but now the ship is about to leave, I go out once again to look one last time at the funny faces peering up. (Don't disturb me, you traveling companion who shared a free laugh in Kalaa-srira, I am now straddling between Africa and Europe! Don't speak to me about the landscape being quite Cubist there!!)[19]

Unlike Macke, Klee approached his form studies soberly. Recalling Klee's previous silences regarding important artistic influences—one need cite only his minimal coverage of the Paris trip—Klee's comparative lack of discussion of Cubism and other formal matters on the Tunisian trip is not surprising.

He was very productive in Tunisia, doing possibly more than twenty watercolors, most identifiable by the various place names. An examination by the criterion of Cubism shows a generally straight line of development. Through the sequence of four locations—Tunis, Saint-German, Hammamet, and Kairouan—a Cubist composition can be seen to emerge gradually.[20]

The earliest elements of the transformation appear in the watercolors Klee did around April 8 in Tunis. These works make explicit the grid orientation hinted at in advanced 1913 watercolors such as *A Hotel. Tunisia Sketch, Street Café* is presumably an early naturalistic sketch.[21] This appears to have been followed by *Red and Yellow Houses in Tunis* (Plate 44) and several other related paintings.[22] In Plate 44 a large step is taken toward organizing the whole picture

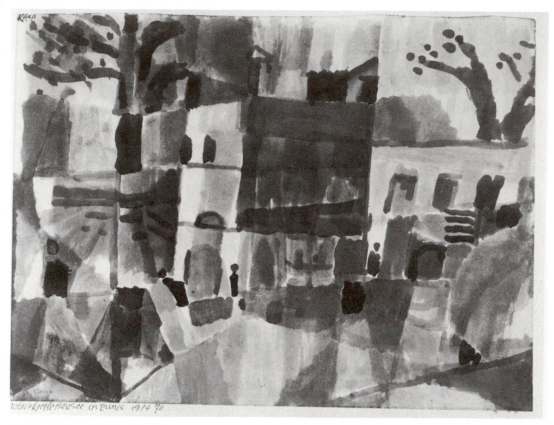

44. Paul Klee, *Red and Yellow Houses in Tunis*, watercolor, 1914.70, 8¼ x 11⅛".

plane in terms of a grid. The previously understated vertical, horizontal, and diagonal composition lines of *A Hotel* (Color Plate I) now divide *Red and Yellow Houses in Tunis* into a series of loose rectangles—representing house fronts, the cafe, etc.—which are in turn further subdivided by internal grid lines.

Despite the broadness of conception compared to the earlier *Hotel*, there is still indecision, a lack of subordination of the various parts of the picture to a central focus. We are familiar with a similar lack in the abstract etchings of 1913 (e.g., Plate 41).[23] The linear details of *Red and Yellow Houses*, the half-circles and scallops, small squares, diagonals, and "X" marks—appear throughout the watercolors of the Tunisian group. But in these earliest works they are somewhat scattered, and are not used as a means to focus.

The problem of foreground integration observed in 1913 is still much present here. The diagonal lines in the lower third of the watercolor read, in one aspect, as receding perspective orthogonals which do not fit easily with the general

124

flatness of the upper portion of the picture. The profusion and lack of dominance among the many shapes and lines add to a sense of spatial indecision.

Klee declared that one work done in *St. Germain, the European Suburb*, was "still somewhat European."[24] And by comparison, he felt that his next watercolor, *View of St. Germain* (Plate 45), painted from Dr. Jäggi's summerhouse balcony, was much more successful.[25] The middle zone of this work is the most thoroughly integrated part, in terms of a Cubist-derived grid and in its use for the rich development of an ambiguous space. This zone is broken into a fairly regular pattern of contiguous rectangles and triangles. The small forms are then articulated by color, tone, and texture into suggestions of spatial *passage* which, while remaining close to the picture plane, indicate the ambiguous complexity of the scene.

The lower third of the picture presents a more thorough wedding of the foreground with the middle ground than in the Tunis watercolors, achieved by suppressing the foreground and making it subordinate to the central zone in plasticity and in quantity of detail. The foreground is reduced to nonspecific *passage* planes leading from the border to the dense central image. The elevated location, the balcony from which Klee painted this work, with its optical diminution of the foreground, probably contributed toward this solution. In contrast to the diffuse Tunis works, *View of St. Germain* is further centralized by means of the triangles of the mountains and house gables.

Garden in the Tunisian European Colony St. Germain (Plate 46) and *In the Houses of St. Germain* are possibly based on segments of the same scene.[26] A mere accident of viewpoint cannot account for the full employment of a grid pattern to organize the whole picture surface. We cannot tell if the scene was observed from an elevation since the whole view, top and bottom, has been consistently flattened. Plate 46 is divided into five or six vertical bands and three large horizontal zones with very narrow blue and red strips reserved, respectively, for sky and nearest "foreground." However, with the exception of the narrow vertical strip along the right border, in which hard contrasts are stated, the rectangles of Klee's grid are not highly contrasted, but are blended into the borders of neighboring squares. It is apparent that for all of the consistency of the grid scaffolding, no objects have been broken, analyzed, or obviously displaced. Rather, the objects have been visualized in a one-to-one relationship with the squares of the grid, with small variations in size and orientation to break the monotony. But as was so often the case with Klee's earlier grids, the composition is here somewhat diffuse and discursive, with the unemphatic central focus being underscored by a near-symmetrical distribution of color.[27]

In his Hammamet watercolors, Klee explores the spatial possibilities of the

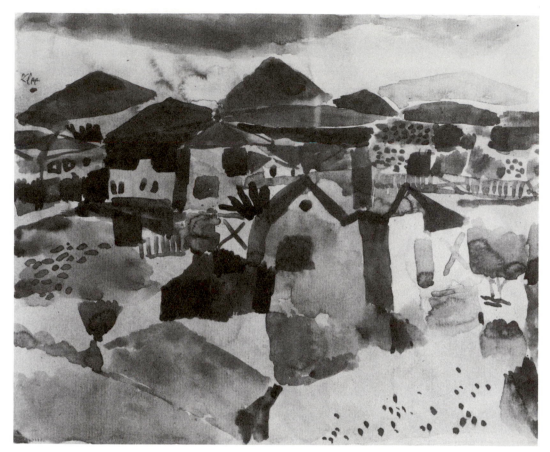

45. Paul Klee, *View of St. Germain*, watercolor, 1914.41, 9 x 11".

grid in a more active way. *Hammamet with the Mosque* (Color Plate II) depicts a segment of the town with its towers at a distance and, in the foreground, probably the foliage which Klee describes in his diary as "a beautiful rhythm of patches (*Fleckrhythmus*)." In its direct and fresh execution and brilliant color, *Hammamet with the Mosque*, perhaps more than any other Tunisia watercolor, reflects Klee's excitement for the North African motifs. The intense immediacy expressed in the diary passage is unmistakably present here visually.

Hammamet with the Mosque may readily be seen to develop the grid pattern used in the St. Germain works. The scaffold of *Hammamet* was laid out first by pencil lines that are still visible. It consists, as in the earlier works, of several crossed vertical and horizontal zones or bands. The various forms, large and small, are congruent with the divisions and planes of the grid. In contrast to the rather dense and heavy feeling of the earlier works, however, an extreme openness and translucency are indicated by the pattern of *Hammamet*. The saturated colors

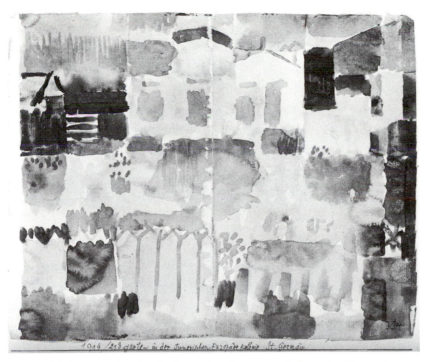

46. Paul Klee, *Garden in the Tunisian European Colony St. Germain*, watercolor, 1914.213, 8⅝ x 10⅝″.

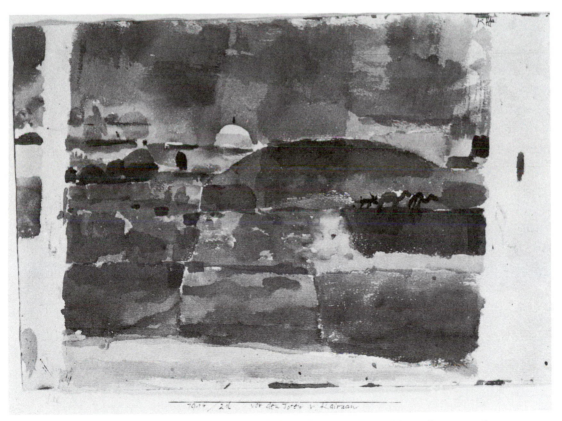

47. Paul Klee, *Before the Gates of Kairouan (Original Version from Nature)*, watercolor, 1914.216, 8⅛ x 12⅜″.

of the last St. Germain works are replaced by light reds, pinks, oranges, and blues applied apparently very dryly, with flecks of white paper frequently showing through. The directness of execution is underscored by tiny accidental spatters of red color in the sky region. Too, the rhythm of details—the flecks and patches derived from vegetation—are quite open and coloristically create a surface shimmer distantly reminiscent of Impressionism.

We have already examined the color and tonal *passage* of the planes of the sky and the central zone. Virtually each plane in these areas is spatially tilted by a color change. Through this means, Klee inflects the grid into a shallow, Cubist depth.

With his previous difficulties in foreground composition in mind, we can examine Klee's successful resolution in this painting. In the lower half, two strong diagonals cross the principal vertical-horizontal grid. Indicated first graphically and then by color, the diagonals present a number of possible spatial readings. The diagonals, particular the one slanting down from the right side, suggest foreground or middle-ground hills. The large triangular wedges, however, cannot be considered solid because they interlace and interpenetrate with each other and with the horizontal-vertical grid patterns. The resulting triangular- and trapezoid-shaped planes are spatially inflected with constant reference to the surface scaffold, but with variable references to the landscape description. For example, the coloring of the planes surrounding the intersection (just to the right of center) of the central vertical and the diagonal from the left has been managed for striking surface contrast and near-total spatial ambiguity. The colors are intense and include, for one reciprocal pair of triangles, the vibrating complementary contrast of red and green. The colors of the contiguous planes are faded into *passage*, slanted back into depth from the grid lines.

As landscape description, these planes are ultimately contradictory. The coloring, in analogous reds, of all the planes touching the lower border creates an apparent third foreground hill formed by the intersection of the two lateral hills. Alternatively, the red foreground triangle can be read as a flatland or valley receding by perspective between the flanking, triangular slopes.

The mechanism of Cubist ambiguity—the indication of spatial richness by means that are paradoxically extremely flat—is thus applied to every detail. Cubist-like, too, is the general centrality of the composition, with the major images and intersections falling in the middle. Klee's refusal here to institute complete centrality should, however, be noted. His composition is balanced between centripetal and centrifugal tendencies, with the strong contrasts around the borders resolving and dissolving themselves toward the center. This com-

128

positional point, plus the brilliant coloring, refers to Delaunay as the main Cubist source here, a matter to be discussed shortly.[28]

Klee's work from Kairouan, such as *Before the Gates of Kairouan* (*Original Version from Nature*) (Plate 47), represents the last phase of his Tunisian development. The compositional grid has been enlarged and relaxed. Strict regularity is not insisted upon, and the planes appear to fold quite broadly into a shallow space, with large areas left undefined. Correspondingly, the strict identification of each facet with a feature of the landscape is not maintained, and the linear details are quite loosely annotated on two or three planes.

A close group of four or five other watercolors share the style of *Before the Gates of Kairouan*; all are magnificently understated.[29] The Cubist *passages* suggest but do not describe complexities of space; and sublimated distances, as in a dream or mirage, are created by the dominant colors. The blues or purples of *Before the Gates of Kairouan* and the pink and purple of *View of the Harbor of Hammamet*,[30] for example, compose the works subtly in the two-dimensional sense. Detail and an occasional strong statement of a grid line fix the floating planes to key points in the compositional scaffolding.[31]

No agency outside of Klee's great talent and the sympathetic chord struck in him by the North African landscape need be adduced to account for the high quality of his Tunisian works. All of the elements were present before the trip: Cubist form and *passage* had been mastered in 1913, and he had known Delaunay's *Fenêtres* since mid-1912. Yet before April 1914 he had not utilized this full potential for his painting; instead methodically, even timidly, he had annexed elements slowly, one after another. Suddenly everything came together in the Tunisian watercolors, and the compositional meaning, in particular, of the *Fenêtres* was realized. It appears that the precipitating factor for this transformation was Klee's work alongside August Macke. The discussions they undoubtedly had provided a second wave of inspiration from Delaunay, so richly embodied in the works of Hammamet and Kairouan.

That Macke provided the impetus for Klee's final Cubist assimilation can be said without overstatement. Although the underlying nature of his art was different from Klee's, Macke was an obvious and vocal disciple, at this time, of Delaunay's style. Over the previous half-year, Macke had adopted the strongly stated grid composition of the 1912 *Fenêtres*. In much of his work he applied the Cubist-Orphist scaffolding in a bold, somewhat literal way, but he had grasped the full potential of the scheme for application to landscape and it is likely that Macke's approach acted as a catalyst for Klee, helping him to finally integrate the lessons painstakingly learned from earlier study. No one work need be singled

129

out to elucidate the transfer of ideas, but general working proximity, mutual observation, and comment would have been sufficient for the communication of influence.

Macke's pre-Tunisian contact with Cubism was a little different from Klee's. Like Klee, he had been concerned with Cubism and Delaunay since mid-1912, and had seen the same Cubist works, possibly even more. But he had had a real friendship with Delaunay, exchanging visits and letters. Moreover, Delaunay's influence had been taken up quickly and was visible in Macke's work before the Tunisian period.

In the wake of the Blue Rider shows and the international Cologne Sonderbund exhibition, Macke, too, had visited Paris, accompanying Franz and Maria Marc on a trip from September 26 to October 14, 1912.[32] They called on Le Fauconnier, Delaunay, and others, as Klee had done several months before. Macke had mixed feelings about what he saw—for example, at the Salon d'Automne—and he wrote his mentor Bernhard Koehler, "What struck us in Paris was the lack of talent of the exhibited Cubists. What we saw of Picasso and Delaunay impressed me very much."[33]

Macke's friendship with Delaunay grew from this point on. Delaunay had a large exhibition of his *Fenêtre* series in Berlin in February 1913 accompanied by much publicity, including the publication of Klee's translation of "La Lumière."[34] Delaunay and Apollinaire traveled to Berlin for the exhibition and stayed overnight in Bonn with the Mackes on the return trip, cementing the friendship.[35] Not long after, Macke expressed great enthusiasm over some *Fenêtres* he saw in Cologne. He wrote to Koehler,

> I had already in Paris the feeling of having very significant things before me. . . . When I see the houses and the Eiffel Tower through these sundrenched windowpanes—I am talking about the most recent pictures— my heart expands with joy . . . trust me that these pictures above all others can fill you with a downright heavenly joy in life and in sunshine—they are not abstract at all; they are of supreme reality.[36]

Over the first half of 1913, Delaunay, Macke, and Marc continued to exchange letters, engaging sometimes in heated discussion. For example, they argued over mystical interpretations of their works, each accusing the other of obscurantism—though all their work shows tendencies toward abstract symbolism.[37] The contact climaxed with the *Erster Deutscher Herbstsalon*, where the three artists exhibited and which they personally attended.[38] Delaunay was heavily represented, with *The Cardiff Team* and his most recent series of can-

vases, the *Formes Circulaires*, as well as by his first simultaneous sculpture. Sonia Delaunay showed objects of applied art—a poster, boxes, cushions—all decorated according to the principles of "simultaneity."

In response to this exhibition and to meeting Delaunay again in Berlin, the Marcs became disenchanted.[39] But Macke's interest in Delaunay's art was further strengthened. At this time Marc and Macke were struggling to overcome the stylistic dominance of Kandinsky, and Macke took the occasion to praise Delaunay at Kandinsky's expense: he wrote Marc that with Delaunay one can see what *"living* color is . . . Delaunay began with a spatial Eiffel Tower, Kandinsky with gingerbread."[40]

During these months, Klee was still on the margins of this circle and took no part in these controversies. By the time Klee and Macke came together in April 1914, Macke had had much more experience in discussion and debate over the Cubist measures that engrossed them both.

Macke's first major response to Delaunay had been in his well-known *Large Bright Showwindow* (Plate 48) of 1912. The early date shows that Macke, unlike Klee, openly borrowed elements from Delaunay immediately after his first acquaintance. *Showwindow* is a central Macke motif, and this version shows clear adoptions from the *Fenêtres* (for example, Plate 17): the grid is comparatively regular; the solid handling of the tonal transitions in the triangular facets and their close identification with the objects and reflections in the window, however, preclude the lightness and fantasy of the *Fenêtre*. This tendency is often ascribed in the Macke literature to his physical, "Rhenish" approach to painting. Concerning a similar shopwindow, Gustave Vriesen has well expressed this aspect of Macke's literalism:

> He simply shifts the great mirror-glass facets—which with Delaunay were identified with the picture plane—back into real space: he makes them into show windows . . . [he] discovered anew in the reality of the everyday the form elements of Orphic Cubism.[41]

In a series of abstract sketches from 1913, Macke explored the grid concept more directly. *Small Colored Forms Composition II*, for example,[42] accords a degree of absolute value to nonobjective color which surpasses even Delaunay's work of the same date. The picture consists solely of a colored grid organized by diagonal lines.

At this point, in the fall of 1913, Macke faced, just as Klee did, the uniting of these two extremes. He did not, apparently, wish to confine himself to showwindows or other motifs providing the literal reflections of a "realistic"

131

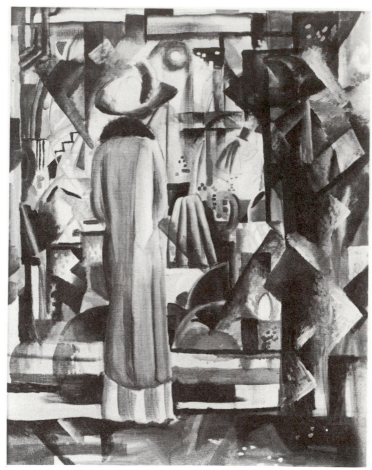

48. August Macke, *Large Bright Showwindow*, oil on canvas, 1912, 42 x 32⅝".

Cubism. Nor did he wish, as in the color abstractions, to wholly set aside the observation of nature. Two paths seemed to be open: the analytical fragmentations of 1909-1910 Cubism or the transformation of objects, as in Delaunay, into stylized, flattened color planes. Not surprisingly, he chose Delaunay's direction. In late 1913, Macke moved to Hilterfingen, in Switzerland, leaving all his earlier work behind.[43] In this new location he resolved the spatial problems in his work, which now forms a consistent stylistic group with his Tunisian output. These Macke works are the most similar to Klee's, and by virtue of their earlier dates, show that Macke solved certain compositional problems before Klee, and subsequently influenced him.

Two of Macke's most advanced paintings prefigure Klee strikingly. They are combination landscape—still-life scenes based on Macke's garden in Hilterfin-

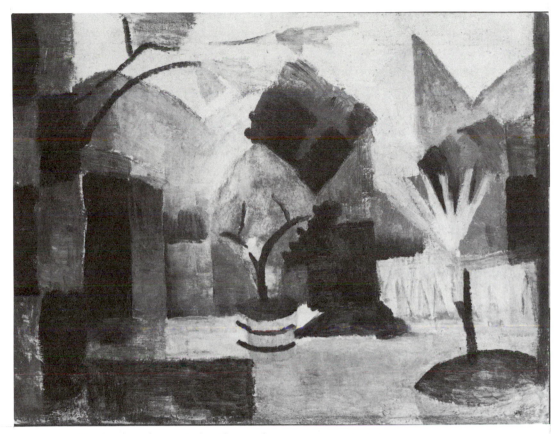

49. August Macke, *Garden at Lake Thun*, oil on canvas, 1913, 19¼ x 25⅝".

gen: a watercolor, *Pomegranate and Palm in a Garden*, and on oil, *Garden at Lake Thun* (Plate 49).[44] The color patterning reaches a high degree of autonomy and the foreground "still life" in the lower and middle horizontal zones is completely united, by means of the grid, with the background forms. Macke achieves here his own equivalent to Delaunay's *Fenêtres*, in which the tensions between object-form and composition are held in near-perfect balance. Macke anticipated by several months the major developments usually associated with the Tunisian watercolors of both himself and Klee. The question of stylistic precedence between the two artists is not wholly resolved by this chronology, but it appears that Macke was stylistically in advance of Klee just before Tunisia, and that he was able to provide him with important compositional ideas during the trip.

Klee and Macke painted some of the same motifs, working possibly side by side, affording us examples for detailed comparison. Klee's *View of St. Germain* (Plate 45) is the same scene and was probably taken from the same angle as

Macke's *St. Germain Near Tunis* (Plate 50). Klee has chosen a wider segment, and Macke a taller and narrower format, but the central features of houses, gardens, and mountains are nearly identical.

This Macke is more naturalistic than his *Garden at Lake Thun*, which embodied his pre-Tunisian adoption of the Delaunay *Fenêtre* grid. But the grid is clearly present here in the several parallel orientations of verticals and diagonals. In both this and in Macke's pre-Tunisian work there are verticals that punctuate the mountains; and more importantly, jarring tensions between the flattening tendencies of the grid and the plastic qualities of landscape. Spatial depth shifts rapidly from foreground to background to middle ground, and so forth, with a minimum of formal transition along the planar edges where these shifts take place. The most abrupt feature is the balcony railing of *St. Germain*, which, while it derives two-dimensionality from the grid of a *Fenêtre*, is depicted as an abrupt close-up, spatially disjunctive from the rest of the scene. There are other examples in Macke, such as in the late 1913 *Pomegranate and Palm*, or another Tunisian work, *Terrace of a House in St. Germain*, of this jarring perspective.[45]

In terms of Klee's relationship to Cubism, it can be said that Macke has only selectively applied *passage*. The abruptness of Macke's spatial transition is partly but not solely a result of Delaunay's influence. Delaunay created a comparatively deep space, unlike Picasso and Braque, for the centers of his pictures; but in all cases, he maintained an angled, or alternatively step-wise, *passage* between planes where no spatial contrast was desired. Around borders, particularly, Delaunay insisted on a flattened zone which mediated between the picture plane and the more complex central area. Macke's abrupt spatial leaps from foreground to middle ground to distance in all zones of the balcony picture are convincing and naturalistic, but relatively noncubistic.

Turning to Klee's *View of St. Germain* (Plate 45), it is clear that while he too had problems with space, his strategy was different from Macke's. By devaluing rather than emphasizing the foreground, Klee limits the depth he must bring into agreement with his surface pattern. We have already remarked, in the slightly uncertain foreground *passage*, the vestiges of such previously unsatisfactory attempts as in *A Hotel*. But *View of St. Germain*, by comparison relies much more upon a grid of horizontals, verticals, and diagonals for the shape of mountains, houses, and other landscape features. Klee avoids harsh spatial juxtapositions, and each plane is gently inclined from the frontality of the grid. In 1913 Klee had employed the grid pattern for the overall surface of a work, and had established as well its principle of spatial control. Only at the time of *View of St. Germain*, however, was he able to apply this scheme boldly and successfully

134

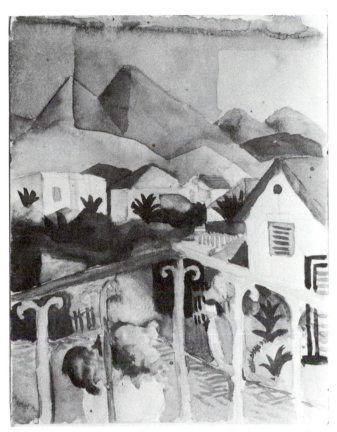

50. August Macke, *St. Germain Near Tunis*, watercolor, 1914, 10¼ x 8¼".

to a complex landscape motif and to break through, with the same step, into truly Cubist composition. The integration of Cubist shape, space, and composition is the central formal meaning of Klee's Tunisian achievement.

The role Macke played can be expressed as one of emboldening Klee before his motif. In many ways, Macke is less consistent in his painting, less subtle in composition and space. But Klee observed Macke's direct, even unsophisticated, attempts to structure a landscape by the principles of the Cubist grid. Klee had not done this before; but with the Macke catalyst he united, almost suddenly, his previous Cubist experiments and experiences.

Comparison of Macke's *Landscape by the Sea* (Plate 51) with Klee's *Hammamet with the Mosque* (Color Plate II) shows other aspects of the close approach of the two artists and of their mutual debt to Delaunay. It is probable, though not certain, that the Macke was also done in Hammamet. The grids both combine horizontals, verticals, and diagonals in a strong surface pattern again derived from

135

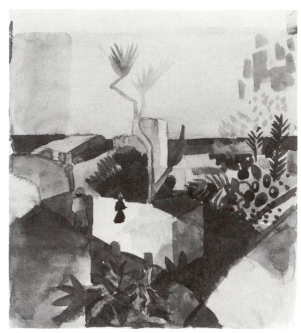

51. August Macke, *Landscape by the Sea*, water-color, 1914, 9 x 8¾".

the *Fenêtres*. Macke applies the system, in his foreground, more regularly than Klee, and the resulting triangles, parallelograms, and diamonds are very reminiscent of Delaunay. Macke has judiciously colored these facets, particularly in the lower right quarter, to create the effect of brilliant translucency. And as with Delaunay, the very regularity of the surface effect contributes to its dissolution into, apparently, a faceted window. Macke's foreground detail is caught up in the grid pattern and integrated through color so that it, too, unlike the St. Germain balcony rail, contributes to spatial unity. Also remarkable in comparison to the earlier Mackes, is the delicately centralized composition. Linear, spatial, and coloristic tensions, strong in the middle, resolve themselves around the edges. In this, Macke resembles Analytical Cubism more than usual and differs a bit from Delaunay and from Klee. Delaunay, in his *Fenêtre*, makes the clearest grid statement at the edge of his pattern.

Klee's grid in *Hammamet with the Mosque* is close to the Delaunay model, but the comparison further reveals some very subtle spatial differences. The essential difference between the lower half of *Hammamet* and a *Fenêtre* is that Klee used fewer diagonals. He has generated fewer intersections and fewer planes, and by understating the "X" configuration, he shows a hesitancy in the face of the full *Fenêtre* effect. While a Delaunay, or Macke's *Landscape by the Sea*, can

136

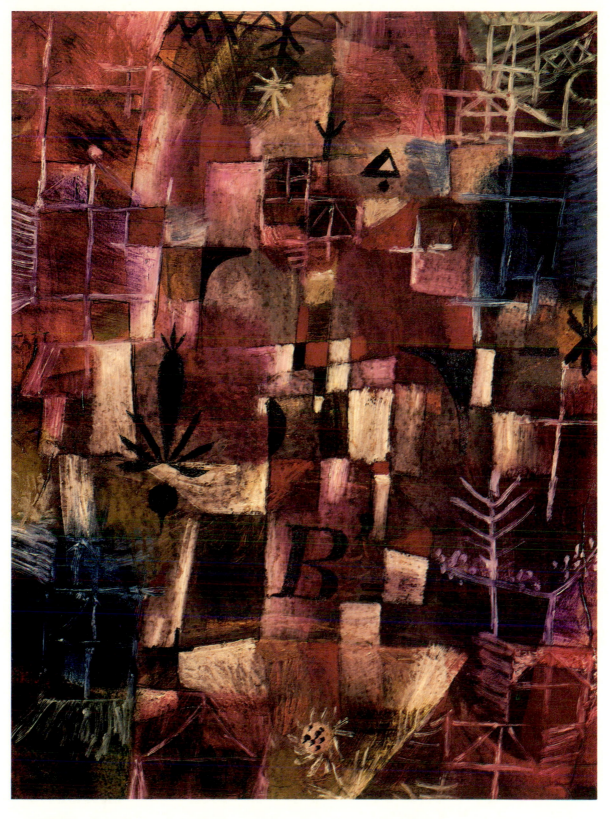

V. Paul Klee, *Composition with Windows (Composition With a B')*, oil over pen and ink on cardboard, 1919.156, 19⅞ x 15⅛".

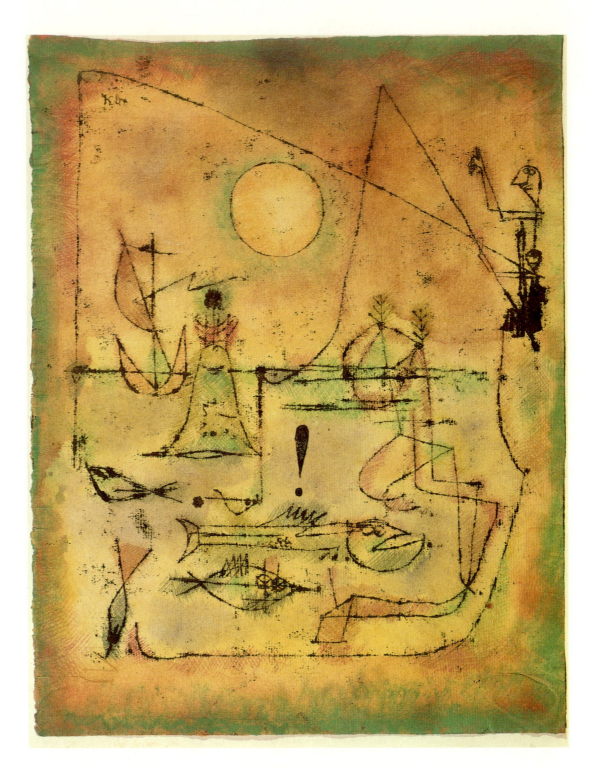

VI. Paul Klee, *They're Biting*, watercolor, 1920.6, 12⅜ x 9¼".

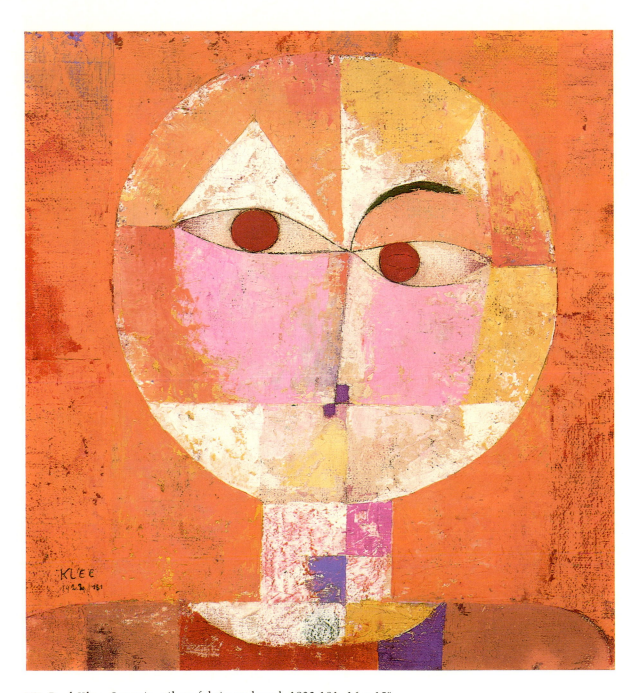

VII. Paul Klee, *Senecio*, oil on fabric on board, 1922.181, 16 x 15".

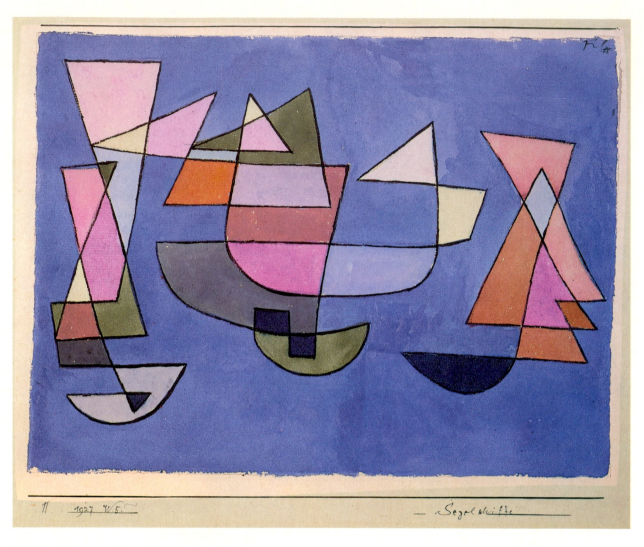

VIII. Paul Klee, *Sailing-Ships*, watercolor, 1927.W5, 9 x 11⅞".

be read as all surface or all depth, in the full ambiguity of its "window" surface, Klee's very small jogglings of intersections and irregularities of facets have an effect that is a bit more Cubist than windowlike. There is a greater tension between motif and grid, between *passage* and surface, in the Klee than in the dematerialized transparency of the *Fenêtre*.

The variations in compositional emphasis here cannot have been lost on Klee, as he made comparisons with Macke, for in the coming decades he would use a wide variety of these Cubist-related effects. In the present comparison, Klee's compositional lines are clearly extended to the borders. As in a *Fenêtre*, his color facets are clearly stated around the edges and dissolve, as it were, into more relative and naturalistic spatial statements as they approach the center. Although the difference is not large, we have noted that Macke, in *Landscape by the Sea*, has more nearly followed the model of Braque and Picasso. Macke's borders are soft, and his grid emerges more toward the center. Klee's scene dissolves in the center; Macke's solidifies; the Klee seems slightly concave; the Macke convex. Klee freely used both these options, the fade-out and crystallization, in the coming years.

These comparisons make clear the nature of the Klee-Macke stylistic interchange on the trip. Each artist borrowed from the strengths of the other. Macke's watercolors, such as the *Landscape by the Sea*, gain a subtlety in form and color and a formal integration that he had not achieved before. This reflects, I think, Macke's observation of Klee.

Macke's works of St. Germain embodied aspects of his style that, on the other hand, most influenced Klee. Macke stated the three-dimensional tensions of the landscape. Observation of this would have dramatized for Klee the vital role Cubism could play in resolving such spatial problems. Klee came to value more highly the power of *passage* and other Cubist techniques he had learned. And Macke's directness, both personally and artistically, may well have emboldened Klee to go outside his usual indirect paths and attack compositional problems directly. Macke's conversation and work reawakened Klee's dormant interest in Delaunay's *Fenêtres* and enabled Klee to finally unify longstanding Cubist developments.

Three months after the artists returned from Tunisia, Germany entered World War I—in early August 1914. Marc and Macke were immediately mobilized. Macke was killed at the front on September 26. Klee reports few facts in his *Diaries* for late 1914, but we know that he spent August and September in Bern. On their return trip toward Munich, the Klees visited briefly with Kandinsky and Gabriele Münter, who had fled from Murnau, near the Swiss town of Rorschach.[46]

137

Some of the longterm effects of the war, particularly on Klee's relationship with French Cubism—will be discussed in the next chapter. In the present context we may note that despite the tensions and difficulties of wartime, Klee continued an extremely rich production throughout 1914. He did a series of semiabstract drawings which clearly referred to the war, and a few watercolors which he gave war-related titles. For the most part, however, his *formal* direction was unchanged by the war: he continued in his same prewar interests. His work of the time, in fact, is surprisingly consistent and unbroken, considering the disruption that surrounded his life.

Klee's drawing production of 1914 is quite large, and not all of it related to the Tunisian advances.[47] There are for example sheets that date probably early in the year which contain the allover, near-abstract patterns of Group Four from 1913.[48] A number of satirical works, biomorphic in form, could have been done almost any time during the year. Examples of the type include *Love of Three*, *Critic*, and *The German in a Brawl*.[49] Because of its subject the last of these is often associated with the beginning of the war.[50]

A few drawings, such as *Decadence* and *Harsh Law*, have fragmented and stylized figures whose faces, in particular, reflect the unusual attempt by Klee to apply Cubist ideas directly to the human form.[51] But by far the most impressive biomorphic drawings are the abstract battlefield scenes which must certainly date from the wartime months. Superficially, *Death on the Battlefield* (Plate 52) does not appear to be cubistic. The eye deciphers the biomorphic shapes as the fragments of shells and bombs and dismembered bodies, understated, but terrifying as symbols of destruction. Nonetheless, the individual forms are distributed according to an implied grid, in a rhythmically centralized scheme that reflects the compositional influence of Cubism.

Clock in the City (Plate 43) and *Jerusalem My Highest Joy* (Plate 53), two of Klee's most advanced drawings of 1914, contain motifs traceable to Tunisia. Chronologically, this places them in the latter part of the year. But more importantly, we find in them the same concerns of space and composition that had preoccupied Klee in Tunisia; these drawings indeed are linear equivalents of the more famous watercolors. Among the Tunisian details that appear in *Jerusalem My Highest Joy*, we may note the dome from the Kairouan pictures, and the use of the ornamental "X" and eight-pointed star shapes, which appeared frequently in the Tunis and St. Germain watercolors. In several places, steplike forms recall the crenelations in *Sketch from Kairouan* (Plate 30), and the curious onion-shaped hood of a figure in that drawing recurs in *Jerusalem* to the lower left as an apparently architectural form. The exotic title *Jerusalem My Highest Joy* is ac-

52. Paul Klee, *Death on the Battlefield*, pen drawing, 1914.172, 3½ x 7".

tually a quotation from Psalms, and relates the drawing on one level to Klee's Bible illustrations of 1913.[52] On another level, of course, Klee seems to be identifying Kairouan, and North Africa in general, with a spiritual *Jerusalem*, and the drawing can thus be seen further as a symbol of his personal attainment.

An interesting relationship between *Jerusalem* and Klee's Hammamet series is the inclusion in the drawing of the curve of what seems to be a foreground hill, very similar to that of *Hammamet with the Mosque* (Color Plate II).[53] In the latter, the curve or hill intrudes on, and acts as a counterpoint to, the Delaunesque regular grid, adding great richness to the spatial ambiguity. With its thorough integration into the surrounding grid rhythm, the curve in *Jerusalem* can be seen both as a translucent hill and as a receding shallow foreground courtyard among architectural forms.

The grid form of the drawing, too, is free of the rigidity of the *Fenêtre* scheme. While for a *Fenêtre* pattern, the "X" intersection was necessary, here line (and hence plane) intersections are variously given, in places of the transparent sort, but often of the semi-opaque "⊣" configuration. The result is a very elegant control of spatial openness and ambiguity. In the upper right of the drawing, for example, an emptiness is balanced by a semiopaque stack-up of fantastic architecture. To the center and lower right, a greater two-dimensional density of form

is relieved by a more frequent use of the wholly transparent intersection. The overall composition of *Jerusalem* is a balance between the two columnar forms on the side and a more cubistic spatial interlace in the center.

There is no mistaking the Analytic Cubist composition of *Clock in the City* (Plate 43), which is structured of the "X's" and arch forms we have identified as Tunisian detail motifs. One of Klee's most obviously Cubist works, *Clock in the City* has all the hallmarks of the style practiced in 1911-1912 by Picasso and Braque. The composition is centralized but intricately designed, with staccato inter-relations between large *passage* planes and clusters of smaller detail. Lines are simultaneously linear figures and the edges of tilted planes. A few longer compositional lines connect the central forms with the borders, and traversing intermediary planes accent the ambiguity and paradox of a drawing style which is both flat and richly spatial. *Clock in the City* was less precisely drawn than *Jerusalem*, and its informal blots and uneven strokes increase the similarity to the more vigorous execution of French Cubism.

For the most suitable comparisons to these two Klee drawings we could adduce any number of Picasso and Braque prints and drawings of the high Analytic period. Klee had known of this graphic style since early 1912 when he saw Picasso's etchings for *Saint Matorel* (Plate 16) in the second Blue Rider exhibition. He had very likely seen such works in Paris soon after. Over 1913 he probably restudied the *Saint Matorel* in Rupf's collection along with Braque's *Job* print. At the point in his development represented by *Clock* and *Jerusalem*, however, Klee finally addressed these Cubist sources not so much as a disciple but as a mature practitioner of a common idiom. Having assimilated into his drawing Cubist shape, space, and now finally composition, Klee was capable in mid-1914 of creating works on a par with, and at times very similar to, those of Picasso and Braque of two to three years before. There may indeed be in these drawings detailed references to specific Cubist prints and drawings Klee had seen in the past, but the similarities may just as profitably be seen as parallels, which at this point underscore the identity of Klee's structure with the structure of Cubism.

There are striking resemblances, for example, between Klee's *Clock* and *Jerusalem* and the famous pair of Cubist prints which Kahnweiler published in 1912: Picasso's *Still Life with Bottle (Bottle of Marc)*[54] and Braque's *Fox* (Plate 54). While Rupf, curiously, did not own them, it is quite possible that Klee could have seen these etchings in Paris or at a Munich print dealer such as Goltz, since they had been printed in editions of one hundred each.

These prints present the high Analytic Cubist scaffolding in its most abstract form, and they demonstrate how Klee had extracted the essence of the style. His *Clock in the City* is perhaps closest to Picasso's *Bottle of Marc* with an implied,

140

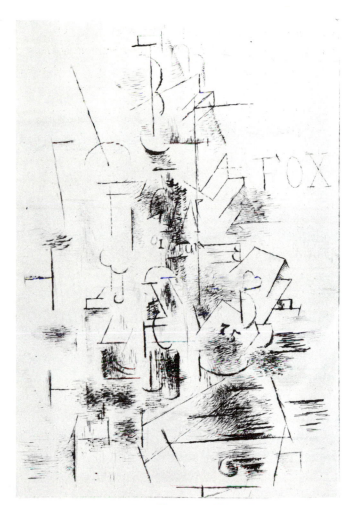

53. Paul Klee, *Jerusalem, my Highest Joy*, pen drawing, 1914.161, 7½ x 3⅜".

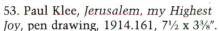

54. Georges Braque, *Fox*, drypoint, 1911-1912, 21½ x 15".

slanted vertical axis and a cantilevering of horizontal elements. Klee's details—quite similar to Picasso's at times—refer, of course, to fantasy architecture, while Picasso's refer to still-life objects on a table. Despite the differences in subject and scale, however, the drawings share a subtle Cubist balance between an abstract design, and at juncture points in the design, an allusion made to the support of physical objects. Of course, Klee's drawing is more closed than Picasso's, and as a result it is slightly more flat and graphic in effect. Picasso is more painterly, creating a more fluid space, in part through the use of floating hatch-marks, a legacy in his work from Impressionism.

But it is Braque's print *Fox* (Plate 54) that Klee's *Jerusalem* most resembles

in lightness and delicacy. Elements of Klee's "towers" compare interestingly to the upper right quarter of *Fox*, where Braque's scaffolding is less open than usual, and the linear connections suggest stereometric solids. These elusive "blocks" correspond, more than any other area of the Braque and Picasso etchings, to the literal aspect—the suggestion of actual cantilevers—in Klee's towers.

There are other parts of *Fox*, for example the diagonal in the upper left, and the half-circles and patterns in the lower half, that resemble Klee's *Clock in the City*. *Fox* may indeed have held special interest for Klee, since it is precisely a linear rendition of Braque's painting *Bar Table*, which Klee had known from Rupf's collection.

But differences, too, are important. First, the tendency of Klee's drawings to be closed to exclude the painterly or Impressionist element resembles Synthetic more than Analytic Cubism. This prefigures Klee's post-1914 development. Second is what we may call the Constructivist aspect of Klee's drawing, as evidenced in the two towers of *Jerusalem*. By this I refer to the apparent structural coherence of these towers which, with their cantilevers, roof lines, and flag spires, resemble an actual wire model of architecture.[55]

This Constructivist aspect of Klee's work, from ca. 1923 to 1927, slowly grew to stylistic dominance. This tendency, already visible in 1914, was later stimulated by the historical Constructivist movement, properly named, a branch of which flourished at the Bauhaus. But even in 1914, the Constructivist tendency in Klee is non- or anticubistic. It represents an autonomous abstraction, as opposed to the spatial and descriptive ambiguity and relativism of Cubism. The Cubist structural sensibility, as epitomized in the Picasso and Braque 1911-1912 prints, operates precisely at the boundary between flat pattern and depicted space, between abstract line and represented substance. Until the mid-1920s this sensibility continued to dominate and to qualify the Constructivism in Klee's work.[56]

In his post-Tunisia 1914 paintings, Klee explored several directions. There are some works, such as the watercolor *Abstraction of a Motif from Hammamet* and an oil *Concerning a Motif from Hammamet*, which grew directly out of Tunisian developments and are essentially variations on an earlier theme.[57] In another group of watercolors, which includes *Abstract Colored Circles Bound with Colored Bands* and *In the Style of Kairouan*,[58] Klee develops his earliest pure color abstractions, introducing the form he would emphasize over the succeeding five years.

Most relevant for immediate consideration, however, are those watercolors and oil paintings that combine advanced characteristics of both the Tunisian watercolors and the drawings (Plates 43 and 53) just discussed. These paintings culminate Klee's relationship to Cubism in 1914, and they are stylistically the

142

most broadly based and balanced of the year. The group includes *Thoughts of Battle*, *Thoughts on Mustering Up*, *Red and White Cupolas*, *With the Red X*, *Nature Theater*, and *Carpet of Memory*.

Some of the ways in which the planar and linear are united in the paintings hold true in Klee's art for many years. Like the drawings, they relate closely to high Analytic Cubism, and they have a degree of openness to which Klee would return only after the war years. Drawing upon both Tunisian color and Tunisian-related detail and referring at times to the war, they date to later 1914, although their exact chronology is not known.

With *Nature Theater* (Plate 56), *With the Red X* (Plate 55), and *Carpet of Memory* (Color Plate III), we may consider Klee's post-Tunisia formal balance. Here, the "X" 's, circles, triangles, and offset quasi-Constructivist scaffolding are stated quite as positively as in *Clock in the City* and *Jerusalem My Highest Joy*, which they greatly resemble in line. Linear forms are given full equivalency with planar forms. The two means effect rich compositional and spatial patterns by close coordination, and neither line nor color plane is charged with the full weight of the grid. The linear marks in general lie on the surface and the color planes usually effect *passage* into shallow depth behind this surface.

Overlapping and translucencies create a richly ambiguous space. The color planes developed in Tunisia have been loosened and applied in a more open context. The overt Tunisian framework of horizontals, verticals, and diagonals, too, is replaced by sophisticated understatement. To a measure, the influence of Delaunay's *Fenêtres* still survives in the slightly decentralized quality of these works which, compared to Picasso, are somewhat void in the center.

This group of paintings has further importance because Klee uses signs and symbols that he will employ many times in the future. The graphic "X" signs, triangles, circles, grid forms, and six- and eight-pointed stars form a kind of detail alphabet which Klee will use later, far from their original context. It is essential therefore to examine their structure and meaning at this point of origin.

These graphic signs first appeared as incidental marks in 1913 works, such as *N.t., Abstraction II* (Plate 41). Subsequently they were developed in North African as a shorthand for Tunisian landscape and architecture types. We may recognize them in *Sketch from Kairouan* (Plate 30), *View of St. Germain* (Plate 45), and *Before the Gates of Kairouan* (Plate 47) as wall crenellations, abstracted garden fences, cupola-domes, and so forth. And as decorative motifs, reminiscent of North African architecture, and possibly textile and carpet design, they confer a Near Eastern, exotic flavor whenever they are encountered henceforth. They may even be read, on another level, as symbols of the artistic and psychological importance of Klee's whole Tunisian experience.

143

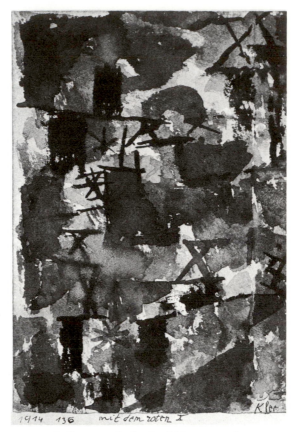

55. Paul Klee, *With the Red X*, watercolor, 1914.136, 6¼ x 4¼".

The forms of dark circles, triangles, stars, understood as explosions, are transformed into war imagery in such works as *Thoughts of Battle, Thoughts on Mustering Up*, and the drawing *Death on the Battlefield* (Plate 52).[59] As floating canon shot, or even dark stars of fate, the details function here as emblems of tension, destruction, and death. The imagery conveys a disturbing, compelling graphic power. Not to be overlooked either are the functions of the "X" and "V" signs as Roman numerals.[60] And equally important we must recognize, as in the *Jerusalem* drawing, the potential of the "X" as a cypher for the human figure.

Clues from *Nature Theater* (Plate 56) remind us moreover of a surprisingly late debt to Delaunay in this emblem vocabulary. The scaffolding of a pine tree in the upper center of this Klee has an unusually close resemblance to the vestigial Eiffel Tower in the upper center of Delaunay's *Fenêtre* (Plate 17). While Klee's "tower" is closest to the *Fenêtre*, examination of Delaunay's earlier *Eiffel Tower* (Plate 12), which Klee had long known, reveal other connections. The rows of

144

56. Paul Klee, *Nature Theater*, watercolor, 1914.142, 9¼ x 11⅞".

"V" 's between parallel lines, which appear in this whole family of Klee works, resemble the girder pattern in Delaunay's tower, and the ubiquitous "X" 's and six- and eight-pointed stars are strongly reminiscent of the large cross-truss patterns in the lower part of Delaunay's structure. Rows of "Tunisian" half-circle arches can, in fact, be found in the area of the first landing of the Eiffel Tower. Domes throughout Klee's series of paintings, from *Carpet of Memory* (Color Plate III) to *Red and White Cupolas*,[61] match form—though in a positive-negative way—with the arch between the legs of the Eiffel Tower. Thus through graphic signs, even sublimated works such as *Jerusalem, my Highest Joy* refer back ultimately to Delaunay's apotheosis of the modern city.

Slightly different again is the quasi-Constructivist function of many of the "X" and rectangle signs, which appear as the spars and stones of a fantasy architecture. In a more authentically Constructivist sense, the larger "X" 's, squares,

and star-intersections, particularly evident in *Clock in the City*, may be read as disembodied abstractions, the joints of the overall compositional grid.

Klee's linear forms, in other words, function simultaneously as ornamental signs, as Cubist structural components, and as pregnant artistic and personal symbols. This amalgam of ornament, structure, and symbol is extremely flexible and complete and, to a great extent, is the essence of the stylistic *multum in parvo* which characterizes the best of Klee's work for the rest of his career. This amalgam unites form and content in a way unique to Klee among twentieth-century artists. It permits him to combine the structural stability of Cubism with the rich, personal subject matter of Expressionism and Symbolism. It permits a decorative and lyric quotient in his work which—unique in the Cubist-abstract tradition, which generally abhorred decorativeness—did not compromise his seriousness of form.

We observed Klee's desire in 1912 for a new form for his personal content. In 1913 we saw the form explored at the risk, at times, of excluding content. Then in 1914, at the confluence of his final structural assimilation from Cubism and Delaunay, his romantic inspiration from North Africa, and his Expressionism at the time of the war, the needed synthesis took place. Once Klee distilled structure, ornament, and symbol into a few forms, they became extremely difficult to analyze into their original components. The process does not "read backward" very easily; thus a historical understanding of the forms which created Klee's stylistic maturity, in late 1914, is prerequisite to serious stylistic discussion of his work after that date.

The two oil paintings *Hommage à Picasso* (Plate 57) and *Carpet of Memory* (Color Plate III) probably embody Klee's last reaction to a major innovation by Picasso and Braque. In these works Klee comes to grips with the issue of pictorial texture. Foreign textures had been introduced into Cubism in 1912-1913 with the advent of collage. In 1913, Klee had probably studied Picasso's major textural painting *Violin on a Wall* (Plate 27) in the Rupf collection. Klee would scarcely have forgotten having seen this work, and he had probably seen other examples of textured and collage Cubism in Munich during the same period. Picasso's *The Poet*, for example, was shown by Thannhauser in early 1913.[62] Klee thus had ample opportunity to study the phenomenon, but his assimilation of it was less decisive than with others.

Hommage à Picasso (Plate 57) derives from the more abstract watercolor *Motif from Hammamet*,[63] and thus stems ultimately from Tunisia. The polygonal format refers clearly to the oval-shaped Cubist canvases of Picasso and Braque which Klee had no doubt seen in Paris and Munich. But by far the clearest *homage to Picasso* here is in the outstanding textures.[64] Working in oil paint, still an

146

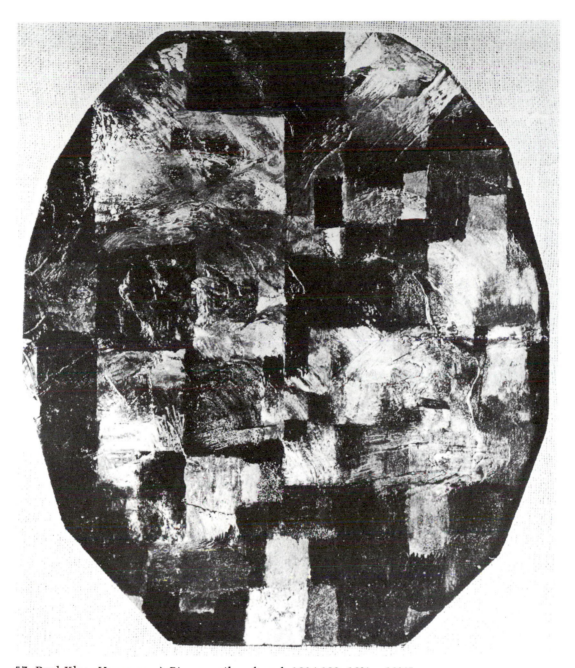

57. Paul Klee, *Hommage à Picasso*, oil on board, 1914.192, 13¾ x 11½".

unusual medium for him, Klee has built up a variety of scumbled, swirled, and granulated effects which refer to Picasso's paintings of one or two years before. Over these textural layers, subsequently, Klee has superimposed several coats of translucent glaze.

By simple superposition, Klee has intended to combine two of Cubism's most extreme effects: the physicality of a heavily textured surface and the disembodied quality of a transparently colored grid. The color net, however, does not consistently engage the texture underneath, and Klee has not made all the compositional adjustments which could bring this about in cubistic terms. The painting is technically and aesthetically an exceptionally bold and straightforward work for Klee, but he had been usually successful with more indirect methods. Texture, that aspect of Cubism that most reflected Picasso's direct, spontaneous, physical working methods, was the aspect which Klee ultimately could not directly accommodate.

Carpet of Memory (Color Plate III) has less direct texture perhaps, but its application is more influential. Here indeed Klee established the standard practice for his wide use of texture throughout the rest of his career. The overall effect of *Carpet of Memory*, true to its title, is a dreamlike floating, where bits and pieces of Tunisian detail lift and submerge themselves coloristically over a sand-colored background.[65]

The physical base or ground of the painting plays an important role. What Klee has given up to monochrome color he has gained in texture. The medium is catalogued as oil on whiting-and-oil-grounded linen, mounted on cardboard.[66] Klee spread over the fabric (the texture of which is visible around the edges), probably with a knife, a thick plasterlike ground of uneven surface. The ground was tinted a warm tan, which accents the unevenness of the surface. Some of the top colors were absorbed into this surface; and others, particularly the bright reds, lie on the surface, in low relief, with a texture suggesting that some variety of encaustic may have been employed in the medium.

The effect reinforces the surface-depth dichotomy of other elements of the painting. The flat physical surface of the picture plane, like an ancient discolored wall, is emphatically stated by the plaster texture. The irregular tan ground, however, simultaneously dematerializes itself. Like a light warm cloud or indeterminate dream space the background color appears to float in ever-changing spatial relationships among the graphic signs. Thus, every element of *Carpet of Memory* contributes to its richness of space. Firmly fixed in a balanced surface scaffolding, the forms of the painting are inflected by color and texture into a *passage* space scarcely equaled for complexity in any other Klee, or in the work of any other painter of the period.

148

Thus, over 1914, Klee reconsolidated the elements of Cubism. His successive adaptations of Cubist shapes, spatial relationships, and composition are recombined in his work to form a coherent language. This language had been internalized, and he could employ it unconsciously and confidently as his own. From 1914 to 1926, Klee will be seen henceforth not as a follower, but as an independent and major artist in the Cubist structural tradition.

Chapter 7

COLOR CUBISM AND THE WAR YEARS

The disruptions of World War I dispersed the European avant-garde. Many artists served in the field; some were killed or injured. Those who were neutral citizens, such as Picasso and Gris in France, or who were too old, as Klee was in 1914-1916, were exempt from active participation, and had to work in comparative isolation. International contacts of the sort freely made before the war by personal travel, exchanges of exhibitions, and the activities of dealers and collectors were stopped completely. The losses and changes in the artists, and the many dislocations, had profound effect on the European art world as it was reconstituted around 1919.

The era and the association of the Blue Rider were certainly ended by the war. On March 4, 1916, a few days after Marc fell near Verdun, Klee was drafted into noncombat service; this was to last through December 1918. By mid-August 1914 Kandinsky was in Switzerland on a journey that returned him to Russia for several years. Thus was ended the milieu in which Klee had received his first major recognition and in which he had become acquainted with advanced French art.

In December 1914 Klee wrote his friend Hermann Rupf in Bern, expressing grief and despair over the cataclysmic rift in the European community:

What a disaster this war is for all of us and particularly for me who owe so much to Paris and cherish spiritual friendship with the artists there. . . . Could you tell me who among the Parisians is taking part in the war? I couldn't learn anything from anyone. From here August Macke

has already fallen, the friend of the French. And Marc with the munitions column, thank God not exposed.[1]

Klee's entries for later 1914 are partly poetic with startlingly sardonic imagery. The beginning of the war is noted by only a sentence—no doubt a later interpolation.[2] In more theoretical passages, however, one recognizes the first clear statement of ideas that were to be central to the theory he elaborated in later years. The idea of art as process and as "becoming" emerges as an important theme:

> In my productive activity, every time a type grows beyond the stage of its genesis, and I have about reached the goal, the intensity gets lost very quickly, and I have to look for new ways . . . becoming is more important than being.[3]

In early 1915 he wrote, "I have long had this war inside me. This is why, interiorly, it means nothing to me."[4] Yet he recognized the part the war played in turning his thoughts on art in an inward direction:

> Abstraction.
> The cool Romanticism of this style without pathos is unheard of.
> The more horrible this world (as today, for instance), the more abstract our art, whereas a happy world brings forth an art of the here and now.
> Today is a transition from yesterday. In the great pit of forms lie broken fragments to some of which we still cling. They provide abstraction with its material. A junkyard of authentic elements for the creation of impure crystals.[5]

This expression "broken fragments" which "provide abstraction with its material" seems Cubist-oriented and indeed seems to describe some of the processes—similar to those of Synthetic Cubism—which Klee's work was to follow in the war years.

Klee's words must be read as poetry running parallel to his painting, and at times shedding much light on his visual forms. However, there are many difficulties encountered in interpreting these writings. Poetry and theory are inextricably mingled, here and in Klee's later writing, making it a rich but problematic literature.[6] The theme introduced here of art as becoming as the result of quasinatural processes, is elaborated as the central belief of a whole aesthetic-philo-

151

sophical system in Klee's *Pedagogical Sketchbook* of 1925, and the numerous teaching notes and lectures published after his death.[7]

Before his induction in 1916, Klee began his association with the Expressionist writer Theodore Däubler and received an encouraging visit from the poet Rilke. A trip to Bern in late Summer 1915 was permitted reluctantly by the military commander of Klee's district, as Klee was a German citizen,[8] but his meetings in Switzerland with Jawlensky, Werefkin, and Moilliet were pervaded by a sense of melancholy.[9] Klee's most significant artistic exchange was with Franz Marc, but like the other relationships of the time, this was not free of conflict. Klee saw Marc in Munich when he was on leave, once in early summer and once in November 1915.[10] New tensions filled these meetings, generated in Marc, Klee felt, by his not being able to paint; and Klee was aware of the prospect of the same thing happening soon to himself.[11] The discussion and a weighty exchange of letters took place around definitions of the artist's ego, and Klee regretted very deeply having raised such questions at all with a friend with whom he was in such basic accord.[12]

Klee was drafted as an Infantry Reservist on March 11, 1916, one week after Marc's death. After basic training at Landshut, Bavaria, he was assigned to an aircraft workshop, from which he escorted airplane shipments to the north. In late 1916 and January 1917, three transports took him to Cologne, northern France and Belgium, and the North Sea region and Berlin.[13] The Berlin trip gave him an important, if brief, opportunity to visit Herwarth Walden, of the Sturm Galerie, and Bernhard Koehler and to see their private collections. Klee was particularly moved by Koehler's fine collection of works by his fallen comrades Marc and Macke.[14]

From late January 1917 through the end of the war in December 1918, Klee was posted as an assistant paymaster at the Bavarian Flying School at Gersthofen, near Augsberg. He managed frequent leaves to visit his family and studio in Munich and was able to continue to paint all during this period. At his paymaster's desk he frequently worked secretly, hiding his art materials in a drawer. Of the whole period 1915-1918, Klee was very productive, managing sales and increasing exhibition and publication of his work. In this regard he suffered less directly from the war than perhaps any other German artist.[15]

Klee's work of 1915-1918 can be described as a Cubism of color planes. Up to then, his chief formal advances were made in line, with plane and color playing subordinate roles. The major turning point was his Tunisian watercolors of April 1914, in which color was suddenly realized as a major pictorial element; but he was still undecided about how to use his new discoveries, and he continued, as in *Carpet of Memory*, to rely on line as his major form of expression and con-

152

struction. In 1915, he picked up the thread of his Tunisian color and began to structure his major work with color planes. This new emphasis continued approximately through 1918, an exceptional period for Klee, who was innately a draftsman. This episode is paralleled in his oeuvre only many years later in some equally color-dominated works of the 1930s.

Klee had little or no opportunity to study contemporaneous French painting during the war years. The similarities between his color Cubism and the color planes of Parisian Synthetic Cubism of around 1915-1918 must, therefore, be understood as parallels based on shared antecedents. We must note, however, that while Klee's planes come to resemble Synthetic Cubism, the manner in which he interrelates and composes them remains true to the Analytic Cubist model. While exploring certain closed, near-solid geometric combination of planes, indeed, Klee came close to recapitulating in brilliant colors the stereometry of early Analytic, ca. 1908, Cubism.

For the intensity and range of his color during those years, Klee had few parallels in his own generation. In French Cubist art, Gris—during the war years—and Chagall come to mind, and Chagall may indeed have briefly influenced Klee's color around 1919. The influence of Klee's Blue Rider friends Marc and Kandinsky can certainly be seen in his painting, and Klee no doubt valued the comparison made at times between his color and Marc's, which he so admired.[16] In 1918 Klee was asked to restore Marc's large painting *Fates of the Animals*, which had been partially destroyed by fire.[17] As a token of thanks, in 1919 Maria Marc gave him Marc's 1913 abstraction *Small Composition*, which Klee kept in his collection.[18] Also in his possession was the brilliantly colored Kandinsky *Sketch I for Composition VII*, 1913, which Kandinsky had left with Klee at the start of the war.[19] In 1915 Klee remarked of this work, "Kandinsky must at least greet me from the wall."[20]

Among the hundreds of Klees from the productive years 1915-1926, a relatively small but representative group of works will be discussed. Not every artistically significant work of this period is structurally innovative. Klee produced "families" of works, the individual items of which—while often widely varying in subject matter—were structurally identical. Such families or modes could be quite large and stretch their internal development over two or three years. Typically, Klee had five or six modes current every year. I have chosen what I believe to be seminal works, in which the major modes are initiated or culminated.

Klee's color "conversion" in Tunisia had been sudden and dramatic, but his shift in interest from linear to planar came about more slowly. We may gain an overview of the transition through a series of his "script pictures" *(Schriftbilder): Vignette-like: Let Glow Aside!* (Plate 58) of 1915, *Part II of the Poem by*

58. Paul Klee, *Vignette-like: Let Glow Aside*, pen drawing, 1915.214, 2¾ x 4¾".

59. Paul Klee, *Part II of the Poem by Wang Seng Yu*, watercolor, 1916.22, 2¾ x 9½".

Wang Seng Yu (Plate 59) of 1916, and *Once Emerged from the Gray of Night* (Plate 60) done in 1918. In this family of works Klee develops the depiction of letters, common as a random element in Cubism since 1911, into a new poetic form. The works remain part of the art of painting, however, and conform in interrelation and composition to Klee's prevailing types.

Formally, the fragmentary *Let Glow Aside! ("Lass! Abseits Glühen)* is composed much like Klee's 1914 war-theme work (for example, Plate 56) with the letters here—in place of explosions and heavenly signs—floating above a geometrized strip of architecture.[21] In individual form, the letters—particularly the

60. Paul Klee, *Once Emerged from the Gray of Night*, watercolor, 1918.17, 8⅞ x 6¼".

"s"—are similar to the Germanic *Fraktur* printing style. However, the elements of the letter have been interpreted as transparent strip planes, as if they were straps of some actual material. A kind of planar Cubism results, particularly in the "a" 's and the "e." There is a constructive aspect to the letters similar to that which was encountered in *Jerusalem My Highest Joy*; but the letters are still held in the spatially ambiguous realm of Cubism by their transparency and

patterns of graphic intersection. Klee uses this curiously crystalline interpretation of Cubism, in which he recapitulates the stereometry of 1908 French Cubism while at the same time maintaining translucency of form, many times in 1915 and 1916.

Part II of the Poem by Wang Seng Yu (Plate 59) uses Latin letter forms and integrates them, through *passage* planes, with the background. The words of the poem are not lined up in consistent rows, and some of the displacements and interrelations of words and abstract forms—such as the arrangement of the funnel shape with the word *Ahnen*—suggest sophisticated ideas of visual-phonetic equivalents.[22] Slanted, receding, and parallel planes, descend from either side of the letter strokes and supplementary lines. While the "seams" of this shallow mesh add up on the surface to the words of a poem, below this the grid and *passage* create the pictorial space precisely of Analytic Cubism, as a glance at Picasso's *"Ma Jolie"* (Plate 18) verifies. The *passage* planes in *Poem by Wang Seng Yu*, for example (on the left side) those to the left of the large "D" and below the small "D," match the familiar tilted planes of Picasso, and Klee's rhythmic distribution of color and tones reinforces the resemblance of the script picture to the undulating space of French Cubism. The comparison demonstrates again how Klee freely employed Cubist structures in contexts distant from their origins. A script picture is far removed from a still-life with playing cards or a model with a musical instrument, yet the pictorial means used are the same.

The variations in letter size and compositional management which make *Poem by Wang Seng Yu* so curiously legible are given up in *Once Emerged from the Gray of Night* (Plate 60), two years later.[23] The Latin letter forms—reduced to severely regular rectangle, triangle, and arc forms—are an interesting prefiguration of the highly rationalized typeface used at the Bauhaus in the 1920s. The upper and lower halves of the "poem," corresponding to stanza divisions, are separated in the mounting by a band of silver foil. Facets produced by the letters are sharply edged and differentiated by evenly applied color; and the interrelationship to adjacent planes is that of abutment or juxtaposition rather than the obviously tilted *passage* in *Poem by Wang Seng Yu*. Small planes, lacking *passage*, still tend to move back and forth, as complete units, by virtue of the advancement and recession of their colors.

Reduction in the use of *passage* in favor of the flatly stated color-plane juxtaposition is a major characteristic of Synthetic Cubism. Note, for example, the strong similarities between the hard-edged shapes and the abruptly stated juxtapositions of Picasso's 1915 Synthetic Cubist *Harlequin* (Plate 61) and *Once Emerged* of 1918.

We recognize in these similarities an independent development rather than

156

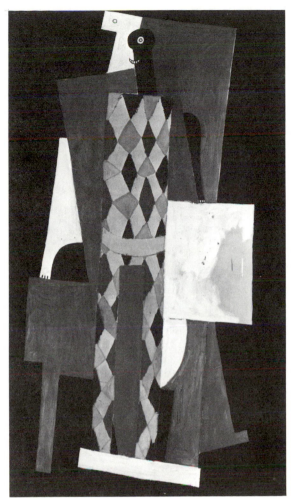

61. Pablo Picasso, *Harlequin*, oil on canvas, 1915,
72¼ x 41⅜".

a derivation from French Cubism, for, as we have seen, the war years offered Klee no opportunity to study the emergent Synthetic style. This comparison with Synthetic works by Picasso, moreover, also makes it clear that Klee still adhered to Analytic-style composition. *Once Emerged* is composed overall in a diamond shape; and the letters are mostly confined to this shape. Between the implied edges of the diamond and the borders of the picture, groups of squares, acting as color-steps, constitute a zone of *passage* between the spatially active center and the flattened edges. This is still the centralized space of Analytic Cubism.

The three discrete aspects of Cubist structure, shape, shape interrelation, and composition, are much more closely integrated in Synthetic than in Analytic

Cubism. Picasso's *Harlequin*, for example, is made up of shapes, or divisions of the pictorial field, so large as to be virtually synonymous with the composition in its traditional sense. A change in composition would involve a change in shape, and vice versa. There is some apparent overlapping, and relative spatial positioning of planes by color, but insofar as the interrelation of shapes in Synthetic Cubism is defined by juxtaposition, this aspect, too, tends to be synonymous with shape and composition. Any change in shape, or in composition, would necessarily change the interrelationships. The three aspects are locked together in Synthetic Cubism.

Klee's *Once Emerged*, and his Cubist work in general, does not have this tight consistency. His "Synthetic" shapes maintain the latitude of the Analytic style. Synthetic Cubist form has been employed in *Once Emerged* in an Analytic Cubist manner. Again, as in 1912-1914, Klee used one aspect of Cubism—here the abstract Synthetic shape—in a context quite different from that of its evolution in French Cubism. Before mid-1914, we recognized this practice as a selective assimilation of Cubist sources. Working after 1914 in a comparative vacuum, Klee naturally continues his prewar Cubist mode. The manner becomes ingrained, and we will see how even in the twenties, when examples of French Synthetic Cubism come available for study, Klee continues his own Analytic-Synthetic combination.

Klee was extremely productive during 1915-1918 and created many variations within the scheme just described. He explored the potentials inherent in the Cubist forms for unusual, even idiosyncratic, expression, mixing the several Cubist-related modes in difficult, experimental combinations. The major 1915 works, *The Niesen* (Plate 62) and *Architecture with the Red Flag* (Plate 63), both build upon aspects of Klee's 1914 work, but with major variations. *The Niesen* relates very closely to the 1914 Hammamet series. *Architecture with the Red Flag* owes a debt to Hammamet colorism, and among post-Tunisian works, it is closest to *Concerning a Motif from Hammamet* and *Hommage à Picasso* (Plate 57).

The dominant pictorial units in *The Niesen* are the colored planes. Although they are flatly stated, their total effect—as with the script picture *Once Emerged*—is the ambiguous, shifting, translucent space of Analytic Cubism. Even the mountain itself, on close inspection, has a line or "seam" down the center and subtle variations in color, which give it the spatial tilt of Analytic *passage*. This is the dominant pictorial formula of Klee's color Cubism; and many of his major paintings of 1915-1918 can be understood in these terms.

In contrast to this delicate openness, *Architecture with the Red Flag* exploits

158

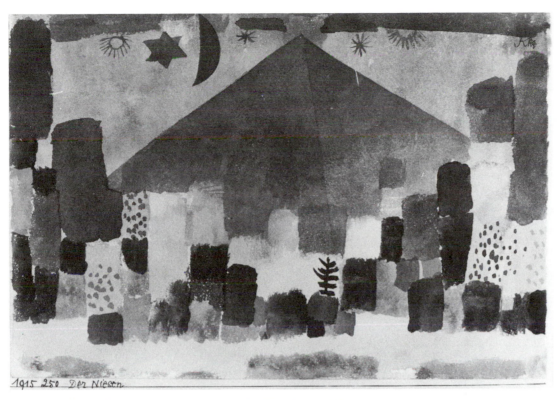

62. Paul Klee, *The Niesen*, watercolor, 1915.250, 7 × 10¼″.

the potential of Cubist form for suggesting a closed, solid geometry. The vague, floating cupolas of the Tunisia-related works have here been interpreted as rigidly three-dimensional structures. The "pseudo-stereometry" of *Red Flag* appears as a secondary element in a number of other works of 1915-1918.

Red Flag appears to derive from the 1914 *Hommage à Picasso* (Plate 57), while clarifying some aspects of that work. Both paintings are irregular polygons, a shape Klee rarely used but which he had borrowed straight from the oval paintings of Picasso and Braque. A tall ellipse is scored on the surface of the later panel inside the polygon and marks the inner edge of Klee's original frame for the work.[24] The polygon called attention, whether consciously or not, to the relationship of the two works to each other and to their common sources. *Red Flag* sheds light, for example, on the near-solidity of the large "cube" in the upper part of *Hommage à Picasso* which, in the 1914 context, had possibly seemed puzzling. This near-stereometry is far from the kind of Analytic Cubism that had interested Klee then, and it has precedents only in the earliest, blockiest

159

63. Paul Klee, *Architecture with the Red Flag*, watercolor and oil on chalk-primed board, 1915.248, 12⅜ x 10⅜".

stages of proto-Cubism. Klee uncovered in *Hommage* a potential in Cubism that he did not fully understand, and he was to explore and fulfill its suggestions only a year later.

In *Architecture with the Red Flag* this locked-in solidity is developed quite far, and spatial ambiguity—the usual hallmark of Cubism—is consequently severely reduced. But there remains, however minimally, the requisite tension to define the work as still Cubist. For example, the "gabled" tower in the upper left can be read two-dimensionally as triangles and trapezoids grouped over rectangular forms. It suggests, three-dimensionally, a kind of isometric or distorted perspective of a rectangular tower with a gabled or pyramidal roof. The two

160

readings coexist; one can recognize in the constructively ambiguous "seams" of the roof-ridge line and of the juncture between the roof slopes and the walls of the tower, grid lines which descend from Cubism and Delaunay. However stereometric the lines become, they always relate to and are embedded in the larger lines of the composition.

This aspect of Klee's 1915-1918 art, the suggestion of stereometric solidity, is the most difficult to read as Cubist. Yet in virtually every instance, he maintains a Cubist-like tension between solidity and flatness, between perspective and surface grid. The balance is equally distinct, on the one hand, from flat abstract painting, and on the other hand, from the kind of extra-pictorial structural consistency we have labled (and will discuss) as Constructivist. *Red Flag* is neither exclusively a flat pattern nor a perspective "house of cards"; it is both simultaneously.

Klee explores here an area of planar implication avoided by most other Cubists, and his result in unique. *Red Flag* is not Analytic or Synthetic in a historical Cubist sense, and neither is it Analytic or Synthetic in a dialectical sense. The spatial tensions of Picasso's *Harlequin* (Plate 61), by contrast, suggest their origin in Cubist analysis. While the forms in the head region of the Picasso may represent, by one reading, a two-dimensional construct, this must subsequently resolve itself intellectually in favor of the original three-dimensional construct—the human head. The major poles of the tension are the head and its flattened fragments. The poles of tension in *Red Flag*, however, are flatness and the suggestion of a new three-dimensional creation. No original model from reality was involved. The difference here is not just one of subject matter—the difference between Picasso's naturalism and Klee's fantasy. Even if, by iconographic association, one sees a reference in *Red Flag* to the towers of Kairouan, this realization is not a term in the Cubist tension of Klee's painting, as it is in true Synthetic Cubism. Recognition of the image in the Klee does little to explain its structure.

Klee's drawing *Poet-Draftsman* (Plate 64) introduces his most fanciful stereometric variation. Forms here may remind one of Léger at his most tubular, but the composition's closest parallel in both subject and composition is Marc Chagall's *Half Past Three (The Poet)* of 1911 (Plate 65).

Whether Klee had ever seen Chagall's *Half Past Three*, or whether the similarities are only accidental, is still again an open question.[25] Nevertheless, the comparison dramatizes Klee's exploration, starting in 1915, of the problems of stereometry regularly avoided by the other Cubists. As similar as the Klee and Chagall are in subject, as a result of their form they offer very different psychological expressions: an open hallucinatory mood in the Chagall; a crystalline, almost pedantic clarity in the Klee.

161

64. Paul Klee, *Poet-Draftsman*, pencil drawing,
1915.195, 9½ x 6⅛".

Klee's stereometry is created here by a variety of strip form, which we can consider in greater detail. In the arms of the *Poet-Draftsman*, in the piece of writing paper, and particularly in the apparently hollow curve of the forehead, parallel lines described ribbonlike planes which variously bend, fold, and terminate in scroll-like coils. This was not, of course, Klee's first use of strip or ribbon forms; he had employed them as early as 1911-1912 in figurative drawings such as the *Candide* illustrations. But the ribbon form here has a different function from earlier works. The 1911-1912 strip was essentially a graphic pattern, whose spatial effect was negligible. The ribbon forms of *Poet-Draftsman* are equally disembodied, graphically, having no physical thickness in themselves.

162

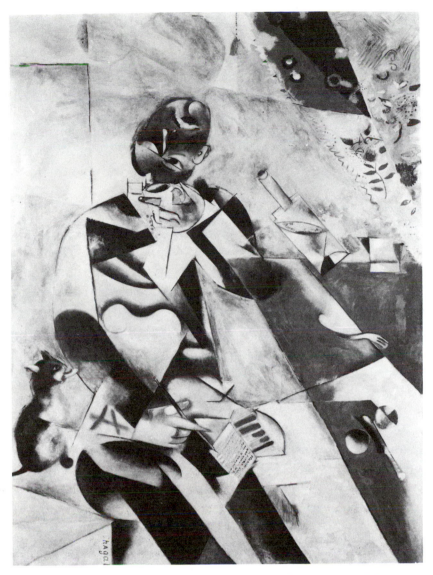

65. Marc Chagall, *Half Past Three (The Poet)*, oil on canvas, 1911,
77½ x 57½".

But by careful management of their folds and scrolls, Klee gives the ribbons
important spatial functions. Where the folds and scrolls are opaque, as at the top
of the forehead or the torso, they convey the sense of cubic-stereometry discussed
above. Where the scrolls and folds—as at the end of the writer's paper, in the
features of the face, or in the hand supporting the chin—are transparent, they
convey the more standard Cubist kind of spatial multiple reading.

163

A variety of handsome Klee drawings use the strap and scroll form almost exclusively. *Drawing on the Letter Envelope* and *Harbor-Like with the Ship-Fish* both of 1917,[26] for example, employ a narrow and apparently "brittle" form in a near-Constructivist way. Perhaps the best-known color work of these years in which the strap form is dominant is the 1916 *Demon above the Ships*,[27] in which scroll and strip forms are transformed into Cubist planes in a variety of ways. Toward the top, large planes become winglike flaps; in the central zone, transparent scrolls generate a number of small planes which, brightly colored, interrelate with the same pseudo-Synthetic Cubism observed above in *Once Emerged from the Gray of Night* (Plate 60).

Klee used three modes of planar relation—the regularized Analytic Cubism of *The Niesen*, the stereometric forms, and the strips and scrolls—in combination in most major works of 1915-1918. The modes are closely interwoven in the complex *Cacodaemonic* (Plate 66) of 1916, a Klee type often compared to Delaunay. Its dense, strongly colored triangles, diamonds, and bars—suggesting prisms and crystalline solids—was used by Klee frequently in 1917; and watercolors such as *With the Rainbow* and *Green Churchtower as Center* continue the type with even greater density.[28]

The related *Childhood of Iris* (1917) includes circular bands which prompted Gerd Henniger to suggest a similarity to Delaunay's *Circular Form: Sun and Moon*.[29] The very rich watercolor *Composition with the Yellow Half-Moon and the Y* (Plate 67) and the well known *Ab Ovo* further explore the faceted effects of *Cacodaemonic*.[30] Comparisons among these works, too, establish a stylistic bridge between the dense forms of 1915-1916 and some extremely open forms of 1918, in which Klee culminated his color-plane Cubism.

Composition with the Yellow Half–Moon and the Y (Plate 67) takes an important intermediate step. Many of the forms along the lower zone and left side are nearly identical with forms in *Cacodaemonic*. The planes of *Yellow Half-Moon* are less translucent, but lighter, less tonal in color, than those of *Cacodaemonic*. In the "perspective box" at the lower center of *Yellow Half-Moon*, and in the several strapwork "landscape" forms, there are renewed suggestions of the stereometry first studied in *Architecture with the Red Flag*. But for all the opacity of its individual forms, and its virtual elimination of *passage* in the tonal sense, *Yellow Half-Moon* still has a more open spatial effect than *Cacodaemonic*.

The large compositional lines of the 1917 work, for one thing, are less obtrusive than in the 1916 painting. In *Yellow Half-Moon* dramatic tonal contrasts are suppressed, most of the colors are reduced, by admixture of white, to a lower intensity contributing to a homogenous effect. Much as in the script picture *Once Emerged* (Plate 60) of the next year, *Yellow Half-Moon* has the shallow,

undulating relief space of high Analytic Cubism. The discrete geometric shapes appear to hinge with one another along the various lines of juxtaposition. The multiplication of these shallow steps produces what can be best described as a "quilting" of the picture plane. This effect, without precedent in French art, is quite properly termed "color Cubism."

In major works of 1918, Klee structured large areas this way, almost entirely by color. The basic innovation here is color *passage*, in which structural planes are given their spatial inflection by color change rather than by the traditional Cubist tonal change. The entire picture plane is modulated by color *passage* in *Hermitage* and in *Night Flowers*, both 1918 works in which linear elements act only as minor compositional punctuations.[31] In a more widely known 1918 group, which includes *The Tree of Houses*, *Flower Myth*, and *Little Vignette for Egypt*,[32] dark tonal structures and signs frame the perimeters of large color fields.

With the Eagle (Color Plate IV) relates centrally to the forms and mysterious imagery of both these groups and is one of Klee's masterpieces of color *passage*. With the exception of the crown of the central arch form, there are no strongly stated tones. Where, as at the top of the arch in the upper right corner, the extremes of color tone—yellow-oranges versus wine-red or red-browns—are juxtaposed, a spatial shift, or fold, on the order of *Composition with the Yellow Half-Moon and the Y* occurs. For the most part, however, *With the Eagle* is given its subtle relief space by extremely delicate color change. The basically orange ground lifts and recedes in response to the spatial position given it by patches of yellow, red, green, and purple. While the orange ground may be read on one level as an infinitely deep space—as of a sunset—the color *passage* just described conforms in its regularity of distribution, its "quilting" across the picture, to the pattern of an understated but prevailing Cubist grid.[33]

There is much evidence that 1919, the first year after the war, was a time of stylistic reappraisal for Klee. Fulltime in his Munich studio after leaving the army at Christmastime 1918, Klee was again surrounded by his past works, and he responded to them. Two watercolors, for example, *Tunisian Gardens* and *Southern Gardens*[34] were painted almost as exact replicas of the 1914 Tunisian *St. Germain Near Tunis, Inland*. The close prewar association with Franz Marc had been called to mind since 1918, when Klee restored Marc's partially burned *Destinies of Animals* and subsequently received, as a gift, the beautiful Marc *Composition I* of 1913. Klee's vigorous colorism of this time must surely owe something to Marc's posthumous influence.

A further result of this stocktaking was a reappraisal by Klee of the role of line in his painting. During 1919, he reinstated the linear element to a position of importance it had not held since 1914 in work such as *Carpet of Memory*. But

165

66. Paul Klee, *Cacodaemonic*, watercolor on plaster-primed fabric, 1916.73, 7¼ x 10″.

in 1919 line was no longer overwhelmingly dominant as it had been in his work before the war. In 1919, line functions as a balancing equivalent to the color-tone planes which Klee had so richly strengthened over the previous four years. Lines become frequently white or colored, further demonstrating the equivalency of the elements. This re-emergence of line plays a part in Klee's surprising re-capitulations in 1919 of some of the major forms of earlier Cubism. Some works of the period have the closest objective resemblance in his entire oeuvre to Delaunay's *Fenêtres* and Picasso's high Analytic style.

The new line can be studied in a comparison between *Feather Plant* (Plate 68) and *With the Eagle* (Color Plate IV). *Feather Plant*, one of the large number of 1919 oil paintings, has very nearly the same red-orange and green color scheme as the 1918 watercolor. Color *passage*, too, is retained for the 1919 work. But while the spatial structure of *With the Eagle* is almost wholly a function of color

166

67. Paul Klee, *Composition with the Yellow Half-Moon and the Y*, watercolor on plaster ground, 1918.4, 10¼ x 8¼".

68. Paul Klee, *Feather Plant*, oil and pen on fabric, 1919.180, 16⅜ x 12⅜″.

plane advancement and recession, line punctuates and modifies the color transitions and inflections within each strip of the later work. The resulting complex, ambiguous relief space is held in resolution by the linear pattern. Wider and more dramatic spatial tensions can be accommodated by such a line-color system than by color control alone. The gentle floating unity of *With the Eagle* is exchanged for a system that includes a sharp, dynamic punctuation.

Many 1919 Klees are structured basically like *Feather Plant*. The linear patterns of *Rose-Pink* and *Rocky Landscape with Palms and Firs*[35] are, for example, more complex and interlaced than the simple branching patterns just mentioned. And yet the planes of these richly colored works hinge back and forth with exactly the same line-color *passage* as employed in *Feather Plant*.

Klee's development of color *passage*, it need hardly be emphasized, was almost unique in the whole Cubist school. Among Parisians, only Chagall developed a color structure comparable to these 1919 Klees. As early as 1911, in, for example, *I and the Village*,[36] Chagall evolved a color Cubism which clearly foreshadowed Klee's form of eight years later. Chagall and Klee have the same eccentric relation to "central" Cubist sources and employ similarly, for poetic fantasy, a mode originally developed from the analysis of still-life objects. More important, their colors are extremely close: blues, greens, strawberry pinks, and oranges dominate in both schemes. And the color planes are inflected in the same way: increased in intensity with a slight admixture of black for their dark range, and faded through the pastel tints toward white at their lightest edges. The transitions are smoothly brushed, equally by both artists, with an almost icy, gliding sensation imparted by the color *passage*.

Once the principle of the comparison is established, it is easy to see the colors of Chagall's 1911-1912 period reflected in Klee's late color Cubism. We recall at this point the several Klee-Chagall parallels in earlier years, beginning in 1912. Here, Chagall's secondary color scheme of pinks, violets, blues, and greens seems partially to replace, around 1919, the more primary colors reminiscent of Franz Marc that Klee had used the year before. While this change should not be exaggerated, it may reflect the distant influence of the Chagalls Klee had seen in Berlin, on one of his only occasions during the war to study French art. Klee had visited Walden's collection in January 1917. Presumably, he saw there the Chagalls Walden owned at the time, which included *I and the Village*, *To Russia*, *Asses and Others*, and other masterworks which had been acquired circa 1914.[37]

As Franz Meyer has related, around 1917 a number of younger German artists, including Max Ernst and Kurt Schwitters, became enthusiastic about Chagall; and Walden reproduced about twenty-five Chagalls, in black and white, in *Der*

Sturm between 1917 and 1922.[38] Klee's friend Theodor Däubler wrote essays on Chagall in 1919 and 1920, in which he discussed *The Soldier Drinks* and the *Animal Dealer*,[39] which find coloristic and even iconographic reflection in Klee. Klee does not mention Chagall in his published *Diaries*, which end with 1918, nor in his family letters, and the exact nature of the contact remains open to further investigation. However, it seems likely, in light of what we know of Klee's delayed reaction to sources, that the Chagallesque colors of 1919-1921 were, at least, a distant reflection of brief observations made at Walden's collection two years before.[40]

In such magnificent 1919 works as *The Full Moon*, *Cosmic Composition* and *Composition with Windows (Composition with a B')* (Color Plate V), Klee made his closest approach, objectively considered, to the forms of French Cubism.[41] *Composition with Windows* presents most convincing evidence that in 1919 Klee was reconsidering his Cubist sources. Comparisons with this painting enable us to sum up the long-range results of Klee's approximately seven-year involvement with Cubist form. If we return to Picasso's *"Ma Jolie"* of 1911-1912 (Plate 18), we spot the ultimate generic source of Klee's letter B, delta-sign, and the flowerlike punctuation to the left. The letters and signs, which in Picasso and Braque evoke associations only with the artist's studio and his favorite still-life objects (the sheet music of a popular song, in *"Ma Jolie"*), seem now to evoke in the Klee mysterious depths of poetic association and philosophic meaning.

The tightly knit and centralized composition of the Picasso is partly the result of its figurative subject; the more diffuse Klee suggests the breadth of a landscape. Spatially, too, the Picasso is more dense; its *passage* planes are closely woven, presenting the eye with not only countless Cubist spatial paradoxes, but also with a strong, if elusive, feeling of bulk and plasticity. The central zone seems, in one possible reading, to illusionistically project into the real world. By comparison, Klee's *passage* planes are more spread out, less stacked up, and convey as their predominant effect a concave space.

The constructive details, too, have different functions in Picasso and Klee. The black lines of *"Ma Jolie"* are closely bound to the planes, of which they form the edges, or upon which they are inscribed. The white and tinted lines of *Composition with Windows*, by contrast, appear to float above the major planes of the composition. The *passage* is accomplished overwhelmingly by tone in the Picasso, while Klee's plane modulation is frequently the result of a color change. Moreover, the color element in Klee often floats free of the underlying structure, to form intermediate, transparent planes. The elements in the Picasso are, as a whole, integrated in the service of the artist's exploratory, analytic-plastic vision; the means are tightly bound to the pictorial concept.

170

Klee, by contrast, applies the elements loosely in *Composition with Windows*, building up several layers. He evidently painted first, along the coordinates of an underlying grid, a basic planar structure in white, red, and a dark olive green. A superstructure of the various black signs, and the white accents to the grid, were next applied. Finally, transparent films of red, blue, purple, and green were glazed across the underpainting in several areas.[42] While the results in *Composition with Windows* are certainly unified, and the steps described probably a little over-simplified, Klee must certainly have followed some such step-by-step, consecutive process. The painting demonstrates this, in its additive, built-up look. This technical procedure establishes Klee's position, historically, as a "second-generation" Cubist. To a great extent, he anticipates and contrives his effects in a way that would have been impossible for Picasso during the days of the first Cubist inventions. Klee's layered and separate employment of the elements, too, is an inheritance of his stepwise method of assimilating Cubism over 1912-1914: first one element had been adopted, then another.

Finally, the translucency of *Composition with Windows*, the layered, windowlike effect, represents a revival of Delaunay-*Fenêtre* interests, most reminiscent of Klee's art of 1914-1915. The conceit of the tinted, white-line "windows" in *Composition with Windows* ought not be overlooked in this connection. Other images that return here out of the past include the dome or cupola, to the upper left of center, descended from the *Fenêtres*, Kairouan, and the *Carpet of Memory*. The "X"-grid black scaffolding at the top has even more distant roots in the Eiffel Tower depictions. This inventory establishes yet again that forms, once adopted by Klee, have vitality for many years. He continued variations on his early themes throughout his career.

With this form, Klee seemed to be restating in 1919 his balanced relationship to Analytic Cubism. *Composition with Windows* can be seen as a point of equilibrium between color Cubism and the final, more linear, Cubist idiom which dominated his work of 1920-1926. Occasionally during the early 1920s period, as in *God of the Northern Woods*,[43] Klee repeated this formula, so redolent of his prewar sources. But for the most part—and apparently even by late 1919—he had proceeded to a new interpretation of Cubist structure.

Chapter 8

FROM CUBISM TO CONSTRUCTIVISM IN THE 1920s

Klee's works of 1920 to 1926 are the most widely known of his entire oeuvre. They provide the most familiar and popular image of his art, and they are well represented in the largest Klee collections on both sides of the Atlantic. Their high quality apparently reflects Klee's increased personal and artistic confidence of the time, a result of his more favorable material circumstances. We noted how, during 1915 through 1919, Klee's work had a somewhat troubled, hermetic quality, reflecting the conflict and withdrawal brought on by the war. Beginning around 1920, this situation greatly changed, as Klee found himself suddenly at center stage in the postwar German art world.

There were important exhibitions, and three Klee monographs were published in rapid succession;[1] late in 1920, he was appointed to teach at the Bauhaus. Just as he had managed the difficulties of the war years, he weathered this leap to comparative fame. As one of the senior surviving German modernists, Klee was a guiding influence at the Bauhaus, and with the confidence of maturity, he opened himself to the influence of new currents around him. Consequently, Klee's art of the 1920s is a clear record of the trends and countertrends in the post-World War I aesthetic.

The start of this period was marked by Klee's appointment in the fall of 1920 as a Master at the Weimar Bauhaus, recently founded by Walter Gropius. Exchange of ideas among artists in the same and different media was a central tenet of Bauhaus thought. In this context Klee renewed his contact with Kandinsky, who, having returned to Germany after seven years in Russia, joined the Bauhaus in 1922. The work of younger Bauhaus colleagues, including Oskar Schlemmer and Laszlo Moholy-Nagy, also interested Klee.

172

Postwar Europe offered renewed opportunities for international artistic contact through travel, exhibitions, and publications, and the Bauhaus was one of its most active centers. But in the twenties, unlike the prewar period, Parisian Cubism was no longer the most prestigious style. Klee, as we have seen, had already forged an independent, Cubist-related manner. Then, when he studied Cubist works in the 1920s—such as, for example, the Léger print that had been sent to the Bauhaus-Press for a planned French print portfolio[2]—he did so as an equal rather than a pupil. But Cubism had less general credibility in the postwar world than it had in 1912-1914. It was attacked from both left and right, by the younger generation. Proponents of the anti-formalist Dada and Surrealism movements took strong issue with Cubism. Moreover, the Bauhaus was a center for the other wing of attack, the reductive, post-Cubist gospels of de Stijl and Constructivism. Even Picasso and Braque appeared to vacillate and abandon the Cubist style for forays into neo-classicism, decorative painting, and near-Surrealism.

Leaders of almost all the new movements of the 1920s—Dada, de Stijl, Constructivism, Suprematism—personally visited Weimar, and several saw their theories published as *Bauhausbücher*. Klee no doubt met these interesting personalities—Schwitters, van Doesburg, Gabo, Malevich, and others. Within this stimulating context, he formulated his own major contribution to contemporary theory as set forth in his lectures. In this, he responded positively, to quote Grohmann, to "the necessity of clarifying in his own mind (in order to be able to explain them to the students) procedures which he had hitherto adopted almost unconsciously."[3] The satisfactions of being valued as a first-generation leader, in such an active milieu, must account in part for the strength and consistency of Klee's early 1920s production.

The de Stijl, Constructivist, and Suprematist influences had important consequences for Klee. The Dutch and Russian movements contributed heavily to the emergence in the Bauhaus during the Weimar years of a dominant Constructivist aesthetic. Bauhaus Constructivism—as we may call it—gained impetus in 1923, with the arrival of Moholy-Nagy, whose rationalized, experimental approach revolutionized the "fundamentals" course (*Vorkurs*), which had been led earlier by the mystical Expressionist Johannes Itten. By 1925-1926 and the removal of the Bauhaus to Dessau, Constructivism dominated most thinking at the school. With its emphasis on architecture and "functional" design, the Dessau Bauhaus became increasingly alien and inhospitable to Klee, with his personal approach and "Romantic" commitment to easel painting.[4]

The effects of Constructivist philosophy ultimately led Klee, in 1931, to leave the Bauhaus. Nevertheless, he responded positively to the direct influence of Constructivist art, for by 1926-1927 pictorial ideas best defined as Construc-

tivist replaced Cubism as the guiding structural principle in his work. Thus, after some thirteen years in the Cubist tradition, Klee moved to a position closer to the dominant European movements of the 1920s and 1930s.

After 1926, Klee's art had its most convincing parallels in the schools of Constructivism, geometric abstraction, and abstract Surrealism. Consequently, after this point, analysis by the Cubist criteria yields much less insight into his structure. His post-Cubist transition around 1926-1927, therefore, will be the final subject of our study.

By the definitions we have employed, Klee continued through 1920-1926 to be a structural Cubist. This is most obvious in the first part of the period, when his structure consists of variations of the formula established in 1919. During the last part of the period—ca. 1922-1926—his Cubist form and space is progressively modified in the direction of pictorial Constructivism. This shift constitutes the most important long-range development of these years. Of his many impressive works from this period, discussion and comparisons will therefore be oriented specifically toward the explication of this change.

We may consider once again a group of three drawings: from Klee's earlier Cubist period, *Clock in the City* (Plate 43); from the 1920s transitional period, *Drawing for "Star Container"* (Plate 69); and from the end of the period, *Accomplished* (Plate 70). In terms of the Cubist criteria, the contrasts between *Clock in the City* and *Accomplished* are clear. The shapes of the 1914 drawing—open, dislocated, and relatively unsystematic—can be considered the result of a Cubist fragmentation. By their complex interrelations, as partially transparent planes, the shapes define a shallow Cubist space. An active tension is felt between the two-dimensional surface of the drawing and its three-dimensional implications. Compositionally, too, a tension is felt between the random intuitive distribution of the shapes and the tendency—expressed here in the larger compositional lines— to align them along the internal geometric coordinates of the rectangular field.

The shapes in the 1927 *Accomplished* (Plate 70) by contrast are closed, regular, and generated by a linear geometric system. Although closed in contour, the shapes are wholly transparent in their interrelationships. They may be read as a two-dimensional graphic pattern or as a totally transparent crystalline structure, floating in an undefined space. The absence of *passage*, or of any strong indication of a foreground-background slant to the planes, dictates that all planes be read as parallel to the picture plane. The composition too appears to be governed by internal concerns of system and imagery. The forms are arranged as an abstract description of a city, with comparatively little reference to the boundaries of the field. In all aspects, then, the active tensions and inconsistencies of the Cubist drawing have been resolved in favor of system, the appearance of construction, and complete transparency.

174

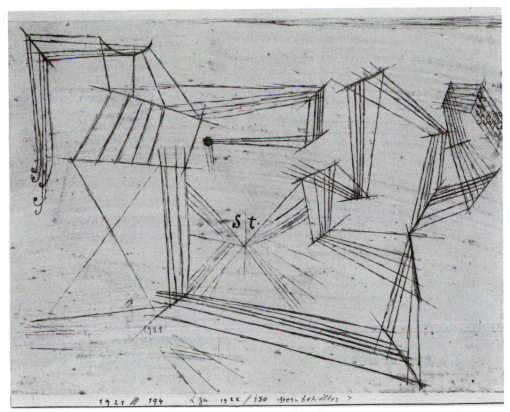

69. Paul Klee, *Drawing for "Star Container,"* pen drawing, 1921.194, 8⅛ x 10¾".

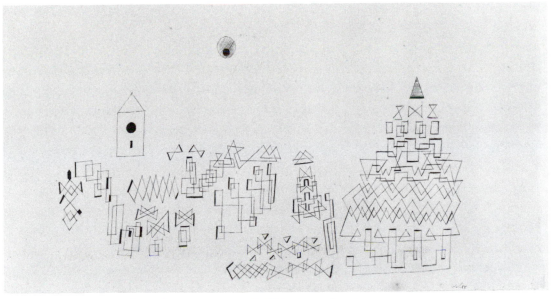

70. Paul Klee, *Accomplished*, pen drawing, 1927.F3, 9⅝ x 18⅛".

The most significant of these changes is in the pictorial space. If Klee's earlier work had lacked Picasso's heavily plastic, almost physical spatial tensions, he, Klee, had consistently employed, from 1913, a decidedly Cubist management of space. In all his modes, *passage*—embodied by one device or another—created and regulated a shallow, ambiguous, pictorial box. But the 1927 work, lacking the spatial measure and control of *passage*, may now be read most easily as absolutely flat or absolutely deep. The background wall of the box, always ambiguous—but always present—in Cubism, has been dropped out, producing an infinity of suggested space. This undefined abstract space can be recognized as that employed by both the Constructivists (for example, Rodchenko and El Lissitzky) and the abstract Surrealists (for example, Miro and Arp) in the 1920s and 1930s.

In its appearance of representing a geometric construction in space, *Accomplished* is closest to Constructivism. Klee had for many years combined small geometric shapes into composite imaginary structures; for instance, one recalls, the proto-Constructivist towers of *Jerusalem my Highest Joy* of 1915. The continuity and consistency of the geometry of *Accomplished*, however, is unbroken by Cubist dislocation. The parts of the fantasy city respond only in the generalities of their placement and alignment to the usual canons of Cubist composition. The internal coherence of such imagery, its appearance of being literally descriptive of a construction, lies outside the Cubist dialectic of image and pictorial structure.

Moreover, the importance and consistency Klee accords to a generative system in *Accomplished* has no really close parallel in any other contemporaneous artist's work. The linear method of Klee's run-on contour resembles the automatic drawing of Surrealism, as in André Masson's *Fish Drawn on the Sand*.[5] Masson's irregular, random line is created purportedly by automatic drawing or chance. By contrast, Klee's line is extremely controlled and repetitive, a calculated, self-defining geometric system. Where Masson's latent fish-battle imagery is evoked, Klee's fantasy city is consciously constructed with a quasi-logic.[6]

The geometric rigor of Klee's line is approached in some Kandinskys; but Kandinsky remains essentially pictorial, avoiding Klee's emphasis on uncompromising system. For example, Kandinsky avoided the symmetry inherent in many of Klee's systems—such as in the righthand tower of *Accomplished*. Piet Mondrian, whose geometric abstractions, like Klee's, are the products of analytic, systematic thought, rather pointedly avoided repetitive forms and symmetry.

In its most regular, repetitive applications of the mid- and late 1920s, Klee's systematic drawing has its closest parallel in the applied, rather than the fine, arts. The patterns of fabric design which he could have observed in the Bauhaus

176

weaving workshop may have encouraged his exploration in this direction. Among the important modernists of his generation, Klee was unique in giving a central place in his oeuvre to the characteristics of system and repetition, ordinarily denigrated as "decorative."[7]

Drawing for "Star Container" (Plate 69), intermediate in structure between Cubism and Constructivism, is typical of most of Klee's work of the Weimar period. Some Cubist involvement is maintained between the forms and their enclosing rectangle; the whole surface is divided and activated by the longer lines, and the continuity of the linear system is broken in the left half for compositional reasons. Even in the right half, the linear system has some of the looseness and approximation associated with Cubist draftsmanship. Irregular planes are generated within and around the linear skein. The discontinuities in the folds of the linear "ribbon" and the tangencies along its outer contours suggest a complex interlocking of translucent *passage* planes. Thus defined as Cubist in several important ways, the drawing still embodies tendencies toward Constructivism. "Star Container" has those potentials for graphic consistency, constructive fantasy, non-*passage* transparency, and a resultant undefined space which, completing themselves, take Klee's 1927 drawing outside the scope of Cubist art.

Klee developed the innovative technique of oil-transfer watercolor in 1919 and employed it as a major vehicle up through ca. 1925. By this method, he was able to translate his drawing directly into painting, and most of his important linear-dominant works of the early 1920s were done in this technique. A number of transfer pairs from the early period have been preserved, including *Drawing to "They're Biting!,"* 1919 (Plate 71), and the watercolor made after it (Color Plate VI), of 1920.[8]

Klee first did the drawing (Plate 71) in a light, sketchlike pencil line on paper. He then positioned the drawing over a sheet of watercolor paper, placing between them an intermediate sheet, the underside of which was coated with partially dry oil paint, or possibly printer's ink. The drawing was then retraced on its surface with a sharp stylus, offsetting the lines, in the manner of carbon paper, onto the watercolor paper below.[9] The transferred drawing (Color Plate VI) was then watercolored. Light tan and darker green were applied, both in large washed areas and in drier, cross-hatched patterns. The watercolor separated away slightly from the oil-impregnated lines, thus preserving a clear distinction between the drawing and the color.

The effect that this color-tone application has on the oil-traced drawing is to provide the line with a color-plane context. Shadings and gradations of color transform the lines in a number of places into the edges of transparent planes.

177

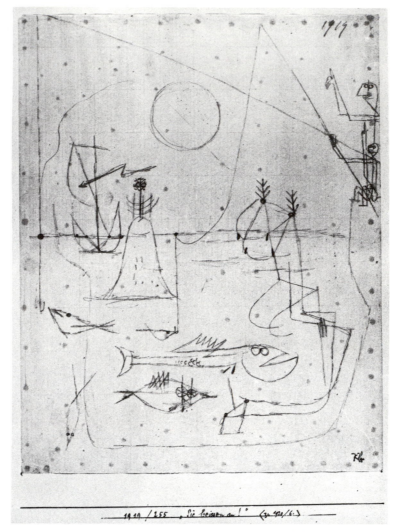

71. Paul Klee, *Drawing to "They're Biting!"* pencil drawing, 1919.255, 11 x 8⅝".

This effect is most decisive along the vertical line in the upper left, the bottom-most contour, around the sun circle, and in the bodies of the lower left fish and the "sea-monster," center right. The work may still be read as a graphically autonomous line drawing with a certain wirelike, constructive quality. But the color context affords a spatial reading, in which translucent color *passage* planes hinge from the linear edges, inflecting the drawing with a shallow ambiguous space.

Klee used this technique as a frequent—possibly even dominant—mode for

178

linear expression for 1920-1924, and it reflects an important decision by him regarding the respective functions of line and color. We observed in the previous chapter the emerging importance of line in 1919 in works of comparatively traditional technique. In *Feather Plant* (Plate 68) and *Composition with Windows* (Color Plate V), line was reinstated to the importance it had held in his work before 1915. Line reemerges, so to speak, as a dominant mode of expression after its four-year subordination to the color-plane. Line tends to lie on the surface, and color and tone tend to lie visually behind the linear pattern, generating the spatial context. But the relationship in works like *Composition with Windows* remains loose and flexible, with some white surface lines even taking on color functions, by virtue of their blue and purple over-glazes; and other, smaller, black lines functioning deep within the matrix of the color *passage*.

The development, the same year, of the oil-transfer watercolor represents, by contrast, a technical and aesthetic *separation* of the functions of line and color. In *They're Biting*, the line scheme is totally realized first, then only secondly given its color context. In Cubist terms, line produces shape, color produces *passage*. Klee even takes advantage of the oil-water antipathy to keep the two layers from blending. The means and their functions are separate but interrelated. Over the 1923-1926 period, Klee's line patterns become increasingly Constructivist, but insofar as a color context of this type is provided, such works may still be considered Cubist. When, about 1926, color takes on an autonomy equal to that of line, the visual bond between the two layers is broken. At that point, *passage*—and its concomitant, Cubist space—ceases to be present.

To further measure the growth of Klee's Constructivism during the early 1920s, we may compare his transfer lithograph *Tightrope Walker* (Plate 72) with a contemporaneous Constructivist work by El Lissitzky, *Proun 99* (Plate 73). Both works appear to represent assemblages of wirelike lines and geometric elements suspended in a spatial void. While the vertical stripe and the two-dimensional aspects of the cube in *Proun 99* represent the problematic confluence in Lissitzky's art of Suprematism and de Stijl—and, via both movements, an ultimate reference to Cubism—the perspective grid, by contrast, is a veritable illustration of Constructivist spatial doctrine. The grid establishes a Renaissance perspective, receding plane complete with horizon and vanishing points. The plane, however, is wholly disembodied and transparent, renouncing in its abstract spatial statement any reference to the physical world. The two curved lines which spring from the grid are formally intermediate between it and the isometric cube. The cube itself, with its precisely equivalent planes, embodies the abstract, measurable, spatial projection used by engineers.

In the most articulate manifesto of the Russian Constructivist movement,

179

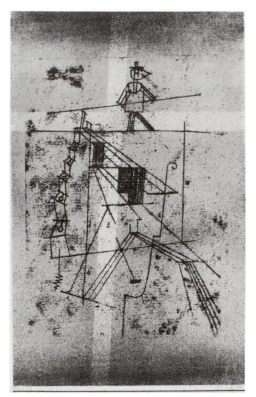

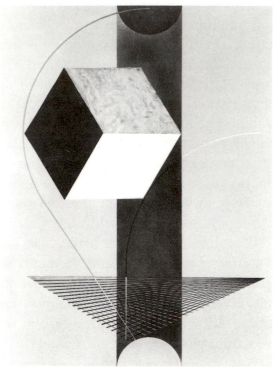

73. El Lissitzky, *Proun 99*, oil on wood, ca. 1924, 50¾ x 39".

72. Paul Klee, *Tightrope Walker*, lithograph, 1923.138, 17⅜ x 10½".

Gabo and Pevsner had stated in 1920 that "Cubism, having started with simplication of the representative technique, ended with its analysis and stuck there. The distracted world of the Cubists, broken in shreds by their logical anarchy, cannot satisfy us who have already accomplished the Revolution or who are already constructing and building up anew." Among the forcefully stated tenets of the new movement are: "We renounce in a line, its descriptive value. . . . We affirm the line only as a direction of the static forces and their rhythm in objects. We renounce volume as a pictorial and plastic form of space. . . . We affirm depth as the only pictorial and plastic form of space."[10]

Klee's *Tightrope Walker* print shares many of these qualities. In comparison to the earlier linear work *They're Biting* (Color Plate VI), the Cubist interrelation between the tightrope apparatus and its background has been severely limited. Mediating between the line and the color background, here in the 1923 print, are only the tonal gradations at the top and bottom of the field, the softened edges and smudges of the line technique, and the congruence of the tightrope

180

with the horizontal cross-element of the background. With Cubist qualification thus weakened, Klee's line drawing takes on much of the feeling, as in the Lissitzky, of a disembodied construct. There is even a suggestion, in the orthogonal convergence of several of Klee's planes, of the irrational perspective of the Constructivist. While Klee had several years before interested himself in pseudo-perspective drawing, he had always been careful, as in the 1918 *Souvenir of Gersthofen*,[11] to qualify and flatten it by his usual Cubist means. In *Tightrope Walker* he appears, by contrast, to be drawing in empty space.

It need hardly be stated that the Constructivists' insistence on nonrepresentation and their uncompromising seriousness are not shared by Klee. But this leads us to subtle distinctions in the purposes of abstraction. In contrast to the cold nonobjectivity of the Lissitzky, Klee's little performer and his scaffold have a "second" reading as a nonsense, perhaps a toy, machine. Linear details, apparently of the joints, struts, and bracings, give the Klee a pseudo-mechanical nature and hint that it might actually be constructed out of wire and string. This aspect is equally foreign to the pictorial ideas of the Cubists and the Constructivists, falling nearer the aesthetic borders of Dadaism. Klee seems to have shared with many Dadaists a mistrust of mechanization and the machine. Like certain works of Picabia and Ernst, Klee couches his questioning of the machine ethic (and esthetic) in a visual paradox: the machine by its absurdity parodies itself. A "Rube Goldberg" machine, whirring and clattering to no effect, is hardly an affirmation of Bauhaus art-and-industry positivism. The element of poetic absurdity and parody is never wholly absent, one feels, in Klee's Constructivism. In some linear works of around 1922-1923, such as the famous *Twittering Machine*,[12] Klee's parody of the machine is so specific as to suggest that the conflicts of the day between Expressionism and Constructivism, both within the Bauhaus community and in his own work, were the source of anxiety—if not some bitterness—for an artist of Klee's generation.[13]

We have observed that Klee was, among Modernists, unusually interested in self-generating modalities and systems. During the 1921-1926 period, "systematic" work forms a large part of his oeuvre. The dominant types are fugue pictures such as *Growth of Night Plants*,[14] stripe pictures such as *Double Tent* (Plate 75), rectangle and diamond backgrounds such as *Lions—Beware of Them!* (Plate 74), and the more or less strict grid pictures, the "magic squares," such as *Old Sound*.[15]

On reflection, we may observe that these idiosyncratic modes—as surprising as it may at first seem—usually follow Klee's major trend. For example, it is not difficult to classify *Growth of Night Plants*, of 1923, or *Ceramic-Erotic-Religious (The Vessels of Aphrodite)*,[16] of 1921, as Cubist, since their forms emerge one

181

from another in orderly rows that are a virtual paradigm of *passage*. In a similar way, rectangle-background paintings such as *Lions—Beware of Them!* (Plate 74) of 1923, and magic squares such as *Old Sound*, 1925, both of which have dark borders and light centers, are cubistically composed by the familiar stepwise transitions.

Stripe pictures with a very precise application, such as *Double Tent* (Plate 75) of 1923, by contrast, exist at the outer limits of the *passage* definition. One can hardly overlook the dynamic interpretation that Klee gave these works in his theoretical Bauhaus writings. As a single example, I cite paragraph 41 of *Pedagogical Sketchbook*, where a "Table of chromatic incandescence (mainly blue-orange)" and a "Table of chromatic cooling (mainly orange-blue)" are diagrammed–referring obviously to such paintings as *Double Tent*.[17] Nonetheless, we may always detect a vestige of Cubism whenever the diagram unfolds itself stepwise by a color or tonal progression.

This modality of Klee's ceases to be Cubist only when all accent and punctuation to the system is dropped. By 1927, *Sailing-Ships* (Color Plate VIII)—a painting on the order of the *Accomplished* drawing—for example, has become thoroughly Constructivist in its linear consistency, even tone and color, and undefined space. The planes appear completely transparent to one another, their intersections generating smaller planes without spatial differentiation. The question, in Cubism, of the relative order of planes is here resolved by all answers, all spatial orders, being made equally possible. Only differences in size and, as one follows the generative line, one's momentary concentration within the scheme offer temporary patterns of spatial layering. Along the outer contours of the ships, no trace of *passage* qualifies the relationship of the forms to the infinite blue background.

The Bauhaus afforded many opportunities for Klee to become personally acquainted with the Constructivists and their art. Although we lack published reports on personal meetings, new works seen, and the like, the Constructivist influx in the early twenties lies behind the changes in Klee's work we have observed. The most outstanding circumstantial influences can be briefly outlined. Theo van Doesburg, the leader of the de Stijl movement, based his lecturing and stylistic propaganda activities, as well as the publication of the periodical *de Stijl*, in Weimar from 1921 to 1923. Around the end of 1921 Kandinsky, El Lissitzky, Gabo, and Pevsner, all of whom had been deeply involved in Constructivism and the allied avant-garde movements in Russia, came to Berlin. A comprehensive exhibition of modern Russian art was held in Berlin in 1922, at the Galerie Van Diemen, with installations designed by Lissitzky.[18] In the same year, Kandinsky took up the teaching post at the Bauhaus which he held until 1933.

182

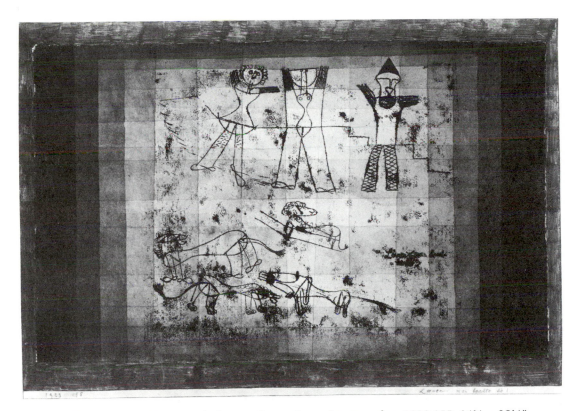

74. Paul Klee, *Lions—Beware of Them!* oil transfer and watercolor, 1923.155, 14⅛ x 20⅛".

Gabo and Pevsner, likewise, remained in the West from 1922 on. Lissitzky alone of those named remained in Soviet Russia, active there to the end of his life. Nonetheless, he too traveled widely in the 1920s as a propagandist of Constructivist ideas, maintaining contact and collaboration with the artists of de Stijl in Germany and Holland. Lissitzky was in Weimar, for example, in the autumn of 1922 for the Congress of the Constructivists, organized by Van Doesburg, a conference which also included—paradoxically—several Dadaists.

Another participant in the Congress, and a very active member of the Berlin Constructivist circle, was Moholy-Nagy who, in 1923, joined the Bauhaus faculty. Moholy-Nagy took over the Bauhaus *Vorkurs*, which had been previously taught by Johannes Itten. This introductory course was quickly diverted from its earlier romantic Expressionist direction to become a "laboratory" for the exploration of materials and abstract construction in space, Moholy-Nagy's central preoccupations.[19] In 1923 as well, Josef Albers, earlier a Bauhaus student, began to teach; and Oskar Schlemmer, sculptor and painter, took over the Bauhaus Theatre workshop. These young masters, maturing in the post-Cubist period, contributed a great deal to the emergence of Bauhaus Constructivism.

183

75. Paul Klee, *Double Tent*, watercolor, 1923.114, 19⅞ x 12½".

In the center of this activity, in 1922, Klee painted *Senecio* (Color Plate VII), a small but highly developed canvas which, perhaps more than any other work of the 1920s, sums up the Cubist-Constructivist dialogue, with references to sources in many surprising directions. While it may seem at first as merely a whimsical, imaginary portrait, *Senecio* is nevertheless a crossroads between Bauhaus formalism and Klee's personal interest—stretching back to the turn of the century—in facial types and the psychology of expression.

Senecio's structure is deceptively simple. The circular head is placed a little to the right of the center of a nearly square ground. As a counterpoint to the dominant circle, one detects a vertical-horizontal linear grid, expressed subtly by textural variation in the unusually painterly background. The grid is more obvious in the horizontal and vertical divisions of the face. The internal space is tightly organized in the manner of a shallow, Analytic Cubist relief: by means

184

of color *passage*, the surface appears to undulate, bending in and out along the grid lines. By changes in tone and color, the large facets appear to move themselves, as in the left cheek, into spatial concavity or, as above the right eye, into convexity.

The face is both a flat surface and a plastic disc, which swells out from the surface along its rim, sinks toward the middle zone, and pushes back out along the line of the nose. The eyes are generated by an abstract linear pattern: a pointed figure eight or infinity sign. They are asymmetrical, the left lying above, the right below, the horizontal. This subtle imbalance, augmented by the form of the brows, lends them the appearance of rotating on their fulcrum and contributes greatly to the psychological impact of the face. We will presently return to the non-Cubist implications of such linear autonomy.

In overall design, there is no doubt that *Senecio* has a relation to the disc-head child-beauty dolls of the West African Ashanti people, which Klee had apparently known for some time. We noticed his first formal reference to these small African sculptures in drawings of 1913.[20] *Senecio* is but one example of his greatly renewed interest in primitive art sources during the early 1920s.[21] In a conversation of 1922, reported by Lothar Schreyer, Klee reaffirmed, in much the same language as ten years before, during the Blue Rider period, that he felt a special sort of direct emotional power could be seen in the art of children, the insane, and primitive peoples.[22]

Senecio also connects with an old tradition in Klee's art of large, full-face heads, stretching back to the *Comedians*, *Perseus*, and *Menacing Head* (Plate 2) prints of 1904-1906. A look at *Menacing Head* confirms that asymmetrical, abnormally rolled and/or enlarged eyes formed part of the psychological equipment of the type from the beginning. There is, further, a naturalistic drawing from 1913, *Sketch for Portrait*, that appears to be a forerunner for *Senecio*, separated from it by many years.[23] Briefly stated, the 1913 sketch prefigures *Senecio* in the form of its eyebrows—triangular on the left, and a quarter-circle on the right, both springing from the bridge of the nose—its profile treatment of the nose, and the minuscule indication of the mouth. However, what appears at first to be spontaneous invention here, may in fact be a reference, done from memory, to Picasso's famous *Portrait of Uhde*,[24] which Klee had conceivably seen earlier. *Sketch for Portrait* and *Uhde* are remarkably alike in facial features.

Working from similar Analytic Cubist sources, Chagall had painted a face extremely close to *Senecio* in his *The Soldier Drinks* of 1912, which Klee had not seen before his own 1913 drawing, but very likely saw in Walden's collection when he visited Berlin in 1917.[25] Having established that Klee was interested, around 1919-1921, in the forms and colors of Chagall's prewar work, it is therefore

185

very possible that the divided forehead, triangular and curved forms around the eyes, and convex-concave plasticity of *The Soldier Drinks* contributed on some level to *Senecio*.

This proposed relationship is, however, far from simple, as a reference to another Klee will indicate. The face of *Senecio* was also prefigured very closely, particularly in the nose and mouth forms, in the 1917 drawing *Spirit of Fruitfulness*.[26] This work was done possibly around the time of the exposure to the Chagall source, yet it resembles the Chagall, paradoxically, much less than does *Senecio*, five years later.[27] Very rarely in Klee does a simple relationship prevail.

The list of precedents for *Senecio*, by this time, is rather long: Ashanti sculpture, Klee's own early prints such as *Menacing Head*, Picasso's *Portrait of Uhde*, Klee's naturalistic sketch of 1913, his more stylized work of 1913 and 1917, and the drinking *Soldier* of Chagall. The interrelation of these precedents in Klee's mind, one is forced to conclude, can never be fully unraveled.

But an even more timely relationship exists between *Senecio* and the *Bauhaus Insignia* (Plate 76) designed by Oskar Schlemmer,[28] in the same year, 1922. Schlemmer had come to the Bauhaus in 1920, was first the *Formmeister* of the sculpture shop, and then, from 1923, director of the Bauhaus Theater.[29] About ten years younger than Klee, Schlemmer had enthusiastically admired Klee's work from well before the Bauhaus period.[30] We may safely assume that Klee's *Senecio* influenced Schlemmer, and not the other way around; but nonetheless, comparison with the *Insignia* highlights aspects of the Klee we might otherwise overlook. The greatest resemblance is in the right half of *Senecio*'s face in its aspect as left-facing profile. Both the Klee and Schlemmer profiles are thus seen as products of extremely similar, joggled, chord lines which traverse the circles. The resemblance is closest in the noses, and in the checker pattern used by Klee for the mouth, and by Schlemmer for the chin.

Both faces have their ultimate ancestry in the Cubist double-face, internal profile idea. The sense of Cubist derivation is, of course, much stronger in the Klee, with its complete left half of the face and its *passage* along the nose line. Schlemmer's profile line is more obviously related to Constructivism or de Stijl, in that its dominant "second" reading is understood as an abstract, tangent construction of uncompromised rectangular units. These are intended to add up to a face while losing none of their elemental purity.[31]

The Constructivism of Schlemmer's *Bauhaus Insignia* certainly enables us, by comparison, to more easily recognize Klee's tendencies in this direction. In contrast, for example, to the undulating *passage* planes of *Senecio*'s nose, cheeks, and forehead, there is a closed, near-mechanical aspect in his hard almond eyes with their circular irises and precise branching point on the nose line. This

186

76. Oskar Schlemmer, *Bauhaus Insignia*, 1922.

tendency to gather all the facial features, graphically, into a branching, almost Calder-like line construction is carried much further in post-Cubist Klee, in, for example, the etching *Girl's Head* of 1928.[32] Interestingly, comparison of the two states of this etching shows how Klee successively closed off the top of the head and continued the eyebrows as a single line across the bridge of the nose, just as in *Senecio*. In both heads, the internal, quasi-mechanical connection of parts challenges the coherence of the image of the face as whole.

Once recognized in principle, examples of Klee's Constructivism, dominant in the later 1920s, can easily be multiplied. We might compare Klee's disembodied construct in *Hovering (Before Rising),*[33] of 1930, with Moholy-Nagy's abstract, weightless forms in such paintings as *Axl II,*[34] of 1927. In work like *Air Station,*[35] and *Temple of Bj* (Plate 77), both of 1926, Klee develops other post-Cubist forms. In these watercolors, he no longer uses oil-transfer, but rather a combination of a very sharp, direct pen-and-ink line and a finely textured spray or spatter paint. Kandinsky uses an identical spatter technique as well, during the late twenties, and both artists sometimes employ a mechanical drafting instrument for the precise control of the width of line. The artist's personal "hand-writing" or facture is studiously excluded in favor of "objectified" applications, and in this Klee clearly follows the lead of anti-Romantics, like Moholy-Nagy and Rodchenko, among the younger Constructivists.[36]

187

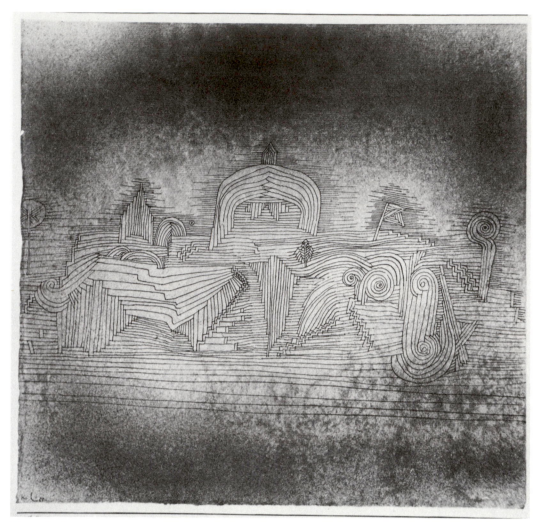

77. Paul Klee, *Temple of Bj*, pen and watercolor, 1926.59, 11¾ x 12⅜".

Klee's *Temple of Bj* (Plate 77) presents another deterministic scheme, in the order of its line. The lines of the temple are "woven" together by a quasi-physical pattern of intersection that compels the eye to read it as a three-dimensional interlace. This interlace, which appears in a number of well-known drawings, is in effect a parody of *passage*, optically forcing an illusion of spatial construction.[37]

Equally absolute, and irrational, is the obsessional order in the mode of *ARA. Coolness in a Garden of the Torrid Zone* (Plate 78). In this mode, Klee took conscious instruction not only from fabric-weaving patterns, but also from the art of the insane, as attested by the comparison of illustrations from Hans Prinz-

188

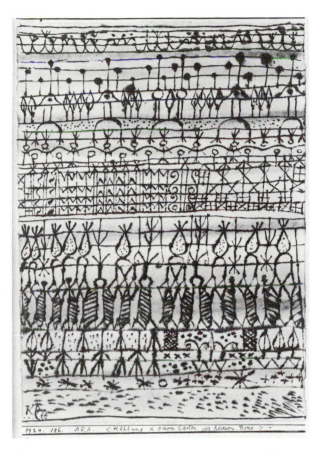

78. Paul Klee, *ARA. Coolness in a Garden of the Tor-
rid Zone*, pen drawing and watercolor, 1924.186,
11⅝ x 8⅛".

horn's *Bildnerei der Geisteskranken (Art of the Mentally Ill)*, a book to which
Klee made reference in the 1922 conversation with Lothar Schreyer.[38] But beyond
this source, the idea of an infinitely repetitive system came to full expression in
Klee's art only when, during the mid-1920s, the older Cubist canons were thor-
oughly weakened.

Finally, in what is probably Klee's closest Constructivist contact of the pe-
riod, a work that has a specific Russian inspiration, there are implications about
the changing meaning of forms. Consider Klee's 1927 painting *Limits of the
Intellect* (Plate 79) with the extremely similar drawing *Project for a Radio Station*
(Plate 80) of 1919-1920 by one of the founders of Constructivism, Naum Gabo.
In Gabo, we deal with a different aspect of historical Constructivism than en-
countered—at least in any obvious, visual sense—in the Moholy-Nagy, or El
Lissitzky works already considered. The Gabo drawing reflects the widespread

189

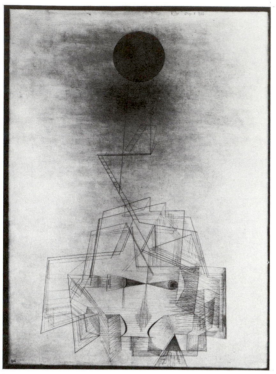

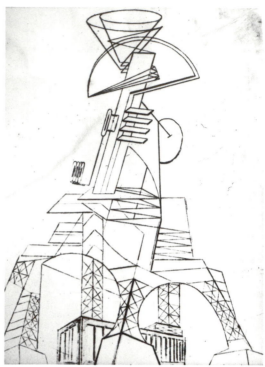

79. Paul Klee, *Limits of the Intellect*, mixed-media oil and watercolor, 1927.Omega 8, 21½ x 15¾".

80. Naum Gabo, *Project for a Radio Station*, pen drawing, 1919-1920.

attempt in the Soviet Union, particularly between 1917 and 1922, to utilize the talent of leading artists—at least theoretically—for the visionary and ultimately practical solution of applied design problems. Gabo's *Project for a Radio Station*, like Tatlin's famous *Monument to the IIIrd International*[39] of the same years, was clearly more visionary than practical, and was never actually constructed.

Gabo's drawing (Plate 80) reveals, in its arched supports and massive footings, formal reminiscences of the Eiffel Tower, or very possibly, of Delaunay's dynamic renditions of that monument. Above the lower stages, which include a naturalistic rendering of a building, Gabo's tower proceeds as an abstract, linear construct in space. Perspective planes are mixed with freely cast lines. The whole tower is, however, knit together visually, if not precisely structurally, by graphic continuity. Klee's *Limit of the Intellect* (Plate 79) reaches upward by similar means. Its base may be recognized, in one reading, as a cagelike human head, from the cerebral regions (intellect) of which upward probing lines are projected. By its thinness and transparency, which is much greater than in the Gabo, Klee's "tower" resembles a wire sculpture more closely than architecture.

190

The stereometry of a triangular solid to the bottom left in the Klee, the triangle to the bottom right, and the pair of black curves between them bear a striking resemblance to the lower forms of the Gabo. The crossed and strutted—apparently cantilevered—planes of the middle zones of the two drawings are similar as well. Similar sharp changes in linear direction—with the inclusion in both cases of representations of stairs or ladders—also mark the upper reaches of both drawings.

At its pinnacle, however, the Gabo tower has a cone, symbolic of a communications megaphone. Beyond indicating a public function for art, the cone was one of the regular geometric figures much prized by the Constructivists for their elemental perfection, purity, and almost Platonic truth. Klee's construct, by contrast, reaches up through a dusky, obscuring cloud and points toward a dark circle, sphere, or possibly heavenly body. The form, while equally pure and elemental, is not a symbol of rational perfection but, enshrouded by mists, a Romantic emblem of the mystic ineffable.

The many similarities of form indicate that Klee had at some point seen the Gabo drawing, which in fact had been shown in the 1922 exhibition of Russian art at the Galerie Van Diemen in Berlin, and in other exhibitions.[40] Klee met Gabo when the latter lectured on Constructivism at the Dessau Bauhaus, possibly before 1927, when Klee did his painting.[41] These circumstances underscore again the visual evidence of how closely, by this year, Klee had approached the Constructivists. In its closed, constructed climb through empty theoretical space, the line of Klee's *Limits of the Intellect* bears little resemblance to the discontinuous contours and broken surface grids of his earlier Cubist style.

191

Conclusion

KLEE
AND THE MODERN
TRADITION

After a fourteen-year involvement with Cubism, by 1927 Klee had turned to Constructivism. Within a few years he explored a number of related post-Cubist modes as well: an abstract "Neo-Impressionism," a completely nonobjective mode of stripes and strata, and several new kinds of pictorial system. Klee's runic pictures, such as for example *Pastorale*, of 1927,[1] have little connection with the relativities of Cubism. Inscribed with a stylus on a gesso panel resembling a stone tablet, these marks are an absolute, symbolic statement, resembling language more than Klee's earlier forms of pictorial art. In his later years, Klee's increasing use of pictographs, ideograms, signs, and symbols in a direct equivalency to ideas and emotions seems to completely bypass the whole cubistic, visual-structural tradition.

In the midst of this period, we observe only occasional, distant references to the older structure. These recollections are, however, divided from Klee's pre-1927 Cubism not only by time but also by changed methods of relationship. As an example, when compared with the decidedly post-Cubist *Mask of Fear* of 1932,[2] *Bust of a Child* (Plate 81) of 1933 appears to have a strong Cubist component. *Mask of Fear*, with its evenly weighted mechanical line, absolute planar statement, and directional arrow, has evolved clearly from Klee's Constructivism of 1927. By contrast, *Bust of a Child* seems to embody all the elements—broken geometry, interpenetrating planes, plastic suggestion, strong compositional lines—of a Cubist reprise.

Nonetheless, comparison again with the Cubist-period *Senecio* (Color Plate VII) reveals a number of differences in Klee's later form. First, *Bust of a Child*

192

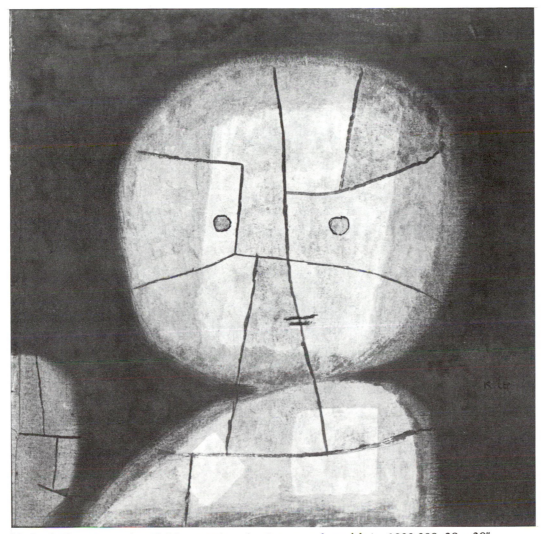

81. Paul Klee, *Bust of a Child*, water-based paint, waxed, on fabric, 1933.380, 20 x 20".

reads much more readily than *Senecio* as a flat, uninflected, or weightless pattern. This reflects the stylistic intervention of the flattened, abstract mode of *Pastorale*. On the other hand, in the absence of any defining, structural relationship between the face and its cloudlike background, the 1933 work seems to float. Spatially it has little in common with the controlled bas-relief of *Senecio*'s cubistic face. This is a result, of course, of Klee's total abandonment of *passage* in the late 1920s.

Finally, we have seen how, throughout 1926, Klee clung tenaciously, in even so closed a work as *Senecio*, to his basic reference point in Analytic Cubism. No matter how abstract or puristic his forms were, they were always put together

193

in the relational style of Cubism's early phase. The approach by the time of *Bust of a Child* is completely changed. Klee now employs Cubism consciously and retrospectively in the service of a new stylistic allegiance. In the final analysis, the Cubism of Klee's later years is so qualified by intervening styles that it no longer constitutes, as it earlier did, a real structural basis. Klee's late Cubism is just one "mode" among other, equivalent, modes, all used interchangeably for abstract, symbolic statement. Cubism had faded from the center of his activity.

By 1905 Klee had achieved early sophistication as a Symbolist-Jugendstil illustrator. Immediately, however, he felt the limitations of the style, and he spent the whole second half of the decade exploring looser, less rigid forms. By 1911 he realized, with characteristic self-awareness, that he had recapitulated the late-nineteenth-century premodern progression from Naturalism, through Impressionism, to post-Impressionism. He was thus well equipped by intellect and experience to understand the innovations of Cubism when he saw them. Then, from late 1911 to 1914, through various contacts, he pursued a course of cubistic self-education. He immediately grasped the logic of Cubist structure and was able to express this verbally with great accuracy.

The assimilation of this structure into his work was a much slower process, however. His first Cubist adaptation was of the facet form, wrenched, somewhat awkwardly, from its context. Through the crucial year of 1913, he thrashed out and incorporated the essential component of Analytic Cubist space, *passage*. He completed his basic Cubist reconstruction in 1914, when he replaced an allover pattern derived from Fauvism with a full Cubist compositional style. Involved in this conclusion were a rethinking of all his Cubist sources and a reappraisal, particularly of Delaunay's *Fenêtres*, before the motifs of Tunisia.

The isolation and difficulties of the war years did not stop Klee's exploration of his new pictorial language. During 1915-1919 he developed a unique style of color Cubism in which he subordinated his native graphic talent and explored the potential of the color plane as a bearer of structure. In this respect he had few peers among first-generation Cubists. By 1920 he had attained such stability of color balance that he ventured to add line back into his work in the capacity of lyric superstructure. Throughout the early Bauhaus years, Klee's picture formula was one of extreme linear freedom built upon, and given spatial context by, a fundamentally color-tone *passage*.

In a sense, it was the freedom accorded line in this formula that led to the balance being ultimately superseded around 1927 by his version of Constructivism. The final transformation was, however, only partially a result of the influence of international Constructivism. Klee had already, in his theories of the late 1910s, toyed with the idea of a separation of the pictorial elements.[3] Now,

194

during the Dessau years, line, color, tone, and plane were pulled apart from their cubistic matrix.

Subsequently, when Klee added them back together, he took care to preserve their uncompromised, elemental nature. His late, pure forms stand or float in an unqualified space. In this sense, they resemble the mainstream of a much younger generation. The Surrealists employed blank space, starting in the 1920s, as a setting for dream images,[4] and the Constructivists used such backgrounds to generate an empty, ideational volume.

The method of this study has been predominantly *un*-iconographic. I have provisionally set aside most of the problems and interest of Klee's rich content and attempted specifically to define Klee's formal means as thoroughly and accurately as possible. At this point, we may join the means to the ends and briefly consider the whole picture of Klee's position in the broader context of modern art.

One conclusion is that the formal-analytical method works well with Klee. His paintings yield key information by this approach. The method would work less well for Franz Marc and possibly some of Chagall, where structure is less obvious and consequently might be too diminished by a separation from content. Such strict application of formal analysis fails, to a measure, with Kandinsky and Mondrian as well—although for a different reason. Here, the elements of form themselves presuppose a content. Squares and circles are thought by these philosophical painters to have an inherent meaning. The two aspects of form and content cannot be pulled apart, even provisionally, as well and profitably as they can be with Klee.

The capacity for separation, for the rational breakdown of art into its factors, is present in Klee from the first. His earliest diaries are full of analysis and critique. When he came to study Cubism, this talent enabled him to abstract Cubist form wholesale, away from its original iconographic context. It enabled him subsequently to suspend even his most personal concerns, whenever this was demanded for the perfection of form. As instances, we recall the derailment of Klee's style of narrative in 1913, and the abandonment of his depictive line over the years 1915-1918. Both of these measures were taken in the interests of a balanced formal development.

Klee's flexibility on the form-content question goes a long way to define his unique position in his artistic generation. The looseness of his approach was very rare in the early years of this century when stylistic change was typically a traumatic, often dogmatic, affair, akin to a religious conversion. Over the long run, we may even note a certain discrepancy in the fact that Klee's content, historically considered, was usually out of phase with his form, even up to the

195

latest works of the 1930s, which still seem to speak the language of his beginnings, the ironic sentiments of the Jugendstil, of fin-de-siècle Symbolism. This style of meaning does not change much over the forty years of Klee's career. The pre-Cubist *Menacing Head* (Plate 2), the Cubist *Senecio* (Color Plate VII), and the post-Cubist *Mask of Fear* are really quite close in their ironic psychology.

And yet Klee's form does change, moving as we have seen from one stylistic pole to another. His symbolic content is embodied in a succession of timely styles, linear Jugendstil, Impressionism, Cubism, Constructivism, and abstraction. He used all the advanced forms of the day, without ever leaving his symbolic path to convert to their alien iconographies.

This set Klee off ultimately from most of his contemporaries. Among the German Expressionists, the Blue Rider artists for example, Klee is the most "Latinate." Instead of simply distorting forms to directly match his content, he weds his "northern" meaning to the most rational, even classical, of structures. Stating the converse of this, Klee's metaphysics and symbolism on the other hand distinguish him from the rest of the Cubist-Constructivist School, even though he surpasses many of the formalists in the rigor and purity of his structure.

In the late 1920s, Klee paralleled yet another school, the abstract Surrealists. Like them, he rejected the generality and approximation of Cubism for a more specific, concrete statement, and his art consequently has at times been confused with Surrealism. But unlike the younger artists, he did not respond to the Freudian crisis. He might deal, even more frequently than some Surrealists, with psychosexual appearance and meaning, but he never subscribed to the basic Surrealist premises that content was more important than form and that the ideal artist, driven by his unconscious, had control of neither structure nor poetry.

Klee's art thus lies outside of most standard definitions, challenging our usual generalizations. He borrowed the structural essence of most of the early modern movements while remaining true to his own beliefs. For the middle years of his career he was closely affiliated with the Cubist branch, finding its forms ideally suited to his purpose. The Cubist world of broken, shifting forms, of mysterious, half-revealed relationships, was most congenial to his style of intricate, referential symbol.

In the end, Klee apparently felt that no theory, no *a priori* doctrine, was binding on him when he faced the work at hand. Whatever elements might contribute to the work, amorphous or defined, arcane or popular, from the past or present, Klee fit with the sureness of the master craftsman into his tiny monument to creative insight. The student of Klee's art must constantly return to the single work, the blackboard where Klee teaches lessons about form and content that can never be fully comprehended in a history book.

196

NOTES

Frequently cited works have been abbreviated in the footnotes according to the following list. In all cases, complete publication information is given in the Selected Bibliography.

Diaries Klee, Paul. *The Diaries of Paul Klee, 1898-1918*. Edited, with an Introduction, by Felix Klee (1964).

Frühwerk Städtische Galerie im Lenbachhaus, München. *Paul Klee: Das Frühwerk: 1883-1922*. Exhibition catalogue (1979).

Glaesemer, *Handzeichnungen I* Glaesemer, Jürgen. *Kunstmuseum Bern: Paul Klee Handzeichnungen I: Kindheit bis 1920* (1973).

Kornfeld Kornfeld, Eberhard W. *Verzeichnis des graphischen Werkes von Paul Klee* (1963).

A Note on the Artist

1. My account here is drawn from the standard sources. The basic biography remains Will Grohmann's *Paul Klee* [1955]. Klee's *Diaries* cover the years 1898-1918. Felix Klee's *Paul Klee* (1962) is invaluable biographically, particularly for the post-diary years. Klee's family letters, edited by Felix Klee, have recently been published as Paul Klee, *Briefe an die Familie: 1893-1940*, Herausgegeben von Felix Klee (2 vols.; 1979). It has not been possible to assimilate all the new information from this source into my account, which was written several years before publication of the correspondence; but a few passages that bear directly on my discussion will be cited below. The collation of details from the letters with previous accounts, particularly those in the *Diaries*, will be a major task for Klee scholarship in the future. I must also note that the *Diaries* themselves have already been the subject of critical examination, in Christian Geelhaar's article "Journal intime oder Autobiographie?" in *Frühwerk*, pp. 246-260. Geelhaar has determined through textual and graphological study that "Diary III" (the manuscript volume with entries from June 1902 through March 1916), for example, was carefully edited and recopied by Klee no earlier than 1921 (pp. 251-252). This line of study has implications for the chronology of Klee's thought, and may for example shed light on the variable "density" of the *Diaries*, that is, on why some periods are reported in great detail, while others are passed over in near silence. Beyond underscoring below, in light of Geelhaar's discovery, the few anachronisms I had earlier noted, it has not seemed appropriate to attempt a reevaluation of the *Diary* source here; this too is a task for future scholarship.

Introduction

1. Will Grohmann, *Paul Klee* [1955]; Werner Haftmann, *The Mind and Work of Paul Klee* (1965); Max Huggler, *Paul Klee* (1969).

2. Paul Klee, *Pedagogical Sketchbook* (1953 ed.), pp. 58-60. See also Jürg Spiller, ed., *Paul*

Klee Notebooks: Volume I: The Thinking Eye (1961), pp. 389-391, for Klee's similar dynamic analysis of *Oscillating Balance* where the directional arrows, moreover, symbolize the physical forces of gravity and thrust.

Chapter 1

1. *Diaries*, p. 259, no. 899.

2. Klee's letters, like the *Diaries*, shed less immediate light on his sources than one might expect. A few letters of the ca. 1910-1914 period were published in the Staatliche Kunsthalle, Baden-Baden, *Der Frühe Klee*, exhibition catalogue (1964). In recent years, various other letters have appeared, particularly in the publications of Jürgen Glaesemer, Curator of the Collection of the Klee-Stiftung. The recently published Paul Klee, *Briefe an die Familie: 1893-1940*, Herausgegeben von Felix Klee (2 vols.: 1979), like the *Diaries*, offers comparatively little material for the 1911-1914 period. There are, for example, only two brief postcards to his wife from Tunisia (p. 784). Klee did not travel alone much, all told, during the period here under study; the early period of his long-distance courtship with Lily, and the years of wartime service are, by contrast, times of rich correspondence.

3. A number of scholars have devoted major work to Klee's early period, and I will refer to their writings in regard to specific sources below. Most of the early Klee sources discussed here, however, are the result of my own study carried out in 1969-1970, before the recent publications on the subject.

4. See, for example, four satirical *Fish* drawings illustrated in Hans. H. Hofstätter, "Symbolismus und Jugendstil im Frühwerk von Paul Klee," *Kunst in Hessen und am Mittelrhein*, V (1965), 97, 101, illus.; and the related print, dated May 1901 (Kornfeld, no.1).

5. *Virgin in the Tree* is Kornfeld no. 4. The Segantini source was first suggested in Leopold Zahn, *Paul Klee: Leben, Werk, Geist* (1920). Carola Giedion-Welcker, in *Paul Klee* (1952),

p. 13, agrees with these possibilities; and Hofstätter, "Jugendstil im Frühwerk," pp. 115-117, illustrates and discusses the Segantini connection at length. Segantini's *The Evil Mothers* was reproduced, I have found, as an illustration to an article on this artist in *Pan* (Berlin), I, no. 3 (September-October 1895), 193. It was supposed for a number of years that Klee had based this figure on Pisanello's drawing *Allegory of Luxury* (as suggested by Ruth S. Magurn and James Thrall Soby in Soby, *The Prints of Paul Klee* [1945], p. 4), but Kornfeld ("Einleitung," n.p.) and Marcel Franciscono ("Paul Klee's Italian Journey and the Classical Tradition," *Pantheon* XXXII, no. 1 [Winter 1974], 59, n. 36) have established more recently that Klee could not have known the Pisanello.

6. Compare, for example, the Klee drawing of an arm—closely related to *Virgin in the Tree*—of 1903 (illustrated and discussed in Glaesemer, *Handzeichnungen* I, pp. 111, 114, no. 279) with Hodler's *Spring*, 1901, Folkwang-Museum, Essen.

7. Klee expressed, for example, great admiration, in a letter of May 1902, for the major Hodler paintings, including *The Night*, which had just been acquired by the Kunstmuseum in Bern (Klee, *Briefe an die Familie*, pp. 234-235). A few months later, in November 1902, he commented on the general Hodler influence in a life drawing class he was attending (*Diaries*, p. 130, no. 456: "All Hodlerize more or less.").

8. Kornfeld, no. 15. Hofstätter, "Jungendstil im Frühwerk," pp. 109-110, illus. That Klee knew Lavater's work from his school days is indicated in marginalia in Klee's German literature school notebook of 1897, where (p. 23) by tiny comic heads Klee notes, "das ist Lavater . . . und das seine Frau." I am much indebted to Felix Klee for showing me his father's notebooks in early 1970. The Lavater image relationship reinforces my conjecture that the odd stippling technique of Klee's early etchings owes something to the near-mechanical engraving processes of the eighteenth century; though, to be sure, an eighteenth-century dot-and-loz-

enge pattern was intended to blend itself visually into the semblance of smooth tonality, while Klee's dots are seemingly exploited for their obtrusive and disagreeable suggestion of texture. Max Klinger's etchings may also relate here. Klee's textures are closely paralleled, to my own observation, in the etchings of the obscure Viennese *Jugendstil* artist of about this time, Josef von Divecky. Divecky's drawing style, like Klee's, appears to reflect the influence of Hodler.

9. Franciscono, "Klee's Italian Journey," pp. 56-57. Franciscono's other suggestions of Classical sources, such as the *Doryphoros* (p. 57) as a model for *The Hero with the Wing* (Kornfeld no. 16), are enlightening; and the thoughts he expresses (pp. 57-59) on the difficulties of source study for this period of Klee are relevant to our present survey.

10. *Diaries*, p. 158, no. 578.

11. Giedion-Welcker, *Klee*, pp. 14-15, illus. Hofstätter has found "imaginary portraits," generally similar, by William T. Horton, which appeared in the 1896 *Savoy* (Hofstätter, "Jugendstil im Frühwerk," p. 109, illus.); but they too most probably derive from Beardsley. Franciscono, by contrast, denies any Beardsley influence except possibly in the *Menacing Head* subject; he finds the form of the print closer to "late Antique portrait busts" (Franciscono, "Klee's Italian Journey," p. 57).

12. *The Early Work of Aubrey Beardsley*, prefatory note by H. C. Marillier (London: John Lane, 1899); *The Later Work of Aubrey Beardsley* (London: John Lane, The Bodley Head, 1912, first published November 1900; reprinted. October 1911.

13. There are other examples of general reference to Beardsley's line drawing style, particularly of facial features, as in Klee's glass picture *The Compress, Two Figures* of 1905; and in the more-well-known glass picture *Girl with a Doll* of the same year, which compares very closely with Beardsley's dwarf and monster types, for example, in *The Cave of Spleen* (*Late Beardsley*, p. 92, illus.). Both of the Klee glass pictures are illustrated as Plates 9 and 4,

respectively, in Jürgen Glaesemer, *Paul Klee: The Colored Works in the Kunstmuseum Bern* (Original German ed. 1976; English ed. 1979; all references here are to the latter).

14. Klee's paintings on the back of glass, *Hinterglasmalerei*, antedate Kandinsky's and Münter's use of the medium by several years. Münter dated their earliest *Hinterglasbilder* around 1908-1909 (Hans Konrad Roethel, *The Blue Rider* [1971], entries, pp. 146, 164, "Catalogue of the works . . . in the Municipal Gallery, Munich"). Klee's glass pictures are much less related to the folk art tradition than are those of his later friends. Kandinsky and Münter adopted not only the technique but also the bold forms and strong colors of their Bavarian folk prototypes, and Klee's *hinterglas* sgraffito line derives from drypoint and etching. Klee first hints at behind-the-glass work in June 1905 (*Diaries*, p. 175, no. 632) as a solution to a need voiced earlier (pp. 151-152, no. 561, ca. May 1904) for a linear technique less restrictive than intaglio to the free drawing of line. At first Klee experimented with photographic prints made from glass plates (p. 177, no. 639). The final form of the technique—essentially ground-sgraffito-backup color, to be seen through the unpainted side of the glass—is described in Spring 1906 (p. 198, no. 760).

15. *Late Beardsley*. The list of plates identifies this as an illustration to Theophile Gautier's romance "Mademoiselle de Maupin."

16. Illus., Glaesemer, *Handzeichnungen* I, p. 125. I am indebted to Frau Dr. Katalin von Walterskirchen for first pointing out to me the inscriptions and the evidence of the etching under the drawing. Jürgen Glaesemer in his "Die Kritik des Normalweibes: Zu Form und Inhalt im Frühwerk von Paul Klee," in *Paul Klee: Das graphische und plastische Werk* (1975), pp. 38-46, proposes that Felicien Rops' lithograph *La femme au cochon* of 1896 was Klee's chief source for the *Dame—Portrait of a Sentimental Lady* image. Glaesemer (whose research in this postdates my own) has convincingly reconstructed the lost state of Klee's *Dame* etching, and emphasizes in his article

the ethical-satirical nature of Klee's content. From the evidence, however, it appears to me that the case for the Rops source is no stronger than for the Beardsley.

17. *Diaries*, p. 158, no. 578, quoted above.

18. Ibid., p. 151, no. 561. The entry goes on to express dissatisfaction with the restrictions of etching technique.

19. The "stone" feet aspect of *Dame* greatly resembles another Klee print of summer 1904, *Pessimistic Symbolism of the Mountains (Allegory)* (Kornfeld no. 11), which iconographically is one of Klee's closest approaches to Hodler.

20. *Diaries*, p. 187, no. 693.

21. In Klee's oeuvre catalogue, the figure is specified as a half-nude (*Halbakt*) (Glaesemer, *Colored Works*, pp. 62-63, illus. in color). The complete figure, except for orange hair, is colored blue, thus obscuring the contrast of half-nudity.

22. *Diaries*, p. 193, no. 743.

23. Ibid., p. 158, no. 578.

24. Ibid., p. 169, no. 602.

25. Ibid., p. 202, no. 765. The book in all probability was Valerian von Loga's *Francisco de Goya*, the earliest of several books on Goya by this author, published in Berlin, 1903.

26. *Diaries*, p. 204, no. 767-768.

27. Klee, *Briefe an die Familie*, p. 658.

28. *Diaries*, pp. 168-169, no. 602; and p. 175, no. 632: June 1905, "So now the motto is, 'Let there be light.' Thus I glide slowly over into the new world of tonalities."

29. Mark Rosenthal, "Der Held mit dem Flügel," in *Paul Klee: Das graphische und plastische Werk* (1975), pp. 30-32; also Rosenthal, "The Myth of Flight in the Art of Paul Klee," *Arts Magazine* 55, no. 1 (September 1980), pp. 90-92; and Franciscono, "Klee's Italian Journey," p. 56. *Hero with the Wing* is Kornfeld no. 16.

30. Illus., *Diaries*, p. 209.

31. Kornfeld, nos. 20, 21, illus. In the 1907 diary passage referring to *reservage* etchings, Klee does not however mention Goya (*Diaries*, p. 218, no. 801).

32. Illus. in color in Glaesemer, *Colored Works*, p. 67.

33. The version of *Boy in Fur Coat*, illustrated in Will Grohmann, *Paul Klee Drawings* (1960), p. 55, and the wash drawing *The Friends*, in the collection of The Museum of Modern Art, are other examples of this date and stylistic group.

34. *Diaries*, pp. 259-260, no. 899; quoted in part above.

35. Ibid., pp. 179-181, nos. 644-645/649.

36. Ibid., pp. 197-198, no. 758.

37. Ibid., p. 211, no. 785.

38. Ibid., p. 229, no. 843.

39. Illus., Kornfeld no. 23.

40. Illus., Grohmann, *Klee Drawings*, p. 57.

41. *Diaries*, p. 244, no. 874. Glaesemer, *Handzeichnungen I*, p. 203, no. 459, illustrates *Waitress behind a Table*, along with several other drawings of the light-form series.

42. *Diaries*, p. 229, no. 834.

43. Ibid., p. 244, no. 874.

44. *Diaries*, p. 192, no. 733; and Klee, *Briefe an die Familie*, p. 556.

45. *Diaries*, p. 236, no. 853, and p. 240, no. 864.

46. Ibid., p. 223, nos. 813a and 816.

47. Julius Meier-Graefe, *Impressionisten* (1907). Charles W. Haxthausen, in "Paul Klee: The Formative Years" (1976; Garland ed., 1981; the latter ed. is cited here), pp. 249-250, states that Klee was given a copy of *Impressionisten* by Lily on his birthday in December 1908, and that the book is still in the collection of Felix Klee. Haxthausen (whose early dissertation research was carried out contemporaneously but separate from my own) states his view as well that Klee could have seen the 1907 book before receiving his own copy. Haxthausen presents (pp. 248-254) an excellent discussion of the influence of Meier-Graefe's critical ideas on Klee at this time.

48. *Diaries*, p. 216, no. 798.

49. Ibid.

50. Klee, *Briefe an die Familie*, p. 713, letter of July 4, 1909, reporting the gift of Ensor's *Squelettes voulant se chauffer*, from Ernst

Sonderegger, Klee's friend who had first introduced him to Ensor as well as Van Gogh.

51. *Diaries*, p. 220, "1908."

52. Ibid., p. 224, no. 816.

53. Illus., Glaesemer, *Handzeichnungen* I, p. 176.

54. Meier-Graefe, *Impressionisten*, p. 121. Compare to Klee's drawing "Sheep in the Fold," 1908 (illus. in Will Grohmann, *Paul Klee*, [1955], p. 115), and to the glass painting *Sheep Herd at Rest* (illus. in *Frühwerk*, p. 340, no. 101).

55. *Dr. Gachet* has been widely reproduced, for example in Wassily Kandinsky and Franz Marc, eds., *Der Blaue Reiter* (1912; documentary ed., ed. by Klaus Lankheit, 1965), p. 204. (All of my citations are to this 1965 German edition.) I have not, however, been able to narrow down a specific source through which Klee could have known the *Dr. Gachet* in 1911. It is not illustrated in Meier-Graefe, *Impressionisten*.

56. As with the *Dr. Gachet*, it is difficult to establish which Van Gogh self-portraits Klee could have known. Haxthausen points out ("Klee, Formative Years," p. 269) that an 1888 *Self-Portrait* was reproduced in Meier-Graefe's *Impressionisten* (p. 145), and he compares it to Klee's self-portrait drawing of 1908, *Young Man with a Goatee* (collection Felix Klee). In many respects, this Van Gogh could have served as a model for the 1911 *Self-Portrait* as well. See Haxthausen, pp. 244-247, for interesting observations on Klee's relationship to Van Gogh's published *Letters*.

57. *Diaries*, p. 260, no. 899.

58. Ibid. In the same passage, Klee mentions Van Gogh "in historical retrospect—how he came without a break from Impressionism and yet created novelty."

59. Ibid. p. 197, no. 757 (February 1906).

60. Klee's study of printed illustrations dates back to his gymnasium years. It has long been surmised that many of his precocious school-age drawings were copied from popular magazines. Following marginal notations—presumably made by Klee himself—on some of these drawings in the Paul Klee-Stiftung, I located (in 1969-1970) a number of specific sources from the travel and art magazine *Von Fels zum Meer*, published in Stuttgart from the early 1880s. Subsequently Glaesemer studied these and other similar sources independently, and published them in *Handzeichnungen* I, pp. 21-24. The reader is referred to his excellent illustrations. What makes these early sources of more than documentary interest is Klee's great fidelity to the originals, not only in the forms of the drawings but in the minutiae of technique. The sharpness and regularity of their tonal hatchings was carefully facsimiled by Klee with the pen. It is significant, I think, that even during his early school days Klee was aware of the means by which images are produced and reproduced and that his interest in the illustrations seems as much technical as image-related. This objectivity, I suggest, is unusual for children's copy work. These early copies anticipate Klee's later study after reproductions and underscore his seemingly constant awareness of the means of a picture as on a par with the image. (I am again indebted to Fr. Dr. von Walterskirchen for making the early Sketchbooks, still unpublished at the time, available to me for study in the Klee-Stiftung.)

61. *Diaries*, p. 197, no. 757.

62. Paul Klee, "Die Ausstellung des Modernen Bundes im Kunsthaus Zurich," *Die Alpen* (Bern), 12 (August 1912), 697-698 (my translation). This essay was recently reprinted in *Paul Klee, Schriften, Rezensionen und Aufsätze*, Herausgegeben von Christian Geelhaar (1976), pp. 105-111. My references are to the original periodical.

63. *Diaries*, p. 123, no. 425.

64. Ibid., p. 175, no. 632.

65. Ibid., p. 211, no. 784.

66. Ibid., p. 221, no. 811.

67. Ibid., p. 232, no. 842.

68. Ibid., p. 244, no. 873.

Chapter 2

1. *Diaries*, pp. 264-267, nos. 901-907.

2. For Klee's first hesitant contacts with the

dealers Thannhauser and Brackl, see *Diaries*, pp. 256-258, no. 896.

3. Ibid., p. 265, no. 903. In 1930, Kandinsky said of these early meetings, "My neighbor in Schwabing was Paul Klee. At the time he was still 'small fry.' But I can say with justifiable pride that in his tiny drawings of that period (he was not yet painting) I already sensed the great Klee of the future" (from *Das Kunstblatt*, vol. 14 [1930], p. 57, quoted in English in Hans Konrad Roethel, *The Blue Rider* [1971], p. 33).

4. Klee's work as an art and music critic, heretofore little known, has been assembled and reprinted by Christian Geelhaar in Paul Klee, *Schriften: Rezensionen und Aufsätze*, Herausgegeben von Christian Geelhaar (1976). My citations, however, are to the original editions.

5. *Diaries*, p. 266, no. 905. Robert Goldwater in *Primitivism in Modern Art* (rev. ed., 1967), pp. 192-204, discusses this passage in the context of Klee's own sources in children's art. It is, in the 1911 context, a restatement of the more generalized Blue Rider primitivizing aesthetic (ibid., pp. 125-140).

6. *Diaries*, p. 267, no. 907.

7. My material on the NKVM is drawn from the authoritative accounts in Peter Selz, *German Expressionist Painting* (1957), pp. 184-198; Lothar-Günther Buchheim, *Der Blaue Reiter und die Neue Künstlervereinigung München* (1959); and Roethel, *Blue Rider*, which makes available new details on the two related groups; so Otto Fischer, *Das Neue Bild: Veröffentlichung der Neuen Künstlervereinigung München* (1912).

8. Donald E. Gordon, *Modern Art Exhibitions: 1900-1916*, 2 vols. (1974), vol. 1, pp. 78, 179-181; vol. 2, pp. 422-424, reproduces the illustrated catalogue of the Modern Galerie, München, Neue Künstlervereinigung, München, E.V., II. Ausstellung, Turnus 1910-1911 (1-14 September 1910).

9. John Golding, *Cubism: A History and an Analysis: 1907-1914* (rev. American ed., 1968), pp. 23-24, 146.

10. Ibid., p. 28.

11. Ibid., pp. 24, 150, 151.

12. The drawing is in the Art Institute of Chicago and is widely reproduced, as in Selz, *Expressionist*, pl. 75.

13. Klee, *Diaries*, pp. 247-249, no. 881.

14. The NKVM Exhibition opened December 4, and the Blue Rider, December 18, 1911. *Die erste Ausstellung der Redaktion Der Blaue Reiter*, exhibition catalogue (1911-1912). The basic discussions of the Blue Rider exhibitions appear in Selz, *Expressionist*, pp. 206-214, and Buchheim, *Blaue Reiter*, pp. 48-62, 70. Klaus Lankheit's "Wissenschaftlicher Anhang," pp. 253ff., in the 1965 reprint edition of Kandinsky and Marc, eds., *Der Blaue Reiter*, is particularly useful in its methodical recording of facts. Roethel's recent *Blue Rider* has a wealth of details on the artists and specific paintings.

15. Lankheit, "Anhang," p. 259, quotes the Kandinsky letter of June 19, 1911, which sets forth the first plans for the Almanac. Also Gustav Vriesen, *August Macke* (2d rev. ed., 1957), p. 88.

16. *Erste Ausstellung Der Blaue Reiter*, nos. 15-19. Pierre Francastel, ed., *Robert Delaunay: Du Cubisme a L'Art Abstrait* (1957), p. 362, in Guy Habasque, "Catalogue de L'Oeuvre de Robert Delaunay" (which comprises pp. 243-408 of the volume). Habasque oeuvre numbers, such as "H.A. 100," will be used to identify Delaunay paintings, and Habasque's catalogue hereinafter will be cited as Habasque, "Catalogue."

17. Lankheit, "Anhang," pp. 309-312, facsimile of early lists of contents by Kandinsky and Macke.

18. The canvas was destroyed in World War II.

19. Illus., Kandinsky and Marc, *Der Blaue Reiter*, p. 98.

20. Reproduced here is the *Eiffel Tower*, 1910 (H.A. 78), Solomon R. Guggenheim Museum, which is virtually identical to the lost *Eiffel Tower* (H.A. 77) in both composition and detail.

21. *La Ville No. 2* (H.A. 82) is in the collection of the Musée National d'Art Moderne, Paris; *The City* (H.A. 87, illus. here as Plate 13) is in the collection of the Solomon R. Guggenheim Museum, New York. Angelica Zander Rudenstine, in *The Guggenheim Museum*

Collection: Paintings 1880-1945 (2 vols., 1976), pp. 96-98, convincingly argues that of these two similar *City*s, only the Paris version appeared in the first Blue Rider exhibition; and that the second *City* in the catalogue referred to a now-lost version, rather than to the Guggenheim picture. This revises Habasque's assumption, which I earlier followed, that the Paris and Guggenheim versions appeared together. They are, nonetheless, nearly identical, and Plate 13 can serve for both in our present examination of Delaunay's development.

22. Selz, *Expressionist*, p. 209, briefly discusses this work; *Erste Ausstellung Der Blaue Reiter*, no. 12, illus.

23. Gordon, *Modern Art Exhibitions*, vol. 2, pp. 422-423. My illustration is taken from Kandinsky and Marc, *Der Blaue Reiter*, p. 43.

24. Selz, *Expressionist*, pp. 203, 207-208, discusses this Marc, and Macke's *Storm* painting, in the exhibition context. The Marc is illustrated, ibid., p. 81; the Macke in Vriesen, *Macke*, p. 209. *Erste Ausstellung der Blaue Reiter*, nos. 30 (Marc's *Yellow Cow*), 27 (Macke's *Storm*), 28 (Macke's *Indians*).

25. *Erste Ausstellung Der Blaue Reiter*, no. 24; illus., Kandinsky and Marc, eds., *Der Blaue Reiter*, p. 203.

26. The obvious differences between Kandinsky's turbulently romantic subjects, and the still-life subjects of French Cubists, hardly need comment at this point.

27. Wassily Kandinsky, *Über das Geistige in der Kunst* [*Concerning the Spiritual in Art*] (1912; rev. English ed., 1947). My references will be to this English edition.

28. Kandinsky, *Concerning the Spiritual*, p. 93 ("Foreword to the Second German Edition"); Lankheit, "Anhang," p. 267, gives the earlier appearance date.

29. *Diaries*, p. 266, no. 905. The article appeared in the January 1912 number of *Die Alpen*.

30. Kandinsky, *Concerning the Spiritual*, p. 73.

31. Ibid., p. 36; p. 49, n. 8, for Cézanne's abstract composition.

32. Ibid., pp. 67-68, 70-71.

33. Ibid., pp. 48, 50.

34. Ibid., p. 67.

35. Ibid., p. 54.

36. Ibid., p. 73.

37. Ibid., p. 93; Kandinsky, in his foreword, mentions that one part of the book dates from 1910, and another was written in 1911, without being specific. Exact textual criticism is of course beyond our present purposes.

38. All quoted passages are from ibid., pp. 38-39.

39. Lankheit, "Anhang," p. 262.

40. Hans Goltz Kunsthandlung, München, *Die zweite Ausstellung der Redaktion der Blaue Reiter: Schwarz-Weiss*, exhibition catalogue (1912). The lack of specific catalogue dates seemingly has given rise to different opinions about the time of the exhibition. Selz (*Expressionist*, p. 212) and Lankheit ("Anhang," p. 257) suggest March; Roethel (*Blue Rider*, pp. 11, 20) gives both January and March-April; Edward F. Fry (*Cubism* [1966], p. 184) gives February; and Buchheim (*Blaue Reiter*, pp. 70, 314) gives an opening date of February 12, 1912. Gordon (*Modern Art Exhibitions*, vol. 1, p. 86) gives the general date as February, and also notes that August Macke and Franz Marc, *August Macke, Franz Marc Briefwechsel* (1964), p. 105, confirms an "exhibition opening prior to 23 Feb."

41. Selz, *Expressionist*, pp. 212-214; Buchheim, *Blaue Reiter*, p. 70.

42. Kandinsky, in Klaus Lankheit, ed., *Franz Marc im Urteil seiner Zeit* (1960), p. 49 (my translation).

43. Ibid., p. 50.

44. Lankheit, "Anhang," pp. 264-265, dates Marc's Berlin journey around New Year's, 1911-1912, discusses Marc's enthusiasm over his "discovery" of Die Brücke, and Kandinsky's initial (letter of February 2) reservations regarding their significance vis-à-vis the planned Almanac.

45. *Diaries*, pp. 274-275, no. 915. The periodical was *Die Alpen*.

46. Kunstmuseum Winterthur, *Kubismus Futurismus Orphismus in der Schweizer Malerei*, exhibition catalogue (1970), contains the essential "Daten zum 'Kubismus' in der Schweiz," by Hans Christoph von Tavel. Much

of relevance for Klee is to be expected of von Tavel's research in this area. I have been able to draw somewhat on his "Daten," and on my experience studying this exhibition, which included works by Lüthy, Gimmi, Moilliet, Itten, and others.

47. For Klee's further mention of the Moderner Bund and Arp, *Diaries*, p. 272, no. 913, p. 276, no. 917.

48. Goltz Kunsthandlung, *Zweite Ausstellung Schwarz-Weiss*, illus. The two copies of the Goltz Kunsthandlung, *Zweite Ausstellung Schwarz-Weiss*, which I have consulted, in the libraries of the Metropolitan Museum of Art and the Museum of Modern Art, are slightly different. Only the Metropolitan Museum version—possibly a later printing—has the illustrations here referred to; the Metropolitan version has as well the addendum entry: "12a, Konstruktions-Zeichnung, Robert Delaunay." During the 1911-1912 winter, Lüthy had established his own connections with Paris, working there from time to time (Kunstmuseum Winterthur, *Kubismus in Schweizer Malerei*, "Oscar Lüthy"). This stage of Klee's drawing development will be further discussed in Chapter 4.

49. Goltz Kunsthandlung, *Zweite Ausstellung Schwarz-Weiss*, no. 257: Rahmen mit Radierungen und Seiten aus dem Werke "Saint Matorel." Preis des Buches auf Japan 150 Fr., auf Holl. B. 75 Fr.

50. Bernhard Geiser, *Picasso Peintre-Graveur: Catalogue Illustré de L'oeuvre Gravé et Lithographié 1899-1931* (1933), title page of *Saint Matorel* and nos. 23-26.

51. For the bas-relief simile and the current replacement by "high Analytical Cubism," of the older term "Hermetic Cubism," I am indebted to several lectures on modernist painting by Professor William Rubin. A succinct statement of this area of his Cubist analysis appears in his *Picasso in the Collection of the Museum of Modern Art* (1972), pp. 68-70. I must also refer at this point to the background provided in Robert Rosenblum's second chapter, "Picasso and Braque, 1909-11," in *Cubism and Twentieth-Century Art* (1960). Winthrop Judkins' pioneering article, "Towards a Reinterpretation of Cubism," *The Art Bulletin*, XXX (December 1948), 270-278, has influenced my analytical method perhaps more than any other earlier writing on the subject.

52. *Diaries*, p. 267, no. 908; p. 270, no. 910.

53. For Klee on El Greco: Paul Klee, "München (Literature und Kunst des Auslandes)," *Die Alpen* (Bern), VI (November 1911), 184-185.

54. Golding, *Cubism*, pp. 153, 159.

55. Ibid., pp. 96-97. *Société des Artistes Indépendants, 28e Exposition*, Quai d'Orsay, Pont d'Alma, Paris, du 20 Mars au 16 Mai inclus, 1912; as reprinted in Gordon, *Modern Art Exhibitions*, vol. 1, p. 87; vol. 2, pp. 558-562. Gordon gives selected entries. For Léger and Gris, only nonspecific titles are listed, which presumably include those works named in such other sources as Golding.

56. Rosenblum, *Cubism*, p. 308.

57. Kandinsky of course distinguished in his work of this period among "Impressions," "Improvisations," and "Compositions," essentially by the degree of formality (Kandinsky, *Concerning the Spiritual*, p.77).

58. Illus., Golding, *Cubism*, pl. 69B.

59. Ibid., pp. 156-157; Gustav Vriesen and Max Imdahl, *Robert Delaunay: Light and Color* (1967), pp. 40-42. As Imdahl's contribution to the book is an essay (pp. 71-80) which does not concern us here, his name will be omitted from future references.

60. Habasque, "Catalogue," p. 362.

61. Vriesen, *Delaunay*, p. 40.

62. Klee may have acquired a copy of the catalogue of the Barbazanges exhibition which contained, for example, an illustration of *The Towers of Laon* (Habasque, "Catalogue," p. 263).

63. Ibid., p. 363.

64. That Klee helped to organize the exhibition remains, however, a supposition. The fact that works by Picasso, Friesz, Herbin, and Matisse had been included in the first Moderner Bund exhibition in Lucerne, December 1911, establishes that the small Swiss group already had effective Parisian contacts (von Tavel, "Daten," in Kunstmuseum Winterthur, *Kubismus in Schweitzer Malerei*).

65. Golding, *Cubism*, p. 27; and Douglas Cooper, *The Cubist Epoch* (1970), pp. 61-62, for discussions of this "self isolation" (Cooper) of the two Cubist leaders.

66. In response to my inquiry, Mr. Kahnweiler stated that he could shed no new light on the probable contents of his gallery at the time of Klee's 1912 visit (letter to the author, December 28, 1974).

67. Braque's *Portuguese* is in the Kunstmuseum, Basel, and Picasso's *Clarinet Player* in the collection of Douglas Cooper. Both are well known and widely reproduced.

68. Rubin, *Picasso in the M.O.M.A.*, p. 72, for a discussion of this innovation in Picasso and Braque.

69. Golding, *Cubism*, p. 159.

70. Ibid., p. 150; Kandinsky and Marc, *Der Blaue Reiter*, p. 127. *L'Abondance* is in the Gemeente Museum, The Hague.

71. Between April and July, Le Fauconnier participated in exhibitions in Barcelona, Hagen, and Zurich (the Moderner Bund) (Gordon, *Modern Art Exhibitions*, vol. 2, pp. 578, 602, and 607). Most of the works he showed were landscapes, and *L'Abondance* appeared in none of these three exhibitions.

72. Paul Klee, "Ausstellung des Modernen Bundes," p. 701 (my translation).

Chapter 3

1. *Diaries*, pp. 272-274, nos. 913-914.

2. Klaus Lankheit, in his "Anhang" to the 1965 edition of Kandinsky and Marc, eds., *Der Blaue Reiter*, recounts all the details of the planning and publication (by Piper) of the volume. The mid-May publication date is given p. 268. All my references to texts and illustrations, unless otherwise noted, will be to this 1965 German edition of *Der Blaue Reiter*, which will be abbreviated henceforth in this chapter as *DBR*. Translations, as noted here, are my own. The general reader may also wish to consult a more recent, 1974, English translation of the complete edition of *The Blue Rider*. This English version, however, is paginated differently from the German edition referred to here.

3. See Lankheit, "Anhang," pp. 288-292, for a detailed discussion of the illustration choices.

4. Both were from Koehler's collection; the latter is now considered to be from the school of El Greco (Lankheit, "Anhang," p. 344).

5. Marc, "Geistige Güter," *DBR*, p. 23.

6. Kandinsky, "Uber die Formfrage," *DBR*, p. 168.

7. Kandinsky, "Uber die Formfrage," *DBR*, pp. 155-156; see O. K. Werckmeister, "The Issue of Childhood in the Art of Paul Klee," *Arts Magazine* 52, no. 1 (September 1972), pp. 138-151, for a discussion of these illustrations in relation to controversial childhood art theory.

8. *DBR*, pp. 77-86; the translation from French to German was by Marc. The English translation in Edward F. Fry, *Cubism* [1966], pp. 70-73, will be referred to for this discussion. It is possible that Allard was asked for this article by Le Fauconnier, with whom Kandinsky had been in correspondence over the previous autumn (see Lankheit, "Anhang," pp. 260, 262).

9. Fry, *Cubism*, pp. 62-63 (an Allard text of 1911).

10. Ibid., p. 71 (Allard).

11. Ibid. Goethe is quoted (*DBR*, p. 87, immediately following Allard) on the lack of an accepted theory in painting, when compared to music.

12. Fry, *Cubism*, p. 72 (Allard).

13. Ibid., pp. 70-71 (Allard).

14. Ibid., p. 72 (Allard).

15. Ibid., pp. 72-73 (Allard).

16. *DBR*, p. 188 (my translation).

17. Ibid., pp. 132-182. The English translation by Kenneth Lindsay which appears in Herschel B. Chipp, *Theories of Modern Art* (1968), pp. 155-170, will be referred to.

18. Chipp, *Theories*, p.168 (Kandinsky).

19. Ibid.

20. Ibid.

21. *DBR*, p. 31 (my translation—unless otherwise noted all translations from *DBR*, below, are my own). It is not clear from the context that Marc's burst is not aimed at some unnamed German imitators rather than at the Cubists themselves.

22. *DBR*, pp. 49-50

23. *DBR*, p. 97.

24. Ibid., p. 100.

25. *DBR*, pp. 100-102. In discussing a "first" and "second" *City*, von Busse refers to the two versions in the first Blue Rider exhibition: *The City No. 2* (H.A. 82, the Paris version), and an earlier probably 1909 version (H.A. 72) which was purchased at the exhibition by Jawlensky, but is now lost (see Angelica Zander Rudenstine, *The Guggenheim Museum Collection: Paintings 1880-1945* [2 vols., 1976], pp. 85-87, 96-97, for a discussion of the various *City* versions).

26. Paul Klee, "Die Ausstellung des Modernen Bundes im Kunsthaus Zürich," *Die Alpen* (Bern), VI (August 1912), 696-704. All translations here from this article are my own.

27. For a typically minimal appraisal of Klee's review, see Gualtieri di San Lazzaro, Klee (1957), pp. 70-73. As an exception in the literature, Felix Klee reprinted in a French translation the central portion of Paul Klee's review in Felix Klee, *Paul Klee par lui-même* (1963), pp. 138-140. Felix Klee also reproduced (ibid., opp. p. 137), exceptionally, the Delaunay *Fenêtre* most relevant for Paul Klee (here Plate 17). More recently, however, the full text of Klee's review has been reprinted in *Paul Klee, Schriften: Rezensionen und Aufsätze*, Herausgegeben von Christian Geelhaar (1976), pp. 105-111.

28. Paul Klee, "Ausstellung des Modernen Bundes," p. 701.

29. Ibid., pp. 697-698.

30. Ibid., p. 698.

31. Ibid.

32. Ibid.

33. Ibid., p. 699.

34. Fry, *Cubism*, p. 71 (Allard).

35. Paul Klee, "Ausstellung des Modernen Bundes," p. 699.

36. Ibid., p. 700.

37. Delaunay's *Les Fenêtres sur La Ville, 1re partie, 2e motif* (here Plate 17) was illustrated in an album of reproductions issued on the occasion of the Moderner Bund exhibition (Habasque, "Catalogue," p. 265). As a participating artist and publicist-critic, Klee would most likely have had a copy, and this would have prolonged his opportunity for further study of Delaunay's development. To date, however, it has not been possible to trace Klee's ownership of this album. Felix Klee, who has begun to catalogue his father's library, told me that he had not so far found record of this Delaunay reproduction in the legacy (letter to the author, March 15, 1973).

38. Paul Klee, "Ausstellung des Modernen Bundes," p. 703.

39. Robert Delaunay, "Uber das Licht," trans. by Paul Klee, *Der Sturm* (Berlin), ed. by Herwarth Walden, III, nos. 144-145 (January 1913), 255-256. Vriesen, *Delaunay*, pp. 6-9, gives a facsimile of Delaunay's manuscript and an English translation. I rely here on the translation in Chipp, *Theories*, pp. 319-320, as the more literal.

40. *Diaries*, p. 274, no. 914.

41. Vriesen, *Delaunay*, pp. 52, 54, and n62; a Klee letter to Delaunay concerning the translation is dated December 30, 1912.

42. The history of these essays and their textual variants, along with documentation and discussion of Apollinaire's closely related writings from this period, are given in Francastel, *Robert Delaunay Du Cubisme*, pp. 144-166.

43. Chipp, *Theories*, pp. 319-320 (Delaunay).

44. Francastel, *Robert Delaunay Du Cubisme*, p. 178, dated 1912 (my translation).

45. *Diaries*, pp. 274-276, nos. 914-916.

46. Der Sturm, Wochenschrift (and Gallery), Berlin, *Zweite Ausstellung: Futuristen*, exhibition catalogue (April 12—May 15, 1912); and Joshua C. Taylor, *Futurism* (1961), pp. 41-54, 122 (chronology).

47. Taylor, *Futurism*, p. 122. Donald E. Gordon, *Modern Art Exhibitions: 1900-1916*, 2 vols. (1974), vol. 1, pp. 89, 231; vol. 2, pp. 609-610, reprints the catalogue of this *Futuristen Wanderausstellung*, circulated under the sponsorship of the *Zeitschrift Der Sturm*. Although Munich is not listed among the four cities to which this exhibition traveled, during August-December 1912, there is no doubt that this is the exhibition that Klee discusses. Munich was obviously added to the exhibition schedule at

the last minute. The catalogue contained Marinetti's "Manifest des Futurismus," and trilingual entries.

48. Der Sturm, *Zweite Ausstellung: Futuristen*, pp. 3-9, "Manifest des Futurismus"; pp. 10-22, "Die Aussteller an das Publikum"; pp. 30-39, "Manifest der Futuristen."

49. *Diaries*, p. 275, no. 916. Klee's quotation from the manifestoes appears to be a paraphrase of a passage in "The Exhibitors to the Public," referring to Boccioni's painting *The Noise of the Street Penetrates the House* (see also Taylor, *Futurism*, p. 128, and note).

50. Taylor, *Futurism*, p. 128, "Exhibitors to the Public."

51. Fry, *Cubism*, p. 72 (Allard).

52. My thanks to Gert Schiff who first pointed out to me the full range of implication in the "Holy Laocoön" remark.

53. Paul Klee, "Ausstellung des Modernen Bundes," p. 700.

54. Illus., Douglas Cooper, *The Cubist Epoch* (1970), p. 170.

Chapter 4

1. Illus. Kornfeld no. 37.

2. The first drawing mentioned illus. in Eberhard W. Kornfeld, *Paul Klee: Bern and Surroundings: Watercolors and Drawings, 1897-1915* (1962), p. 15; the second in Hans Konrad Roethel, *Klee in München* (1971), p. 89.

3. In the original drawings for these illustrations, in the Klee-Stiftung, the borders are indicated by pencil lines which "drop out" and do not appear in the linecut reproduction.

4. Hans Goltz Kunsthandlung, München, *Die zweite Ausstellung der Redaktion der Blaue Reiter: Schwarz-Weiss*, exhibition catalogue (1912), no. 106, illus.; Wassily Kandinsky and Franz Marc, eds., *Der Blaue Reiter* (1965 ed.), p. 197, illus.

5. Klee's *Two Ladies*, 1911 (illus. in Will Grohmann, *Paul Klee* [1955], p. 130), shows yet another type of pseudo-Cubism. Done in the line and wash technique, this drawing has a passage representing the interlaced back of an openwork chair, which could be, at first, mistaken for Cubism.

6. Illus., Glaesemer, *Handzeichnungen I*, p. 201.

7. *Diaries*, p. 244, no. 874.

8. Donald E. Gordon, *Modern Art Exhibitions: 1900-1916* (2 vols., 1974), vol. 2, p. 609. The dating of much of Boccioni's work is problematic; but Gordon's compilation first lists the appearance of *Materia* in an exhibition held May 18—June 15, 1913, in Rotterdam (ibid., vol. 1, p. 96; vol. 2, p. 722); and the appearance of *Anti-Graceful* in a one-man sculpture exhibition of June 20—July 16, 1913, in the Galerie La Boëtie, Paris (ibid., vol. 1, p. 96; vol. 2, p. 724). There is therefore little possibility that Klee could have seen these works before doing his own drawings.

9. *Diaries*, p.258, no. 897 (Spring 1911).

10. Will Grohmann, *Paul Klee Drawings* (1960), p. 20.

11. The sticklike proportions prompted Carola Giedion-Welcker to compare these Klees, very aptly, with Martin Disteli's insect-comedy illustrations of the mid-nineteenth century (Carola Giedion-Welcker, *Paul Klee* (1952), p. 25, and illus. 16b).

12. Illus., Glaesemer, *Handzeichnungen I*, p. 206. A large number of strap-figure drawings of 1912 are compiled and reproduced in the appendix of Kornfeld.

13. Illustrated, for example, in Felix Klee, *Paul Klee* (1962), pp. 120-124.

14. James Smith Pierce, "Paul Klee and Primitive Art" (Ph.D. dissertation, Harvard University, 1961), pp. 31-36.

15. Ibid., pp. 35-36. *Battle Scene from the Comic Opera Fantasy "The Seafarer,"* illus. in Grohmann, *Klee*, p. 195; *A Girl's Adventure* illus. in Herbert Read, *Paul Klee* (1960), p. 130.

16. Pierce, "Klee and Primitive Art," pp. 33-34.

17. Ibid., p. 36. A number of Egyptian shadow-play figures were reproduced in *Der Blaue Reiter*.

18. Margaret Plant, in her recent *Paul Klee: Faces and Figures* (1978), appears to accept the idea that the lines in *Harlequinade* are strings

(p. 47). Her chapter 3, "Acrobat, Dancer and Clown," is an interesting survey of a whole constellation of ideas about marionette figures, with Klee and his contemporaries.

19. For two other examples, see Glaesemer, *Handzeichnungen I*, p. 199, no. 444, a sketch for Candide, and p. 208, no. 476, *The Expectant Ones*.

20. With regard to dating Klee's works within a year, the following matter should be noted. Klee's drawings and paintings have code numbers, along with their dates, both on their mountings and in Klee's carefully kept *oeuvre* catalogue. *An Uncanny Moment* for example is 1912.127. The *oeuvre* numbers are not assigned chronologically, and are seldom a reliable guide to intrayear chronology. They were probably inscribed by Klee at various cataloguing sessions, presumably toward the end of the year. They do not describe a true stylistic series, but at most indicate at times small stylistic groupings within the year. Needless to say, the *oeuvre* numbers, so systematic and at the same time so confusing, are a topic of constant discussion among Klee scholars.

21. Pierce, in "Klee and Primitive Art," pp. 137-139, also makes this point about this drawing.

22. Illus., John Golding, *Cubism* (1968), pl. 69B.

23. Illus., Wassily Kandinsky and Franz Marc, eds., *Der Blaue Reiter* (1965, ed.), p. 127.

24. Gordon, *Modern Art Exhibitions*, vol. 2, p. 559, for Chagall's entries in the 1912 Indépendants. None of the three paintings (also identified in Franz Meyer, *Marc Chagall* [1963], p. 153) is close in form to *Temptation*. *Temptation* was shown in the Indépendants of 1913.

25. A typical general parallelism between Klee and Chagall is given, for example, in Robert Rosenblum, *Cubism and Twentieth-Century Art* (1960), chap. 11.

26. More direct relationships, between Chagall's painting and works by Klee, will be proposed below, for ca. 1919 and the early 1920s.

27. See the recent thorough account of Klee's relationship with Kubin in Jürgen Glaesemer, "Paul Klee's persönliche und künstlerische Be-

gegnung mit Alfred Kubin," in *Frühwerk*, pp. 63-77. This article reprints Klee's letters to Kubin (pp. 78-97) and reproduces as well the collection Kubin built up of Klee drawings. Glaesemer concludes (pp. 65-67) that Klee influenced Kubin, and not vice-versa.

28. This pen and ink drawing is illustrated in Wieland Schmied, *Der Zeichner Alfred Kubin* (1967), plate 77.

Chapter 5

1. Felix Klee, *Paul Klee* (1962), p. 15.

2. *Diaries*, pp. 274-280, nos. 915-923. Paul Klee, *Briefe an die Familie*, Herausgegeben von Felix Klee (1979), with only one letter (p. 777) from 1913, adds little to our knowledge of this year.

3. Edward F. Fry, *Cubism* [1966], p. 184 ("Cubist Exhibitions"); and Alfred H. Barr, *Picasso: Fifty Years of His Art* (1946), p. 306 (bibliography). Donald E. Gordon, *Modern Art Exhibitions: 1900-1916* (2 vols., 1974), vol. 1, pp. 93, 245-246; vol. 2, pp. 663-664, reprints the catalogue of this large exhibition of 114 Picassos.

4. Gordon, *Modern Art Exhibitions*, vol. 1, pp. 96, 262-266; vol. 2, pp. 728-732.

5. Fry, *Cubism*, pp. 184-185.

6. The work is illustrated in Gordon, *Modern Art Exhibitions*, vol. 1, p. 246, no. 1213.

7. Max Huggler, a friend of Klee and Rupf and former director of the Berner Kunstmuseum, places the meeting in the summer (Max Huggler, *Paul Klee* [1969], p. 249, "Lebensdaten"). Hugo Wagner also places the meeting sometime in 1913 (Hugo Wagner, "Zur Entstehung der Sammlung und Stiftung Rupf," and also "Paul Klee" entry, in Kunstmuseum Bern, *Hermann und Margrit Rupf-Stiftung*, 1969).

8. *Diaries*, p. 276, no. 918.

9. Illus., Gordon, *Modern Art Exhibitions*, vol. 1, p. 246, no. 1212.

10. Ibid., p. 265, no. 1388.

11. All the facts noted here are taken from the *Rupf-Stiftung* catalogue, cited above, which gives the source and date, by year only, of each

acquisition. Braquis' *L'Echo d'Athènes* is illus., ibid., pl. 15.

12. Felix Klee, in *Paul Klee*, p. 202, states that a total of 205 works were done by Klee in 1913: 6 oil paintings, 54 colored sheets, 139 drawings, and 6 etchings. Not all of these works are accessible, or even known, today. The bulk of work by such a prolific artist presents obvious problems for the researcher; with such large numbers, not everything can be seen. Nevertheless, my study sample includes between one-half and two-thirds of the total, and I am confident that most of Klee's significant 1913 forms are embraced by my schema. I have learned, only since the completion of the present text, of the group of loose, painterly 1913 watercolors with colored lines, represented by *Suburb Milbertshofen* and *The Courtyard (Sun in the Courtyard)*, illus. in *Frühwerk*, respectively p. 118 and p. 116. These, as Charles Haxthausen has convincingly shown (see note 33 below), reflect the painterly influence of Kandinsky and therefore lie outside of Klee's Cubist progression. I have determined, consequently, not to add them to the discussion here.

13. The *Policemen* drawings illus. in *Diaries*, respectively, pp. 279 and 281.

14. A subject relationship may exist between these two drawings and a Klee diary passage (*Diaries*, p. 278, no. 920) which appears to date during or after the Summer 1913 trip to Bern. There Klee discusses possible comic drawings of Bernese policemen. Neither drawing nor diary entry is specifically dated. That *The Afflicted Policemen* is from earlier 1913 is, in a measure, supported by the watercolor *Munich Policeman in Conversation*, 1913 (collection of Felix Klee; illus. in Hans Konrad Roethel, *Klee in Müchen* [1971], p. 101), which is similar in composition and subject, somewhat resembles our drawings in the uniform type, and relates clearly to the righthand *Afflicted Policemen* in gesture, head, and facial type. The relevant frontal face in *Munich Policeman* most certainly has an early 1913 origin, as it is of the 1912 light-form discussed in the previous chapter.

15. Illustrated in Kunstsammlung Nord-

rhein-Westfalen, Düsseldorf, *Paul Klee* (2d rev. ed., 1964), no. 58.

16. James Smith Pierce, "Paul Klee and Primitive Art" (1961); pp. 52-53. The well-known drawing *Good Conversation*, 1913.84, partakes of the Kota influence as well.

17. Robert Goldwater, *Primitivism in Modern Art* (rev. ed. 1967), pp. 125ff. (particularly pp. 126-127), discusses the wide range and the kinds of the Blue Rider interest in primitive art.

18. Ibid., p.127.

19. Ibid., Chap. V, particularly pp. 147-148, for a discussion of the Kota source. Picasso's relation to African art is a very complex subject and has been discussed by every major author on Picasso since the 1930s—for example by William Rubin (Picasso in the *Collection of The Museum of Modern Art* [1972], entries concerning work of 1907 and 1908). Alfred H. Barr (*Picasso: 50 Years of His Art*, p. 60 and note), in one of his several discussions of Picasso's *Dancer* (1907), credits J. J. Sweeney in a book of 1934, *Plastic Redirection in 20th Century Painting*, with the first discovery of the Kota source for Picasso.

20. Pierce, "Klee and Primitive Art," pp. 52-53.

21. Similar examples are *Construction with Three Heads*, 1913, illus. in Glaesemer, *Handzeichnungen I*, p. 214, and *Pointed Hats*, 1913, in an American private collection. There is in *Heads* (Plate 33 here), it should be noted, a further African relationship, a similarity to the animal–beaked masks of the Guro (see, for example, William Fagg, *The Webster Plass Collection of African Art*, exhibition catalogue [1953], Plate XI).

22. Der Sturm (Gallery), Berlin, *Erster Deutscher Herbstsalon*, exhibition catalogue (September 20—November 1, 1913), Paul Klee entries.

23. Illus., Lothar-Günther Buchheim, *Der Blaue Reiter und die Neue Künstlervereinigung München* (1959), p. 246.

24. Illustrated, respectively, in Glaesemer, *Handzeichnungen I*, p. 215; and Will Grohmann, *Paul Klee Drawings* (1960), p. 4.

25. Pierce, "Klee and Primitive Art," pp. 151-155. It should be noted that Pierce sees many aspects of Klee's art as related to children's art, aspects which I believe were more integrally related to Cubism. As another example, see his discussion (ibid., pp. 143-151) of "Transparencies."

26. Klee had catalogued his own childhood drawings in 1911, at the beginning of his oeuvre catalogue (*Diaries*, p. 255, no. 890 [February 1911]). He had also written early in 1912, in his review of the first Blue Rider exhibition, that children's art ought to be taken seriously.

27. An example is illustrated as Plate XVII in Fagg, *Plass Collection*. If the Ashanti source for Klee has been recognized in the past, it has been only for such later works as *Senecio*, of 1922.

28. *Don Juan* illus., Glaesemer, *Handzeichnungen I*, p. 212; *Suicide* in Kornfeld, nos. A111 and 67 (both after the 1913 drawing); and *Fiery Ensemble* in Buchheim, *Der Blaue Reiter*, p. 72.

29. A photograph of the concert hall in the Odeon is compared to the drawing 1911.9 in Roethel, *Klee in München*, pp. 72-73. The related print is Kornfeld, no. 36.

30. *Diaries*, p. 265, no. 903.

31. Comparison between Kandinsky's *Study for Composition II* (Guggenheim Museum) and the lost large-scale *Composition II* (formerly Collection Baron de Gamp; illus. in Will Grohmann, *Kandinsky* [1930], Plate 4), reveals virtually no difference in form between the two works. For photographic clarity I have used the surviving work for my illustration.

32. *Composition V* illus., Kandinsky and Marc, eds., *Der Blaue Reiter*, p. 203. For a further discussion of these Klee-Kandinsky comparisons, see the author's "Paul Klee and Cubism, 1912-1926" (Ph.D. dissertation, Institute of Fine Arts, New York University, 1974), vol. 1, pp. 116-117, 257-260.

33. For a recent discussion presenting Klee derivations from Kandinsky, in 1913, of a more painterly kind, see Charles Werner Haxthausen, "Klees künstlerisches Verhältnis zu Kandinsky während der Münchner Jahre," in

Frühwerk, pp. 117-119; or Haxthausen's "Paul Klee: The Formative Years" (1976; Garland, 1981), pp. 410-412.

34. Sixten Ringbom wrote the first serious discussion of Kandinsky's relationship to Theosophy in his "Art in the Epoch of the Great Spiritual: Occult Elements in the Early Theory of Abstract Painting," *Journal of the Warburg and Courtauld Institute*, 29 (1966), 386-418. Other scholars since have focused extensively on the role of apparent and hidden religious imagery in Kandinsky in 1911–1912 (see, for example, Rose-Carol Washton Long, "Kandinsky and Abstraction: The Role of the Hidden Image," *Artforum*, X [June 1972], 42-49).

35. The iconographic meaning of *Garden of Passion* is further explored, in the larger context of Blue Rider imagery, in the author's dissertation, "Klee and Cubism," vol. 1, pp. 260-263.

36. Klaus Lankheit, "Bibel-Illustrationen des Blauen Reiters," *Anzeiger des Germanischen Nationalmuseums* (Nuremburg), Ludwig Grote zum 70. Geburtstag (1963), pp. 199-207. Lankheit discusses at length Klee's planned contributions to the project on the Book of Psalms (including *Sketch for 137th Psalm*), as well as the contributions of Marc, Kandinsky, Heckel, Kokoschka, and Kubin. The association of the Klees discussed above, with this project, does not in itself guarantee that they were done early in 1913. Klee continued to work on "Psalm"-related subjects for several years, and Lankheit publishes (ibid., p. 200) documentation that Klee and Marc were still busy with the project in 1914. Yet one feels the first excitement of the project, around March 1913 (see ibid., p. 199), likely prompted Klee to begin work on it at an early date. This reinforces, I think, the other stylistic evidence that this group of Klees belongs to early in the year.

37. *Spirit* is illustrated in Glaesemer, *Handzeichnungen I*, p. 216; *Lamentation* in Grohmann, *Klee Drawings*, p. 67; and *Eden* in Gualtieri di San Lazzaro, *Klee* (1957), p. 19.

38. Illus., *Frühwerk*, p. 301.

39. Much less successful is a group of oil paintings which includes *Flower Bed*, 1913, il-

lus. in color, *Frühwerk*, p. 393. The leaflike forms here, rather uncomposed, resemble those in *Garden of Passion*.

40. Eberhard Kornfeld (along with Grohmann and others) has loosely identified *In the Quarry* with the quarry at Ostermundigen near Bern (Kornfeld, *Bern and Surroundings* [1962], p. 24); and the mountain in *Small Landscape in the Rain* and in *Mountain Behind the Evergreens* as the Niesen, seen from the vicinity of Lake Thun (ibid., pp. 50, 52). *Villa in the Valley* and *A Hotel*, I think, were very likely done in the same lake region where Klee often spent part of his Swiss vacations.

41. *Villa in the Valley* is illustrated in Felix Klee, *Paul Klee par lui-même* (1963), p. 32f. *Small Landscape in the Rain* appears in Kornfeld, *Bern and Surroundings*, p. 53

42. Illus., Robert Rosenblum, *Cubism and Twentieth-Century Art* (1960), p. 33.

43. There is a similarity here as well between the foregrounds in *A Hotel* and *Small Landscape in the Rain* and Delaunay's *Formes Circulaires* (the *Simultaneous Suns and Moons*). A direct influence, however, would be hard to account for. Delaunay created the *Formes Circulaires* from late 1912 through the summer of 1913 and exhibited them first in September 1913 in the *Erster Deutscher Herbstsalon*. Klee did not see this exhibition. It is possible, however, that he could have learned about it from his friends Marc and Macke, who saw the exhibition and could have easily conveyed the new form to Klee through an informal sketch. See, for example, the watercolor sketches Marc sent to Klee on postcards in 1913, reproduced in Klaus Lankheit, *Franz Marc: Katalog der Werke* (1970). There are full-scale Marc oils, from 1913, with compositions based on interlocking circles, which could have influenced Klee as well.

44. *Smoking Man* is illustrated in Aichi Kunstmuseum, Nagoya, Japan, *Ausstellung: Paul Klee (1879-1940)*, exhibition catalogue (1969), no. 121; *Cardgame* in *Frühwerk*, p. 396, and *Schosshalde Woods* in ibid., p. 395.

45. *Mountain* is illustrated in Kornfeld, *Bern and Surroundings*, p. 51; *Utility Poles* in ibid.,

p. 49. They are identified there, by the editor, as originating at Lake Thun.

46. Illus., *Frühwerk*, p. 396. There are, for the earlier years of Klee's oeuvre catalogue, indications of whether a work was done before the natural motif. This would be most relevant, obviously, for Klee's Impressionist style. Interestingly, and confirming our observations from the works themselves, this distinction was dropped after 1913. (Glaesemer, *Colored Works*, p. 10).

47. The *Crossroads* drawing appears in Glaesemer, *Handzeichnungen I*, p. 210.

48. *Diaries*, p. 278.

49. The entry appears on pp. 288-290 of the German edition of *Diaries* (*Tagebücher von Paul Klee, 1898-1918*).

50. Illus., respectively, in di San Lazzaro, *Klee*, p. 19; and Grohmann, *Klee Drawings*, p. 67.

51. I have been intensely aware of this number-chronology problem while stating my several chronology propositions for 1913. Unable, with the information at my disposal, to resolve every possible conflict, it has yet seemed desirable to take some steps toward an internal order for 1913 where previously there has been none. Ultimately, graphological examination of Klee's *oeuvre* catalogue and the inscriptions on the mountings may shed light on such matters.

52. As illustrated, for example, in Grohmann, *Klee Drawings*, p. 170, and *Diaries*, p. 285. I express my debt again to the Klee-Stiftung for allowing me to study at length all the drawings of its collection. Note also in my Plate 43 Klee's subscript for the drawing, giving its alternative title (shortly to be discussed).

53. The *Flight* title is from the oeuvre catalogue, while the more abstract title appears on the mounting itself. (See Glaesemer, *Handzeichnungen I*, pp. 217, 297.)

54. *Plants* is illus. in Kornfeld, no. 57.

55. The fragmentary nature of the sheet, easily established by examination of the way forms run off the lower border, was confirmed by the author's observation of the original. Dimly visible through the paper is another drawing on the other side, characterized by a more regular

grid. Evidently Klee painted over the backs of some drawings with ink to prevent such show-through. *An Uncanny Moment* was treated this way, I have observed, with the black showing a little around the edge (as shown in my Plate 25).

56. Illus. Glaesemer, *Handzeichnungen I*, p. 217. One wonders, indeed, where the minutiae of style match, if several of the surviving drawings might not have been parts of the same sheet. The same suggestion could be made for some of the less-happily composed "Garden of Passion"-type works.

57. Illus., Kornfeld, no. 58.

58. Some other 1913 works, as well, combine the fabled and abstract tendencies: *Old City*, in Felix Klee, *Paul Klee par lui-même*, p. 34 f.; and *Street Traffic*, illus. in *Frühwerk*, p. 392. Neither of these, however, is as compositionally advanced as *Abstraction I*.

59. See Marcel Franciscono, "Paul Klees kubistische Druckgraphik," in *Paul Klee: Das graphische und plastische Werk*, exhibition catalogue (1974), pp. 46-56, for another view of Klee and Cubism (exploring the symbolism of fragmentation), which has appeared since my dissertation.

60. The two artists remained close friends throughout their lives, however. In 1914 Kandinsky gave Klee his highly coloristic *Sketch I for Composition VII*, of 1913, which Klee admired all during the war years and later. I am indebted to Felix Klee for the details on how Klee came to own this work.

61. The quotations and ideas from the Moderner Bund review are given with full context and references above, in Chap. 3.

Chapter 6

1. *Diaries*, pp. 283-307, nos. 926, 926a-u. Among specialized publications are Uta Lazner, *Stilanalytische Untersuchung zu den Aquarellen der Tunisreise 1914: Macke, Klee, Moilliet* (Ph.D. dissertation, Rheinischen Friedrich-Wilhelms-Universität, Bonn, 1967);

Jean-Christôphe Ammann, "Die Tunisien-Aquarelle Paul Klees von 1914," *Nachrichten Kunst* (Lucerne), II (December 1965); Hans Christophe von Tavel, "Vor 50 Jahren: Reise nach Kairouan," *Separatdruck aus Mitteilungen* (Kunstmuseum, Bern), no. 69 (March 1964), 2-5; *August Macke: Tunisian Watercolors and Drawings*, with essays by Günter Busch and Walter Holzhausen [1969]; Jean Duvignaud, *Klee en Tunisie* (1980); and other studies to be cited below.

2. *Diaries*, pp. 278-280, no. 923; p. 283, no. 926; Gustav Vriesen, *August Macke* (2d rev. ed., 1957), p. 142.

3. *Diaries*, p. 283, no. 926; Vriesen, *Macke*, p. 144; Von Tavel, "Reise," p. 2. Elisabeth Endmann-Macke, *Erinnerung an August Macke* (1962), p. 235, gives the date of the visit as January 8.

4. In a number of passages (e.g., p. 283, no. 926) there are turns of phrase that suggest a rewriting by Klee at a later date. Christian Geelhaar, in "Journal Intime oder Autobiographie? Uber Paul Klees Tagebücher," in *Frühwerk*, pp. 246-260, has recently established that *Diary III*, which contains the Tunisia notes, was edited and recopied by Klee in 1921.

5. As recorded by Walter Holzhausen in *Macke Tunisian Watercolors*, pp. 18-19.

6. *Diaries*, nos. 926f, i, m, o, and p, respectively. To avoid unnecessary confusion, the page numbers of the Tunisia diary notes will be omitted for the rest of this chapter.

7. Ibid., nos. 926k and o, respectively.

8. Ibid., nos. 926r and t, respectively.

9. See, for example, the mystical Buddha-like image of the lithograph *Self Portrait (Lost in Thought)* of 1919 (Kornfeld no. 73).

10. In a memorable phrase, Carola Giedion-Welcker equated Klee's art with tropical growth: "Klee's art seems to have flourished in almost tropical exuberance" (Giedion-Welcker, *Paul Klee* [1952], p. 40). Wilhelm Hausenstein's *Kairouan oder eine Geschichte vom Maler Klee und von der Kunst dieses Zeitalters* (1921) contributed to the early symbolic status of the journey. This identification of Klee with Kai-

rouan was recently noted as well by Jürgen Glaesemer in *Paul Klee: The Colored Works in the Kunstmuseum Bern* (English ed., 1979), p. 31.

11. Regula Suter-Raeber, "Paul Klee: Der Durchbruch zur Farbe und zum abstrakten Bild," in *Frühwerk*, pp. 131-165, is a major new advance, clarifying many chronological problems of 1914.

12. *Diaries*, no. 926e.

13. In the literature on this Tunisia journey, Von Tavel specifically—if only in passing—brackets these two passages on "Formenrhythmus" with "der kubistischen Formidee" ("Reise," p. 4).

14. Holzhausen, in *Macke Tunisian Watercolors*, p. 18.

15. *Diaries*, nos. 926k and o.

16. Holzhausen, in *Macke Tunisian Watercolors*, p. 19. In a footnote the translator of the English edition of the book renders *Plätzli*—incorrectly—as "the Swiss-German word for a kind of roll."

17. *Diaries*, no. 926r.

18. Ibid., no. 926n. My translation has differed slightly from that in the standard English edition. From the German edition, p. 307: "Aus dem Käsestückchen wurde noch ein Käsekubus, und dann war es still."

19. *Diaries*, no. 926r.

20. Suter-Raeber ("Durchbruch zur Farbe," p. 140) follows an idea first put forth by Ammann ("Tunisien-Aquarelle Paul Klees"), that at *each* Tunisian locale Klee recapitulated a development from description to abstraction.

21. Illustrated in Ammann, "Tunisien-Aquarelle Paul Klees," pl. 1.

22. One of the related watercolors, *Before a Mosque in Tunis*, 1914.204, interestingly, was for years in the collection of Dr. Jäggi, with whom the painters stayed. (This provenance is given in Musée National d'Art Moderne, Paris, *Paul Klee*, exhibition catalogue [1969], no. 18.)

23. Pre-Tunisian 1914 works have been identified by Charles Haxthausen ("Paul Klee the Formative Years" [Garland ed., 1981], p. 441) and Suter-Raeber ("Durchbruch zur Farbe," pp. 132, 135-138, and notes). The latter cites a March

1914 exhibition in Munich as *terminus ante quem* for a group of watercolors which includes *Memory of a Garden* and *City with the Three Domes* (illus., *Frühwerk*, pp. 138, 136) and discusses other examples as well. Haxthausen would add *Villas for Sale* (illus., ibid., p. 400) to the pre-Tunisia group. With the exception of *City with the Three Domes*, all of the works identified continue the generally unfocused 1913 type of drawing, patterned across a colored background.

24. Glaesemer, *Colored Works*, pp. 28-29, and 92, nominates *Villas on the Beach* (illus.) as the work "noch etwas europäisch."

25. The identification of 1914.41 with this diary passage is verified by the color illustration in *Ganymed* (Marées Gesellschaft), III (1921), p. 8f, to which Klee retroactively referred.

Though they bear the same place name as the works discussed here, I am convinced that *St. Germain Near Tunis (Inland)* (illus., Solomon R. Guggenheim Museum, New York, in collaboration with the Pasadena Art Museum, Pasadena, California, *Paul Klee*, exhibition catalogue [1967], no. 14) and *Beach of St. Germain Near Tunis* (illus., Haus der Kunst, Munich, *Paul Klee*, exhibition catalogue [1970], no. 21) are later works. I believe their style draws upon the experience of both Hammamet and Kairouan. This is typical of a number of detailed sequential-stylistic problems that concern current researchers on this period.

26. Illus., *Frühwerk*, p. 408.

27. Because of the obvious inadequacy of black and white illustrations, my remarks on color are necessarily limited. Fortunately, the compositional patterns under discussion are usually adequately visible in black and white.

28. Klee's Hammamet watercolors, like those of St. Germain, present problems of chronology and identification. *Abstraction of a Motif from Hammamet* (illus., *Frühwerk*, p. 149) and *Concerning a Motif from Hammamet* (ibid., p. 403) are no doubt works done on the theme after Klee's return to Munich.

29. Recently published works of the Kairouan style include *Kairouan Before the Gate*

(illus., *Frühwerk*, p. 144), and *View of Kairouan* (illus., ibid., p. 406).

30. Illus., *Frühwerk*, p. 143.

31. Glaesemer, *Colored Works*, p. 30, has proposed a convincing explanation for the unpainted areas that appear as stripes on the left in *Before the Gates of Kairouan* and on the right in *Beach of St. Germain Near Tunis*. These he says are probably the result of Klee's use of an elastic band to secure his paper to a drawing board when working outdoors. Klee simply had to paint around the band, which therefore "reserved" a stripe through the composition.

32. Vriesen, *Macke*, p. 116.

33. Ibid. (letter of October 21, 1912).

34. Guy Habasque, "Catalogue," in Pierre Francastel, ed., *Robert Delaunay: Du Cubisme à l'Art Abstrait* (1957), p. 363, for catalogue listing. *Der Sturm*, III, no. 144-145 (January 1913), 255-256, for Klee's translation "Über das Licht."

35. Vriesen, *Robert Delaunay: Light and Color* (1967), p. 55; Vriesen, *Macke*, p. 166; also Erdmann-Macke, *Erinnerung*, pp. 204-205, for the personal recollections of the visit by Frau Macke.

36. Vriesen, *Macke*, p. 118; the translation, beyond my own of the first sentence, is from Vriesen, *Delaunay*, p. 46.

37. Delaunay to Marc, probably late 1912, quoted in Francastel, *Robert Delaunay: Du Cubisme*, pp. 181-183; Marc to Delaunay, December 1912, quoted and discussed in Vriesen, *Delaunay*, p. 57; and Delaunay to Marc, April (?) 1913, quoted in ibid., pp. 57-58.

38. Peter Selz, *German Expressionist Painting* (1957), pp. 265-271, for a full basic account of the Salon. Vriesen, *Delaunay*, pp. 64-65, and Vriesen, *Macke*, pp. 124-126, are sources for further details; as of course is the *Erster Deutscher Herbstsalon* catalogue, for specific listings.

39. Maria Marc, in August Macke and Franz Marc, *August Macke, Franz Marc Briefwechsel* (1964), p. 175 (letter of December 2, 1913).

40. Macke, ibid., p. 174 (letter from Hilterfingen, November 11, 1913).

41. Vriesen, *Macke*, p. 138.

42. Illus., Hutton-Hutschnecker Gallery, *Kandinsky, Franz Marc, August Macke: Drawings and Watercolors*, exhibition catalogue (1969), p. 106.

43. Vriesen, *Macke*, p. 135.

44. *Pomegranate and Palm in a Garden* is illustrated in *August Macke: Aquarelle* (1958), pl. 13.

45. *Terrace of a House in St. Germain* is illustrated in Vriesen, *Macke*, p. 301, watercolor no. 484.

46. Felix Klee, *Paul Klee* (1962), pp. 35-38.

47. Beside *Sketch from Kairouan*, only a few other drawings seem to come directly from Tunisia; such as the street scene sketch illus. in Glaesemer, *Colored Works*, p. 28, fig. a.

48. See, as examples, these 1914 drawings that belonged to Alfred Kubin, illus. *Frühwerk*, p. 73.

49. *Love of Three* and *The German in a Brawl*, illus., Glaesemer, *Handzeichnungen I*, pp. 225, 228; *Critic*, illus. Felix Klee, *Paul Klee*, p. 110.

50. See O. K. Werckmeister, "Klee im Ersten Weltkrieg," in *Frühwerk*, pp. 168, 170, where it is discussed as a satire on war propaganda imagery.

51. *Decadence*, illus., Glaesemer, *Handzeichnungen I*, p. 226; *Harsh Law*, illus. *Frühwerk*, p. 74.

52. The source is, as with the drawing illus. in my Plate 36, Psalm 137; here verse 6. Klaus Lankheit, "Bibel-Illustrationen des Blauen Reiters," *Anzeiger des Germanischen Nationalmuseums* (Nuremberg) (1963), pp. 202-204, also notes the relation of *Jerusalem* to the 1913 series.

53. The same intrusive foreground hill can also be seen in the newly published *Hammamet (View in the Gardens)*, illus. in Suter-Raeber, "Durchbruch zur Farbe," p. 141.

54. Illus., John Golding, *Cubism* (1968 ed.), pl. 26. *Still-Life with Bottle* is no. 33 in Bernard Geiser, *Picasso Peintre-Graveur: Catalogue illustré de l'oeuvre gravé et lithographié, 1899-1931* (1933); and *Fox* is no. 5 in *George Braque: His Graphic Work*, introduction by Werner Hofmann (1961). Curiously, neither print is in the Rupf collection. Beyond the apparently for-

tuitous similarity of title, there is little to compare between Klee's *Jerusalem* and Picasso's three etchings for Max Jacob's *Le Siège de Jérusalem* (Paris: Kahnweiler), published in January 1914. (Rupf owned a copy of this limited-edition work.) The Picasso etchings (Geiser, *Picasso Oeuvre Gravé*, nos. 35-37) are quite dark and heavy in form and, dating from 1913 and early 1914, are transitional between Analytic and Synthetic Cubism—a phase to which Klee becomes really comparable with Picasso only after 1914.

55. Klee actually uses the phrase "wire model" when, in the 1930s, he discusses this effect: "One could sometimes almost think that something had been painted after nature, so to speak after a model, after a wire model or something like that. This kind of abstraction obviously raises curiosity. But is it abstract?" (author's translation). From Klee's lessons at the Kunstakademie Düsseldorf, as reported in Petra Petitpierre, *Aus der Malklasse von Paul Klee* (1957), p. 11. Literal linear construction will be discussed in Chapter 8.

56. Because they relate most cogently to the post-assimilative work of 1915, I omit mention of an important group of untitled abstract drawings which includes *oeuvre*-numbers 1914.150, 1914.153, and 1914.163. They are more closely related to concerns discussed in the next chapter.

57. The two works mentioned are illus. *Frühwerk*, p. 149, and p. 403, respectively. In this Tunisia-related category I would also include the recently published *In the Desert (In der Einöde)*, illus. *Frühwerk*, p. 146.

58. Illus., Suter-Raeber, "Durchbruch zur Farbe," pp. 155, 161.

59. *Thoughts of Battle* (location unknown), illus. in the author's dissertation, "Paul Klee and Cubism, 1912-1926" (1974), pl. 187; *Thoughts on Mustering Up*, illus. *Frühwerk*, p. 411.

60. The Städtische Galerie im Lenbachhaus has, interestingly, a ca. 1914 Klee drawing from Gabriele Münter's collection (which I have not seen) catalogued as *Drawing with Roman Numerals* (Hans Konrad Roethel, *The Blue Rider*

[1971], p. 152). Klee's richest exploration of Roman and Arabic numerals occurs along with letter forms in the late 1910s and early 1920s. The "X" as figure is also frequently employed in the 1930s.

61. Illus., Suter-Raeber, "Durchbruch zur Farbe," p. 145.

62. The 1913 Munich exhibitions of Picasso and Cubism are discussed above in Chapter 5.

63. Illus., Suter-Raeder, "Durchbruch zur Farbe," p. 148.

64. *Hommage à Picasso*, given by Klee in French, is virtually the same title as Juan Gris' inscription on his well-known portrait of Picasso, which Klee had seen in the Paris Salon des Indépendants of 1912. Klee's painting is certainly not a portrait of Picasso; it does not with great clarity "quote" any specific Picasso that I know of; and it was not planned, as Gris' was, for exhibition in a Cubist-salon context where the tribute would have a clear meaning. Nevertheless, Klee's intention may have been similar, to acknowledge his stylistic debt to the founder of the Cubist style. Examination of the *oeuvre* catalogue in the Klee-Stiftung indicates that this title, as entered, was possibly tentative. *Hommage à Picasso* is noted, by 1914.192, in a very light script. The title of the next entry, 1914.193, *Teppich der Erinnerung*, was written in heavy ink over such a similar provisory title (no longer legible) in the same light script.

65. Glaesemer, *Colored Works*, pp. 32-33, has recently discussed this work's structure, emphasizing the well worn "carpet" effect of its texture. He has shown, in addition, that when turned 90 degrees left from its present orientation, *Carpet of Memory* has many linear similarities with *Jerusalem my Highest Joy*. As he indicates, the work has a half-obliterated date and number that prove that Klee, at one time, had given it this vertical orientation.

66. Ibid., p. 90.

Chapter 7

1. Klee to Rupf, December 4, 1914, from Munich; quoted in Staatliche Kunsthalle, Baden-

Baden, *Der frühe Klee,* exhibition catalogue (1964) (my translation).

2. *Diaries,* p. 309.

3. Ibid., p. 307, no. 928.

4. Ibid., p. 313, no. 952.

5. Ibid., p. 313, no. 951.

6. I have recently attempted a theoretical and psychological appraisal of Klee's thought of this period in an Expressionist context, in "Garten der Mysterien: Die Ikonographie von Paul Klees expressionistischer Periode," in *Frühwerk,* pp. 227-245, esp. 227-231.

7. Paul Klee, *Pädogogisches Skizzenbuch,* Bauhaüsbucher 2 (1925); English ed., intro. and trans. by Sibyl Moholy-Nagy (1953). Around 1918 Klee began to write his "Creative Credo," an early draft of which is reprinted in Felix Klee, *Paul Klee* (1962), pp. 151-156; it appeared in 1920 in K. Edschmidt, ed., *Tribüne der Kunst und Zeit,* vol. XIII, pp. 28-40. The lecture of January 24, 1924, to the Jena Kunstverein is reprinted in Felix Klee, *Paul Klee,* pp. 168-179. Klee's Bauhaus teaching notes, edited by Jürg Spiller, have appeared in English as *Paul Klee Notebooks: Volume I: The Thinking Eye* (1961). A second volume, also edited by Spiller, has appeared as *Paul Klee: Form und Gestaltungslehre: Band II: Unendliche Naturgeschichte* (1970). Klee's teaching notes the "Pädogogischer Nachlass" are preserved in the Klee-Stiftung. See the critique of Spiller's first volume vis-à-vis this source, by Max Huggler: "Die Kunsttheorie von Paul Klee," *Separatdruck aus der Festschrift Hans R. Hahnloser,* 1959, pp. 425-441. A facsimile edition of Klee's 1921-1922 Bauhaus notebook has recently appeared: Paul Klee, *Beiträge zur bildnerischen Formlehre,* Herausgegeben von Jürgen Glaesemer (1979). The availability of this original will no doubt inspire new analysis of Klee's theoretical work. Petra Petitpierre's *Aus der Malklasse von Paul Klee* consists of transcriptions taken in Klee's Düsseldorf Academy class in the early 1930s.

8. Klee inherited his German citizenship from his father and was unable in later life to complete Swiss naturalization.

9. *Diaries,* pp. 320-322, no. 963.

10. Ibid., pp. 319-320, no. 962; pp. 322-323, no. 964.

11. Ibid., p. 323, no. 965 (1916).

12. Ibid., pp. 318-319, no. 961, where Klee described his own letter to Marc. A Marc letter to Klee of 10 May 1915 is quoted in full in Felix Klee, *Paul Klee,* pp. 38, 47-48.

13. *Diaries,* pp. 327-346, nos. 966-1012, for Klee's life as a recruit and trainee. The transport escort trips, from Schleissheim, are chronicled pp. 347-364, nos. 1013-1051.

14. Ibid., p. 363, no. 1043 (January 9, 1917), for Klee's brief account of the Berlin visit.

15. Ibid., pp. 364-411, nos. 1052-1134, for Klee's life through the duration of the war. Klee's published diaries end abruptly with Book IV, the last entry being a copy of Klee's formal letter, after the end of hostilities in mid-December 1918, requesting his release from military service. O. K. Werckmeister ("Klee im Ersten Weltkrieg," in *Frühwerk,* pp. 166-226) reviews Klee's career during these years in great detail. He suggests moreover that some of Klee's changes in theme and title were influenced, in part, by sales and reactions to his work in the art market. See also Michèle Vishny, "Paul Klee and War: a Stance of Aloofness," *Gazette des Beaux-Arts* 120 (December 1978), pp. 233-243, for a review of the war years subject.

16. Walden's remark about Klee's color resembling Marc's was recorded by George Muche, whose memoir of a meeting at the January 1917 visit at the Sturm Galerie is quoted in Felix Klee, *Paul Klee,* pp. 185-186.

17. Klaus Lankheit, *Franz Marc: Katalog der Werke* (1970), no. 209 (the painting is now in the Kunstmuseum, Basel). Klee carefully differentiated his restoration from the original by mixing all of his colors with brown, which memorializes as well the loss by fire.

18. Lankheit, *Marc Katalog,* no. 228; and letter from Felix Klee to the author.

19. This is widely reproduced, as in H. W. Janson, *History of Art* (1966), colorplate 74. The circumstances of Kandinsky leaving the work with Klee was described to me in a letter from Felix Klee. In the 1920s, Kandinsky refused Klee's offer to return the work but ac-

cepted a Klee in exchange. My thanks to Felix Klee for graciously answering this and many other detailed questions.

20. *Diaries*, p. 322. no. 963.

21. The earlier *Clock in the City*, 1914 (Plate 43), and a few other drawings of 1912-1914 in the Klee-Stiftung, contain readable number and letter forms. These are, variously, illustrative (cartoonlike) labels and rudimentary *Schriftbilder*. One example is *The Thirteen*, 1914 (illus., Glaesemer, *Handzeichnungen I*, p. 230).

22. Glaesemer, *Colored Works*, pp. 38-39, discusses the Chinese literary source and verbal and visual structure of this work at length.

23. Ibid., p. 45, where Glaesemer states that the literary source for this *Schriftbild* is still unknown.

24. Klee's elliptical frame is visible in a photograph of his Munich studio of 1920, reproduced in (among other places) Carola Giedion-Welcker, *Paul Klee in Selbstzeugnissen und Bilddokumenten* (1961), pp. 62-63. Klee apparently collected old-style frames—probably found in secondhand shops—for his works.

25. *Half Past Three*, now in the Philadelphia Museum of Art (Arensberg collection), was in Walden's collection until about 1926 (Franz Meyer, *Marc Chagall* [1963], p. 316). Walden probably acquired it in 1914, at the time of Chagall's first one-man exhibition in the Galerie Der Sturm (ibid., p. 731, Exhibitions). It is conceivable that Klee could have seen the work in 1914-1915 in some Sturm-related exhibition or publication; he did not, however, have an opportunity to personally view Walden's collection until early 1917 in Berlin.

26. Illus., respectively, in Glaesemer, *Handzeichnungen I*, pp. 251, 247.

27. Illus., Jordan, "Garten der Mysterien," p. 232.

28. Illus. in Aichi Kunstmuseum, Nagoya, Japan, *Ausstellung: Paul Klee (1879-1940)* (1969), no. 65; and Musée National d'Art Moderne, *Paul Klee* (1969), no. 25.

29. Gerd Henniger, "Paul Klee und Robert Delaunay," *Quadrum*, no. 3 (Summer 1957), p.139, illus. Henniger's comparisons, as in most early studies of this relationship, are extremely general.

30. *Ab Ovo*, illus., Glaesemer, *Colored Works*, p. 109.

31. Illus. in ibid., p. 114; and in Grohmann, *Paul Klee* [1967]), colorplate V.

32. *Tree of Houses*, illus. in color in Nello Ponente, *Klee* (1960), p. 54. The latter two are illus. in Jordan, "Garten der Mysterien," pp. 236-237.

33. See the author's "Garten der Mysterien," pp. 240-244, for an iconographic discussion of *With the Eagle* and a comparison with Surrealism, matters which are outside the scope of the present study.

34. Illustrated in color in The Solomon R. Guggenheim Museum, New York, in collaboration with the Pasadena Art Museum, Pasadena, Calif., *Paul Klee: 1879-1940*, exhibition catalogue (1967), no. 25; and Grohmann, *Paul Klee* [1967], p. 85.

35. Illus., Haus der Kunst, *Paul Klee*, exhibition catalogue (1971), no. 30; and *Frühwerk*, p. 492.

36. Illus., Robert Rosenblum, *Cubism and Twentieth-Century Art* (1960), p. 245.

37. Meyer, *Chagall*, pp. 315-316.

38. Ibid., p. 315, and notes.

39. Ibid., pp. 179-180, and notes.

40. The appearance in Klee at about this time of a Chagallesque imagery and color promises to be an interesting vein for further study. For example, the kind of human-animal allegory of sexuality common in Chagall from at least 1911, as in *Dedicated to My Fiancée* (1911; illus., Meyer, *Chagall*, p. 133), appears in Klee's "Drawing for the Billy-Goat" (1919.238; illus., Glaesemer, *Handzeichnungen I*, p. 275) where a nude woman is humorously poised on the brow—and presumably in the thoughts—of a billy goat. The animal strongly resembles the usual ram-goat formula of Chagall. The deeply romantic fantasy and the forms of the houses in Klee's *Night Feast* (illus., The Solomon R. Guggenheim Museum, *Paul Klee: 1879-1940* [1967], p. 45) resemble any number of thatched, log-walled villages in Chagall; for example, that in the upper right of *I and the Village*. Klee

uses the Chagallesque log-house parallel line formula extensively from 1919 (e.g., *Architecture with a Window*, 1919, illus., Glaesemer, *Colored Works*, p. 122) through the early 1920s (e.g., *Site for a Strawberry Inn*, 1921, illus., The Solomon R. Guggenheim Museum, *Paul Klee: 1879-1940*, p. 47). The mysterious house in Klee's famous 1919 *Villa R* (1919, illus., among many places, in The Solomon R. Guggenheim Museum, *Paul Klee: 1879-1940*, p. 37) may well owe a debt to Chagall's *Burning House* (1913, illus., Meyer, *Chagall*, p. 200). Solid ground for this speculation exists in the fact that *Burning House*, now in the Guggenheim Museum, was also in Walden's collection, which Klee saw (Angelica Zander Rudenstine, *The Guggenheim Museum Collection Paintings: 1880-1945* [2 vols., 1976], vol. 1, p. 60). *Villa R* may also have references to Delaunay. The composition of the house between framing theater curtains is not unlike, for example, the curtain-frame pattern of *The City* (Plate 13). Without suggesting any specific initial, or name, references for Klee's large green letter R, the precedent for this emphatic use of letter symbols can be found in Robert Delaunay's *Cardiff Team*.

41. *Full Moon*, illus. in color in Werner Haftmann, *The Mind and Work of Paul Klee* (1967), p. 128f; and *Cosmic Composition* in Kunstsammlung Nordrhein-Westfalen, Düsseldorf, *Klee* (1964), no. 5. Before its publication with its full title by Glaesemer, in *Colored Works*, pp. 120-121, *Composition with Windows (Composition with a B')* was more commonly known by the latter half of its title.

42. Glaesemer (ibid., pp. 49-50) has also discussed the structural layering of this painting. He was the first to point out that the underlying gridwork, beneath the first layer of paint, was drawn in pen and ink on the cardboard.

43. Illus., ibid., p. 189.

Chapter 8

1. Klee signed a sales contract with Goltz in Munich in 1919, and in the spring of 1920 a large retrospective exhibition of his work was held at this dealer's gallery (Will Grohmann, *Paul Klee* [1955], pp. 62 and 441 [bibliography]. The three early monographs were Leopold Zahn, *Klee: Leben, Werk, Geist* (1920); H. von Wedderkop, *Paul Klee* (1920): and Wilhelm Hausenstein, *Kairouan oder ein Geschichte von Maler Klee* (1921).

2. Hans Maria Wingler, *The Bauhaus* (1969), pp. 354-355, illus., for the Léger and a 1912 Marcoussis which were printed by the Press in 1924, even though the full portfolio never materialized. My general account of Klee's Bauhaus years is drawn largely from Wingler's documentation.

3. Grohmann, *Klee*, p. 63.

4. Wingler, *Bauhaus*, amply documents the shift from Expressionism and Constructivism in all its manifestations at the Bauhaus. For a convenient synopsis, including some of the changes in the faculty and courses, see Christian Geelhaar, *Paul Klee and the Bauhaus* (1973), pp. 9-20. Geelhaar does not, however, discuss the comparable changes in Klee's art of the period. For the intellectual background of the Bauhaus founding and first transitional period, see Marcel Franciscono, *Walter Gropius and the Creation of the Bauhaus in Weimar* (1971).

5. Illus., William Rubin and Carol Lanchner, *Andre Masson* (1976), p. 125.

6. Ibid., pp. 19, 102, for Klee's influence, via reproductions, on Masson starting in 1922.

7. Exponents of the so-called Systemic school, since the mid-1960s, have explored the possibilities of repetitive pattern (see The Solomon R. Guggenheim Museum, New York, *Systemic Painting* [1966]). The terms "post-" and "Anti-Cubist" figure large in the literature of this movement. Comparisons of Systemic theories and art to the parallel aspects of Klee would appear to be a fruitful area for critical research.

8. The drawing is in the Klee Foundation Collection; the watercolor is in the Tate Gallery, London. Most such drawings are in the Klee Foundation because, as the artist's son has frequently stated (e.g., Felix Klee, *Paul Klee*

[1962], p. 205), Klee intended his drawings to be preserved as a kind of visual archive. My analysis of the oil-transfer technique is based on study carried out in 1969-1970 at the Klee Foundation. Since then, Jürgen Glaesemer (*Handzeichnungen I*, pp. 258-261) and Christian Geelhaar (*Klee at the Bauhaus*, pp. 87-88) have independently published descriptions of the oil-transfer procedure that have a technical clarity entirely lacking in the older literature. Glaesemer reproduces a number of reunited transfer pairs of watercolors and paintings; and the drawing and watercolor pair for *Barbarian Venus* is reproduced in color in my article "The Structure of Paul Klee's Art in the Twenties: From Cubism to Constructivism," *Arts*, 52 (September 1977), p. 154.

9. Drawings so used are identifiable by the stylus line incised in their surface.

10. Naum Gabo, "The Realistic Manifesto," Moscow, August 5, 1920, quoted in English translation in Herschel B. Chipp, *Theories of Modern Art* (1968), pp. 325-330.

11. Illus., Grohmann, *Klee*, p. 217.

12. Illus., ibid., p. 171.

13. Maurice L. Shapiro ("Klee's Twittering Machine," *The Art Bulletin*, L [March 1968], pp. 67-69) bases his iconographic interpretation of this work on its mechanistic ambivalence. He does not, however, examine the connection with either Bauhaus Constructivism or Dadaism.

14. Illus., *Frühwerk*, p. 547.

15. Illus., Museen der Stadt Köln, *Paul Klee: Das Werk der Jahre 1919-1933* (1979), p. 251.

16. Illus., Glaesemer, *Colored Works*, p. 183.

17. Paul Klee, *Pedagogical Sketchbook*, p. 59.

18. Galerie Van Diemen, Berlin, *Erste Russiche Kunstausstellung*, exhibition catalogue (1922). My thanks to Ronny H. Cohen for bringing this rare catalogue to my attention.

19. For documentation I have depended upon Wingler's *The Bauhaus*, which is an "official" compilation from the Bauhaus-Archiv. Camilla Gray's *The Russian Experiment in Art: 1863-1922* (new ed., 1971) and H.L.C. Jaffe's *de Stijl: 1917-1931* (1956) provide basic accounts of the activities and works of the leaders of their respective movements. *El Lissitzky: Life: Letters: Texts* by Sophie Lissitzky-Küppers (1968) provides, in addition, many interesting closeup views, in the form of Lissitzky's letters and other writings, of the international Constructivist scene of the early 1920s. For Moholy-Nagy's influential theories, see his *The New Vision* (4th rev. ed., 1947).

20. See Chapter 5, above.

21. Among the primitive sources for Klee in the 1920s which I have been able to identify, but which lie properly outside the scope of the present study, I may list the following: The drawing (1922.232; Klee Foundation) for the watercolor *At the Mountain of the Bull* (1923.152) draws closely upon an East Indian bronze image of the *Bull of Shiva*, reproduced in Wilhelm Hausenstein, *Barbaren und Klassiker: Ein Buch von der Bildnerei Exotischer Völker* (2d ed., 1923), pl. 110. The first edition of this book by Klee's friend was no doubt involved. *Cat and Bird Scherzo* (1920, illus., Glaesemer, *Handzeichnungen I*, p. 286), in its vertical superposition of images, symmetry, in the specific nature of its "face-bodies," and its stylizations of wings and claws, clearly reflects the influence of Northwest Coast American Indian Art. The example of a Chilkat blanket from the Munich Staatliches Museum für Völkerkunde, not distant from this Klee in form, had been illustrated (p. 58) in Wassily Kandinsky and Franz Marc, eds., *Der Blaue Reiter* (1965 ed.) Klee's lithograph *The Infatuated* (1923, Kornfeld, no. 94) adheres closely to the type of Ashanti child-beauty doll which has tiny arms— of which there is an example in the Musée d'ethnographie, Geneva (illus., for example, in Claude Lapaire, *Schweizer Museumsführer* [2d rev. ed., 1969], opp. p. 65).

22. Felix Klee, *Paul Klee*, pp. 182-184, where a quotation is given from Lothar Schreyer, *Erinnerungen an Sturm und Bauhaus* (1956). Schreyer came to the Bauhaus in 1921 and left in 1923 (Wingler, *Bauhaus*, p. 269). O. K. Werckmeister, in "The Issue of Childhood in

the Art of Paul Klee," *Arts Magazine* 52, no. 1 (September 1977), pp. 144-145, discusses the Schreyer conversation in a context that emphasizes subtle changes in Klee's attitude to children's art over the years.

23. Illus., Will Grohmann, *Paul Klee Drawings* (1960), p. 65.

24. Illus., John Golding, *Cubism* (1968 ed.), p. 8.

25. Angelica Zander Rudenstine, *The Guggenheim Museum Collection: Paintings 1880-1945* (2 vols., 1976), pp. 56-57, illus.

26. Illus., Glaesemer, *Handzeichnungen I*, p. 248.

27. Among other closely related works are *Study for MA* (1922, watercolor, in the Yale University Art Gallery) and *Maid of Saxony* (1922, illus., The Solomon R. Guggenheim Museum, New York, in collaboration with the Pasadena Art Museum, *Paul Klee: 1879-1940* [1967], p. 41). In these variants, the brow forms of *Senecio* are expanded to define the whole shape of the forehead.

28. Wingler, *Bauhaus*, p. 44, states the insignia was adopted in 1922.

29. Ibid., p. 257.

30. Felix Klee (*Paul Klee*, pp. 155-167) has published the interesting letters of Schlemmer which record his enthusiastic but unsuccessful proposal of 1919 that Klee be appointed to the faculty of the Stuttgart Academy of Art. At the time, Schlemmer was a leader in the student organization there.

31. The classical, "Greek profile" aspect of Schlemmer's facial type could be explored as a possible parallel to the rationality of his theories of the body in movement. The relationship between Klee's and Schlemmer's forms can be followed far beyond the present examples. Something very like Schlemmer's profile, atop a bulbous, puppet body, appears in Klee's *Governess*, both drawing (1922.214, illus., Grohmann, *Klee Drawings*, p. 90) and transfer painting (1924.71, illus., Glaesemer, *Colored Works*, p. 215). The interesting relation of this Klee to Schlemmer's renderings of costume for his *Triadic Ballet* was first suggested to me by Frau Dr. Kathalina von Walterskirchen of the

Klee Foundation in 1969-1970. Many other comparisons between Klee "puppets" and Schlemmer stage figures are doubtless to be found. Grohmann reports (Grohmann, *Klee*, p. 333) Klee's comment about some puppetlike drawing of 1938: "I must have learned that from Schlemmer." Christian Geelhaar's thoughts on the relevance to Klee of Schlemmer's stagework and "mechanism," expressed in his *Paul Klee and the Bauhaus* (esp. pp. 66-69, 81), run rather parallel to my own. His remarks, unlike mine, however, are primarily thematic or iconographic. See also David R. Burnett, "Klee as Senecio," *Art International* XXI, no. 6 (December 1977), p. 16.

32. Kornfeld, no. 101, illustrates the second state and describes the first state.

33. Illus., Glaesemer, *Colored Works*, p. 269.

34. Illus., Rudenstine, *Guggenheim Museum Paintings*, p. 551.

35. Illus., Glaesemer, *Colored Works*, p. 230.

36. See, for example, Rodchenko's depersonalized machinelike line in *Line Construction* of 1920 (illus., Gray, *Russian Experiment*, p. 214).

37. Marianne L. Teuber ("Zwei frühe Quellen zu Paul Klees Theorie der Form," in *Frühwerk*, pp. 261-296, esp. p. 288) discusses this "form dovetailing" (*Gestaltverzahnung*) in the context of the early literature of perception psychology, with which Klee may have been acquainted.

38. Hans Prinzhorn, *Bildnerei der Geisteskranken: Ein Beitrag zur Psychologie und Psychopathologie der Gestaltung* (1922). For Klee's discussion of this book with Lothar Schreyer, see Felix Klee, *Paul Klee*, pp. 182-183.

39. Illus., Gray, *Russian Experiment*, p. 227.

40. Naum Gabo, in a communication to the author, 1977. This work was probably that listed in the Galerie Van Diemen catalogue as no. 309, *Architectonic Project for an Electric Plant (for the Electrification of Russia)* (my translation). I am indebted to the late Naum Gabo for his interest in my inquiries. I must state in fairness, however, that he saw fewer similarities between his work and Klee's than I do.

41. Naum Gabo, to the author. Gabo recalled

Klee's remarkable openness to the newer non-objective trends of the day, such as Constructivism, expressed in their several friendly discussions of the 1920s.

Conclusion

1. Illus., Margaret Miller, ed. *Paul Klee* (3rd ed., 1946), p. 44.

2. Illus., ibid., p. 54.

3. Klee's first tentative definition of the separate elements appears in his "Creative Credo," written in 1918 (reprinted in Felix Klee, *Paul Klee* [1962], pp. 151-155). Klee's more highly developed theory of the elements is given in the lecture he read to the Jena Kunstverein in 1924 (reprinted, ibid., pp. 168-179). The elements and their separate characteristics are of course a central motif in all of his Bauhaus notes and lectures (as in Jürg Spiller, ed., *Paul Klee Notebooks: Volume 1: The Thinking Eye* [1961]).

4. For a specific comparison between a Klee painting and a Max Ernst, emphasizing the different symbolic purposes for which the blank space is employed, see the author's "Garten der Mysterien," in *Frühwerk*, pp. 240-244. I am indebted to Robert Goldwater's *Space and Dream* (1967), for its identification of space as a common concern in the diverse schools of the 1920s and '30s.

SELECTED BIBLIOGRAPHY

This bibliography includes only works cited, plus recent publications that bear directly on the subject of Paul Klee and Cubism. For more comprehensive bibliographies on Klee, see the monographs of Grohmann and Glaesemer.

Aichi Kunstmuseum, Nagoya, Japan. *Ausstellung: Paul Klee (1879-1940)*. Exhibition catalog. Nagoya, Japan: Aichi Kunstmuseum, 1969.

Ammann, Jean-Christophe. "Die Tunisien-Aquarelle Paul Klees von 1914." *Nachrichten Kunst* (Lucerne), II (December 1965).

August Macke: Aquarelle. Munich: Piper Verlag, 1958.

August Macke: Tunisian Watercolors and Drawings. Essays by Günter Busch and Walter Holzhausen. New York: Harry N. Abrams [1969].

Barr, Alfred H. *Picasso: Fifty Years of His Art*. New York: The Museum of Modern Art, 1946.

Berner Kunstmuseum. *Franz Marc: das graphische Werk*. Exhibition catalogue. Bern: Kunstmuseum, 1967.

Braque: Georges His Graphic Work. Introduction by Werner Hofmann. New York: Harry N. Abrams, 1961.

Buchheim, Lothar-Günther. *Der Blaue Reiter and die Neue Künstlervereinigung München*. Feldafing: Buchheim Verlag, 1959.

Burnett, David. *A Tribute to Paul Klee: 1879-1940*. Exhibition catalogue. Ottawa: The National Gallery of Canada, National Museums of Canada, 1979.

Chipp, Herschel B. *Theories of Modern Art*. Berkeley: University of California Press, 1968.

Comini, Alessandra. "All Roads Lead (Reluctantly) to Bern: Style and Source in Paul Klee's Early 'Sour' Prints." *Arts Magazine* 52 (September 1977), 105-111.

Cooper, Douglas. *The Cubist Epoch*. London: Phaidon Press in association with the Los Angeles County Museum of Art, Los Angeles, and the Metropolitan Museum of Art, New York, 1970.

Delaunay, Robert. "Über das Licht." Translated by Paul Klee. *Der Sturm* (Berlin), edited by Herwarth Walden. III, no. 144-145 (January 1913), 255-256.

Der Sturm (Gallery), Berlin. *Erster Deutscher Herbstsalon*. Introduction by Herwarth Walden. Exhibition catalogue. Berlin: Der Sturm, September 20—November 1, 1913.

Der Sturm, Wochenschrift (and Gallery), Berlin. *Zweite Ausstellung: Futuristen*. Exhibition catalogue. Berlin: Der Sturm, April 12—May 15, 1912.

Die erste Ausstellung der Redaktion Der Blaue Reiter. Exhibition catalogue. Munich: 1911-1912.

Drudi Gambillo, Maria, and Teresa Fiori, eds. *Archivi del Futurismo*. Rome: De Luca, 1958.

Duvignaud, Jean. *Klee en Tunisie*. Lausanne: La Bibliothèque des Art, 1980.

The Early Work of Aubrey Beardsley. Prefatory note by H. C. Marillier. London: John Lane, 1899.

Erdmann-Macke, Elisabeth. *Erinnerung an Au-*

gust Macke. Stuttgart: W. Kohlhammer Verlag, 1962.

Fagg, William. *The Webster Plass Collection of African Art*. Exhibition catalogue. London: The Trustees of the British Museum, 1953.

Fischer, Otto. *Das Neue Bild. Veröffentlichung der Neuen Künstlervereinigung München*. Munich: Delphin-Verlag, 1912.

Francastel, Pierre, ed. *Robert Delaunay: Du Cubisme à L'art Abstrait*. Paris: S.E.V.P.E.N., 1957.

Franciscono, Marcel. *Walter Gropius and the Creation of the Bauhaus in Weimar: The Ideals and Artistic Theories of Its Founding Years*. Urbana: University of Illinois Press, 1971.

———. "Paul Klee's Italian Journey and the Classical Tradition." *Pantheon*, XXXII, no. I (Winter 1974), 54-64.

———. "Paul Klees kubistische Druckgraphik," in *Paul Klee: Das graphische und plastische Werk*. Exhibition catalogue. Duisburg: Wilhelm-Lehmbruck-Museum der Stadt Duisburg, 1974, 46-56.

———. "Paul Klee in the Bauhaus: The Artist as Lawgiver." *Arts Magazine*, LII, no. 1 (September 1977), 122-127.

Fry, Edward F. *Cubism*. New York: McGraw-Hill Book Co. [1966].

Fumet, Stanislas. *Georges Braque*. N.p.: Maeght Editeur [1965].

Galerie Van Diemen, Berlin. *Erste Russische Kunstausstellung*. Exhibition catalogue. Berlin: Galerie Van Diemen, 1922.

Ganymed (Munich, Marées Gesellschaft), III (1921), 8f.

Geelhaar, Christian. *Paul Klee and the Bauhaus*. Greenwich, Conn.: New York Graphic Society, 1973

———. *Die Vorgeschichte der Tunisreise*. Bern. 1974.

———. "Journal intime oder Autobiographie?" in *Paul Klee: Das Frühwerk: 1883-1922*. Exhibition catalogue. Munich: Städtische Ga-

lerie im Lenbachhaus, December 1979—March 1980, 246-260.

Geiser, Bernhard. *Picasso Peintre-Graveur: Catalogue Illustré de l'Oeuvre Gravé et Lithographié 1899-1931*. Bern: By the author, 1933.

Giedion-Welcker, Carola. *Paul Klee*. London: Faber and Faber, 1952.

———. *Paul Klee in Selbstzeugnissen und Bilddokumenten*. Reinbek bei Hamburg: Rowohlt Taschenbuch Verlag, 1961.

Glaesemer, Jürgen. *Kunstmuseum Bern: Paul Klee Handzeichnungen I: Kindheit bis 1920*. Bern: Kunstmuseum, 1973.

———. "Paul Klees persönliche und künstlerische Begegnung mit Alfred Kubin," in *Paul Klee: Das Frühwerk: 1883-1922*, Exhibition catalogue. Munich: Städtische Galerie im Lenbachhaus, December 1979—March 1980, 63-97.

———. Die Kritik des Normalweibes. Zu Form und Inhalt im Frühwerk von Paul Klee," in *Paul Klee. Das graphische und plastische Werk*. Exhibition catalogue. Duisburg: Wilhelm-Lehmbruck-Museum der Stadt Duisburg, 1974, 38-46.

———. *Paul Klee: The Colored Works in the Kunstmuseum Bern*. Bern: Kunstmuseum Bern, 1976; English edition, 1979.

Golding, John. *Cubism: A History and an Analysis: 1907-1914*. Rev. American ed. Boston: Boston Book & Art Shop, 1968.

Goldwater, Robert. *Primitivism in Modern Art*. Rev. ed. New York: Random House, Vintage Books, 1967.

Goltz, Hans. Galerie neue Kunst, München. *Neue Kunst: Katalog der II. Gesamt-Ausstellung*. Exhibition catalogue. Munich: Neue Kunst, Hans Goltz, August-September 1913.

Goltz, Hans Kunsthandlung, München. *Die zweite Ausstellung der Redaktion Der Blaue Reiter: Schwarz-Weiss*. Exhibition catalogue. Munich: Hans Goltz Kunsthandlung, 1912.

Gordon, Donald E. *Modern Art Exhibitions: 1900-1916*. 2 vols. Munich: Prestel Verlag, 1974.

Gray, Camilla. *The Russian Experiment in Art:*

1883-1922. New ed. New York: Harry N. Abrams, 1971.

Grohmann, Will. *Kandinsky*. Paris: Editions "Cahiers d'Art," 1930.

———. *Paul Klee*. New York: Harry N. Abrams [1955].

———. *Paul Klee*. New York: Harry N. Abrams, 1967.

———. *Paul Klee Drawings*. New York: Harry N. Abrams, 1960.

The Solomon R. Guggenheim Museum, New York. *Paul Klee: 1879-1940*. Exhibition catalogue. New York: The Solomon R. Guggenheim Foundation, 1967.

———. *Selections from the Guggenheim Museum Collection: 1900-1970*. New York: The Solomon R. Guggenheim Foundation, 1970.

———. *Vasily Kandinsky 1866-1944*. Exhibition catalogue. New York: The Solomon R. Guggenheim Foundation, 1962.

———, in collaboration with the Pasadena Art Museum, Pasadena, Calif. *Paul Klee: 1879-1940*. Exhibition catalogue. New York: The Solomon R. Guggenheim Foundation, 1967.

Haftmann, Werner. *The Mind and Work of Paul Klee*. New York: Praeger Publishers, 1967.

———. *Painting in the Twentieth Century*. 2 vols. New York: Praeger Publishers, 1965.

Haus der Kunst, München. *Die Maler am Bauhaus*. Exhibition catalogue. Munich: Prestel Verlag, 1950.

———. *Paul Klee*. Exhibition catalogue. Munich: Haus der Kunst, 1971.

Hausenstein, Wilhelm. *Barbaren und Klassiker: Ein Buch von der Bildnerei Exotischer Volker*. 2d ed. Munich: Piper Verlag, 1923.

———. *Kairouan oder eine Geschichte vom Maler Klee und von der Kunst dieses Zeitalters*. Munich: Kurt Wolff Verlag, 1921.

Haxthausen, Charles Werner. "Paul Klee: The Formative Years." Ph.D. dissertation, Columbia University, 1976. (New York: Garland Publishing, 1981.)

———. "Klees künstlerisches Verhältnis zu Kandinsky während der Münchner Jahre," in *Paul Klee: Das Frühwerk 1883-1922*. Exhibition catalogue. Munich: Städtische Ga-

lerie im Lenbachhaus, December 1979—March 1980, 98-130.

Henniger, Gerd. "Paul Klee und Robert Delaunay." *Quadrum*, no. 3 (Summer 1957), 137-141.

Hofmann, Werner. *Paul Klee: Traumlandschaft mit Mond*. Frankfurt: Insel-Verlag, 1964.

Hofstätter, Hans H. "Symbolismus und Jugendstil im Frühwerk von Paul Klee." *Kunst in Hessen und am Mittelrhein*, V (1965), 97-118.

Hope, Henry R. *Georges Braque*. New York: The Museum of Modern Art, 1949.

Huggler, Max. "Die Kunsttheorie von Paul Klee." Separatdruck aus der *Festschrift Hans R. Hahnloser*, 425-441. Basel/Stuttgart: 1961.

———. *Paul Klee*. Frauenfeld, Switzerland: Verlag Huber, 1969.

Hutton-Hutschnecker Gallery, New York. *Kandinsky, Franz Marc, August Macke: Drawings and Watercolors*. Exhibition catalogue. New York: Hutton-Hutschnecker Gallery, 1969.

Jaffe, H.L.C. *de Stijl: 1917-1931*. Amsterdam: J. M. Meulenhoff, 1956.

Janson, H. W., *History of Art*. Englewood Cliffs, N.J.: Prentice-Hall and Harry N. Abrams, 1962.

Jordan, Jim M. "Paul Klee and Cubism, 1912-1926." Ph.D. dissertation, The Institute of Fine Arts, New York University, 1974. (Ann Arbor, Michigan: University Microfilms, 1974.)

———. "The Structure of Paul Klee's Art in the Twenties: From Cubism to Constructivism." *Arts Magazine* 52, no. 1 (September 1977), 152-157.

———. "Garten der Mysterien: Die Ikonographie von Paul Klees expressionistischer Periode," in *Paul Klee: Das Frühwerk: 1883-1922*. Exhibition catalogue. Munich: Städtische Galerie im Lenbachhaus, December 1979—March 1980, 227-245.

Judkins, Winthrop. "Toward a Reinterpretation of Cubism." *The Art Bulletin*, XXX (December 1948), 270-278.

Kandinsky, Wassily. *Über das Geistige in der Kunst* [*Concerning the Spiritual in Art*]. Munich: Piper Verlag, 1912; rev. English ed., New York: George Wittenborn, 1947.

———. and Franz, Marc, eds. *Der Blaue Reiter*. Munich: Piper Verlag, 1912; documentary ed., edited by Klaus Lankheit, Munich: Piper Verlag, 1965; English ed., New York: Viking, 1974.

Klee, Felix. *Paul Klee*. New York: George Braziller, 1962.

———. *Paul Klee par lui-même*. N.p.: Les Libraires Associés, 1963.

Klee, Paul. *Beiträge zur bildnerischen Formlehre*. Facsimile. Herausgegeben von Jürgen Glaesemer. Basel: Schwabe & Co., 1979.

———. *Briefe an die Familie: 1893-1940*. Herausgegeben von Felix Klee. 2 vols. Cologne: DuMont Buchverlag, 1979.

———. *The Diaries of Paul Klee, 1898-1918*. Edited, with an Introduction, by Felix Klee. Berkeley: University of California Press, 1964.

———. "Die Ausstellung des Modernen Bundes im Kunsthaus Zürich." *Die Alpen* (Bern), VI (August 1912), 696-704.

———. "München (Literatur und Kunst des Auslandes)." *Die Alpen* (Bern), VI (November 1911), 184-185.

———. *Pädagogisches Skizzenbuch* [*Pedagogical Sketchbook*]. Munich: Verlag Albert Langen, Bauhausbücher 2, 1925; English ed., introduction and translation by Sibyl Moholy-Nagy, New York: Praeger Publishers, 1953.

———. *Schriften: Rezensionen und Aufsätze*. Herausgegeben von Christian Geelhaar. Cologne: DuMont Buchverlag, 1976.

———. *Tagebücher von Paul Klee 1898-1918*. Cologne: Verlag M. DuMont Schauberg, 1957.

Köln Museen derr Stadt. *Paul Klee: Das Werk der Jahre 1919-1933*. Exhibition catalogue. Cologne: Museen der Stadt Köln, Kunsthalle Köln, April 11—June 4, 1979.

Kornfeld, Eberhard W. *Verzeichnis des graphischen Werkes von Paul Klee*. Bern: Verlag Kornfeld und Klipstein, 1963.

———. *Paul Klee: Bern and Surroundings: Watercolors and Drawings, 1897-1915*. Bern: Stämpfli & Cie., 1962.

Krannert Art Museum, University of Illinois, Champaign. *Paintings, Drawings and Prints by Paul Klee from The James Gilvarry Collection*. Exhibition catalogue. Champaign, Illinois: Krannert Art Museum, University of Illinois, 1964.

Kunsthaus Zürich. *Sammlung Sir Edward und Lady Hulton, London*. Exhibition catalogue. Zurich: Kunsthaus, 1967.

Kunstmuseum Bern. *Hermann und Margrit Rupf-Stiftung*. Bern: Kunstmuseum, 1969.

Kunstmuseum Winterthur. *Kubismus, Futurismus, Orphismus in der Schweizere Malerei*. Exhibition catalogue. Winterthur: Kunstmuseum, 1970.

Kunstsammlung Nordrhein-Westfalen, Düsseldorf. *Paul Klee*. 2d rev. ed., Düsseldorf: Kunstsammlung Nordrhein-Westfalen, 1964.

Lankheit, Klaus. "Bibel-Illustrationen des Blauen Reiters." *Anzeiger des Germanischen Nationalmuseums* (Nuremberg), Ludwig Grote zum 70. Geburtstag, 1963, 199-207.

———, ed. *Franz Marc im Urteil seiner Zeit*. Cologne. Verlag M. DuMont Schauberg, 1960.

———. *Franz Marc: Katalog der Werke*. Cologne. DuMont Schauberg, 1970.

Lapaire, Claude. *Schweizer Museumsführer*. 2d rev. ed. Bern: Verlag Paul Haupt, 1969.

The Later Work of Aubrey Beardsley. London: John Lane, The Bodley Head, 1912; first published November 1900; reprinted October 1911.

Laxner, Uta. *Stilanalytische Untersuchungen zu den Aquarellen der Tunisreise 1914: Macke, Klee, Moilliet*. Ph.D. dissertation, Rheinischen Friedrich-Wilhelms-Universität, Bonn, 1967.

Leonard Hutton Galleries, New York. *Fauves and Expressionists*. Exhibition catalogue. New York: Leonard Hutton Galleries, 1968.

Levine, Frederick S. "The Iconography of Franz Marc's Fate of the Animals." *The Art Bulletin*, LVIII (June 1976), 269-277.

Lissitzky-Küppers, Sophie. *El Lissitzky: Life: Letters: Texts*. Greenwich, Conn.: New York Graphic Society, 1968.

Loga, Valerian von. *Francisco de Goya*. Berlin:

G. Grote'sche Verlags-buchhandlung, 1903.

Long, Rose-Carol Washton. "Kandinsky and Abstraction: The Role of the Hidden Image." *Artforum*, X (June 1972), 42-49.

Macke, August, and Franz Marc. *August Macke, Franz Marc Briefwechsel.* Cologne: Verlag M. DuMont Schauberg, 1964.

Marc, Franz. *Briefe, Aufzeichnungen, Aphorismen.* 2 vols. Berlin: Casirer, 1920.

———. *Briefe 1914-1916 aus dem Felde.* 5th ed. Berlin: Rembrandt-Verlag, 1959.

Meier-Graefe, Julius. *Impressionisten.* Munich: Piper Verlag, 1907.

———. *Vincent Van Gogh.* Munich: Piper Verlag, 1912.

Meyer, Franz. *Marc Chagall.* New York: Harry N. Abrams [1963].

Miller, Margaret, ed. *Paul Klee.* 3rd ed. New York: The Museum of Modern Art, 1946.

Moholy-Nagy, László. *The New Vision: 1928.* 4th rev. ed. New York: George Wittenborn, 1947.

Musée national d'Art Moderne, Paris. *Paul Klee.* Exhibition catalogue. Paris: Réunion des Musées Nationaux, 1969.

Overbeck-Gesellschaft, Lübeck. *Georges Braque: Bewegung, Ruhe und Reife: Das graphische Werk.* Exhibition catalogue. Lübeck: Overbeck-Gesellschaft, 1964.

Pan (Berlin), I, no. 3 (September-October 1895), 193.

Paul Klee: Bern and Surroundings: Watercolors and Drawings: 1897-1915. Bern: Stämpfli & Cie., 1962.

Paul Klee-Stiftung: Verzeichnis der Werke. Bern: Berner Kunstmuseum, n.d.

Petitpierre, Petra. *Aus der Malklasse von Paul Klee.* Bern: Bentelli-Verlag, 1957.

Pierce, James Smith. "Paul Klee and Primitive Art." Ph.D. dissertation, Harvard University, 1961. (New York: Garland Publishing, 1976.)

Plant, Margaret. *Paul Klee: Figures and Faces.* London: Thames and Hudson, 1978.

Ponente, Nello. *Klee.* Geneva: Skira, 1960.

Prinzhorn, Hans. *Bildnerei der Geisteskranken: Ein Beitrag zur Psychologie und Psychopathologie der Gestaltung.* Berlin: Verlag Julius Springer, 1922.

Raynal, Maurice. *From Picasso to Surrealism.* Geneva: Skira, 1950.

———. *Picasso.* Paris: Skira, 1959.

Read, Herbert. *Paul Klee.* Berlin: Safari-Verlag, 1960.

Roethel, Hans Konrad. *The Blue Rider.* New York: Praeger Publishers, 1971.

———. *Kandinsky: Das graphische Werk.* Cologne: Verlag M. DuMont Schauberg, 1970.

———. *Klee in München.* Bern: Stämpfli & Cie., 1971.

Rohe, M. K. "Bewegungen in der neueren Malerei und ihre Aussichten." *Die Kunst für Alle* (Munich), XXVIII (April 1, 1913), 292-305.

———. "Pablo Picasso." *Die Kunst für Alle* (Munich), XXVIII (May 15, 1913), 377-383.

Rosenblum, Robert. *Cubism and Twentieth-Century Art.* New York: Harry N. Abrams, 1960.

Rosenthal, Mark. "Der Held mit dem Flügel," in *Paul Klee: Das graphische und plastische Werk.* Exhibition catalogue. Duisburg: Wilhelm-Lehmbruck-Museum der Stadt Duisburg, 1974, 30-38.

———. "The Myth of Flight in the Art of Paul Klee." *Arts Magazine* LV, no. 1 (September 1980), 90-94.

Roters, Eberhard. *Maler am Bauhaus.* Berlin: Rembrandt Verlag, 1965.

Rubin, William. *Picasso in the Collection of the Museum of Modern Art.* New York: The Museum of Modern Art, 1972.

Rubin, William, and Carolyn Lanchner. *Andre Masson.* New York: The Museum of Modern Art, 1976.

Rudenstine, Angelica Zander. *The Guggenheim Museum Collection: Paintings 1880-1945.* 2 vols. New York: The Solomon R. Guggenheim Foundation, New York, 1976.

San Lazzaro, Gualtieri di. *Klee.* New York: Praeger Publishers, 1957.

Schmied, Wieland. *Der Zeichner Alfred Kubin.* Salzburg: Residenz Verlag, 1967.

Schreyer, Lothar. *Erinnerungen an Sturm und Bauhaus.* Munich: Albert Langen & Georg Müller, 1956.

Selz, Peter. *German Expressionist Painting.* Berkeley: University of California Press, 1957.

Shapiro, Maurice L. "Klee's Twittering Machine." *The Art Bulletin,* L (March 1968), 67-69.

Soby, James Thrall. *The Prints of Paul Klee.* New York: Curt Valentin, 1945.

Spiller, Jürg, ed. *Paul Klee: Form und Gestaltungslehre: Band II: Unendliche Naturgeschichte.* Basel: Schwabe Verlag, 1970.

————, ed. *Paul Klee Notebooks: Volume 1: The Thinking Eye.* London: Lund Humphries; New York: George Wittenborn, 1961.

Staatliche Kunsthalle, Baden-Baden. *Der Frühe Klee.* Exhibition catalogue. Baden-Baden: Staatliche Kunsthalle, 1964.

Städtische Galerie im Lenbachhaus, München. *Paul Klee: Das Frühwerk: 1883-1922.* Exhibition catalogue. Munich: Städtische Galerie im Lenbachhaus, December 1979—March 1980.

Stedelijk Museum, Amsterdam, and Carnegie Institute, Pittsburgh. *Vincent van Gogh.* Exhibition catalogue. Amsterdam: Stedelijk Museum, 1962.

Suter-Raeber, Regula. "Paul Klee: Der Durchbruch zur Farbe und zum abstrakten Bild," in *Paul Klee: Das Frühwerk 1883-1922.* Exhibition catalogue. Munich: Städtische Galerie im Lenbachhaus, December 1979—March 1980, 131-165.

Tavel, Hans Christophe von. "Von 50 Jahren: Reise nach Kairouan." Separatdruck aus *Mitteilungen* (Kunstmuseum Bern), no. 69 (March 1964), 2-5.

Taylor, Joshua C. *Futurism.* New York: The Museum of Modern Art, 1961.

Teuber, Marianne L. "Zwei frühe Quellen zu Paul Klees Theorie der Form," in *Paul Klee: Das Frühwerk: 1883-1922.* Exhibition catalogue. Munich: Städtische Galerie im Lenbachhaus, December 1979—March 1980, 261-296.

Vishny, Michele. "Paul Klee and the War: A Stance of Aloofness." *Gazette des Beaux-Arts,* 120 (December 1978), 233-243.

Vom Fels zum Meer (Stuttgart), IV (October 1884–March 1885), XV (October 1895–March 1896).

Vriesen, Gustav. *August Macke.* 2d rev. ed. Stuttgart: W. Kohlhammer Verlag, 1957.

————, and Max Imdahl. *Robert Delaunay: Light and Color.* New York: Harry N. Abrams, 1967.

Wedderkop, H. von. *Paul Klee.* Leipzig: Klinkhardt & Biermann, 1920.

Werckmeister, O. K. "The Issue of Childhood in the Art of Paul Klee." *Arts Magazine* 52, no. 1 (September 1977), 138-151.

————. "Klee im Ersten Weltkrieg," in *Paul Klee: Das Frühwerk: 1883-1922.* Exhibition catalogue. Munich: Städtische Galerie im Lenbachhaus, December 1979—March 1980, 166-226.

Wijsenbeek, L.J.F. *Piet Mondrian.* Greenwich, Conn.: New York Graphic Society, 1968.

Wilhelm-Lehmbruck-Museum der Stadt Duisburg. *Paul Klee und seine Malerfreunde.* Exhibition catalogue. Duisburg: Wilhelm-Lehmbruck-Museum, 1971.

Wingler, Hans Maria. *The Bauhaus.* Cambridge, Mass.: MIT Press, 1969.

Zahn, Leopold. *Paul Klee: Leben, Werk, Geist.* Potsdam: Kiepenheuer Verlag, 1920.

INDEX

**Library of Congress Cataloging
in Publication Data**

Jordan, Jim M.
 Paul Klee and cubism.

 Bibliography: p.
 Includes index.
 1. Klee, Paul, 1879-1940. 2. Cubism.
I. Title.
N6888.K55J67 1984 760'.092'4
83-13898
ISBN 0-691-04025-7